WILD THING

BY THE SAME AUTHOR

EDVARD MUNCH
Behind the Scream

STRINDBERG
A Life

I AM DYNAMITE!
A Life of Nietzsche

WILD THING

A LIFE OF
PAUL GAUGUIN

SUE PRIDEAUX

W. W. Norton & Company
Independent Publishers Since 1923

First published in Great Britain by Faber & Faber Limited in 2024.

Copyright © 2024 by Sue Prideaux

All rights reserved
Printed in China
First American Edition 2024

For information about permission to reproduce selections from this book,
write to Permissions, W. W. Norton & Company, Inc.,
500 Fifth Avenue, New York, NY 10110

For information about special discounts for bulk purchases, please contact
W. W. Norton Special Sales at specialsales@wwnorton.com or 800-233-4830

Manufacturing by Toppan
Production manager: Julia Druskin

ISBN 978-1-324-02042-4

W. W. Norton & Company, Inc.
500 Fifth Avenue, New York, NY 10110
www.wwnorton.com

W. W. Norton & Company Ltd.
15 Carlisle Street, London W1D 3BS

1 2 3 4 5 6 7 8 9 0

In loving memory of Felicity Bryan,
who inspired me, and so many.

CONTENTS

List of Illustrations	ix
Preface	xiii
1: Revolutionary Road	1
2: 'I am a savage from Peru'	16
3: The Outsider	26
4: Becoming	39
5: Impressionism and Bourgeois Bliss	55
6: Lost	70
7: Evolution of a Dream	90
8: 'I've never painted so clearly'	106
9: Vincent. 'My God, what a day!!'	122
10: The March of Science	145
11: A Throw of the Dice	170
12: Poisoned Paradise	193
13: Tehamana	222
14: 'I hate nullity, the halfway'	248
15: Pent Up in Paris	272
16: Return to Tahiti	285
17: Reinventions	308
18: Koké	324
19: The Barefoot Lawyer	342
Acknowledgements	365
Select Bibliography	367
Notes	371
Permissions Credits	387
Index	389

ILLUSTRATIONS

Gauguin, *Aline*, 1889–93	7
Peruvian Moche fox warrior jug, c. AD 100–800	13
Gauguin, *The Loss of Virginity*, 1890–1	14
Édouard Manet, *Olympia*, 1863	29
The Statue of Liberty by Bartholdi rises over Paris in the 1880s	59
Gauguin, bust of Emil, 1877–8	61
Gauguin, bust of Mette, 1877	61
Gauguin, *Woman Sewing*, 1880	65
Gauguin, *Mette in Evening Dress*, 1884	73
Gauguin, *Clovis Asleep*, 1884	76
Gauguin, *Self-Portrait at the Easel*, 1885	81
Gauguin, *Round Dance of the Breton Girls*, 1888	88
Gauguin, *The Moulin du Bois d'Amour Bathing Place*, 1886	96
Gauguin, *Breton Women Chatting*, 1886	99
Gauguin, ceramic pots, 1886–8	102
Gauguin, *Fruit Porters at Turin Bight*, 1887	112
Gauguin, *The Vision of the Sermon*, 1888	119
Gauguin, *Self-Portrait Dedicated to Van Gogh, Les Misérables*, 1888	124
Van Gogh, *Self-Portrait Dedicated to Paul Gauguin*, 1888	125
Van Gogh, *The Bedroom*, 1888	128
Gauguin, *Les Alyscamps*, 1888	131
Van Gogh, *Falling Leaves (Les Alyscamps)*, 1888	132
Gauguin, *Night Café, Arles*, 1888	136
Van Gogh, *The Night Café*, 1888	137
Gauguin, *Sunflowers on a Chair*, 1901	143
Gauguin, *Self-portrait in the Form of a Jug*, 1889	147
Paul Sérusier, *The Talisman*, 1888	158
Gauguin, *Exotic Eve*, 1889–90	162

ILLUSTRATIONS

Gauguin, portraits on the doors of the Buvette de la Plage, 1889	166
Gauguin, *In the Waves/Ondine*, 1889	171
Gauguin, *Portrait of Stéphane Mallarmé*, 1891, etching	181
Emil, Gauguin and Aline in Copenhagen, 1891	186
Gauguin, *Arearea*, 1892	190
King Pomare V	204
The handover of the flag of the protectorate to Governor Lacascade by Prince Hinoi on 18 June 1881	204
Gauguin, *Suzanne Bambridge*, 1891	207
Gauguin, *Vahine no te tiare (Woman with a Flower)*, 1891	212
Gauguin, *The Man with the Axe*, 1891	215
Gauguin, *Ia orana Maria (Hail Mary)*, 1891	220
Gauguin, *Atiti*, 1892	223
Gauguin, *Matamua (In Olden Times)*, 1892	231
Thought to be a photograph of Tehamana	234
Gauguin, *Manaò tupapaú (Spirit of the Dead Watching)*, 1892	242
Gauguin, *Merahi metua no Tehamana (Tehamana Has Many Parents)*, 1893	246
Gauguin, *Paris in the Snow*, 1894	263
Gauguin, *Maruru* woodcut from the *Noa Noa Suite*	264
Gauguin, *Aita tamari vahine Judith te parari (The Child-Woman Judith Is Not Yet Breached)*, 1893	266
Gauguin, *Oviri*, goddess of mourning, 1894	274
Auckland Museum, c.1880	286
Recreation of Gauguin's hut on Hiva Oa	289
Gauguin's teeth discovered in the well of his house in Hiva Oa in 2000	289
Gauguin, *Te Arii Vahine (The King's Wife)*, 1896	293
Gauguin, *Nave nave mahana (Delicious Days)*, 1896	294
Gauguin, *Nevermore*, 1897	296
Gauguin, *Self-Portrait (Near Golgotha)*, 1896	298
Gauguin, *Where Do We Come From? What Are We? Where Are We Going?*, 1897–8	304
Gauguin, *Portrait of a Young Girl. Vaïte (Jeanne) Goupil*, 1896	309

Gauguin, *The White Horse*, 1898	310
Gauguin, *Ta matete (In the Market)*, 1892	315
Reproduction of Gauguin's house in Atuona	329
Gauguin, five decorative panels carved for the entrance of Maison du Jouir, 1901–2	338
Gauguin, *Père Paillard (Father Lechery)*, 1902	338
Gauguin, *Thérèse*, 1902	339
Gauguin, *Young Girl with a Fan*, 1902	344
Tohotaua in Gauguin's studio, 1902	345
Gauguin, *The Sorcerer*, 1902	347
Gauguin, *Barbarian Tales*, 1902	348
Gauguin, *Self-Portrait*, 1903	361

PREFACE

In 1903, Paul Gauguin died in Atuona on the tiny island of Hiva Oa in French Polynesia. He had lived his last three years there in a hut constructed mostly of bamboo canes and pandanus leaves. Such huts do not have a long life. The location of the hut was well known, and in 2000 the mayor of Atuona decided to clear the site and build a replica.

While the ground was being cleared, a well was discovered close to the hut. This was where Gauguin had stored his drinks to keep them cool. He rigged up a contraption like a stout fishing rod and line poking out of his studio window. When he was thirsty, he could simply haul up a bottle. A century on, the well was completely choked with rubbish, including a glass jar containing four heavily decayed human teeth.

Forensic examinations by the Human Genome Project at Cambridge proved the teeth were Gauguin's. Further tests were carried out for cadmium, mercury and arsenic, the standard treatment for syphilis at the time. All leave mineral traces in the teeth and Gauguin's teeth showed no trace of any of them. If the story of Gauguin as the bad boy who spread syphilis around the South Seas was not true, what other myths might we be holding on to?

In 2020, the manuscript of Gauguin's most important written work, *Avant et après*, which had been missing for a century, suddenly reappeared, thanks to the UK government's Acceptance in Lieu scheme. The long-lost manuscript, now in London's Courtauld Institute, consists of two hundred pages, handwritten during the last two years of Gauguin's life. Part memoir, part last testament, its sweeping narrative reveals fundamental insights into his life, relationships, thoughts, fears and beliefs.

The common assumption that Gauguin was a colonialist becomes more complicated as his manuscript excoriates colonialism and includes the text of some of the letters he wrote pointing out cases of injustice and corruption

PREFACE

in the French colonial government of the Polynesian islands and pleading for greater justice and lower taxation of the indigenous people. He writes of his strong belief that women should be treated as equals. He loves Jesus Christ but hates the Church. We learn all this and he tells us silly stories, and much more.

The manuscript went missing soon after his death. A messed-about version purporting to be authentic was published as *Paul Gauguin's Intimate Journals* in 1918. Subsequent books and biographical assumptions have been based upon it. Now we have the real thing.

In 2021, around the same time as the happy reappearance of the *Avant et après* manuscript, the Wildenstein Plattner Institute brought out the long-awaited final part of the catalogue raisonné of Gauguin's works covering the paintings between 1891 and 1903.

Gauguin's art was, and is, hugely influential. He smashed the established Western canon, ignoring rules handed down over the centuries, trading Renaissance picture-box perspective for multipoint perspective, distorting scale and privileging decorative line over believable solidity, employing colour emotionally rather than realistically and pioneering the assimilation of indigenous themes into Western art: his depictions of the Holy Family as indigenous Polynesians had Paris in uproar. His conceptual approach and stylistic simplification fanned out through Henri Matisse and the Fauves through Bonnard, Vuillard and the Nabis, influencing Edvard Munch and also Ludwig Kirchner, the leading figure of Die Brücke group of German Expressionists. Gauguin's Polynesian pieces led Picasso to explore African art, from which evolved Cubism. It's an enormous legacy.

The recent appearance of so much new material coinciding with contemporary debate around his troubling reputation made it seem important to re-examine Gauguin's life; not to condemn, not to excuse, but simply to shed new light on the man and the myth.

1

REVOLUTIONARY ROAD

Shortly after his first birthday, Paul Gauguin was bundled aboard a ship called the *Albert*, to sail some 12,000 miles from the French port of Le Havre to Peru. The year was 1849, and France was no place for outspoken radicals such as Gauguin's parents. Charles-Louis Napoleon had become president of the French Republic and it didn't take political genius to foresee that he would segue smoothly from the post of president to that of Emperor Napoleon III of France. Gauguin's father, Clovis, was an anti-Bonapartist journalist determined to continue the republican fight from Peru, where he planned to start a newspaper on the back of an excellent connection: Simón Bolívar, who overthrew Spanish rule in much of South America and had Bolivia named after him, had been a family friend. Gauguin's mother, Aline, was also a 'person of danger' on the list of the French Republic's spies and secret police. Aline had not had much time recently to be a national danger. Two years previously, she had given birth to Gauguin's elder sister Marie, and then Gauguin himself had come along. Her hands had been more than full of babies. But sometimes symbols adhere more firmly to particular names than to their recent activities and Aline Gauguin had inherited the symbolic mantle of firebrand feminist and proto-Communist from her mother Flora Tristan.

Karl Marx met and admired Flora Tristan, whose book advocating an international workers' movement, *L'Union ouvrière*, was published four years before his own *Communist Manifesto* calling for the same. A statue of Flora stands in Paris, where she also has a square named after her, and a women's refuge. She has become an icon of the French feminist movement and in 1984 she was honoured with a postage stamp. The philosopher Proudhon called her a genius, and the conservative French press of the time nicknamed her Madame la Colère, Madame Anger. To her grandson Paul Gauguin, she was a heroine; he described her as a beautiful socialist-anarchist bluestocking who probably never learned to cook, ardent and utterly adorable.[1]

By the time he was born, she had been dead four years, but there is no doubt that the example of her moral fearlessness spurred him on to wage his own stubborn political crusades.

Gauguin is chiefly known for his Polynesian paintings, the first European pictures to turn their back on the classical and neoclassical ideals on which the Western comprehension of beauty and culture was founded, to celebrate instead a different beauty: the beauty of an indigenous people and their culture. It is less well known that while Gauguin was creating the paintings that gave visual shape to this most enchanting and exotic Eden, he was infuriating Polynesia's French colonial administrators by fighting for the native Polynesians' rights against the injustices of their French colonial governors. In Tahiti, he started his own newspaper and wrote satirical articles for the magazine *Les Guêpes* (*The Wasps*), delivering sting after sting on the fat flank of the corrupt French administration that ruled over the colony, and lampooning them in merciless cartoons. But Gauguin's political activism didn't stop at journalism; he also acted as an advocate for Polynesians in the French colonial courts, demanding justice for them against the high-handed colonial administrators, the corpulent robots with idiotic faces, who governed them oppressively and taxed them mercilessly.

Gauguin credited his grandmother Flora Tristan not only for his own lifelong readiness to battle for the underdog, but also for his talent as a painter. No discernible artistic red thread ran down the family bloodline until Flora came along. Born in 1803, she was as sketchily educated as almost all girls were at the time, but Flora understood line, and had an exceptional eye for colour. This was a commercially valuable talent in the early decades of the nineteenth century when black-and-white prints and engravings draganchored the racy and influential stories they were meant to be illuminating in magazines and newspapers. Coloured-in images brought illustrations a step closer towards 'realism' and the excitement of immediacy. In 1819, aged fifteen, Flora was apprenticed to the French artist and printmaker André Chazal, who ran a commercial printing business and sold coloured prints of famous artworks. Chazal fell in love. She was seen as exotic, otherworldly. 'She dressed simply. Her eyes were full of the fire of the East. One had only to see her curled up in her armchair like a snake to know she was of remote

origin, the daughter of sunbeams and shadows.'² They married, had three children, and became part of Paris's pre-Impressionist artistic avant-garde whose leader Eugène Delacroix lived a couple of doors down from them in Rue Notre-Dame-de-Lorette. Life promised a satisfying bohemian existence, but Chazal was a violent man and an incurable gambler. The more money he lost, the more violent and unreasonable he became. When there was no money to pay the rent and feed the family he told Flora not once, but repeatedly, to go out on the street and get money by prostituting herself. This was insupportable. She left, and found a job as a shop assistant. At that time, French law recognised only the father's rights to the children, but Flora fought for custody. On discovering that Chazal had sexually abused their daughter Aline (Gauguin's mother), Flora brought charges of incest. She was awarded custody of Aline and she changed her own and her children's surnames from Chazal to her maiden name, Tristan. Chazal now became obsessed. He made a detailed drawing of her tombstone. He bought a brace of pistols and spent the next four years stalking and harassing Flora and Aline, jumping out at them suddenly on the street, or materialising mysteriously at a nearby café table, stroking his pistols. Finally in September 1838, he tried to kill Flora, by shooting her. She survived, but the ball was lodged three centimetres from her heart, too close to be safely removed. It remained embedded in her breast for the rest of her life. Chazal was tried for attempted murder and sentenced to twenty years' hard labour.

After this, one might imagine that Flora would be thrilled to retire into quiet domesticity. On the contrary. Her own struggles spurred her on to right the larger injustices of the world around her, which she identified as the problems of human exploitation and degradation engendered by the galloping success of the Industrial Revolution. Ideals to the fore, Flora put her daughter Aline into what Flora deemed was an excellent republican boarding school to ensure that she should never have to rely on a husband for a living but could make her way in the world. Flora took full advantage of the notoriety gained from her two sensational court cases to turn herself into an investigative writer and reporter, addressing the issues closest to her heart: equal education and equal remuneration for women, workers' rights and universal suffrage. In 1840 she travelled to London, where she attended a secret

meeting of the Chartists as they prepared to present their national petition to Parliament demanding universal suffrage.

Investigating England further, Flora found it ridiculous that under Queen Victoria, the government of Great Britain received 'on its knees' the orders of a woman, but would not allow women to watch its proceedings.[3] Incensed, she disguised herself as a man to get into the Houses of Parliament, where she heard the Duke of Wellington, the hero who had defeated Napoleon, drawling out a lifeless speech, after which he stretched himself out to sprawl on a bench in an attitude that reminded her of a horse with its legs in the air.

At that time, the problem of prostitution in London was no better or worse than in any other great city, but it was in child prostitution that London really excelled. The Society for the Prevention of Juvenile Prostitution estimated that there were between thirteen and fourteen thousand girl- and boy-prostitutes between the ages of ten and thirteen, a number supported by police figures. Madame la Colère found it utterly incomprehensible that Queen Victoria, a monarch of her own sex, a wife and mother, could preside over such a situation. Once again, she dressed up to see for herself, this time in the finery of the profession, and was terrified by the violence of the men who approached her for sex, and the murderous threats of the weapon-wielding brothel-keepers and pimps who simply wanted her off their profitable patch. She visited many of the terrible brothels known as 'finishes' in the protective company of Mr Talbot, secretary of the Society for the Prevention of Juvenile Prostitution, who was presumably masquerading as her pimp. They spent long hours witnessing scenes of horror revealing the paying customers as far more interested in the sadistic humiliation of the poor enslaved creatures than anything that could even remotely be described as pleasurable or erotic. 'Human beings cannot descend lower,' she wrote, and concluded that within the unnatural and inhuman environment of the teeming, overcrowded city, brothels had become torture chambers within which human beings enacted terrible revenge on the violations of the principles of humanity.[4] She named London 'Monster City' in her journal, and made the cutting observation that the British government possibly saw the annual loss of some ten thousand

children to prostitution and resulting early death as a useful contribution to their Malthusian policy of limiting population growth.

A woman before her time, though her books were successful, and her articles read, Flora Tristan never had a party, or even political followers. On returning home to France, she undertook a crusading tour of French cities, trying to rouse factory workers to unite in a fight for their basic human rights. She died during her lonely tour aged forty-one, her life probably shortened by the pistol ball lodged so close to her heart. Socialist and rationalist to the last, she stipulated in her will that her body be used in the cause of medical science; following dissection, it should be thrown into the common pit. Four years after Flora's death, and four months after her daughter Aline had given birth to Paul Gauguin, the workers of Bordeaux raised a monument to Flora, engraved with the French Revolution's historic rallying cry *Liberté – Égalité – Fraternité* updated by the additional word so threatening to the French State – *Solidarité*. No wonder her daughter felt it politic to flee France.

In far-off Peru, Flora's paternal family, the Tristán-y-Moscosos, had swindled Flora out of a family inheritance. This was the material reason Aline and Clovis Gauguin chose it as their destination. Aline was going to claim her mother's birthright. It was a long voyage. The Panama Canal had not yet been dug. In thirty years' time, Paul Gauguin himself would pick up a shovel to work on its construction, but for now he was taking his first tottering baby steps on the bucking and swaying ship that, having crossed the Atlantic Ocean, had to sail all the way down the east coast of South America and most of the way up the other side again, to get to Aline's family in Lima.

The *Albert* was not a comfortable passenger ship. It was a small, square-rigged two-master brig, the speediest type of merchant ship of its time. Captains of such ships were set in a perpetual circular race against each other to be first to deliver their cargoes before their perishable goods perished, or rival captains beat them to it and spoiled the market for the stuff they were hoping to sell. While the captain of the *Albert* was running his commercial race, Gauguin's father Clovis saw the voyage as something quite else, something idealistic and beautiful. He was taking his family back to a pre-industrial country, to a new dawn in whose light he might fight for modern

democratic values. That his compassionate fight would be financed by his wife's family's immense riches derived from slave labour – the pre-industrial equivalent of machine-led profitability – does not seem to have been a worry.

The atmosphere on board became thicker and thicker with antagonism between Clovis and the captain, who lusted after Aline. She was an extraordinarily direct and appealing person, as we see from Gauguin's portrait. Slightly built, dark-haired and dark-eyed, Aline never lost a sense of self-worth and self-determination, despite being abused by her father and having spent her childhood parked in institutions.

While her mother had been out saving the world, Aline had been left in the guardianship of the novelist George Sand, who didn't much like Flora but took her duties towards the child Aline sufficiently seriously to keep an eye on her development from a distance. A fiercely independent spirit, Aline's qualities of candour, receptiveness and optimism made her devastatingly attractive to the rough, tough sea captain, who pursued Aline openly, to the impotent fury of Clovis. They could hardly settle the matter in the usual way: a duel on board guaranteed awkward consequences.

After two and a half months at sea, they reached Tierra del Fuego at the southernmost tip of Chile, a region of terrible arctic beauty where the *Albert* had to thread through the intricate glacier-sheared channels of the Straits of Magellan. At last, they were to be allowed to go ashore, albeit briefly, during the ship's re-provisioning at the ominously named Port Famine. Aline bundled the children into almost all their clothes at once, excitement fuelled by the godforsaken landscape of snow-capped mountains rising from ice- encrusted shores thick with animals they had never seen before: thousands of penguins moving in blocks like sinister armies of little men, doe-eyed seals bobbing up unexpectedly between blobs of sea-ice like floating meringues. Overhead flew enormous birds with huge wingspans and terrifying claws, albatrosses and petrels, large enough to pick up little Paul and carry him away. The stench of guano was all-pervasive. As Clovis followed them down to the jollyboat that was to row them ashore, he had a heart attack, and died. He was aged thirty-five.

Mercantile interest permitted no delay. The very day of Clovis's death, a pickaxe split the icy, stony ground, and a hasty cross was raised. The following day, the *Albert* sailed on.

Aline never recounted how she survived the next month on board, but in November 1849, she and the children disembarked at Puerto del Callao, the port serving Lima. Postcards show it looking reassuringly similar to a European port, complete with ornamental railings all along the quay to stop people from falling in, an efficient-looking unloading system, a recently landscaped park whose palm trees were still in their infancy, and the whole area safely lit by triple-armed gasoliers. Nothing, in short, to frighten Aline, pretty and widowed and alone as she was.

Not all families welcome a distant relative come to lay claim to an inheritance, but the family Tristán-y-Moscoso was used to enacting huge dramas on the world stage. The appearance of an heiress-claimant was merely a diverting subplot in the grand sweep of a family history that had been entwined

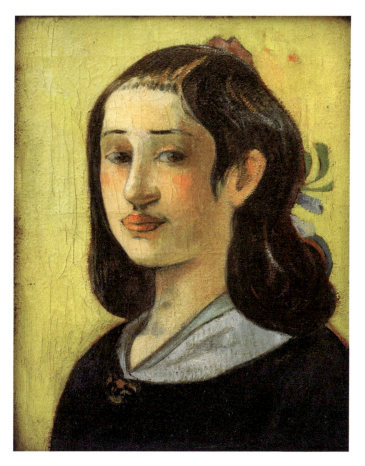

Gauguin, *Aline*, 1889–93

with that of Peru since its discovery by Spain. Proudly they traced themselves back to Pope Alexander VI, Rodrigo Borgia (1431–1503), author of the papal bull awarding the country to the king of Spain. The very epitome of papal gangster guile, Pope Alexander was reputedly one of Machiavelli's models for *The Prince*.

The bloodline flowed down to the Tristán-y-Moscosos through the pope's son, Juan Borgia, who was murdered before he could achieve as much notoriety as his better-known siblings, Cesare and Lucrezia Borgia. Next came a saint: Saint Francisco Borgia y Aragón (1510–72). After him, Francisco de Borja y Aragón, prince of Squillace and viceroy of Peru under King Philip III of Spain. Four or five generations passed while the family built up fabulous wealth in Peru on the backs of their thousands of African slaves, who worked their extensive sugar plantations, hewed silver from their mines and hacked out their great stinking hillocks of guano, super-fertile bird droppings accumulated over hundreds of years. Sugar, silver, guano: all were sent back to the Old World at massive profit.

The inheritance Aline was claiming came down from her grandfather, Flora's father, Mariano Tristán-y-Moscoso. He was now dead but Aline was petitioning his brother, her great-uncle, the magnificent Don Pío Tristán-y-Moscoso, current head of the august dynasty. Don Pío had done his stint as viceroy of Peru. Now retired, his influence still spiderwebbed out over thousands of acres and thousands of human beings: slaves, business contacts, political connections, and an extensive family network built on generations of influential marriages. Gauguin was eighteen months when he came to live under the roof of his great-great-uncle Don Pío, and seven and a half years old when he left. To him the Don seemed an ancient, awesome, magical and eternal repository of power, a Prospero ruling over a tropical Illyria.

'Give me a child until he's seven and I'll show you the man,' said the Jesuits.

'I have a remarkable visual memory and I recall this time in my life,' said Gauguin.[5]

To observe him walking with his small hand in Don Pío's great paw was to see history spooling backwards and forwards. Both were strong, sturdy, tough, never tall, dark-haired, blue-eyed and highly sexed. Don Pío would

not have bothered with Aline if she had not been a pretty ornament to his male pride. She immediately became a favourite great-niece. He liked having her around, and so he kept her and the children living the luxurious life of the dependent extended family for years, prolonging the pleasure of having these three charming and decorative relatives under his thumb, with no intention ever of paying out the inheritance.

It was a Rousseauian childhood. Peru didn't care much about educating children of either sex. Gauguin ran free within the annual cycle of the stately progression of the extended family, following the seasons between Don Pío's profitable estates in Arequipa: a wild region dominated by the white cone of the Misti volcano, snow-topped and smoking. The silver mines, doubly harsh with the smell of metal and the sweat of slaves. The sugar plantation where curlicue snakes ringleted the canes. But they spent the majority of their time in Don Pío's main residence and power base in the capital, Lima, a prototype Spanish colonial city dominated by a double-towered neo-Castilian baroque cathedral rising scornfully above a weary mass of brown, low-crouched adobe houses waiting for the next earthquake that would inevitably flatten them again. On the far horizon, the white zigzag of the Andes sporadically washed the sky red with the eruption of a distant volcano.

They lived with Don Pío in a house on the Calle de Callos (now Avenida de la Emancipación) that had been built for one of Pizarro's conquistadores. A low street frontage of massive, rusticated stone blocks lent it the air of a fortress topped by a high line of heavily barred, balconied windows where ladies could take the air while remaining invisible. Its long façade stretched like a sleeping dragon along the whole length of a city block. Behind it, a complex warren of internal courtyards and dark passages had grown organically to meet the family's needs over the centuries. As a result, there was plenty of room to slot Aline and the children into the palace and into the hierarchy.

They lived in luxury, looked after by their own personal slaves. It was a life of theatre and of contrasts, of long dark passages bursting into light from clustered constellations of candles in silver candlesticks as high and heavy as a man. Formal meals were taken at a shiny table with lines of white napkins folded in cones, like a miniature range of the snowy Andes volcanoes.

Gauguin loved it that when he stepped the short step to the cathedral to say his prayers surrounded by veiled women caressing large rosaries with voluptuous agility, he was preceded by an African slave girl carrying the rug on which he was to kneel. No difference was made between such operatic high ritual and utter carelessness. The same girl was his chief companion and mischief-maker when they played out in the hot dust of the street with the local children, who went naked except for Sundays in church when both sexes were dressed in a square apron. 'I still see our street with the chickens pecking among the refuse.'[6] His descriptions of these years seem detached and hallucinatory. He recounts them not as a child who was developing a personality and talents and interests. We have no idea, for instance, whether he ever read a book, or whether he even could read. Did he pick up a pencil, or draw with his finger in the dust? He writes and speaks about none of these things at all. Nor whether he thought about anything, or looked at anything with the unusual attentiveness that is credited to the eye of the artist. Most autobiographical fragments insert prophetic signposts, keenly nurturing legends of their own precocity, but Gauguin only recounts his childhood as a series of strange dreamlike experiences. Later, he would refer to his art as 'the dream' and he would always scorn people who elevated the realm of sight above the mysterious realm of thought and memory.

'In those days in Lima, that delicious country, where it never rains, the roofs were terraces and if there was a lunatic in the household, he would be kept on the terrace, fastened by a chain to a ring, and the owner of the house or the tenant was obliged to provide them with a certain amount of very simple food. I remember that once, my sister . . . and I, who were sleeping in a room, the open door of which gave on to an inner court, were awakened and saw opposite us the madman climbing down the ladder. The moon lit the court. Not one of us dared to utter a word. I saw and I can still see the madman enter our room, glance at us, and then quietly climb up again to his terrace.'[7]

Beneath his bed, his chamber pot was of solid silver. It was emptied for him by slaves. He slept beneath a superb portrait of Don Pío, whose eyes seemed to watch him. One night the eyes actually moved. No surprise this, in a place of improbable happenings, but on this occasion the reason was a mild earthquake. He experienced a bigger one in the port of Iquique where

the earth began to writhe and dance and he saw parts of the town crumble and the waves play with the ships as if they were balls tossed by a racquet.[8] The resulting tidal wave behaved as impressively as the wrath of God, picking up a huge trading brig and dashing it to destruction on the rocks.

Slavery had nominally been abolished in Peru in 1821 (in Britain 1833, in the USA 1865). Abolition did not take meaningful effect in Peru until 1854, halfway through Gauguin's seven-year sojourn. The emancipation of slaves led to a shortage of labour for the great estate-owners like Don Pío, but as they were enjoying a boom moment, thanks to the European passion for guano, they could afford to pay wages, and the problem was solved by immigration schemes to tempt Chinese labourers. Gauguin became very fond of his Chinese servant, 'so clever at ironing', who understood him well and rescued him from all sorts of scrapes; 'He was the one who found me in a grocery-shop, sitting between two barrels of molasses, busily sucking sugar cane while my weeping mother was having them search for me everywhere. I have always had a fancy for running away . . .'[9]

We don't learn anything at all about Gauguin's sister Marie from his memoir, or much about his extended family, even though one of his cousins became president of Peru during his stay, exalting their exalted status even higher. But only two people really existed for him: Don Pío, the despot who ruled over this vividly appealing world, and his mother. The women of Peru fascinated him. Young as he was, he observed how his mother behaved here, compared to her behaviour later when they went back to France. The Lima of those times rejoiced in the reputation of being 'the heaven of women, the purgatory of husbands and the hell of asses'.[10] Aline led the slow, odalisque life of her female relations. Rising late, she would decorate her hair with heavily scented flowers, sprigs of orange blossom or jasmine, before a long and leisurely breakfast yielded to a gossipy siesta taken in a hammock or on a day bed in the company of the other ladies while they smoked a leisurely cigar or sniffed snuff, pleasures that would lose a lady her reputation if she were seen enjoying them in public.

There was nowhere on earth where women were freer, observed Gauguin's beloved grandmother Flora Tristan who, as we know, was keen on women's freedom. She compared Lima to Paris in the days of Louis XV. Sensuality

reigned.[11] The all-pervasive atmosphere of voluptuousness owed much to the *saya y manto*, the ultra-modest pre-Columbian Peruvian costume which the conquistadores had bundled their ladies into, and which their descendants still adopted if they wanted to pass incognito. The *saya* was a stiff silk skirt reaching right down to a pretty pair of embroidered slippers. The *manto* was a veil of thick black silk, fastened to the *saya* at the waist and drawn closely over the face leaving a small triangular space for just one eye to peep out.

This costume not only changed a woman's appearance but even her voice sounded different as her mouth was covered. Unless she had some outstanding characteristic, such as being unusually tall, or short, or stout, it was impossible to recognise her. In Peru's oppressive patriarchal society, women took advantage of the all-concealing costume to arrange intrigues and assignations beneath the noses of husbands. 'How graceful and pretty my mother was when she put on her Lima costume,' Gauguin remembered, 'the silk *mantilla* covering her face and allowing the glimpse of only one eye: an eye so soft and so imperious, so pure and caressing.'[12]

Aline did not adopt the *saya y manto* in order to conduct intrigues, rather to pass quietly and anonymously, undisturbed. She was constantly dodging Don Pío, who could hardly conceive of relating to a woman, even a great-niece, without sex involved. Aline had had enough of that after her father.

Aline was not an artist, but she had fine artistic taste and independent judgement. She saw beauty and interest in the remnants of the indigenous culture around her, and she was curious about the art and mythology of the conquered people. Her attitude was in strong contrast to the whole identity of the colonial society she moved in, which was based on racism and exploitation and taking great pride in ignorance of what it had crushed. Colonial superiority was bound up with the suppression of native culture, which it branded as savage, barbaric and inferior to anything European. Importation equalled prestige. Don Pío went about in a chocolate-soldier mock-Spanish uniform, his floor tiles came from Italy, and he hung generic beaux arts pictures on his walls. The Inca god Amaru meant nothing to Don Pío and his fellows, though they probably knew the proper name of every centaur that had clip-clopped through Arcadia's classical meadows.

As Aline rode out on horseback in the countryside around Lima, and as she moved in the family's semi-royal progress from one great estate to another, she could not help but come across the ruins and remnants of temples, villages and grave complexes that scattered the plains. Gold and jewellery had long ago been looted but pottery and carvings and figurines, being of no apparent worth, still lay about. Learning of her interest, locals brought her pieces for sale. Aline began a collection that would have enormous influence on Gauguin's art, particularly the Moche pieces, dating from AD 100 to AD 800. Many Moche vessels recall ancient Greek pottery in that they are storytelling pieces, painted with the doings of gods and men, often recording heroic battles and the grisly doom of the defeated. The vessels are much thicker and clumsier than the Greek, but painted with great vivacity, and in the same colours: cream and black and terracotta.

The Moche also depicted the gods and the mythology of their vanished civilisation in their sculpted vessels and figures. Strange and mysterious idols,

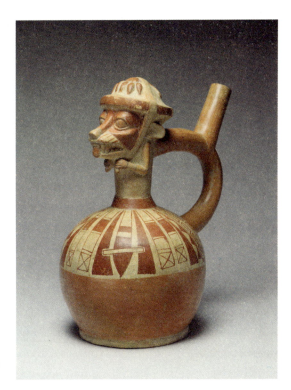

Peruvian Moche fox warrior jug,
c. AD 100–800

WILD THING

Gauguin, *The Loss of Virginity*, 1890–1

disturbing apparitions, mythical creatures, hybrids half-man half-animal, anthropomorphised plants, copulating couples, sun discs incised with incomprehensible symbols, winged messengers, feathered warriors, corncobs with human faces, effigy jugs in the shape of human heads. The whole pantheon that had come dancing out of the wild imaginings of the Moche while they were striving to make religious sense out of life and death rooted itself in Gauguin's unconscious. 'I have the sensation of something endless of which I am the beginning,' he wrote. He would create his own original symbolism through the Peruvian mythology, which was so much more meaningful and resonant to him than the overused tropes of classical and biblical symbolism that had dominated Western art down the centuries. The dog that sometimes trots into his canvases is the dog that accompanied the Moche mythological heroes on their adventures; it symbolises the anarchy of the everyday, as well as the larger anarchy of fatalistic outcomes. He uses the Moche fox warrior

as an alter ego, his subconscious self, his Dionysian impulse, his animal self. Often it stands for lust: sometimes his own, sometimes other people's.

Seven years passed. Day followed day in an endless, agreeable, dreamlike *mañana* as Don Pío fobbed Aline off with a shopping allowance while never granting her the legacy that would assure independence for her and the children. But then, in 1855, Aline received a letter from her father-in-law, Clovis's father, Guillaume Gauguin. He had now reached the age of seventy, and he felt himself growing old. He wrote to say that he would like to see his grandchildren Paul and Marie before he died. The letter included the information that the children would inherit half his wealth and his bachelor brother Zizi would inherit the other half. Guillaume Gauguin was a hard-working, comfortably off *petit bourgeois* living in the city of Orléans, south of Paris. He owned a modest estate with some houses and small vineyards and a considerable amount of first-class agricultural land where he ran a thriving market garden business. Hardly the wealth of kings, but this was a legacy that promised to materialise, and also promised some sort of independent future.

Aline didn't have much to pack up other than her fine collection of pre-Columbian artefacts to take back to France.

Early in 1855, they arrived.

Now he must live on a river plain in a northern French provincial city noted for its high rainfall. He must learn to speak French. He must walk grey pavements, and go to school. But through all the long years of his domestication he never lost sight of the sense that 'I is another', never ceased to yearn for the lost beatitude, the harsh, primitive place which had given him what he referred to as 'the dream', an enduring vision of a spiritual world pervading the material world: the place he would seek all his life, and would believe he had found when he at last reached Tahiti.

2

'I AM A SAVAGE FROM PERU'

In his memory it had never rained in Peru. In ghost-grey Orléans it seemed to rain incessantly. The family wealth that he had been brought back to France to inherit was entirely dependent on the rain that he so disliked, watering the regimented rows of Grandfather Guillaume's crops growing either side of the great river Loire that ran frothing and furling through the family fields.

Once the glorious capital of Merovingian kings, Orléans had now sunk so low as to be described in a contemporary encyclopedia as 'of lifeless appearance', a description borne out by a watercolour (*Orléans, Loire Valley,* c.1826–8) by J. M. W. Turner, who set up his easel on the Quai Neuf (now the Quai de Prague) where Gauguin lived between the ages of seven and fourteen in his grandfather's house, 25 Quai Neuf. It was a grand but dreary view that Turner painted and Gauguin looked out on during those slow seven years of his life. Gloomy and glaucous; mostly river and sky. Unlike many of his contemporary painters – Monet and Degas, for example – Gauguin would never turn out obsessive skyscapes capturing the fleeting architecture of clouds, or studies of the changing tonalities of water. Maybe he'd had enough of involuntary observation during those years. The overwhelming impression of the view from the Quai Neuf is a monochrome wash: the colour of the Orléans sky, be it blue, dun or yellow-grey, reflected monotonously on the surface expanse of river, here a quarter of a mile wide. The city on the far bank cuts across the general tonality in a low, horizontal line of sepia stone buildings culminating, on the right-hand side, in the two great square-topped towers of the Gothic cathedral. From this angle the towers appear to squat on top of Orléans's famous bridge, the Pont Royal, running at an angle across the river in a line of depressed arches of the same yellow-grey stone.

For one used to mountains, earthquakes and snow-topped volcanoes, palaces where monkeys ran wild, and streets where rowdy vultures fought every evening over discarded kitchen offal there was little excitement to stir

the soul. The French family whose name he bore boasted nothing grand.[1] Unlike the Tristán-y-Moscosos, the Gauguins claimed no distinguished ancestry, and their present members were unambitious. Aesthetic, cultural and psychological issues were of no importance. What mattered was that the family name should be well respected within the solid, bourgeois community. Politically, they were as libertarian and republican as Gauguin's father, Clovis, had been: strongly against the tiresome and economically destabilising periodic power-grabs between the Bourbon and Napoleonic dynasties.

Gauguin's forebears had settled on the southern side of the river Loire before it became commercially developed. A loose network of cousins based themselves in the neighbourhood of Saint-Marceau, where the extended family seems to have been thoroughly decent and co-operative, helping each other out and occasionally intermarrying, living the intertwined, middle-class life that is the stuff of Balzac's novels, but seemingly without succumbing to the guzzling greed and venality that Balzac saw as underlying the human condition. Grandfather Guillaume had started as a shopkeeper in a small grocery store and had grown the business into an agricultural empire whose headquarters were two good houses on the Quai Neuf. The houses stood back-to-back, one facing the river and the other looking out on to the street; the space in between was occupied by one of Guillaume's commercial market gardens. This placed his business ideally for trade: boats tied up at the quay just outside the riverside house to collect the agricultural produce and deliver it to the big markets in Blois and Paris. Records show a week in February 1844 when 197 boats docked here with cargo valued between 12 and 13 million francs.[2] Ten years later, when Gauguin came to live here, boat traffic had been dented by the arrival of the railway, but this only meant increased capacity for trade, allowing Grandfather Guillaume's cornucopia to pour into Paris more speedily as the city's population increased. For little Paul, newly arrived in Orléans, the lovely by-product of the switch to rail was that fewer boats on the Loire meant more fun for seven-year-old him. He and his sister Marie, who was now eight years old, experienced the childish joys of inexpert fishing with a string tied to a stick, paddling in the shallows, and mudlarking on the sandy banks of the river.

They were sent to the local school. He hated the whole thing. It was

horrible to walk to school with his body crammed into a thick winter coat so he couldn't move freely, and when he arrived everybody was speaking French, and he couldn't understand what they were saying. Language learning was unusually difficult for Gauguin. It came much more easily and quickly to Marie. Despite being by far the most widely travelled of the Impressionist and Post-Impressionist painters, Gauguin was no natural polyglot. He always said that he felt happier and more at home speaking Spanish than French.

The family had been installed only a few months when Grandfather Guillaume died. He left his wealth divided equally: half to Paul and Marie, the children of his dead son Clovis; half to his living son Isidore, known as Zizi.

Uncle Zizi was unmarried and childless; he was to share guardianship of the children with their mother until they came of age. Aline was not, strictly speaking, a blood relation, so it was proper that she should not receive any material property, but Grandfather Guillaume was a kind and thoughtful man and his will granted her the usufruct from her children's portion. This meant that she could enjoy the profit from the land and the rental from the few agricultural cottages they inherited, but it did not make her rich, as the business and the vineyard gobbled up most of the profits in salaries and reinvestment, and the cottages ate most of their rents in repairs. Nevertheless, Aline had been left the wherewithal to lead a decent and modest life in a fine house while bringing up the children.

Shortly after this, Don Pío died in Peru. He had doted on Aline and left her the princely sum of 25,000 francs in his will.[3] The Tristán-y-Moscoso family refused to honour the legacy, offering her a much smaller sum which she was too proud and too angry to accept. After this, she refused to have anything more to do with her Peruvian family. She severed the connection so completely that later in life when Gauguin was serving in the French merchant marine and the winds of fate blew his ship into the port of Iquique, which he knew well from childhood visits to the family property nearby, he made no attempt to contact his cousins. Aline must have been bitter indeed to have had this effect on her son, who based his lifelong perception of himself on the self-mythologising words, 'I am a savage from Peru.' He tells us he said them first at the age of seven at his Orléans school, where

'I AM A SAVAGE FROM PERU'

he felt himself disconnected, culture-shocked, isolated, misunderstood and purposeless. His teachers and fellow pupils found him touchy, inarticulate, rough and quick to take offence. When anyone made him feel stupid, helpless or inferior he would say threateningly, 'I am a savage from Peru', and he would continue to do the same throughout his life if he felt himself cornered, scorned, threatened or belittled. At school he is not recorded as following up the words with his fists or his feet, as he sometimes did in adult life, but the words were enough to position him in his own mind as an outsider, and push him into the same cold, excluded space in the minds of others.

The frustrating inability to make himself understood stands out as the strongest sentiment that Gauguin associates with this French part of his childhood. 'I was beginning to speak French, and I suppose, because I was in the habit of speaking Spanish, I pronounced all the letters with affectation.'[4] This did not endear him to his schoolmates. Nor did his physical aspect. Gauguin was small for his age, but he was broad, swarthy and strong. When he looks back on this time, he concludes that his isolation caused him to analyse himself to a degree that is unusual at such an early age; he was continually watching himself, judging himself and feeling dissatisfied with himself, hounded by an existential discomfort he didn't understand. Self-judgement more often makes for self-condemnation than self-congratulation, and when Uncle Zizi looked out of the window, he observed an angry and unhappy child. Zizi used to watch him stomping round the garden by himself, occasionally snatching up handfuls of earth and flinging them about furiously. When Zizi asked him, 'Well, little Paul, what's the matter with you?' he just stamped his foot all the harder and said, in his inadequate French, 'Baby is naughty!'

In contrast to the financial shenanigans following the death of Don Pío, Grandfather Guillaume's estate was settled calmly and undisputatiously. Uncle Zizi took up residence in the big house facing the road while Aline and the children lived in the better one that looked over the river. They quickly became very fond of Uncle Zizi. By trade, he was a goldsmith and a jeweller. It seems strange that this aspect of the man made no impression on Gauguin. For an artist who also became a renowned sculptor, one would expect Gauguin to be excited by the goldsmith's workshop: one thinks of

Benvenuto Cellini's classic description of his own workshop as a violent and physical place, an alchemist's laboratory where flaming fire was reflected in gilded puddles and husky leather-aproned workmen forged and fired and chased and beat the metal into submission. But Gauguin never talks about it. Uncle Zizi features in Gauguin's memoirs as a small and kindly man who told him stories; he is the mouthpiece of family memory and legend. When Gauguin writes about his childhood, he deliberately shapes the stories at one remove from himself, by making Uncle Zizi the framing device: 'My good uncle in Orléans, whom we called Zizi because his name was Isidore and he was very small, told me . . .'[5]

On the wall at Uncle Zizi's hung a picture that held a special fascination for Gauguin: an engraving with the title *The Merry Wayfarer* picked out in large, ornamental lettering. The picture was an undistinguished descendant of the image that had captivated the Romantic Age, when Caspar David Friedrich's *Wanderer above a Sea of Fog* (1818) had spawned a whole genre depicting the introspective misfit hero alone in an apocalyptic landscape seething in some form of extreme weather convulsion. The key to the universal appeal of the icon lay in the depiction of nature as a vehicle of terror, and the hero always being seen from behind. He has no face and so we imagine ourselves into him, as he confronts the turbulent elemental caprices that hold a mirror to the *Sturm und Drang* within the wanderer's – and our own – troubled soul and intellect. While establishing the glory of individualism, the picture also raised the question of the consequences of introspection, desolation and solitude when magnified to a universal degree. The dangerously anarchic character of a society made up of a lot of fully realised introspective individuals can only be imagined.

By the time that affordable pictures inspired by *The Wanderer* had become popular in bourgeois homes such as Uncle Zizi's, its message had been considerably diluted. The picture that young Gauguin enjoyed looking at depicted a hopeful boy with a bundle on his back, setting out on a path that meandered between soft, mazy meadows towards a promising horizon. Friedrich's lonely and disconnected figure had morphed from a disturbing portrayal of interior desolation into a bright and bland symbol of youth setting out on the winding path of life through a landscape where the sun

always shines. When Gauguin was nine, he decided to follow the merry wayfarer's example. Uncle Zizi had already observed and noted the boy's agitated relationship to the soil in the garden and now the little boy filled a handkerchief with garden soil, tied its corners, hung it on a stick, put the stick over his shoulder and set out towards the forest of Bondy, a legendary haunt of bandits and robbers. The missing boy was discovered at evening time, not, this time, by his personal servant, but by a kindly local butcher who took his hand and led him home. Later, he liked to tell the story as a droll tale against himself, concluding with the rueful observation that it was mighty dangerous to give in too easily to the power of art.

Like her son, Aline found life in Orléans unexciting. In 1859, when she was thirty-four, Gauguin was aged eleven and old enough to be sent away to boarding school. This might sort out her strong-willed misfit son, while at the same time liberating her for a last shot at an exciting and independent life. Aline was still frightened of her father. André Chazal's crazy vengeance fantasies had not decreased during the eighteen years he had served in prison for his crime. He had been released in 1856 but he was not permitted to travel to Paris and so she felt safe to go there to try her luck as a seamstress. She decided to take Marie with her and leave Gauguin to board at a school near Orléans, where Uncle Zizi could keep an eye on him.

Le Petit Séminaire de la Chapelle Sainte-Mesmin was a religious seminary some four miles downriver from Orléans, set in a famously beautiful, landscaped park in a wide loop of the river Loire. Founded in 1816, the Petit Séminaire was part of the right-wing post-Napoleonic push to take France back to pre-Revolutionary values by reinstating Church and State as twin pillars of society. An ambitious example of militant Catholicism, the Séminaire was a neo-Louis Quatorze colossus, half-palace, half-barracks, arranged in the shape of a hollow rectangle with four uniform, four-storey wings. The only inkling of spiritual purpose was the stuck-on-looking spire of the chapel.

Hundreds of priests, intended to revive the Roman Catholic Church in France, were trained at the Petit Séminaire alongside the boys receiving an education from the age of eleven upward. Gauguin slept in a dormitory of forty boys, and though he was subject to all the peculiar miseries of institutionalism, the education he received was far less reactionary than would be expected.

While the Petit Séminaire had been founded to uphold conservative values, it was, during Gauguin's time, the most progressive educational institution in France. It was under the dynamic leadership of Monseigneur Félix Dupanloup, cardinal of the Roman Catholic Church and Bishop of Orléans.[6] A swarthy, spare, charismatic man with a hawk-like profile and a restless brain, Dupanloup's passionate purpose as an educationalist was to destroy all traditions that merely confirm assumption. There was to be an end to the despotic transmission of knowledge by rote and regurgitation. The purpose of education, as Dupanloup saw it, was the liberation of the individual fully to develop the self through the questioning and subsequent application of knowledge.

Gauguin entered the Petit Séminaire in 1859, the year Darwin upended universal assumptions.[7] Dupanloup, both a churchman and a scientist, had already got to grips with Lamarck's pre-Darwinian evolutionary ideas and so Gauguin arrived, most unusually, at a place where the question of religion in relation to the exact sciences had already been fought and settled in the mind of the school's director. Dupanloup found it perfectly possible to exist in the modern world as a rationalist Christian. Religion provided a theory of how scientific knowledge was possible. He was convinced that to connect fully with the infinite potential of knowledge, each individual must feel free to examine their own religious faith as critically as they examined any other subject, including scientific theory. However, he also firmly believed that scholarly self-realisation was divinely nurtured. Ergo, it was inevitable that the scholar would conclude that he could only progress through simultaneous rational and religious fulfilment.

When the problems raised by evolutionism became acute for the Catholic Church, Dupanloup was among those summoned to thrash out the issue in Rome. Predictably, the debate resulted in the rejection of evolutionism, support of creationism, and the establishment of the doctrine of papal infallibility. This was totally unacceptable to Dupanloup who took the elegant way out, leaving Rome the evening before the promulgation of the papal decree of infallibility. This might have led to excommunication, but Pope Pius IX was in no position to take draconian steps against the Frenchman. The pope only remained in the Vatican thanks to the protection of a French garrison who defended him throughout the internal battles raging over Italy's

unification. In France, Dupanloup was a revered figure, one of the forty intellectual 'Immortals' of the French Académie, also the only bishop to sit in the French National Assembly, where he wielded both religious and secular influence while devoting himself to the idealistic experiment of reforming French education. He fought hard for equal educational opportunities for girls and for the retention of the Classics at the heart of French education. For this he was accused of promoting the renaissance of paganism, a charge which he only aggravated by revolutionising the teaching of Classics. It was customary to teach Latin and Greek using passages of the Bible translated into those languages but Gauguin and his fellow pupils at the Petit Séminaire were taught from the original texts: from Greek tragedies and Roman histories. This gave Gauguin a far wider knowledge of the classical world than most of his contemporaries, leading to a fluency in cross-cultural historical connectivity that he would freely reference in his pictures.

But however liberal Gauguin's education was within the contemporary context, it could by no means be described as secular. He and his thirty-nine dormitory companions were woken at five o'clock every morning for prayers, the first of nine offices throughout the day. Between prayers came lessons and meals, taken to the accompaniment of a sermon or a Bible reading, under a huge reproduction of Leonardo's *Last Supper*.

In his memoir, Gauguin does not dwell on his schooldays, as he does on his days in Peru. He does not anecdotalise them. He tells us what matters to him: that, not finding work particularly difficult, he had no eagerness to learn. Science didn't interest him much. He loved French literature. He could never be bothered to master the art of spelling correctly, but we see him misspelling in a beautifully flowing, legible handwriting entirely free from self-consciously artistic flourishes. He suggests that he was fundamentally disengaged because he was motivated by no special interest beyond the negative one of not going into the family fruit and vegetable business. He tells us he was bullied moderately, mostly because of his small size. When this happened, he would either put up his fists and blurt out the threat that he was a savage from Peru, or he would flatter his tormentor, naïvely believing that in so doing he was forming a real bond between the two of them. When this trust was betrayed, as it invariably was, he tells us he was always surprised.

Underlying his schooldays was hatred of mental and physical constraint: the constant feeling of oppression caused by the lack of freedom.

'I won't say . . . that this education did nothing for my mental development; on the contrary, I believe it did a good deal. Speaking broadly, I would say that it was here I learned at an early age to hate hypocrisy, false virtue and sneaking (*semper tres!*).' He is referring to the school rule *semper tres* that stipulated pupils must go about in threes. One boy alone might become dangerously introverted, subversive and anarchistic. Two together might form an unsuitable bond. Three maintained an uneasy balance: each one spying on the other two. In this, Dupanloup's Séminaire was anticipating the watchful principle that would make Communist cells so effective.

'I learned to distrust everything that was opposed to my instinct, my heart, and my reason . . . I acquired the habit of concentration and of continually watching my teachers' game.' His years at the Séminaire grew a mistrust of 'civilised' establishments but, against this, he valued the fact that the school had given him the revelatory gift of empirical thinking. The rest of his life he would take nothing on trust, but question everything. Dupanloup's example had taught him to see all established suppositions as a challenge to the intellect and this, in due course, would lead him to challenge the whole canon upon which the idea of white Western 'civilised' assumptions was founded, so that on his arrival in Tahiti, one of the first pictures he painted, *Ia orana Maria* (*Hail Mary*, 1892), showed a brown-skinned Tahitian Virgin Mary carrying a brown-skinned Tahitian Christ child. When shipped back for exhibition in France, the image shocked the white-skinned world accustomed, however illogically, to a white-skinned Holy Family. Gauguin's iconoclastic disruption of established expectations such as this was all the more disturbing for the fluency with which he could reference the entire Christian and classical canon while provocatively breaking its taboos.

The Christian catechism is a system of explaining beliefs using a list of questions and answers. In response to Darwin, and in order to equip his pupils with souls sufficiently 'virile' to withstand the challenges raised by evolutionism, Dupanloup composed a catechism that included the questions: 'Where do we come from? What are we? Where are we going?'[8] Thirty-two years after Gauguin left the Petit Séminaire, when he was contemplating

suicide in 1897, he painted the strange haunting masterpiece that he called his 'testament'. The biggest picture he ever painted, measuring some 1.4 metres by 3.5 metres, it is his serious attempt at a big statement about the meaning of life. Mythic and monumental, it draws on an interweaving of Polynesian, classical and Christian references. He titled the picture *Where Do We Come From? What Are We? Where Are We Going?*

Gauguin was forty-nine when he painted it, and still he was recollecting the existential questions that Dupanloup had raised in his mind when he was a boy. In the intervening years, Gauguin had put a great ocean between himself and Europe as he sought an alternative to a 'civilised' world whose religious sensibility was founded on guilt following mankind's expulsion from the Garden of Eden for the sin of eating from the tree of knowledge. Looking to reconnect with prelapsarian Eden in Polynesia, he had discovered beauty, luxuriance, mystery, sensuousness and lack of existential guilt, but all this still left him searching for the answer to Dupanloup's three questions in one: the great question of meaning.

3

THE OUTSIDER

In 1862, Aline removed Gauguin from the Petit Séminaire and sent for him to join her and his sister Marie in Paris, where Aline was trying to make ends meet as a dressmaker.

When fourteen-year-old Gauguin arrived, the Second Empire had been in full swing for a decade. Louis Napoleon had turned Paris into a symbol of flamboyant materialism, promiscuous pleasure and flagrant corruption, often referred to as the new Babylon, or even more damningly as 'some *American* Babylon of the future' 'suffering from a moral indigestion brought on by debauchery'.[1] The popular and successful writer Victor Hugo took on the role of Great Voice of Republicanism against the emperor, calling him among other things 'the nocturnal strangler of liberty'. The emperor, all charm, responded with the autocrat's customary smooth riposte that he was only departing from legality in order later to return to the rule of law. Observing that the emperor lied as other men breathed, Hugo fled to the island of Guernsey to uphold the cause of free speech. Here he wrote *Napoléon le Petit*, a swingeing critique of the regime, which he had printed up in a little book small enough to be smuggled back into France in knickers, prompting the formation of long inspection lines at the border and even strip searches.

'I want to be a second Augustus because Augustus made Rome a city of marble,'[2] declared Louis Napoleon and gave Georges-Eugène Haussmann *carte blanche* to sweep away the city's medieval higgle-piggle and replace it with a clean-slate city vision of astonishing clarity and grandeur: the Paris we know today. Throughout the twenty years of the Second Empire, Haussmann flattened hills, drained noxious marshes, and diverted rivers to create long urban vistas of swaggering façades clad in pomp and Lutetian limestone. Rivalling the glories of Augustan Rome included making Paris into the most modern commercial city in the world, the new transport hub and centre of industrialising Europe. Government by decree enabled Louis Napoleon not

only to impose an efficient road grid on the city but also to build six railway lines reaching out to touch all France's international frontiers.

Many believed trains would arrive at stations bearing carriages full of corpses, it being impossible to breathe at such speeds, but Aline was no such sceptic. She delighted in taking the children for adventures on the train for fresh air and respite from the twenty-four-hour building-site racket of central Paris where, thanks to the new technology of electric arc lights, construction was taking place night and day. Added to this was the never-ending clatter-and-clack of the new fast-moving fiacres and double-decker horse-drawn omnibuses on Haussmann's miles of freshly laid asphalt. Proust was not the only one to soundproof his rooms with cork lining. There was a passion for bicycles and knickerbocker bicycling suits. Paris knew itself the capital of luxury and fashion. The excitement of being in the vanguard of things endorsed a shift in perceptions of both time and space. The screeching revolution in transport came to symbolise modernity, as movement came to be seen as an end in itself. All was flux and change. The year Gauguin arrived in Paris, the Impressionists who were later to become his teachers – some friends, some enemies: Cézanne, Monet, Renoir, Sisley and Zola, who was a childhood friend of Cézanne and as much a painter as a writer until literary success overtook him – were first banding together to paint out of doors in the early stages of addressing the problem of how to capture the truth of the ever-changing object. How to lay down the eternal ephemerality of the moment on to a solid, static piece of material, a piece of paper or canvas? How truthfully to represent the uncertainly defined form, as you whizzed past it on your train or your bicycle and both you and the form you were trying to capture moved through the shifting planes of time, space and light? Eventually they arrived, more or less consensually, at a painterly vocabulary of short light-fragmenting brushstrokes to break up the concept of three-dimensionality as a smooth, solid continuity.

Haussmann openly admitted that one of the aims of modernising Paris was to stop further civil insurrection from breaking out in the dense pockets of working-class slums, which he flattened to give way to broad boulevards and avenues, enabling companies of soldiers to move swiftly to suppress uprisings. It was almost impossible for rioters to build their traditional barricades across

such wide thoroughfares. This was city planning as political instrument. Haussmann himself estimated that the building programme displaced some 350,000 people. Public records indicate that 5,000 of them were registered prostitutes and another 30,000 unregistered ones. With their own districts like the Palais Royal destroyed, streetwalking girls now walked into respectable bourgeois neighbourhoods, bringing with them a sense of both social and moral confusion. 'Prostitutes . . . are everywhere,' noted the architect Charles LeCœur in 1870, outraged that the work he was engaged in resulted in the invasion of sex workers into irreproachable bourgeois bastions; 'the cafés-concerts, the theatres, the dance halls. One meets them in public establishments, railway stations and even railway carriages. They are there on all the footpaths, in front of most of the cafés. Late into the night they circulate in great numbers on all the finest boulevards, to the great scandal of the public . . .'[3] Zola described the 'jostling strangers and permissive language' and the pervasive atmosphere of sexual possibility everywhere. 'The wide pavement, swept by the prostitutes' skirts and ringing with peculiar familiarity under the men's boots, and over whose grey asphalt it seemed . . . that the cavalcade of pleasure and brief encounters was passing . . . awakening slumbering desires . . . the din of a city obsessed with the pursuit of pleasure.'[4] This led Zola to name Paris 'the complicitous city', as he fancied the spongy amorality of its corrupt and disorderly construction seeping into the very bones of its citizens.

On arriving in Paris to set herself up as a seamstress, Aline had become part of the great mass of social displacement and confusion, part of the demi-monde of women on the fringes of respectable life, making a living as best they could. 'Thousands of floating existences – criminals and kept women – which drift about in the underworld of a great city'[5] as Balzac wrote to Manet, recommending that the painter take this as the subject of his paintings, which indeed he did, reimagining the Venus of the Second Empire as a streetwalker in his notorious canvas *Olympia*, which was painted in 1863, the year after Gauguin arrived in Paris. *Olympia* was to hold overwhelming significance for Gauguin all his life. In 1891, he spent days in the Musée du Luxembourg trying to copy it; though he eventually gave up, this did not dismay him. Rather the opposite: to be unable to capture the magic only made the magic more alluring. Throughout his mature life, he would carry a

THE OUTSIDER

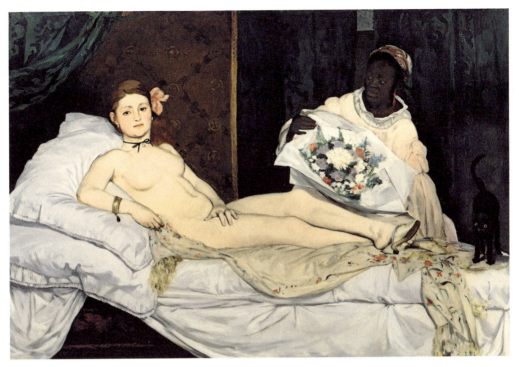

Édouard Manet, *Olympia*, 1863

photograph of the painting and pin it up on the walls of his studio wherever he happened to be in the world.

Olympia lies on a white sheet, naked except for a rose behind her ear, a black ribbon round her neck, a bracelet on her wrist and pretty slippers on her feet. Looking like a girl who's bitten every apple, she is waiting for her next client. If her hard, rather bored look does not tell you this, Manet lets you know. A black cat has jumped up on to her bed with its tail erect: a well-known symbol of promiscuous sex. This was by no means the first painting of a girl offering sex for sale, so why did it provoke such outrage? Manet was, by common consent, the contemporary artist most skilled in painting in the lushly tenebrous style of the most revered Old Masters, such as Rembrandt and Velázquez. He had exercised all that skill in placing Olympia in the traditional pose of an age-old classical composition that had come down, along with the whole idea of European civilisation, from antiquity. Giorgione had taken up the pose in *Sleeping Venus* (1510), Cranach in *Reclining*

River Nymph (1518), Titian in *Venus of Urbino* (1538) Goya in *Naked Maja* (1797–1800) and Canova in *Pauline Bonaparte as Venus Victrix* (1805–8); these, and other similarly posed Venuses upheld an ideal of womanhood as the ennobling sex. Olympia pushed Venus off her pedestal: there she lay, a buyable object and pretty bored about it. Her black maid is trying to show her an enormous bouquet of flowers that some admirer or other has sent. She can't be bothered to look at it. Instead, she looks us straight in the eye. '*Qui paye y va*,' she seems to say; 'Who pays, gets it', famously the motto of La Païva, an expensive celebrity courtesan of the day. *Olympia* scandalised society. A guard was posted by the picture to prevent the public from mutilating it. Critics compared her body to a gorilla's (it was the age of the swiping Darwinian anthropological insult). But the real issue was that Manet had skewered the rampant sexual hypocrisy of the time. Society could not bear the truth it saw about its own exploitative self, reflected in the unwavering stare of its victim.

Gauguin studied the picture for thirty years before he dared attempt his own updating of the timeless icon. *Te Arii Vahine* (*The King's Wife*, 1896) gives us Gauguin's Venus as an indigenous Polynesian. When they were exhibited, his Polynesian Venuses rocked Paris, challenging the entire conspiracy on which white civilisation depended: the silent compact of a comfortable continent to keep up pretence. To go to a Paris gallery and see on a wall a non-white body placed in the pose of a centuries-old white iconographical formula was every bit as controversial as *Olympia*'s challenge to Europe's hypocritical moral code had been thirty years earlier. Looking forward, Gauguin's deliberately provocative transpositions of Venus and the Virgin Mary from white to non-white might be compared to Chris Ofili's *The Holy Virgin Mary* (1996) in which not only is the Virgin Mary black but part of her body, a breast, is moulded from elephant dung.

When Aline arrived in Paris, the number of seamstresses was smaller only than the approximately 35,000 prostitutes, and the similar number of women in domestic service. The borders between the three professions tended to be porous. Despite Bishop Dupanloup's best efforts, girls' education lagged far behind boys', and when they left school their employment opportunities were laughable. The fortunate ones were supported by fathers or husbands; even so, we remember how Flora Tristan's husband thought it acceptable to

send Flora out to make money by prostituting herself when funds were low. The precarious plight of the single woman, a situation fully acknowledged by all, was made acceptable to the public conscience by romanticised, sentimentalised, popular stories like Dumas's *La Dame aux camélias*, turned by Verdi into the tearjerking opera *La traviata*. Priapic promiscuity was greatly admired, but the Olympias, Violettas and Marguerites who were its victims were regarded as harlots who deserved their miserable fates. The fact was, it was impossible for a single woman to live decently without money of her own, or a male protector. Aline found hers in a financier named Gustave Arosa. However much Gauguin resented Arosa at the time, he would later write that he did not know how they would have survived without his support.

Enrichez-vous! Get rich quick! was the watchword of the Second Empire. Gustave Arosa was a very rich man indeed, thanks to the debt incurred in the reconstruction of Paris, so enormous that it was not fully paid off until 1929. Two family banks profited the most: Crédit Mobilier belonging to the Pereire brothers, and de Rothschild frères, founded by James de Rothschild, whose right-hand man was Gustave's father, François-Ezéchiel Arosa. Aline probably met Gustave in his father's house in Rue Laffitte, a few doors down from the Rothschilds, in a street of self-made millionaires where display was competitive and decoration unrestrained. Arosa had South American connections and he ran his opulent house like an embassy, where newly arrived Spaniards and South Americans left their *cartes de visite* on the butler's silver tray, and profitable connections ensued. Liveried servants with cockaded hats guarded his *porte cochère*. His balconies were hoisted by bare-breasted dryads. Gods and goddesses sported across his pediments. Newfangled plate-glass windows gave glimpses into penumbral interiors where Venetian chandeliers scintillated like colossal suspended diamond brooches, and the glowing tips of cigars described orange arcs in the gloom beneath.

The Arosa fortune had been made from importing guano from Peru: those massive hillocks of seabird droppings that had been such a profitable export for Don Pío. The fertility of French fields increased miraculously beneath a layer of Peruvian guano. Aline's protector, Gustave Arosa, was the younger of François-Ezéchiel Arosa's two sons.

Born in 1818, Gustave Arosa was some seven years older than Aline. He was

around forty-four when they met and she around thirty-six. Her photographs show her looking younger than her years. Willowy, dark-eyed, dark-haired, she followed an independent line of dressing in very simple lines, unlike the padded and frilled Second Empire fashionistas for whom she made dresses. Aline was (according to her grandson) 'a proud and authoritative woman'[6] of strong opinions who could be harsh when she felt she was in the right – as in matters of bringing up a troublesome son who was just as strong-willed as his mother – and in her feminist and libertarian political opinions inherited from her own mother, Flora Tristan. Aline loved literature. Keeping up with the latest books gave her an intellectual flexibility and openness to new ideas that reinforced her youthful air of candour and vulnerability. This appealed to Gustave Arosa, who also had a lively intellectual curiosity. Photographs show him looking extremely dashing, with a confident glance, noble forehead and wild black hair flying in random directions.[7] He was a busy man living a comfortable life at the very centre of his city's ebullient capitalist boom. A sophisticated *boulevardier*, elegant rather than flashy, he had long been married to a dark, solid-looking wife. They had two daughters. Gustave Arosa did not work in the bank but in the Paris stock exchange, the Bourse, the phantasmagoric money-go-round that fuelled Babylon's boom time. Stocks and shares went up and down, fortunes were won and lost; Arosa took a percentage. But there was more to him than money. He was interested in all that was avant-garde, and a serious collector of the French artists at the cutting edge when Realism was tipping into Impressionism. Delacroix, Courbet and Pissarro hung on his walls, but he was no mere cheque-writer: when the artists found themselves with nowhere to turn, he had been known to lend them a house he owned in Montmartre. He also took an interest in the new-ish art of photography and was an avid collector of contemporary ceramics.

When Aline left Orléans, she had sold whatever she could to support her new life, but she brought with her to Paris the pre-Columbian collection from Peru. Maybe she could find no market for such alien-looking objects? It would be another sixty years before Picasso and Matisse 'discovered' so-called 'primitive' and 'tribal' art, making it fashionable and valuable. We know nothing about Aline and Arosa's initial meeting, but it was certainly art, rather than his money, that lit the spark between them, as Aline had 'the profoundest

distrust of everything which had to do with money and business'. Gustave Arosa, a man of sensuality and ideas, was bewitched both by Aline and by her Peruvian pieces, whose sphinxian powers captured his imagination. He set out on a collecting spree, using his business connections to send to South America for an indiscriminate trawl of masks, ceramics, sculptures and figurines from the Cupisnique, Moche, Nazca and Inca cultures.[8] He soon had the largest and most important collection of pre-Hispanic art in Paris. The relationship between Arosa and Aline must have been a great deal deeper and more satisfying than the usual married 'protector' and his mistress during this time of building the collection together.

Arosa set Aline up in business as a dressmaker in the Chaussée-d'Antin, the area which Balzac named 'the beating heart of Paris'. It was the centre of everything new, expensive, fashionable and fun. The Bourse was here, Charles Garnier's new opera house, and the Moulin Rouge, next door to a bedding emporium deliciously named the Springy Mattress. A few doors down from Aline's shop at number 33 glowed the word *Nadar* written in tubular lighting. Scribbled neon signatures have been the stuff of artistic self-publicists ever since, but Nadar was the first. He was a tireless self-promoter who originated the role of the celebrity photographer, taking pictures of anybody who was anybody, from the Empress Eugénie to courtesans, criminals and the Impressionist painters. He was the first person to take an aerial photograph when he ascended over Paris in a hot-air balloon in 1858. He taught Arosa to take very creditable photographs and Arosa, whose mind never stopped at the surface of things, was interested in the technology as well as the art of photography. The two men together worked on the problem of producing good-quality, cheap and stable photographic reproductions that could be sold by the thousand. Jacques Offenbach lived in the area as he composed the risqué light operas that provided the soundtrack to the new Babylon. His *Orpheus in the Underworld* gave Paris the cancan. The Neapolitan café on the corner of the Rue de la Chaussée-d'Antin was the place where everybody met to drink absinthe. Aline had arrived in the very centre of urban spectacle and public chic, the heart, brain and body of the moment. The ideal location for a seamstress's shop.

Dresses played an enormous part in the Second Empire. Women's fashions

have seldom been so exaggerated and embellished. Crinolines could reach 4.5 metres across, hats were rampant with slaughtered bird life, nipple-skimming décolletages acted as *vitrines* for spectacular jewels. Fashion was led by the Empress Eugénie and the famous courtesans. Photography meant that their outfits could be copied quickly and be displayed for sale behind the vast plate-glass windows of the newly invented department stores. The Second Empire is often cited as the birth of consumer culture, and it was the advent of the department store that saw the birth of shopping as an end in itself. Zola became so obsessed by the power and importance of clothes in society and their ability to whip up voracious and unsatisfiable desires fuelling cupidity, envy and narcissism, that he centred a whole novel, Au *bonheur des dames* (*The Ladies' Paradise*), on a department store, using it as a microcosm of capitalist consumer culture and the changes it effected on the moral spectrum of society.

The dresses Aline made were beautiful things. Her atelier was the stuff of dreams. Silk and satin dresses susurrated swishily, sexily. Dresses hanging inanimate or casually flung down on a chair mimicked delicious curves as their whaleboning and padding lifted the bosom, stretched out the long waist and exaggerated the globed posterior. Aline's workroom laid the foundation for Gauguin's love of clothes and fabrics that was to play an important part in his paintings, as well as in the clothes he wore himself. Always look at the clothes in his pictures and notice what he himself is wearing in photographs or self-portraits. Fabrics and clothes are part of the narrative, sometimes subtext, sometimes counter-text or subversive suggestion. He enjoys the ways dress can be weaponised: as symbol, cultural reference, political statement, deception, disguise, as a tool to express power or protest, concurrence or camouflage. When he left Paris, and after Brittany had proved disappointing to him, and his dream of uncorrupted humanity had moved to Polynesia, he hoisted the *pareu*, a printed length of cotton, round his loins, much to the fury of the French officials who governed the islands in perfectly pressed Western suits, top hats and military uniform to reinforce the intimidatory power of the oppressor. On the occasions he came back to Paris from these wild places, he refused to clamber into conventional suit and tie but dressed as he felt inclined, raffishly, often in a Breton striped fisherman's sweater or an embroidered shirt, a jacket

with silver buttons and wooden clogs. Always clogs. He loved their defiant sound ringing out on smart pavements.

Paris provoked the teenage Gauguin to obstinacy. Taught to hate hypocrisy and false values by Bishop Dupanloup, the only teacher he had ever paid attention to, and whom he revered deeply for opening his eyes to human qualities and anti-materialist values, Gauguin disdained the new Babylon. He took to referring to it as 'the Kingdom of Gold'. There was nothing he wanted here. And there was nothing it wanted of him. An awkward, underdeveloped fourteen-year-old boy of short stature, unpolished manners and an idealistic bent had no role, and nothing to contribute. His mother and sister found him naïve in the ways of the world. They called him 'Petit Paul' and treated him like a child. Marie was now sixteen, of marriageable age, looking for a husband and loving the glamorous life she had been catapulted into. She was sociable, confident, pretty, beautifully dressed and expert in bending people to her will. She tyrannised over both her mother and Paul who, helpless against her, retreated into the default position he had taken up at school – 'I am a savage from Peru'. He behaved badly. He was rude and surly to his mother and to his sister, and to Arosa. In 1865, when Aline made a new will, she wrote into it the equivalent of a mother's curse. Gauguin had made himself so unpopular with her entire circle of friends, she wrote, that if he carried on like this, he would ultimately have nobody left.[9] Gauguin must have given Aline great pain for her to write such a thing, not knowing when or in what circumstances she would die, and her only son would read her terrible words. She must have wanted to hurt him very much.

The will confirmed Arosa as Gauguin's legal guardian, the third to be appointed since the death of his father and the first who was not a blood relative, neither a Gauguin nor a Tristan. First, in Peru, Aline had entrusted the fatherless boy to the legal guardianship of José Rufino Enchenique, who was both Don Pío's son-in-law and the president of Peru. Next, in Orléans, homely Uncle Zizi had embraced the role steadily and contentedly. Now she had appointed Gustave Arosa, a man completely unrelated to Gauguin. The symbolic break, the idea that his legal fate was in the hands of a man whose blood did not run in his veins, crumpled security and stamped on what little feeling of social belonging he possessed.

However, the relationship between Gauguin and Arosa was more complicated than one of motley resentment and Oedipal complexity. Arosa gave Gauguin the inestimable gift of opening his eyes to art. Some seventy-seven important paintings hung on the walls of Arosa's splendid country house in Saint-Cloud where Aline and the children spent a great deal of time.

Busts stood on plinths; pictures were hung tightly frame-to-frame. Not for Arosa the fashionable favourites of the *haute bourgeoisie*, the erotic lollipops by Courtat and Bouguereau whose marzipan-sweet, creamy-fleshed female nudes, much given to swooning, Gauguin would good-humouredly characterise as 'brothel art'. By contrast, Arosa's tough collection contained an astonishing sixteen pictures by Eugène Delacroix, a painter unafraid of expressing the strongest political statement such as *Liberty Leading the People* (1830) and reinforcing his message by dramatic contrast in light and shade. Nine by Camille Corot, master of the Arcadian vision of serene ruralism. Seven by Gustave Courbet, creator and leader of 'Realism'. Calm *plein-air* aperçus by Eugène Boudin. Savage political snarls by Honoré Daumier. Softly socialist pastorals by the Barbizon School and their associates, Antoine Chintreuil, Narcisse Diaz de la Peña, Henri-Joseph Harpignies, Johan Barthold Jongkind and Théodore Rousseau (not to be confused with Henri Rousseau, Le Douanier) presenting artistic as well as political challenges by rejecting a high degree of finish while hymning the dignity of the worker and the peasant life. Within the collection Octave Tassaert strikes an incongruous note with his highly finished apocalyptic allegories tending in subject matter towards mass orgies. We know all this because the catalogue still exists from the sale of Arosa's collection in 1878.[10] It is illustrated with high-quality photographs, taken either by Arosa or at his direction. Gauguin kept a copy of the catalogue for years.

The Arosa household was no stuffy museum, but an artistic, busy and dynamic home. Arosa's younger daughter Marguerite spent her time sketching and painting and occasionally acting as model (clothed) for her father's experimental photographs. Arosa occupied himself with photography, developing the collotype process and of course stockbroking. Aline was overseeing the growth of the pre-Hispanic collection and deriving satisfaction from watching her daughter absorb a social education. Marie was having a wonderful time wearing pretty dresses and learning to play the social game.

Petit Paul was a problem. Surely this was a God-given opportunity for a future artist to study a treasure trove of pictures close by? But whatever he was noticing privately, he betrayed no sign of interest in art to anybody, certainly not to those who most wished him to do so: Aline and Arosa. Nor was he interested in anything else.

They decided he should go into banking, where they could start him off with every advantage. The heavy eyelids came down: he wanted to go to sea. They tried again. The chin came up: he wanted to go to sea.

Well, it would not be such a bad choice. The navy would surely succeed where they had failed: teach the young savage some manners, and discipline. But if he went to sea, it must be as an officer. Tiresome as the boy was, it was unthinkable that he should swab decks on his knees alongside every common Jack Tar. Naval officers were not far down the social ladder, they were well paid, and they led adventurous lives. The family enrolled Gauguin at the Loriol Institute, a naval preparatory school that specialised in getting students into military colleges. At the end of two years, if he passed the exam, he would go on to the École Navale, the elite naval college. Another exam at the end of that, and he would be free to adventure round the world to his heart's content, having the corners knocked off him on the way.

The Loriol Institute brought pupils up to standard in the general curriculum as well as the specialist subjects required by future soldiers and sailors: algebra, trigonometry and navigation. Map-making and mechanical drawing constituted his first formal training in art. One imagines he might have become engaged by this, but he showed no sign, merely continuing to demonstrate his habitual resistance to authority.

'All trained animals become stupid'[11] was Gauguin's considered opinion, and he had no intention of becoming a trained animal. The only place in the Loriol Institute he bothered to work was the fencing school. Officers carried a sword, and this was where they were taught to use it by Augustin Grisier, the legendary fencing master who instructed both the Czar of Russia and Alexandre Dumas who made him the central character of his novel *Le Maître d'armes* (1840–2). Gauguin adored the sport. He loved the psychology of the duel, the acrobatic drama, the balletic nuance. He wrote pages and pages about the art of fencing and how it taught him to scorn the blunt cudgel blow in

favour of studying his adversary carefully during what he refers to as the dance (of death?) and finding satisfaction in misleading his adversary into believing he would do something entirely different to what he actually intended.[12] Swordplay opened his eyes to the realisation that if you could combine control, stealth and subversion, this was by no means incompatible with being a tremendous swashbuckler. Fencing was 'a game of chess'. The victor was he who had the sharpest wits and the longest endurance. It described the life struggle. Later in his life, Gauguin would be sought after as a fencing master.

Time came for the exam. He went to his mother and told her that he had no chance at all of passing. He simply hadn't done the work. She was furious. Packed him off back to Orléans to board at the *lycée* for a year in a final effort, but by the end of the year he had studied so little that his teachers refused even to enter him for it.

Aged seventeen, he was unqualified for anything. Aline and Arosa arranged for him to join the merchant marine. Unlike the navy proper, the merchant marine had no snob value and poor financial prospects. On 6 December 1865, Gauguin signed on.

Anything but impressive in appearance, Gauguin was only five foot four in height. He would grow taller. He was slender, quick and agile in movement. He was still a virgin, an infuriating fact that itched and irritated and nagged. His face was oval with pronounced cheekbones and olive skin. His dark hair was wavy and thick. In the sun it shone with red-gold lights. His nose was already aquiline and conspicuously large, but it had not yet become the dominant and intimidating feature. His chin was short, he never had much beard, his lips were full and attractive. The eyes dominated: heavily lidded, hazel-green, sarcastic and watchful. *I am a savage from Peru. Noli me tangere! Don't touch me!*

His first job was as pilot's apprentice on a three-master passenger ship of 1,200 tons called the *Luzitano*. He didn't make many friends on board, and he had no special interest in the profession he had chosen, beyond the negative one of escaping from the Kingdom of Gold. What he was escaping *to*, he had not yet given any thought.

4

BECOMING

My first trip as pilot's apprentice was on board the *Luzitano* from Le Havre to Rio de Janeiro . . . A few days before our departure a young man came to me and said, 'Is it you who is taking my place as apprentice? Here's a little package and a letter. Would you be kind enough to see that they reach this address?'

I read, 'Madame Aimée, Rua do Ouvidor.'

'You will see,' said he, 'a charming woman to whom I have recommended you in quite a particular fashion. She comes from Bordeaux, as I do.'

I will spare you the voyage, reader; that would bore you.

I may say however that . . . the *Luzitano* was a fine ship of 1,200 tons, with excellent accommodations for passengers, and that with a fair wind it made its twelve knots an hour.

It was a very fine passage, without a storm.

As you may imagine, my first thought was to take my little package and the letter to the address indicated. This was a joy . . .

'How nice of him to have thought of me, and let me take a good look at you, my dear. How handsome you are!' At this time I was quite small; although I was seventeen and a half, I looked fifteen.

In spite of this I had already sinned at Le Havre for the first time, before sailing, and my heart was beating madly. For me it was an absolutely delicious month.

This charming Aimée, in spite of being thirty, was extremely pretty; she was the leading actress in Offenbach's operas. I can still see her, in her splendid clothes, setting out in her carriage, drawn by a spirited mule. Everyone paid court to her, but at this moment her acknowledged lover was a son of the Czar of Russia, who was a midshipman on a training ship. He spent so much money that the ship's commander tried to get the French consul to intervene

as adroitly as he could . . . Awkwardly, he remonstrated with her. Aimée, not at all put out, began to laugh, and said to him, 'My dear Consul, it enchants me to hear you talk, and I feel sure you must be a very good diplomat but . . . but I feel sure, too, that when it comes to sex you know nothing at all.'

And she went out singing. Tell me, Venus, what pleasure do you find in overthrowing my virtue thus?

And Aimée overthrew my virtue. The soil was propitious, I dare say, for I became a great rascal.

On the return voyage, we had several passengers, among others a fine statuesque Prussian woman. It was the captain's turn to be smitten but fiercely as he burned, it was in vain. This Prussian dame and I had found a charming love nest in the cargo hold for the sails . . . An astonishing liar, I told her all manner of absurdities, and the Prussian dame, who was deeply smitten, wanted to see me again in Paris. I gave my address as *La Farcy, Rue Joubert* [a notorious brothel]. It was very bad of me and I felt remorse for some time afterwards, but I could not send her to my mother's house.

I do not wish to make myself out either better or worse than I am. At eighteen you're always a little bit crazy.[1]

A second voyage on the *Luzitano* brought Gauguin back to Aimée's accommodating arms, but after that, he was reassigned to a three-master called the *Chili*, which ran a different route. It retraced the voyage he had taken in his infancy, rounding the Straits of Magellan where his father's body lay frozen in the ground, but he makes no mention of this. We do not even know if he went ashore. Continuing up the coast of Peru he docked, as his mother had, at the port of Callao, but he did not visit Lima. Nor, when he reached Iquique, did he make any effort to contact the family. The self-declared savage from Peru had, it seems, taken the decision that his chosen land would remain a symbolic realm: the Peru-of-the-mind, untouched by too much reality.

It was the same case when the ship went on to Tahiti, the island that would play such an important part in his later life; he doesn't tell us anything about this first visit. He crossed the Pacific to India, a country whose culture would have a strong influence on his art, but again, he does not enlarge. Travellers' tales are boring, he says firmly. The things he saw must have been rich

in images to stock his imagination and shape his artistic vision but Gauguin's memoir never describes this time as any sort of voyage of observation or creative discovery. On the contrary, he said that life on board left him with little impression of anything except 'an environment of coarseness and fisticuffs'. He put it down to the fact that he had not yet arrived at complete intellectual consciousness. His intelligence was still asleep. He thought that a certain natural resolution in him had been intensified by life at sea but it was not yet directed to any goal. His existence was an affair of the passing day. He thought little of the future, had no dreams, no great aims or ambitions, did not feel that he had any sort of calling.[2]

The best thing about his couple of years on board, he said, was that he grew in height. 'Petit Paul' now found himself as tall as the average shipmate, taller even than some. He became strong as an ox. Bony, bulky, hard and sun-browned, he changed shape, became broad at the shoulder and narrow at the hip. His sex life remained somewhat robust. He neither boasts nor enlarges on this statement. He became a strong swimmer. He learned to box and to wrestle. He became known as a hard man to cross. He broke his nose, maybe in a fight. It took on the shape of a fractured cliff. Not averse to a bottle, he was not a dedicated drinker. Tough, dominant, quiet, sometimes scary, very much his own man, he was deferred to by his fellows who gave him respect and authority. His humour was dry and sarcastic, and he made no secret of the fact that he viewed discipline as a threat on an existential level. The ship's officers couldn't pin much on him, but he made them perpetually uncomfortable. An air of insubordination hung about him. They suspected him of being a troublemaker. He did not receive promotion. The wild animal was successfully resisting training.

The *Chili* delivered him back to Le Havre in January 1868. He had reached the age of conscription for military service, and he was transferred from the merchant navy to the navy proper. Seaman Gauguin, third class, was assigned to the *Jérôme-Napoléon*, in theory a warship, in practice the private yacht of the emperor's cousin, Jérôme Napoleon,[3] a foolish prince nicknamed Craint-Plomb (Prince Fear-Lead) because in the Crimean War he had run away from the bullets at the siege of Sebastopol. Also known as Prince Plon-Plon, he was pompous, self-important and ridiculous.

Prince Plon-Plon fancied himself as an amateur scientist. The *Jérôme-Napoléon*, with its crew of 150, spent the two years leading up to the Franco-Prussian War on quasi-scientific expeditions plentifully punctuated by on-board banquets. They cruised through the eastern Mediterranean, the Black Sea, the Greek islands, Bastia, Naples, Corfu and went up the Thames to London, causing Queen Victoria to flee her capital to avoid the diplomatic awkwardness of meeting the blundering prince. On 3 July 1870, two weeks before the outbreak of the Franco-Prussian War, Prince Plon-Plon decided on a voyage to Norway, where salmon fishing in Trondheim yielded to the thrill of crossing the Arctic Circle. On reaching Tromsø, the prince's further ambitions on the Polar regions were dashed by a telegram from the emperor telling him to hurry home as war was imminent. The yacht made speed for Aberdeen in Scotland, where the prince parted from the boat that bore his name and scuttled off to sit out the war in Italy. Gauguin remained on board while the vessel was refitted for combat.

Napoleon III declared war on Prussia on 19 July 1870, and departed by train to the Front with much flag-waving. On 2 September, after only six weeks of fighting, he capitulated at the Battle of Sedan. He was taken prisoner and sent into the English countryside to enjoy a comfortable exile. Two days after the emperor's capitulation, France proclaimed a republic, which continued to fight the well-organised Prussians, as they advanced inexorably on Paris.

In the years leading up to the war, while Gauguin was at sea, his mother had moved out of central Paris. Aline's health, never robust, was failing. In 1865, she had closed her dressmaking business and settled in the wealthy, bosky suburb of Saint-Cloud where she took a pretty cottage on a quiet street, 2 Rue de l'Hospice, about ten minutes' walk from Arosa's magnificent country mansion on Rue Calvaire. Here she died on 2 July 1867. Her end, like her life, followed the nineteenth-century path of romantic heroines worshipped by their lovers but doomed by lingering sickness to a haunting, premature death: Edgar Allan Poe's Annabel Lee, Puccini's dressmaker Mimì in the opera *La bohème* and Verdi's Violetta in *La traviata*. Like them, Aline was graceful, fragile, talented and determined. She had fought fiercely, and failed, to support herself independently in a patriarchal society where the monetary odds were stacked against women. But within the walls of the Kingdom of

Gold, she had opened doors of perception in the devoted lover who thought it a bargain to support her brave and inspiring soul by the money he found it easy to earn. At the end, he kept faithful watch over Aline's decline and death.

We do not know the cause of her demise; heart trouble is most likely, judging from the symptoms.[4] Aline died at forty-two. Gauguin's father Clovis had died at thirty-five of heart disease. His grandmother Flora Tristan at forty-one. He never expected to live a long life.

Gauguin was still at sea when Aline died. Following her death, Arosa had welcomed Marie to live in his home as an extra daughter, and when the Franco-Prussian War had broken out, Arosa prudently took his family, including Marie, to sit out the war in the Channel Islands. They were well clear of the capital before the Siege of Paris began on 19 September 1870. The following months were a time of terrible hardship that lasted until the following January. Arosa's dashing photographer friend Nadar stayed on in Paris, relishing the chance of derring-do by forming the Compagnie des Aérostiers, the Company of Balloonists, who gathered some sixty balloons on to the hill of Montmartre where they soared, tethered like so many airborne eyeballs to spy on the encircling Prussian troop formations. The balloonists also flew out letters and dispatches, among them tender notes from the painter Édouard Manet, who was missing his wife whom he had sent to safety along with the other things most precious to him, including *Olympia*. Unfortunately, Madame Manet could not respond to her husband's love letters as winds and inadequate steering mechanisms made balloon-post insufficiently accurate to land *inside* the small area of central Paris encircled by Prussian troops.

Manet was one of the brave artists who remained as a volunteer gunner, as did Edgar Degas, another artist who would be immeasurably encouraging to Gauguin and hold great importance for him throughout his life. Both artists suffered severe hardship as the price of their courage. Early in the siege, César Ritz's gung-ho recipes sustained the encircled citizens on roasted elephant and other defiant dishes concocted from slaughtered zoo animals. Next came inventive ways with cats and rats. When even these were gone, Paris starved. On 8 January 1871, the city capitulated.

Three months later, on 23 April, with France defeated and occupied by the Prussians, Gauguin was released from his ship, ostensibly for shore leave

but in fact he never went back to sea again. He had spent his wartime patrolling Danish and German waters. Following the fall of the Napoleonic dynasty, his ship had been renamed the *Desaix*. It had captured four German warships and dealt with the resulting problem of prisoners none too humanely. 'I served in the 1870 war, and I have seen prisoners and the dead. All that at the caprices of the few. I don't like war.'[5]

War over, his ship docked in Toulon on the south coast of France between Marseilles and Saint-Tropez. He made his way northward up the length of his ravaged country to what was now the only place he could call home: his mother's cottage in Saint-Cloud. Here he received a terrible shock. The gentle meadows of Paris's luxuriant suburb had turned into an ashy grey wasteland of rubble and burned spars. It was here that, during the Siege of Paris, the Prussians had set up their headquarters in the Château de Saint-Cloud. Krupp's latest cannons had been planted on the château's elaborate baroque parterres, with a range that could reach Paris. In retaliation, the French had taken up a position on Mont-Valérien, from where their shells could reach the Prussians. The Château de Saint-Cloud, where the emperor had signed the declaration of war, was razed to the ground along with Aline's modest cottage. The collection she had brought from Peru was destroyed, the pottery smashed, the silver melted. Picking his way through the devastation, Gauguin knew his Peruvian heritage was gone.

Amid the charred and scarred wastes, Arosa's splendid mansion rose ash-smeared but almost intact apart from a tunnel bored through its middle. It had taken a direct hit from a shell that had failed to explode on impact. The fabric of the house stood firm around the hole in its heart. As if to underline this small local triumph of culture over barbarism, Arosa's art collection, marvellously, remained unscathed. Flora Tristan's books survived. Maybe Arosa had stored them somewhere safe? For Gauguin, they were sacred relics. He kept his grandmother's books with him wherever he travelled in the world to the day he died: a rare note of sentiment in a man whose notion of his own integrity was built on the idea that he owed nothing to anybody.

On his return from the Channel Islands, Arosa recorded the desolation of Saint-Cloud in a series of hauntingly sad photographs as he set about restoring his house to its former splendour. When Gauguin showed up, Arosa

welcomed him warmly. Given that Gauguin had behaved so offensively to Aline and to himself, he might have been excused for ducking out of any responsibility for the tiresome youth but he offered Gauguin shelter with the family until he found an apartment on Rue de la Bruyère where Gauguin could live independently. It was close to Arosa's town house on the Rue de Bréda and he kept a generous eye on both Paul and Marie, who were always free to run in and out of his houses, his wallet and his life; meanwhile, he administered Aline's small financial legacy with scrupulous honesty. Though Aline had expressed the wish that her daughter become self-supporting through finding a career, Marie was not like her mother or her grandmother. Marie inclined towards neither work nor independence. She liked parties and pretty dresses, and had no greater ambition than to marry a husband who could keep her in both. This was the pattern for girls of her class, and Arosa was content to have her fluttering around fashionable houses with his daughters until a rich husband came along. It was more difficult to know what to do with Gauguin. A man must be self-supporting. He must work for a living. The problem boy was now twenty-two; he had no qualifications behind him and no idea of what he wanted to do.

Arosa pulled strings. He held a lot of stock, and hence a lot of influence, in Bertin, a stock-trading business where his son-in-law, Adolfo Calzado, held a senior post. Gauguin was taken on as a *liquidateur*, the nineteenth-century equivalent of a futures broker, gambling on the buying and selling of certain shares at a certain date in the future. He received commission on each successful trade, as well as an annual bonus on his successes. This was not without responsibility: at the end of each trading period, he had to balance the books to the last franc. Gauguin had never previously shone at mathematics but now he had a reason to apply himself. He had obviously decided to take on the role of tamed animal, for he turned up every day, on time, correctly dressed and with his mind sharpened. His ledgers balanced profit and expenditure on each trading period, flowing elegantly across the page with pleasingly organised clarity. More importantly, he predicted the market with astounding intuition, and made money trading on his hunches.

Bertin was one of the sixty *agents de change* trading on the Bourse; the Paris stock exchange was rising again like a phoenix from the ashes of war,

as the *enrichez-vous* money-go-round restarted with dizzying velocity. Investment in the reconstruction of the devastated city offered lavish profits. The biggest projects were financed by foreign loans through the usual international banks, Rothschild's, etc., but there was plenty of opportunity for smaller private speculation through the Bourse.

By the autumn of 1873, to the astonishment of the world, France had paid the 5 billion francs that Germany had demanded in war reparations. This was the signal for the occupying troops to go home to Germany. France was free, and Haussmann's remodelling of Paris, so rudely interrupted by the war, resumed.[6] The unfinished sewage system was finally completed, as was the Avenue de l'Opéra leading to an opera house so outrageously opulent that Henry James remarked that if the world were ever reduced to the domain of a single potentate, the foyer would do for his throne room.[7]

At Bertin's, Gauguin's talent for reading financial patterns did not go unnoticed. He received promotion and he joined the black-clad crowd of tail-coated dealers hustling on the steps of the Bourse, the stock exchange building loosely modelled on the Acropolis. He started to deal on his own account as well as the firm's. Although he was paid a good salary as well as an annual bonus, prosperity did not make him clubbable. On the contrary, he maintained his essentially secretive personality. Among his colleagues, he was well known for rebuffing approaches.

The painter Archibald Hartrick, who saw quite a lot of him, wrote: 'In manner he was self-contained and confident, silent, almost dour, though he could unbend and be quite charming when he liked . . . Most people were rather afraid of him, even the most reckless took no liberties with this person. "He's a sly one," was the general sort of verdict. He was distinctly athletic in his tastes and had the reputation for being a formidable swordsman. I believe it was truly earned. Anyway, it added to the caution with which he was generally approached, for he was treated as a person who was to be placated rather than aroused.'[8]

Gauguin was living on his own terms for the first time in his life. Completely independent, he could choose what his eye fell on, and what he put into his stomach. He ate alone, at small unglamorous restaurants. Though he had plenty of money, his tastes were not expensive. Purchases were

chosen neither for fashionable appeal, nor for status. Defying the tyranny of social form and shuddering at ostentation, he surrounded himself with handmade things. Machine manufacture revolted him. He bought individual hand-thrown cups and pots and plates rather than matching sets, he covered his floors in hand-knotted patterned rugs rather than imitation Versailles Aubussons, and he hung colourful hand-woven striped fabrics on his walls rather than faux-medieval tapestries. We can see these pieces in the earliest drawings and paintings that he was now beginning to make in the evenings after his day's work at the Bourse, and we can see that it was here, and now, that his taste was formed for good, as he keeps the same pieces; they crop up in his paintings as the years go by.

Following the solitary evening meal, he might drop in on the fencing *salle* or the boxing studio, then home to an evening alone. Spare time from work was increasingly occupied by looking at art.

Gauguin was receiving an education in art despite himself. On his regular Sunday visits to Arosa's house, surrounded by the collection he had known since a boy, it was taken for granted that, following the horrors of war, art was the supreme means of re-establishing a civilised society. Chez Arosa, the latest advances in art and photography were discussed with deep seriousness with fellow guests who often included Philippe Burty, the influential art critic of *Le Figaro* and the ever-stimulating Nadar. Gauguin was encouraged to go sketching, fashionably *en plein air*, in the company of Arosa's younger daughter Marguerite, a red-haired, milky-skinned girl with the bloodless looks of doomed maidenhood made fashionable by Edgar Allan Poe. This made her popular as a photographic model for Nadar and her father, but Gauguin preferred to sketch beside her than to sketch her. His feelings for her were close and tender; brotherly, not erotic. Marguerite was anaemic but her character was robust. She determined to become an artist, an ambition she achieved with a degree of success in Spain and in France.

Marguerite took lessons from Camille Pissarro. Like the Arosas and the Pereires, he was of Sephardic Jewish origin. Gustave Arosa's elder brother, Achille Arosa, had commissioned Pissarro to decorate a *salon* in his house at 44 Rue de Bassano. The quartet of canvases he produced, *The Four Seasons*,[9] is now considered of the greatest importance as the first complete decorative

scheme of Impressionist art. There must have been considerable excitement in the Arosa household in 1873 when Pissarro was producing it. That was also the year leading up to the important first Impressionist exhibition,[10] held from April to May 1874 in Nadar's studio, with Pissarro taking a large part in its organisation.

But for all the feverish interest in art chez Arosa, it was not there that Gauguin received his final shove towards making art, but at the office. It came from a fellow clerk, a small, unimpressive fellow from Alsace called Émile Schuffenecker. A couple of years older than Gauguin, 'Schuff' was the son of a shoemaker, who had died when he was three. His mother, a laundress, could not afford to keep him and entrusted his care to an elderly uncle. It was not an unkind household, but he suffered from depression throughout an unloving childhood. He grew up feeble and timid but with a passion for art burning fiercely in his breast. Schuff had joined Bertin's with the sole purpose of making enough money, quickly, to support himself for the rest of his life as an artist. Humble, but steely and insistent, he attached himself to Gauguin, with his genius for making money, like a suckerfish to a whale.

There were lots of little art galleries in the area around the Bourse, and Schuff dragged an ever-more-willing Gauguin to see what they were showing. The most important was Paul Durand-Ruel's. During the Franco-Prussian War, Durand-Ruel had fled France for England and there he had met Monet and Pissarro, fellow refugees. Now his gallery was exhibiting their work alongside Renoir, Sisley, Cézanne, Berthe Morisot, Armand Guillaumin and Degas, the loose group that would gather together for the first Impressionist exhibition. When Schuff left the trading floor, he would wend his way home looking at art, arriving home to practise it. Schuff had a lot he could tell Gauguin about the technicalities. He had studied under Paul Baudry, who had won the Prix de Rome and found success painting luscious nudes of the sort that Gauguin scornfully called brothel art. Schuff himself had already won a medal for technical drawing. He took Gauguin off to the Louvre to do the traditional studying and copying of Old Masters.

Now, at last, Gauguin tried his hand at art. How much had he done before in his life? Very little, it seems. He does not tell of drawing or sketching when

he was at school, or later on board ship. The only story he does tell is that one day in Orléans when he was seven or eight years old, 'I was whittling one day, carving a dagger-handle without the dagger . . . A good old woman who was a friend of ours exclaimed in admiration, "He's going to be a great sculptor." Unfortunately, this woman was no prophet.'[11] This single reference to early artistic activity ends typically on a note of self-deprecation. Speculation exists that he sketched while he was at sea, and that he whittled things in wood as sailors do. It is perfectly possible. But there is no hard evidence. Likewise, we know of no teacher during the years 1872–4, when Gauguin was turning himself into an artist. Schuffenecker was his daily companion during these years, and he describes Gauguin as 'making his first attempts at painting without assistance'.[12]

Gauguin's first major painting to survive, *Working the Land*, is dated 1873. It shows a flat, panoramic landscape in the environs of Paris. Two small figures are working patchwork green and yellow fields. A few trees provide verticals. The land is well observed, if dully painted. The sky is a disaster. A bank of cotton wool cloud presses down heavily, squashing the earth. Corot is the major influence, along with the other Barbizon painters that Gauguin was so familiar with from Arosa's walls. There is nothing Impressionist about it, but the compositional similarity to the overdoor *Spring* in Pissarro's *Four Seasons* is striking. The other pictures that survive from this couple of early years are similarly cautious landscapes.

It was during this period of artistic exploration in 1872 that one day after work Gauguin found himself strolling along the Boulevard des Italiens. The chestnut trees were bursting into flower, floating above the pavement in a froth of freckled petals, suffusing the air with their light, almondy scent. This is what he tells us, but it cannot be true, because we know from diary dates that the month was November, when chestnut trees are bare and black, and their blossoms are curled up tight inside their lacquered buds. He paused at a street corner, wondering where he was going to eat. A person brushed lightly against the overcoat he was carrying over one arm. He gave a start and turned to see a young, brightly dressed woman with masses of blonde hair blowing freely round a fresh-complexioned face. She was chattering to her friend, but her sparkling blue eyes caught his and said a world of things

before she walked on. He followed the motion of her body with his eyes until she disappeared. Turning, he took the opposite direction; he had decided to eat at Chez Aubé, a modest restaurant in the home of a sculptor whose wife ran a little *pension* with a restaurant downstairs.[13]

And there she was.

'Mette Gad, from Denmark,' said Madame Aubé, who always introduced her guests to each other. Both experienced the *coup de foudre*. Within weeks they were secretly engaged.

Mette was a tall, well-built, statuesque blonde of independent views. She was the eldest of five children of Henry Theodor Gad, a well-respected district judge on the little Danish island of Laesø in the Kattegat. Mette was a year younger than Gauguin. In her way, she had already led as self-determined a life. Her father had died when she was ten, whereupon her mother took up the strong role of head of the family, just as Flora and Aline had done on the Gauguin side. Mette's mother had no hesitation in putting responsibility and authority on ten-year-old Mette over her younger siblings. 'Her father's death had only bonded her more strongly with her mother in a shared attitude of taking whatever life threw at them with positivity and good humour. Moral and religious pangs were unknown to them. Eyes open to the truth and happy to deal with it, she never knew fear,' wrote her son.[14] At seventeen, Mette had taken a job working as governess for the two eldest daughters of Jacob Estrup, then Denmark's Minister of the Interior, who would soon go on to serve as prime minister for almost twenty years. Estrup was an authoritarian conservative, with an enthusiasm for tightening control on the press, strengthening police powers, reinforcing Denmark's fortifications, and building a railway network to keep his country's transport system further up to date than neighbouring Sweden, which was still digging canals and relying on boats. Mette was a great success in the grand political household. She was personable, intelligent, hard-working, resourceful, robustly healthy and fun to have around. She handled the children unaffectedly and naturally, but her greatest success lay in her intellectual attitude. She was uninhibited in expressing her own opinions, a quality Estrup valued. Surrounded by yes-men, as powerful people often are, he liked her fearless truthfulness. In argument and conversation, she treated everyone as an equal, and she was

never afraid to express liberal opinions, though she well knew that Estrup and his guests often held the opposite views. Realising that she spoke and judged from her own experience of life rather than regurgitating second-hand ideas, he valued the different perspective she brought to his own perceptions and those of his children.[15]

After five years at this high political and intellectual level in Denmark, Mette felt it time to expand her horizons. Aged twenty-two, she longed to see the wider world outside Denmark and to practise the French language that she had been teaching Estrup's daughters. She travelled to Paris with her best friend from school, Marie Heegaard, the second, and smaller, blonde chatting to Mette on the street corner and now sitting at Madame Aubé's table.[16]

As Gauguin told it, Mette did most of the talking, not very fluently, with a pronounced foreign accent. He liked her voice; it was deep but not harsh. In the course of the evening they talked about things great and small; he soon found that she shared many of his interests and that her view of most things was based on independent conclusions. There was an unusual frankness and openness about her. When he got up to say goodnight, he promised Madame Aubé, as usual, to come again soon. He meant it.

The days passed quickly. He hurried beneath the chestnuts ever more eager to arrive at Chez Aubé. The intervals between his meetings with the two Danish ladies grew shorter and shorter. He was strongly attracted to Mette sexually. Her blonde amplitude and husky voice were erotically intoxicating but there was more to Mette than bountiful flesh and a throaty alto. He admired her for the same reasons Prime Minister Estrup did. The same reasons he had admired his mother and grandmother. Mette was an independent and provocative woman. Established religion meant nothing to her, but morals and ethics meant a great deal. She liked arguing ideas. It can hardly be overstressed how atypical Mette was of the women of her generation. Self-respecting and unsentimental, she violently rejected the view that a woman's primary purpose was to make herself delightful to men. Department store windows held no allure. Both Zola and Proust expend many words on the typical Parisienne whom men revered for taking at least an hour and a half to be dressed by her maid – and that was before the hairdresser

got to work. For Mette, this was a waste of time. She was not without vanity, but her appearance embedded her philosophy. Rather than making shopping an occupation, she had her clothes, gloves and shoes made for her. She did not ignore the fashion for pretty little ankle boots but found a way to ignore their tyranny. The boots then fashionable were fastened by a row of ten or so tiny pearl-sized buttons running up from instep to ankle. Each fiddly button must be manoeuvred into its tiny leather loop by means of a special button hook. Mette typically found a quick and stylish solution, fastening her boots with a pair of antique silver buckles.[17]

'She held herself away from petty and to her unimportant issues and so she might seem remote and was called cold . . . But practical and intelligent as she was, she was naive' – these are her son's words – 'because she never learned to be cynical and she had not enough imagination to formulate a concept of danger . . . She never felt fear and this lent her a perceived tendency to arrogance. Never insinuating or compromising, never bowing to the superior male, she could be tactless. She, in her own way, was also a noble savage.'[18]

It was a steely wooing. 'There is a young Monsiuer Goguain [sic] who secretly pines for Mette', reported Marie Heegaard in December, 'but she remains stony-hearted . . . you know, she's blossomed here. Mette really stands out. Everyone here finds her very beautiful.'[19] But Mette could not long resist Gauguin. Six weeks after their first meeting, she capitulated. When he asked her to marry him, she immediately said yes.

The Arosas took Gauguin's two new Danish friends to their bosom. Marie Heegaard was the letter writer of the two, and it is she who describes the halcyon months of Gauguin and Mette's engagement. It begins a little stiffly at Christmas 1872 when the two Danish girls were invited to a rather too splendid reception chez Arosa, but by February news of the engagement had slipped out and things loosened up considerably. Arosa held a Mardi Gras costume ball on 25 February. Presumably drawing on memories of Aline's dressmaking atelier, Gauguin made costumes for the guests out of crêpe paper. One he dressed as a champagne bottle, another as a chandelier; he turned Marie Heegaard into a fisherman's daughter and Mette into a baby. Himself he dressed as a soldier.

Fancy-dress balls were all the rage that year and a month later Gauguin and Mette signalled their coupledom by attending as a pair of *incroyables*, the extreme fashion victims of the Directoire period.[20] Daringly, they cross-dressed. Mette, in trousers, made a stylish young man-about-town and Gauguin made a great impression as a woman in a very tight chestnut costume and a tricorne hat. Fancy dress amused them both. It played to his lifelong predilection for adopting alter egos and to her ebullient extrovertism.

As winter rolled into spring, the first spring of the Impressionists, they were guests at the banquet of life, their role to play the young and beautiful lovers inhabiting the moneyed, hopeful fantasy of the Arosas, who wanted to believe they could turn the post-war years into an ever-rolling Watteauesque *fête champêtre*, a feast of joy and art and ideas and brilliant conversation. Pleasure followed pleasure. Great picnics of gilded youth nibbling on truffled chicken transitioned seamlessly into swimming and sketching parties and visits to picture galleries. Talking, always talking. Ideas, books, art. Gauguin and Mette read Balzac and Edgar Allan Poe together, and rambled through the blasted streets of Saint-Cloud as it rose again, resurrected into a new beauty. The chestnut flowers that Gauguin had imagined at their first meeting burst open. The scented air between them grew thick and heavy with longing. Mette decided she should go home to put some space between herself and him. Her family in Denmark were happy at the prospect of her marriage with this well-connected, prosperous husband-to-be but she needed to reassess, to take a breath.

Mette came back in October. In her straightforward way, she had decided that it was right to dedicate her life to marriage with Gauguin. Her time in Denmark had not been spent in the manner of a conventional bride-to-be, sitting beside her mother sewing a monogrammed trousseau and amassing a vast *batterie de cuisine* for the marital kitchen. Instead, Gauguin noted with amusement, her trousseau, such as it was, consisted of some chemises and a set of six knives and forks. He approved wholeheartedly.

On 22 November 1873, almost exactly a year after they first met, they were married. First in a civil ceremony with Gustave Arosa, Paul Bertin and the secretary to the Danish consulate, Oscar Fahle, acting as witnesses.

Later that day, to please Mette's family, a church ceremony was held at the evangelical Lutheran Church of the Redemption in Rue Chauchat.

'I have long known what I am doing and why I do it,' Gauguin wrote in a letter to Mette. 'I am strong because I am never put out of my road by others, and I do what it is in me to do.'[21] It was a sentence that Mette might equally characteristically have written to him.

5

IMPRESSIONISM AND BOURGEOIS BLISS

> There followed a charming winter in which we were a little too unsociable for others' tastes, but nice and cosy in our own apartment.[1]

Nine months and nine days after the wedding, Mette gave birth to their first son. The baby had his mother's Scandinavian blonde colouring. 'He is as strong as Hercules,' Gauguin crowed. 'As to whether he's amiable or not, that I don't know, the odds are against it, his father being so grumpy.'[2]

They decided to call him Emil, spelling it the Danish way, without a final e, rather than the French Émile. Gauguin went down to the Town Hall to register the birth. 'There is nothing more obstinate than a Town Hall clerk,' he fumed. 'I told him to register a boy named Emil *sans e* [without an e]. It took an indescribable quarter-hour to get the spelling right. I was a joker who was making fun of the clerks, etc. . . . A little more and I would have received a fine.'[3]

During the months leading up to the birth, Mette describes a fundamental change in Gauguin: he started to draw obsessively. She was, she said, surprised. He had never shown a serious interest before. 'He went to work with his usual thoroughness, studying the object very carefully and drawing the same hand over and over again in the most various positions.'[4] On Sundays he went out all day, often accompanied by Schuffenecker, to see what he could achieve sketching and painting *en plein air*, like the Impressionists. This was 'a kind of intellectual sport which fascinated and tranquillised him after the dry, mechanical work of the day, the noting of prices and investments which had a stimulating but at the same time a blunting effect on him, since according to his idea, all that sort of work only produced negative values . . . Actually he had no conscious artistic aim . . . It was the purely manual

element which occupied him. But the more Gauguin worked, and discovered all the difficulties involved, the greater was its fascination for him.'[5]

He would make a preliminary study in the open air and then take it into the studio to work it up into a finished picture. Many Impressionists, including Monet and Degas, did the same, for all their proselytising against studio painting.

We have some forty-five paintings from 1872–9, often referred to as his Impressionist period, but the pictures swerve wildly in style.[6] Some, like *In the Forest, Saint-Cloud I* (1873), are dark, smooth and mysterious: Corot without the nymphs. In others, he uses strongly defined brushwork, reminiscent of the Pissarros he had seen chez Arosa. Some imitate Frits Thaulow, the very successful Norwegian painter who was married to Mette's sister Ingeborg. Frits and Ingeborg Thaulow were living in Paris; and the two couples were running in and out of each other's houses and dandling each other's babies. They appointed Thaulow godfather to Emil. A big, jolly bear of a man, Frits Thaulow was popular among the Paris Impressionists, who baptised him 'the painter of snow', for his mastery of the difficult subject of snowlight, ranging from diamond-dazzle sun on frosted crystals to gelid winter mists. There was a lot of snow in Paris in the winter of 1882–3. Everyone, including Gauguin, tried to capture it, but none understood it like Thaulow. His pictures prompted Claude Monet to visit Norway, an unsuccessful venture for the technical reason that tubed French paint froze in Norway's temperatures, a problem Thaulow got over by concocting his own paint recipes. Following his success in Paris, Thaulow returned home to found the Open-Air School of Painting at Modum, where he introduced *plein-air* painting and Impressionism to Norway; guiding, among others, the early career of the young Norwegian Edvard Munch, whose attempts at the French movement's representation of colour and light earned him Oslo's ridicule, and the nickname Bizzarro.

Before Thaulow went back to Norway, he advised Gauguin that if he was serious about painting, he should stick to landscapes. That was what people wanted to buy. But Gauguin never took advice. To understand the thingness of things, he was painting still lifes, based on the tradition of the seventeenth-century Dutch Masters. Stiff, show-off pieces demonstrating mastery of space, form and surface texture: craggy-shelled oysters, furred

and feathered dead game, downy fruit, slimy fish, the transparency of glassware, the gleam of silver and porcelain, artfully foreshortened objects like knives pointing straight at you. The literal appearance of things: surface, texture, solidity, light, weight and perspective seemed to hold no problems for him. Not much individual vision emerges in the still lifes, or the landscapes, but it does in his paintings of children and flowers.

Gauguin would love to paint flowers all his life. Right from the start, he saw them with an original eye that broke from the convention of treating their fragile faces as nostalgic symbols of the fleeting nature of beauty, doomed to decay and death. Instead, Gauguin emphasises their strong life force, portraying them vigorously in clotted impasto paint. China asters were a favourite for their scrunchy, shaggy petals. It was a vision of strength that he would develop further when he was living with Van Gogh in Arles surrounded by his sunflower paintings.

His earliest paintings of children are equally unsentimental. Two survive from this period, one of baby Emil and the other probably of the next child to arrive, his daughter Aline. Gauguin seems to perceive his children as more ephemeral than his flowers. Thinner washes of colour give them the transparent quality of ghostly beings arrived from another world. They recall the unsettling manner of Goya, who had the peculiar talent of imbuing the direct gaze of the child's unformed features with the most painful suggestion that, wherever they had come from, arrival in this world was incomprehensible and hellish. These pictures Gauguin made of his children prefigure the later images he would make of Polynesians, in which he also places himself, the artist, on the outside as he records beings whose mysterious, pre-industrial consciousness similarly excludes both him and us, rendering their remoteness and powerfulness infinitely mysterious and compelling.

There are surprisingly few paintings of Mette. She was not born to be an artist's model. She thought it was boring to sit still for hours, and he had to snatch moments when she was unaware. His most developed picture shows her asleep, lying on the sofa in a long white dress, seemingly too exhausted to undress after a party (*Mette Asleep on a Sofa*, 1875). For all the intimacy of the subject, Mette is as far out of reach as his children; she, too, inhabits a separate state of consciousness. Although she is fully clothed and has her

back to him, the picture exudes a strong eroticism that maybe suggests the influence of *Olympia* in that the real subject of the picture is the power of sexual control exercised by the unreachable female.

Flowers, children, Mette; already he had found a main theme of his painting, the impenetrable discontinuities of consciousness.

In 1876, when he had been painting for four years, he had a picture accepted by the Salon, the annual exhibition organised by the French Academy of Fine Arts.[7] Set up in 1667, it had been exercising a stranglehold on French art ever since, preserving the continuity of the classical tradition, moving France's pictorial landscape forward at a glacial pace as it upheld the sacred values of verisimilitude, correct perspective and 'finish'. The Salon picture should end up as smooth and gleaming as a factory-fresh industrial object. It must also be framed in gold, a condition that often strained the pockets of impecunious garret-dwellers. It was because the Salon had no place for experimentalism that the Impressionists needed to organise their own shows.

To have a picture accepted by the Salon four years after taking up painting was a precocious achievement. Once he had achieved this goal, he valued it little. He wanted to learn to sculpt. This involved moving house, uprooting his family from the chic, moneyed sixteenth arrondissement with its competitive young-marrieds' dinner parties, to Vaugirard, a shabby area full of sculptors' workshops.

The Haussmannisation of Paris gave sculpture a new importance. Civic magnificence demanded façade decoration, monuments and statues, and busts of important men. Sculptors needed room for their big studios and stone-yards. Space was plentiful in Vaugirard, where rents were cheap, but you were not too far from your commissioning patron in the smarter part of Paris. Here Rodin was hammering away at *The Thinker* who would crown his gigantic *Gates of Hell*. Bartholdi's Statue of Liberty was starting to loom above his studio in Rue de Chazelles, just as King Kong would later loom above her. Liberty's arm, over eleven metres in height, toured the United States, to wonder and acclaim.

As he rolled up his sleeves to model in clay and to cut stone after his day at the Bourse, Gauguin noted gleefully that the area he had arrived in was a den of thieves. His corner house on Impasse Frémin was surrounded by

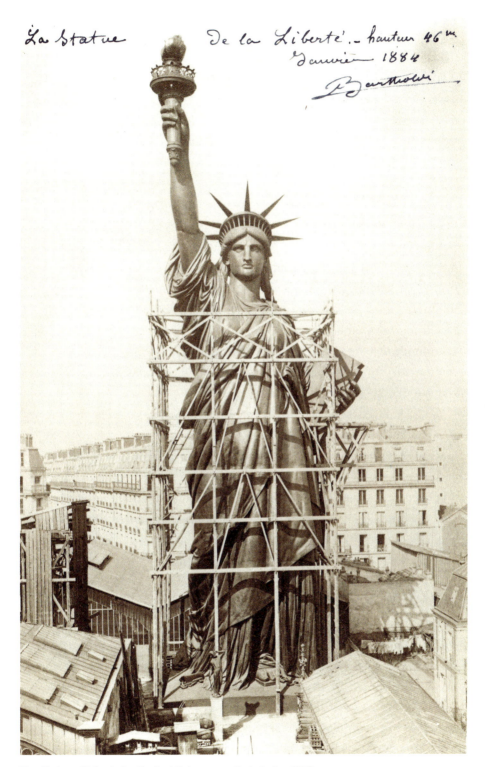

The Statue of Liberty by Bartholdi rises over Paris in the 1880s

market gardens.[8] His neighbours, dressed in *bleu de travail*, cultivated their crops to send to market in Paris. Pigs and chickens scratched about in the dust, as they had long ago in Peru, and would again in Tahiti. He had only to open his window and yell, for a neighbour to cut a melon for his lunch. When the carter who lived opposite hanged himself, the carter's wife summoned Gauguin to help cut the dead man down. His social circle included his neighbouring sculptors and their families, Jean-Paul Aubé, Jules-Ernest Bouillot and Charles Orsolini. Gauguin made his first attempts at sculpture in Bouillot's studio, a mess of marble dust and wood shavings, limbs and heads and torsos, tools honed to a murderous edge on glittery carborundum stones, sketches pinned up any-old-how on splodged walls, revolving turntables holding unfinished works-in-progress shrouded in wet sacking, the musty smell arising from their damp shrouds mixing with the smell of coal from the wretched little cast-iron stove that kept nobody warm. Models wandered about unclothed to demonstrate the movement of muscles, or semi-dressed to show the cock of a hat, the fall of drapery or the tortured shape imposed by a corset, or a soldier's uniform.

Gauguin revelled in the 'authenticity' of this working-class life, even as he was commuting daily to the Kingdom of Gold where he was earning huge amounts of money: 200 francs a month plus an annual bonus of 3,000 francs. Insider trading, doing deals on the basis of confidential information, was not a crime as it is today. Gauguin had plenty of contacts in high-up places and in 1879, he made 30,000 francs dealing on his own account.[9] Carelessly rich, gleefully opulent, Gauguin became legendary for taking a taxi to the office, keeping the driver waiting while he worked, then having it deliver him back to his scruffy neighbourhood.[10] He was reputed to own fourteen pairs of trousers. As well as swaggery trousers, he spent prodigiously on Impressionist pictures, once shelling out 15,000 francs all in one go. His primary purpose was to study and learn from them, but he did not ignore the financial opportunity to make a market; he recommended clients to invest in the artists he was buying himself. He had an eye and he picked up bargains. The least he probably ever paid for a painting was seven francs for a Pissarro. A couple of pictures by Monet and Renoir cost him thirty francs each.[11] He also collected Boudin, Jongkind, Degas, Renoir, Sisley, Cassatt, John L. Brown and

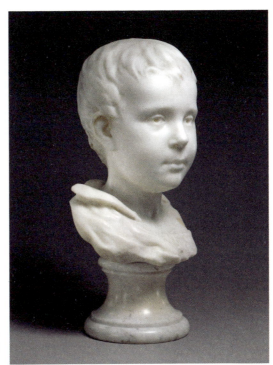

Gauguin,
bust of Emil, 1877–8

Gauguin,
bust of Mette, 1877

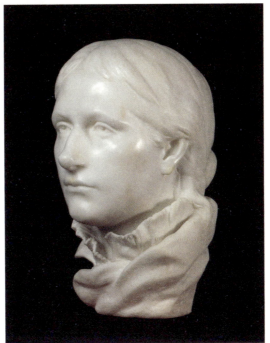

Daumier.[12] The greatest number of paintings he owned by a single artist was twelve by Cézanne. He feared and revered Cézanne, calling him 'the Magician'. Cézanne did not return the regard. He distrusted Gauguin, whom he accused of wanting to copy him. Given Gauguin's habit of buying paintings to analyse and learn from them, Cézanne had a point.

Gauguin mastered the craft of sculpture with extraordinary ease and speed. Two years after his chisel first broke stone, his marble head of Mette is a work of great individuality and charm, and his head of his son Emil was included in the fourth Impressionist exhibition. Dazzling white and slick as an ice rink, the bust stands firmly in the neoclassical tradition. It might be by Canova, or the Roman head of a baby Caesar dug up from the Forum. It is almost as difficult to believe that Gauguin carved it as it is to believe that the Impressionists exhibited it alongside their own revolutionary work. How had this come about?

In 1879, Gauguin realised that he needed a teacher. Technically, you could only go so far on your own. He applied, by letter, to Pissarro. Eighteen years older than Gauguin, Pissarro was the eldest in the Impressionist group that had its roots in 1873, when the Salon had rejected his paintings along with pictures by Monet, Renoir and Sisley. This had spurred them on to hold their first exhibition in 1874, in which the title of Monet's paintings *Impression: Sunrise* (1872) prompted the title that has stuck ever since. Eight Impressionist exhibitions were held over twelve years between 1874 and 1886. Over that time, the number of artists exhibiting varied between nine and thirty. Pissarro was the only artist to exhibit in all of the exhibitions. His energy and belief exercised a strong hand in keeping the shows going and driving the others to persist in exhibiting together, despite poor sales, insulting reviews and differences of opinion between the artists themselves. Degas, classically trained, was the most traditional, Monet the most experimental. Each had their supporters who from time to time stood on some principle and refused to exhibit along with the others.

Impressionism was never a formal movement or school, just a group of like-minded artists experimenting within a loose ideal of breaking free of the endless Salon burden of the classical and historical tradition. Why paint another Crucifixion or another Sack of Rome when you could portray

IMPRESSIONISM AND BOURGEOIS BLISS

contemporary life and actual experience? Their aim of capturing the present moment rather than the permanent aspects of a subject brought a new importance to the fleeting portrayal of light. 'Studying the changing aspects of nature according to the countless conditions of hour and weather, pursuing the analysis of nature all the way to the decomposition of light, to the study of moving air, of colour nuances, of incidental transition of light and shadow, of all the optical phenomena . . .' wrote Zola.[13]

A week after Pissarro received Gauguin's letter requesting lessons, the fourth Impressionist exhibition was due to open. Pissarro hastily extended a last-minute invitation for Gauguin to join in. He knew Gauguin to be the protégé of his patrons the Arosa brothers and famous in his own right as a collector who spent extravagantly on paintings, and who was already lending three Pissarros, a Cézanne and a Degas to the show from his collection.

Gauguin had the sense to realise that his own pictures were not yet up to Impressionist standard and sent along the bust of Emil. It must have looked uneasily archaic surrounded by all their experimental rectangles of decomposed light. A conservative critic, who described the show as 'misguided works of lunatics and painters wielding their brushes in a state of *delirium tremens*',[14] recommended Gauguin's 'pleasant little sculpture' of Emil, as the only thing worth looking at.[15]

Gauguin kept working hard at the Bourse during the day, and towards next year's exhibition in his spare time. At the next Impressionist exhibition, Gauguin submitted eight paintings, including four large landscapes in the manner of Pissarro. He was rewarded with a review in *La Presse* by the brother of Auguste Renoir, who praised the 'admirable impressions' of an artist at once sincere and original.[16]

The following year he exhibited three landscapes, seven still lifes, and had real success with his first important nude, *Woman Sewing* (1880). The model was probably Justine, the children's nursemaid. It is posed in the studio in their home, as we can see from the familiar striped wall hanging. Mette remained undisturbed by jealousy. Their sex life was vigorous and pleasing to them both. Gauguin tells us that he had no interest in straying outside their marriage.[17] *Woman Sewing* is an ambitious canvas, the life-size figure is made up of thousands of flickering brushstrokes. With her back to the light,

63

absorbed in sewing or mending a white piece of cloth, she shows complete disregard for the viewer. The picture is non-idealised and non-erotic. We remember his contempt for brothel art. Not since Rembrandt had the fallible female form been treated so sympathetically.

Woman Sewing caused a sensation. 'I have no hesitation in stating that, among contemporary painters who have worked on the nude, none has produced so vehemently realistic a note . . . The flesh is glaring, it is no longer the flat, smooth porcelain skin of Millet, that skin uniformly dipped in a rose vat and passed under a warm iron by all painters. It is an epidermis, red blood pulsing beneath it and nerves that twitch. I am delighted to hail a painter who has felt, like me . . . disgust for mannequins overweighted by a so-called good taste, drawn according to recipes learnt in copying plasterwork.'

So ran the review by the influential critic and poet Joris-Karl Huysmans, which ended by comparing Gauguin's nude to Rembrandt's, commenting that it was 'eminently desirable' that Gauguin should do for his period what Rembrandt had done for his, i.e. inject a corrective dose of realism.[18] The leading dealer Durand-Ruel bought three of his pictures for 1,500 francs, which Gauguin immediately spent on a seascape by Manet, *Vue de Hollande* (1872).

He was accepted by the group. He had become one of them. He traded pictures with them. This was how real artists behaved. Pissarro told him he had a nice little talent. 'Manet, once seeing a picture of mine (at the beginning), told me it was very good. Out of respect for the master, I answered, "Oh I am only an amateur." "Oh no," said Manet, "there are no amateurs but those who make bad pictures." That was sweet to me.'[19] 'Degas was like a good papa who said to me at my debut: "You have your foot in the stirrup."'[20] They swapped pictures, and Degas eventually valued Gauguin's pictures so highly that he became an important collector.

Gauguin joined 'the Manet gang' at their special tables in the Café Guerbois and La Nouvelle Athènes during their long sessions fuelled by absinthe and tobacco. They all say he was a man of few words. Thirsty to learn, he listened more than he spoke, and kept himself separate from their lives outside painting because, 'What do husbands do? . . . On Sunday they go to the

Gauguin, *Woman Sewing*, 1880

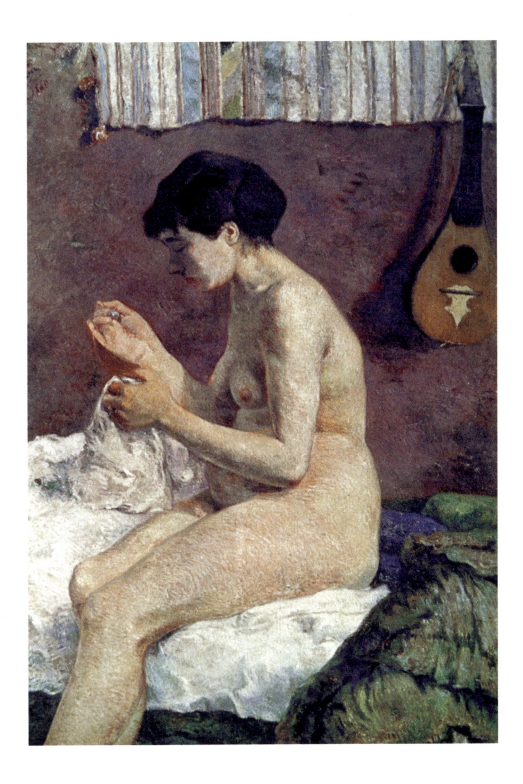

races or to the café or with whores, for men must have a little amusement, otherwise they cannot work, and besides, it's only human nature. For my part I worked, and that was my dissipation.'[21] Art was his mistress. Mette was his wife. He was content.

Between 1879 and 1883, Gauguin would go out at weekends and in the summer holidays to paint with Pissarro in Pontoise. The older man looked like a benevolent Father Christmas with his long white beard and his ample stomach, but his appearance was deceptive. He was tetchy, rude and difficult. He had seven children to support and lived in terror of his wife who was continually asking him for money. His art was too transitional for him to be taken on by Durand-Ruel, who represented so many of the Impressionists, showed them in his gallery and made the market for their work. With no gallery to display and sell his pictures, Pissarro had to go from house to house, knocking on the doors of people who had already bought from him, or who might buy. 'Does your mother believe that I enjoy running in the snow and mud from morning till night,' Pissarro wrote to his son Lucien, 'without a penny in my pockets, scrimping on the cost of a coach when I am dog tired, hesitating before spending on a meagre lunch or dinner? I can tell you, it is no fun.'[22]

A second-rank Impressionist, Pissarro was a great teacher. He had an unparalleled eye for critical analysis and suggesting solutions. He encouraged Gauguin to look less at outlines, to think instead about centres, and to note the effect of different light conditions upon different gradations of colour. To understand that when colours close to each other in the colour spectrum reflect on to one another, both outline and spatial definition become blurred. Complementary colours, on the other hand, such as red and green, sharply define the edges, lending greater physical weight to the volume of objects.

Gauguin learned to stretch his own canvases. This meant he no longer had to fit his pictorial vision into commercially sold shapes and sizes. He worked on lots of pictures simultaneously. He was not looking for immediate results but making studies, documents to be put aside for later. He steeped himself in the principles of atmospheric impressionism: to paint boldly and without restraint lest the first impression be lost; to render perceptions immediately in the form of small strokes of paint; to build forms from animated and disrupted brushstrokes.

Years after Cézanne had found his own voice, he would come back to paint with Pissarro for the benefit of his constructive criticism. It does not take genius to see Gauguin stealing the diagonal brushstroke from Cézanne and enjoying experimenting with its length. The two men met at last in 1882 when they were both painting with Pissarro. Gauguin was star-struck; Cézanne was understandably suspicious of the man who was openly trying to steal his magic.

By the end of this period, Gauguin had mastered precision; now he no longer needed it. He played with distorting the sculpting of solids by building forms from faceted planes, making pictures of contradictory proportions and multiple points of perspective. He had fun with spatial anarchy. Physically and colouristically his spaces cannot exist in nature but as pictures and as springboards for the imagination, they work.

'Precision often destroys the dream, takes all the life out of a fable . . . It is better to paint from memory, for thus your work will be your own; your sensation, your intelligence, your soul . . . The painter uses the model to make a legend, moving from the possible to the impossible . . . Literal pictures are the business of the sign painter . . . In front of the easel, the painter is a slave neither of the past nor of the present; neither of nature nor of his neighbour. Him, him again, always him.'[23]

Mette enjoyed living in Vaugirard; she did not pine for fashionable pavements. She was socially flexible, and never a snob. Engaging and spontaneous, she made friends easily with the landlord's family and the other neighbours, the workmen and the sculptors and their wives. Gauguin's friends came to their house for her quick wits as much as for his. Pissarro became her good friend, Schuff became her friend for life. Schuff had now attained his ambition of making enough money to retire and work as an artist for the rest of his days, which he did, on the sum of 25,000 francs – less than Gauguin had made on the side in a year. Safely invested, it kept Schuff and his family in comfort, with enough left over to support Gauguin when he hit hard times. Somehow, Gauguin always managed to spend more than he earned, however Croesan the sum.

Mette made no secret of the fact that she was not overly interested in art – her husband's or anybody else's. He didn't mind. They read books and discussed

ideas and she was happy entertaining. Parties didn't interest Gauguin much. He'd look in on Mette's gatherings and drift off to the studio to work, maybe to reappear in his nightshirt or paint-spattered clothes to pick up a book or another glass of wine before disappearing again. She would be unperturbed. Domestic details left her unmoved, though she could momentarily get irritated when he used her best linen tablecloth or her finest petticoat for paint rags. Never mind, it wasn't worth a quarrel. There was plenty of money to buy more.[24]

Gauguin's every need was satisfied. Cash flowed in from his job and flowed out in supporting his taste for living exactly as he liked, enjoying the freedom of the process of metamorphosing into an artist. He hung a pair of peasant's wooden clogs on a wall where others would hang a picture. He framed his picture collection in plain white deal. Modern visions shouldn't be imprisoned in old-style gilding and carving. Gauguin was not insistent; he was not didactic or making a political point but quietly following his own taste for artisanal objects over factory-produced stuff. But this did not preclude his enjoyment of his comfort and wealth.

He liked to see Mette well dressed, his children well cared for, and his house and table generously furnished. He was an open-handed husband. Mette took to extravagance gleefully. Their home was free and easy, hospitable, a delicious jumble overflowing with talk and music, food and drink, colour and fecundity. Delightful babies magically appeared at two-year intervals, often coinciding with the opening of an Impressionist exhibition, doubling his delight in his creativity. After Emil came Aline, their only daughter, born 24 December 1877. Then Clovis, named after Gauguin's father, and born on 20 May 1879 Jean-René (usually simply called Jean), born 12 April 1881 during Gauguin's *Woman Sewing* triumph at the sixth Impressionist exhibition. Finally, Paul Rollon, known as Pola, on 6 December 1883.

Gauguin's paintings from these years reflect a consistently calm domestic tenor. There are no storms. The incident-free, almost static pictures of his home and his garden have a Poussinesque quality. Suburban Paris becomes the first of his successive visions of mythic paradise. It would by no means be his last.

He helped organise the Impressionist exhibition of 1882. It was the smallest of them all, due to quarrels, and it was unique in being held in a location

IMPRESSIONISM AND BOURGEOIS BLISS

that had artificial lighting, allowing it to stay open at night in the hope of attracting more visitors. It must have been disturbing for the painters of light to see their work artificially lit. This time, the perceptive critic Huysmans, who had hailed *Woman Sewing* as a masterpiece and Gauguin as a new Rembrandt, called Gauguin's pictures 'moth-eaten and dull'. He was right. The banality of the subjects won out over the experimental ways with representation. The happy, wealthy bohemian life was proving the old maxim that bourgeois bliss is seldom the subject matter of electrifying art. All changed later that year when the stock market crashed.

6

LOST

In 1882, L'Union Générale, an ill-founded bank, collapsed. It had been established six years previously by Roman Catholic grandees with the aim of destroying the hold of German Jews, notably the Rothschilds, over the French economy. Other banks fell in its wake. The Paris stock market crashed. Gauguin was given notice to quit his job. His meteoric financial ascent had never taught him to budget or – God forbid! – to save. He had always enjoyed spending to his limits and beyond; now his portfolio of shares had lost its value, the art market was wiped out, and he was left with debts to pay off, a wife whom he had educated up to expensive tastes and four children to support. He tried hard to get another job in the financial sector but his ostentatious taxi-ticking ways and irritating proliferation of trousers, taken together with his preference for socialising with low-life artists and artisans rather than his smart colleagues, lent a delicious *Schadenfreude* to witnessing his fall. If Gustave Arosa had still been a power in the land, things might have been different, but Arosa was old and ill. In the year following the crash, he died. With his death, Gauguin lost his safety net.

The following year, 1883, was spent fruitlessly job-seeking, with pressure mounting when Mette again became pregnant. In December, she gave birth to their fifth child, Paul, called Pola to differentiate him from his father. Pola brought along with him the spectral vision of Gauguin turning into Papa Pissarro, the father of a multitudinous brood, knocking on doors to sell his pictures for seven francs apiece while his wife became ever more discontented and shrewish. Anywhere would be cheaper to live than Paris. In January 1884, with baby Pola a month old, they moved eighty or so miles north-west, to the city of Rouen, long beloved of artists for its cool northern light and picturesque medieval subjects: spires, bell towers, crooked lanes and half-timbered houses jostling for space inside a ring of tall ramparts rising out of smooth, expansive views of woods and meadows. Turner had painted

there. Monet, already captivated, would soon return to obsess over the light on Rouen's cathedral front. Pissarro had told Gauguin that he never tired of painting the city's inexhaustible motifs. He had also told him that a collector of Impressionist paintings lived there, a pastry chef named Murer. This sounded hopeful.

He rented a little house on the Impasse Malherne (now Impasse Gauguin), a narrow lane on the towering heights of the Rampe Beauvoisine. He figured that he had enough money to keep him going for a year. He started work, producing pictures at a furious rate, more or less one a day. Mostly landscapes, local variations on motifs he had painted with Pissarro and Cézanne. Gauguin was painting alone, and it was not working. Everything was wrong on the canvas, and he had no idea how to put it right. He needed Pissarro's critical guidance. He kept inviting him to come; Pissarro kept refusing. Eventually, in April 1884, he sent seven paintings to Durand-Ruel. The plan was for Pissarro to visit the gallery to critique them, and Durand-Ruel to exhibit and sell them. One painting was 'handed over to the financier Lafuite on the very day that it arrived'[1] presumably in payment for a debt. None of the others sold. Pissarro went to look at them and wrote to tell Gauguin that he found them petty and monotonous. Gauguin knew as much. 'I have not yet arrived where I want to be. I must chafe a little longer yet,' he replied humbly.[2]

He was looking for a money-making job. The pastry cook Murer had been a dreadful disappointment. Far from purchasing, he accepted just one painting to hang in his hotel, where it failed to find a buyer: Gauguin made no further impression on the city, either as a man or as an artist. Accustomed to attention, he felt invisible. His confidence was failing. He and Mette were beginning to squabble about money. He decided to paint a 'society' portrait of her that might bring in commissions from Rouen's pretty women. Wanting to look elegant for the portrait, Mette bought an expensive dress on credit. This led to a row, and then he discovered that she had secretly been borrowing large sums from their friends: 400 francs from Schuffenecker, 2,000 francs from Mrs Heegaard. He was furious; she was furious. She pointed out that children were expensive, and they had more than they could afford to keep. Already they had sent Emil back to Denmark where the Countess Moltke, a contact of bygone days who was rich and fond of Mette, had undertaken to

pay for Emil's education. For fear of getting pregnant again, Mette refused to sleep with Gauguin. He ranted about divorce and the result was *Mette in Evening Dress*, a second passionate portrait of his wife that, like *Mette Asleep on a Sofa*, depicts Mette the Inaccessible.

Sensual, challenging and unnerving, she is decked out in full evening dress, gloves, fan, hair piled up in an elaborate chignon, a narrow black ribbon round the creamy neck directing the eye down to the bosom. Gauguin always struggled with what he saw as potentially saccharine subjects and *Mette in Evening Dress* is certainly not as pretty as a selling canvas ought to be. He could not yet achieve the textural luminosities of silk, satin, roses and pearls that had made Renoir's 1874 *The Theatre Box* the *ne plus ultra* of such portraits. The best bit of painting is the optical mixture of pink and pale apple-green on the swooping bodice; otherwise it is a picture of an angry wife turning away from her husband and refusing to look at him, but even while they were quarrelling over the cost of the dress, Gauguin admitted to her that he liked it very much.

In July, they decided that Mette should go home to Denmark to her mother. She would take Aline and baby Pola with her, leaving Gauguin in Rouen with the other two boys and the nursemaid to look after them. It was a summer of spiritual isolation and artistic failure. Stubbornly he churned out pictures he knew were no good. Introspection threw up no answers, only more questions. What was the magic that Cézanne brought to his paintings? How was it possible for Cézanne to put so much into so little space? Almost all this summer's paintings were responses to Cézanne; many were landscapes copying Cézanne's rhythms in their use of treetrunks as verticals and angles. *Blue Roofs, Rouen*, a spatial jigsaw of town roofs seen from above, plays with geometric planes, like Cézanne, piling them up and setting them against each other. *Abandoned Garden* appropriates Cézanne's colours, showing how wonderful they are in combination. But no amount of analysis or close imitation could make his own voice sing. Alone in the evenings when the nursemaid had put the children to bed, Gauguin sat in the circle of the oil lamp writing and writing, over and over again, mostly about lines. He pondered the idea that particular lines and shapes contain particular spiritual and symbolic qualities of their own.

LOST

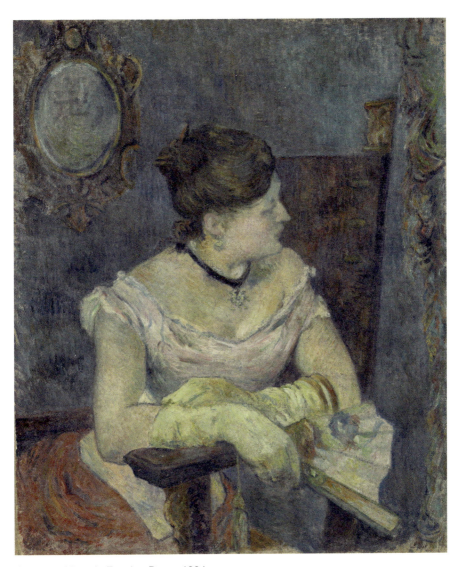

Gauguin, *Mette in Evening Dress*, 1884

'Sensation. Everything is there in this word. Raphael and others, people who in whom sensation was formulated before the mind started to operate . . . A great spider, a tree-trunk in a forest – both arouse strong feeling without your knowing why . . . no amount of reasoning can conjure away these feelings. All our five senses reach the brain *directly*, affected by a multiplicity of things, no education can destroy this. Whence I conclude

that there are lines which are noble and lines which are false. The straight line reaches infinity, the curve limits creation. Have the figures 3 and 7 been sufficiently investigated? Colours, although less numerous than lines, are still more explicative by virtue of their potent influence on the eye . . . Why is a willow called weeping? Because its lines droop.'[3] Are all drooping lines then inherently sad? Why is Raphael's line sublimely uplifting? Is the golden mean really a perfect proportion? Is there actually such a thing as line of beauty? He found no answers.

He was also pondering the wider questions: what actually *is* painting, and what is its relationship to the other branches of art? This was the sort of thing he would have hammered out at the café table with the Manet gang over a glass of absinthe, or with Pissarro during their painting trips, but now he had to come up with the answers on his own. He found the writings of the composer Richard Wagner helpful on the nature and philosophy of culture. Unsurprisingly, Wagner named music as the supreme art. Music was not concerned with physical limitations, not busy creating images of the phenomenal world. Rather, it roamed the abstract, speaking the language of the *Wille* (soul, sensation or spirit) directly. Music was art as pure spirit, untethered from physicality. Only music could open the gate to complete spiritual experience; the gate to completeness, making all the senses vibrate in harmony.

This resonated with Gauguin, who (like Wagner) experienced synaesthesia: an interconnection of sensual experience. When Gauguin heard music he saw coloured images that vibrated. Seeing a painting containing the mysterious magic that was 'art', his thoughts appeared before his eyes, and he saw them written in sentences. In time, he would write words on his paintings, a forerunner of Modernist practice; his contemporaries often found this irritating.

The synthesis of 'sense vibrations' in response to an artwork could only be produced, according to Wagner, by a *Gesamtkunstwerk*, a complete artwork that touched the human spirit and all the human senses simultaneously. Gauguin had now had sufficient experience in practising art to believe, along with Schopenhauer and Wagner, that the true artist is endowed with a divine creative force, and now he believed himself a true artist. He first identified himself as such on Pola's birth certificate, stating his occupation as *artiste*

peintre.⁴ Having acknowledged his calling, it was his high ambition that his artwork should touch all the senses.

With his synesthetic connection between music and colour, he had already taught himself guitar and the mandolin and he was starting to teach himself the piano. Gauguin could 'see' what he heard, and 'hear' what he painted. However, he was far from prepared to yield the prime place in the arts to music, whatever Wagner said. He bought a little exercise book, such as children use at school, and headed it 'Synthetic Notes', meaning notes on the synthesis, or otherwise, of the senses and the arts.⁵ Painting, not music, was the most 'synthetic' of all the arts, the most beautiful and complete. Yes, music could access the soul directly through the senses, as Schopenhauer and Wagner argued so persuasively, but it did so one note at a time. Music remained subordinate to painting, because of its sequential nature. It was never a complete experience. A picture, on the other hand, was complete in its moment of impact. This made picture-making the perfect art.

Literature he consigned to the bottom of the pile. Literature consisted of words. Gauguin saw words as limiting concepts. Every word is an imprisoning hieroglyph. Language is only the surface of the pool. Text puts the reader in the position of a slave to the author's thoughts. There is no natural impulsion towards the written word save that of reason and consent on the reader's behalf and 'God knows that a reasoned sense impression is less compelling . . . [whereas] one vision can create an immediate impulse'.⁶

Sensation is freedom. But that throws up its own problems. For: what are the rules of the senses? Instinct inspires irrationality in us. Why do we experience certain lines and colours as melancholy while others conjure 'noble' sentiments, and yet others 'excite us by their audacity'? Coming back to the weeping willow and to Raphael, he remained unable to reach a conclusion.

He would nag at these problems for years, questioning the emancipatory nature of the irrational versus his need for some sort of structure. It was a subject he would still be writing about in the year of his death. His preoccupation with the problem would lead to him becoming the early inspiration and leader of the Symbolist-Synthetist painters; but for now, as he was trying to find his own voice, he ended up just writing more about Cézanne. 'Strive to attain the state of Cézanne,' he wrote, concluding that the only way to achieve this was

to spend entire days on mountaintops reading Virgil. 'Then your work will attain the sublime power of Cézanne's pictures and Virgil's verse, giving several meanings, so that they work for Everyman on every level.'

How did Cézanne the Magician manage to turn geometric planes into soulscapes? Gauguin hammered away at his hybrids: half fussy Pissarro-esque Realist/Impressionist brushstrokes, half Cézannesque treatment of everything as cylinder, sphere or cone. Finally, in the late summer he painted a picture that owed a debt to neither. It contained power of its own.

Clovis Asleep shows his five-year-old son Clovis fallen asleep at the table. A wooden tankard standing on the table close to the boy's head has grown to an immense size, as things do in nightmares. The rich cobalt-blue wallpaper behind the child's sleeping head has become the night-coloured sea of his dreams. Applied with an agitated brush, the wallpaper acquires a hectic sense

Gauguin, *Clovis Asleep*, 1884

of movement, becoming a whirling landscape of subconscious horror. Birds swoop, monstrous creatures meander. Painted on the line between figuration and abstraction, the wallpaper pattern has become a portrait of an interior state, a chaotic decorative fantasy hinting at a subtext of frustration that the interior life of others, even his own child, is a closed world, ultimately unknowable.[7]

The year continued with no progress except in the size of his debts. Mette came back from Denmark. They agreed they could see no way forward in France. Frits Thaulow, whose Open-Air School in Modum, where he was teaching Impressionism to Norway, was flourishing, suggested Gauguin send him some canvases to exhibit in Oslo. Seven were packed up and sent, including *Clovis Asleep* and *Mette in Evening Dress*.

If Norway was open to Impressionism, why not Denmark? If they moved to Denmark, they could live at practically no cost with Mette's mother. Gauguin did not expect to support them all by his painting straightaway. He cashed in his life insurance at a loss of 50 per cent, and he approached Dillies et Frères, a French manufacturer of waterproof materials and tarpaulins, to become their Scandinavian sales representative. Gauguin's abilities as a salesman were never in doubt but his grasp of waterproof materials was as rudimentary as his grasp of the Scandinavian languages he'd be doing business in.

'Ah my dear Pissarro, what a horrible mess I've made of things!'[8]

Before leaving for Denmark, he made a quixotic dash down to the south of France, where a small group of Spanish republicans-in-exile, including Gauguin's former stock exchange boss, was hoping to mount a general uprising to overthrow the Spanish government. They gathered in Montpellier where the leader, Ruiz Zorrilla, handed them 20,000 francs to purchase a boat in which to storm Spain, come the *moment critique*. While waiting, Gauguin passed fruitful days in the Musée Fabre, copying a painting by Delacroix. He had spent hours in front of Delacroix's study of a rearing horse in Arosa's collection; Delacroix was another 'Magician'. Gauguin marvelled at the powerful fluidity he imbued into wild animals by the flash and dash of his brushstrokes, utterly disregarding literality. The republican plot was uncovered within a fortnight, and the conspirators dispersed. Presumably the 20,000 had been spent on the purchase of the boat by then, or his money worries would have been over.

Back in Rouen, he carefully packed a selection of his Impressionist pictures that were to act as his artistic reference book and inspiration while he was in Denmark. The rest he left in storage with an old friend, Charles Favre, who had recommended him for the job at Dillies et Frères.

Gauguin and Mette moved in with Mette's mother in Lille Rosenborg, an apartment block with turrets and twiddles modelled on the nearby Rosenborg Castle, the summer residence of the Danish royal family. Gauguin never got to grips with the Gad family or its stifling gentility. His son Pola describes Mette's family as 'decorum-obsessed new arrivals in the upper echelons of society . . . They were inclined to look down on business and their interest in art was entirely determined by the degree of appreciation it enjoyed in the eyes of society.'[9] The arrival of a tarpaulin-salesman/artist son-in-law was an embarrassment. Wordlessness intensifies barriers. Danish is a notoriously difficult language, and Gauguin couldn't guess even the gist of the family's conversations. Their manners were formal, their dress code was rigid. He cared not at all about correct clothes, manners or mealtimes. They saw this as covert insubordination of their hard-won values. He longed to take an axe to their big, ugly bits of ancestral brown furniture, smash up their backward-looking veneration of the past for its own sake, make room in their minds for new ideas.

He tried hard to sell tarpaulins. Numerous letters to Dillies et Frères attest to his fruitless diligence. Lugging samples from door to door, every day it became harder and harder to hold his head up in the family that, confident of Gauguin's complete incomprehension, took to referring to him as the 'Missing Link', the conjectured creature who stood between apes and *Homo sapiens* on the evolutionary ladder.[10]

He felt himself becoming ever more estranged from Mette without the ability to prevent it. He persuaded her to move from her mother's to their own apartment. To support this, they would make money giving French lessons. Gauguin's complete lack of Danish stood in the way of the plan. Mette, however, did well. She was still in touch with Prime Minister Estrup, whose children she had tutored, and Estrup was happy to send along budding young Danish diplomats in need of polishing their French, the international language of diplomacy. Smart young men invaded the house. Sprigs of the

Danish nobility required a suitable schoolroom, and Mette's lessons took over their only decent room. Gauguin was banished to the attic along with the tarpaulin samples and his painting paraphernalia. It was cold up in the attic. He lived in his overcoat and was continually bumping his head on the low rafters. The smell of cakes and coffee and Mette's laughter drifting up the stairs forced him into the disagreeable role of involuntary eavesdropper and jealous husband as he sat at his easel. The paints available in Denmark handled differently. He didn't like them. This, together with the dim light filtering in through the skylight, made it difficult to construct pictures he could respect. Nor could he respect himself on any front. They were still not making love, for Mette's fear of becoming pregnant again.

'I'm a cipher.'[11]

'Without a penny and up to my ears in shit, I console myself in dreaming.'[12]

'Sometimes I think I have gone mad, yet the more I think about it in my bed the more I think I am right . . . I'm more tormented by art than ever and I'm not distracted from it by my money torments or business enquiries.'[13]

'Six months without talking. Complete isolation.'[14]

'I assure you I live only when I withdraw into an artistic city of the mind.'[15]

At the end of his tether and his resources, every day in his grim attic he thought about putting a noose over one of its rafters and ending his futile existence. He managed only seventeen paintings in six months. Landscapes lacking magic were relieved by a few flower paintings touched with truth and simplicity. Come spring, he held an exhibition at Kunstforeningen, a society founded by independent artists aiming, much as the French Société des Artistes Indépendants did, at breaking the stranglehold of the Royal Danish Academy of Fine Arts. For the show, Gauguin wanted his pictures framed Impressionist-fashion in plain white wood. No professional frame-maker in Copenhagen would do such a daringly modern thing for fear of losing their other customers. Gauguin fumed. Eventually, he went to a coffin-maker, who obliged. The show lasted only five days. There were no catalogues, no sales and no reviews. 'Cancelled on order of the scandalised Royal Academy,'

Gauguin complained bitterly to Schuffenecker, maybe to save his dignity in the eyes of his friend, or maybe because he did not fully understand that five days and no catalogue was normal procedure for Kunstforeningen shows.

The two most remarkable pieces surviving from this Danish period read like suicide notes. In *Self-Portrait at the Easel*, 1885 he looks unhappy and much older than his thirty-six years. He sits hunched in the attic room. If he gets up, he'll bump his head. Swaddled in his thick, dark overcoat, his nose is red with cold, the rest of the facial skin tones are corpse-coloured: blue-mauve-white. His jawline is blurry, his red-rimmed eyes look shiftily away to the side. No one in their right mind would buy even a tarpaulin from this unreliable-looking fellow. This is the exterior portrait.

The interior self-portrait takes the shape of a carved box, a miniature coffin made out of a block of pearwood.[16] On the lid he has carved figures copied from Degas's paintings: pretty ballet dancers, in tutus, strike attitudes. Open the lid, and you are confronted with the figure of a mummified corpse lying on his side, naked but for the shallowly carved swirl of a loincloth. The corpse cannot be removed but is carved into the same piece of wood as the floor of the coffin. At the dead man's feet, Gauguin has placed a scrap of cowhide. On the underside of the lid he has attached two Japanese Noh masks, one either end. The coffin's strong iron hinges and robust escutcheon lock ensure it remains a private mystery intended only for initiates invited to see. Most must stop at admiration of the innocuously decorative dancers carved into the lid, performing their graceful social-surface ballet. Those given possession of the key realise that Degas's pretty *petits rats* are performing the dance of death over the corpse of a dead man. He never carved anything like it again.

They had been living 'wretchedly' on the 1,300 francs from a Manet he had sold from his collection with dragging reluctance and the 66 francs per month Mette earned from giving lessons. Mette's sister Pylle offered to have their only daughter Aline, now aged eight, come to live with her in Oslo. She would live for free and be educated at no cost up to the school-leaving age of fourteen at a girls' school where Mette's aunt was headmistress. Aline was Gauguin's favourite child, and she was to be taken away from him, sacrificed on the altar of money because he could not afford to support her. It was

LOST

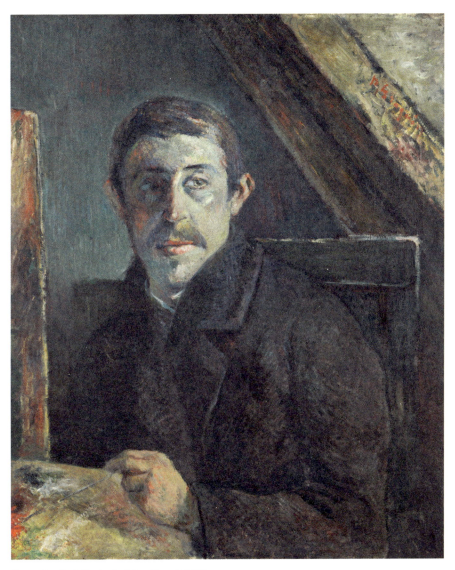

Gauguin, *Self-Portrait at the Easel*, 1885

a terrible blow to his soul and a very public humiliation in the eyes of the world. Two of his five children were now being brought up by other people because of his inability to generate money. By June, he decided it was hopeless. He must leave Denmark.

'I only want to paint. Everybody hates me because I paint but it is the only thing I can do.'[17]

81

Mette endorsed his decision. While she never pretended to understand his art, at this point she still had faith in it, and in him. They agreed that she would remain in Denmark with the children, continuing to support them from the proceeds of her language lessons, while he would return to Paris where he must have his best chance of success. His picture collection would remain with her in Denmark. She would sell individual pictures if absolutely necessary, and then only if she got a good price. Their parting was calm. Both looked on it as a temporary separation. Gauguin was convinced he would soon be summoning the whole family back to live with him in Paris, where his art was bound to take off.

To relieve Mette of some of the family burden, he took six-year-old Clovis with him. At first, they lodged with the ever-supportive Schuffenecker but soon Gauguin sent Clovis to live with his sister Marie, now married to the prosperous Colombian businessman Juan Uribe, who had managed not to lose his fortune during the crash. Their apartment near Parc Monceau was easily large enough to accommodate Clovis alongside their two small children. Marie and Juan made no secret that they strongly disapproved of Gauguin's wastrel tendencies.

He set out to find work. A half-promise from the sculptor Jules-Ernest Bouillot led to dreams of renting his own studio while working as Bouillot's assistant. The project kept being delayed. A chance meeting with Degas revealed news of an artists' colony in Dieppe centred on the enviably successful portrait painter Jacques-Émile Blanche who had a taste for celebrity and for the louche, and painted portraits of Proust, Degas, Debussy, Aubrey Beardsley, James Joyce and Vita Sackville-West's ex-lover Violet Trefusis.

On arrival in Dieppe, Gauguin lacked the confidence to knock on the door, so he set up his easel on the beach in full view of the chalet's numerous windows. No merry figure with outstretched arm came down to welcome him. He must go and ring the doorbell. It gave him courage to see through a window that Blanche and Degas were painting together in the studio but the servant who answered the bell informed him that neither man was at home, and shut the door in his face. Being a portrait painter, Blanche fancied himself an outstanding reader of human physiognomy and when he glimpsed Gauguin through the window he dramatically announced that he detected

the wild gaze of a megalomaniac, madman or alcoholic, and gave orders that he was never to be admitted to the house.

Rejected once more – and Degas complicit – Gauguin went to ground. It is not clear where he stayed between July and September, or who he was with. We can tell he was still in Dieppe by the locations of the twenty-two or so landscapes from the period: some inland, some coastal, all full of light and vivacity. If you can judge an artist's mood from pictures, it looks as if Gauguin was enjoying a carefree few months, simply painting. His colour palette becomes livelier, his contrasts more daring. He uses orange as if he had just discovered it. Tangerine cows and pigs snuffle and moo against surging masses of greenery.

In late August or early September, he dashed off to London for a mysterious week that also remains unexplained. Later detective work on the addresses he jotted down concludes that he was again pursuing the futile business of Zorrilla and the Spanish republican conspirators. The whole trip bored him, he said later, even the zoo and the museums.[18] He returned to Paris.

'My dear Mette,

'My sister has just brought Clovis back to me, regretting that she cannot have him any longer; as I cannot get any work from Bouillot, and painting is under a cloud, I have to think what I can do for both of us. I am therefore seeking a modest position on the Bourse.'[19]

The modest position did not materialise, nor any other. He tried to raise money by selling a Pissarro and a Renoir but failed to find a buyer. After much searching, he secured a job with the Société de Publicité Diurne et Nocturne, an advertising company. It was the age of the poster. No vertical surface in Paris was safe from advertising bills, often marvellous things created by major artists like Mucha and Toulouse-Lautrec. Gauguin was paid five francs a day to paste them up. He rented shabby rooms on Rue Cail, a dirty, desolate place between two railway tracks. There was no furniture. As was the custom of the very poor, he rented furniture: one table, one bed and bedclothes for Clovis. He himself slept on the floorboards, under a rug. The air was damp and sulphurous with coal smoke from the trains. He was feeding himself and Clovis on the cheapest food he could find: boiled rice and stale bread, augmented by an egg or a slice of ham when he could afford

it. He begged Mette to send warm clothes and bedclothes for Clovis, whom he described as 'a hero'. Clovis said nothing, asked for nothing, not even leave to play, when they sat down together of an evening with their pauper's food, after which the boy went quietly to bed. Gauguin worried. Clovis had the lassitude and greenish pallor of the malnourished; he suffered frequently from headaches.

No parcel arrived from Mette. He chided her for not caring, for being too comfortable to bother.

She did not reply, and his bitterness against her grew. Mette was never a good correspondent. When there was something to say, she said it, and when there was not, she did not. She had in fact sent the parcel, but she had sent it to the wrong address. Clovis became paler and thinner and quieter. Gauguin hit out in a letter.

'You tell me cool-headedly and, be it said, with much common sense, that I loved you once but you are now no more than a mother and not a wife, etc. This leaves me with no illusions for the future. It ought not to astonish you therefore if, one day, when my circumstances have improved, I find a woman who may be to me something more than a mother, etc. . . . So you won't think it mean if one day I make another home for myself. A home in which I will be respected for posting bills. We all blush in our own way. Remember me kindly to your family. Your husband, Paul.'[20]

Clovis, weakened by malnutrition, contracted smallpox. The long-awaited bedding at last arrived. The building's concierge helped Gauguin nurse Clovis back to health, but it was obvious this way of life could not continue. He managed to place the boy in a boarding school where he would be fed regularly and kept warm. He knew he could not afford to pay the fees but that was a problem for tomorrow. Today's business was to produce paintings. An Impressionist exhibition was to open in May 1886.

The eighth and last Impressionist exhibition was held in the Maison Dorée on Rue Laffitte, in the very office building where Gauguin had made his now-squandered fortune. Durand-Ruel was not organising it; he was in America arranging the first exhibition of French Impressionists in New York. Without Durand-Ruel to smooth the waters, Monet, Renoir, Caillebotte and Sisley opted out altogether, leaving the organisation to Degas and Pissarro,

who fought like cats in a bag. Degas led the traditional Impressionists, including Gauguin, who was very happy to be given room for nineteen canvases, mostly his recent landscapes from Denmark, Rouen and Dieppe. Pissarro, ever a man for a theory, was fighting Degas for as much wall space as possible for the new art he had named 'scientific Impressionism'. The objective of the 'scientific Impressionists', whose leading exponent was Georges Seurat, was to remove the personal and emotional element from the individual's interpretation of the world around them. The surface of the canvas would be privileged over expression. A scientifically based method of translating light into colour would result in absolute pictorial truth.

Seurat found the supporting scientific theory in the writings of two men: Hermann von Helmholtz, a well-respected physicist and physician who wrote on the perception of colour by the eye's rods and cones, and Charles Henry, an amateur aesthetician and less of a scientist. Henry's *Théorie des directions* and *Traité sur l'esthétique scientifique* set out the theory that each line and each particle of colour should be treated as words are treated. Each word is separated by a white space on the page, so each colour must be treated as a separate entity, because each is possessed of a different identity to every other. Colours must not be blended. This theory of colour separation explains Seurat's pictures, entirely constructed from little coloured dots, often with a little white space between. Expressive brushwork, hitherto a cornerstone of Impressionism, was simply abolished. Colours were set down in specific ratios in the quantity required for a specific optical effect. Viewed from the correct distance, the eye blended the dots, and the space between them, into a picture. Divisionism or pointillism is a theory playing on non-relationships. One is not surprised to discover that Charles Henry also wrote about the Marquis de Sade.

Seurat was showing *A Sunday Afternoon on the Island of La Grande Jatte* (1884–6), an enormous two-by-three-metre canvas depicting forty-eight humans, three dogs and a monkey doing not very much on a sun-drenched Sunday on the banks of the Seine. Frozen in dots, nothing moves: not the river, not the leaves on the trees, not the dogs, not the monkey or the children. The scene is static, monumental; the figures are statuesque, passive. The painting exudes the quality of time stopped for ever, a quality it shares

with the studio photographs of the time, whose sitters must sit as still as statues during long shutter exposure. Maybe this was why pointillism's mannered unreality struck contemporaries as pictorial truth? With no attempt to capture movement or to imbue emotion, Seurat's deliberate removal of the mystery of human complexity was a head-on challenge to the Impressionists whose aim, with their blended colours and highly subjective brushwork, was to blur time, light and movement, to whirl the spectator into the ever-shifting panorama of physical and emotional life.

The walls of the Maison Dorée became a battleground for subjectivity versus objectivity. Gauguin took to referring to Seurat and his fellow travellers as 'little green chemists who pile up tiny dots'. The critic Joris-Karl Huysmans was equally scornful: 'Strip his figures of the coloured fleas they are covered in, and underneath is empty, no thought, no soul, nothing.'[21] But the rest of avant-garde Paris was ravished by Seurat's new art.

Gauguin experimented with pointillism in *Still Life with Horse's Head* (1886) but a decapitated horse does not lend itself to statuesque impassivity any more than Gauguin lent himself to negating emotion. He did not persevere. Strict application of a repertoire of 'scientific' rules to art was both intolerable and absurd. Art was not a matter of objectivity. Subjectivity must be championed. But if he took the obvious course of writing an article for one of the newspapers, it would be seen as Gauguin sucking on sour grapes. Why not play a joke on the critics, the journalists and the little green chemists? Why not 'discover' an ancient treatise giving voice to his own views? Easy to concoct an aged-looking manuscript. Fun to perpetrate a literary hoax.

Mani-Vehbi-Zunbul-Zadi seemed a good name for 'the painter and giver of precepts' who lived 'in the days of Tamerlane, in the direction of the rising sun'. Mani advocates painting from the imagination and the dream. His detailed advice on colour directly contradicts pointillist colour theory. 'Always use colours of the same origin . . . With patience you will then know how to compose all the shades . . . Who tells you that you ought to seek contrast in colours? What is sweeter to the artist than to make perceptible in a bunch of roses the tint of each one?' A maker of patchwork blunts sensibility and immobilises colouring. Mani also disapproves of another pointillist habit, the leaving of bare white between the dots. 'Let the background of your paper

lighten your shades and provide the white, but do never leave it absolutely bare.' As to meticulous detail, 'when you want to discover how many hairs a donkey has on each ear and determine the colour of each, your place is in the stable rather than the studio. Do not finish your work too much, 'in this way you let the molten lava grow cool and turn boiling blood into a stone.' Finally, 'It is preferable to render a thing just as you see it rather than to pour your colour and your design into the mould of a theory prepared in advance in your brain.'[22]

Gauguin's 'discovered' text was hailed as genuine. It caused much chatter. A copy was even found among Seurat's papers after his death. Seurat's chief admirer and promoter, the critic Félix Fénéon, got it published in the periodical *L'Art moderne*, to the general credence of the painters and the consternation of Seurat who also thought it genuine. While this amused Gauguin, it did not earn him any money. The Impressionist exhibition ended on 15 June. He had sold three paintings. All the attention had gone to Seurat. The show had not been the great breakthrough he hoped for, nor had it earned enough money to pay for Mette and the children to come back home to live with him. His lease on the miserable room on Rue Cail ran out on 12 July. He arranged with his sister Marie that she would pay the next set of fees for Clovis's boarding school.

This left him free of domestic responsibility for the moment. Free, also, of his dependence on Pissarro. The older man's new passion for little dots had seen to that. Gauguin must think for himself what direction his art should take. He must liberate himself from comparing his work to his hero-worshipped 'Magicians'. Refocusing his vision would involve a fundamental reconstruction. He needed a wild place to restore the 'savage' self that somehow he had allowed to get lost among the tarpaulins, and the little green dots, and the goldfish bowls of Paris and Copenhagen.

Overleaf: Gauguin, *Round Dance of the Breton Girls*, 1888

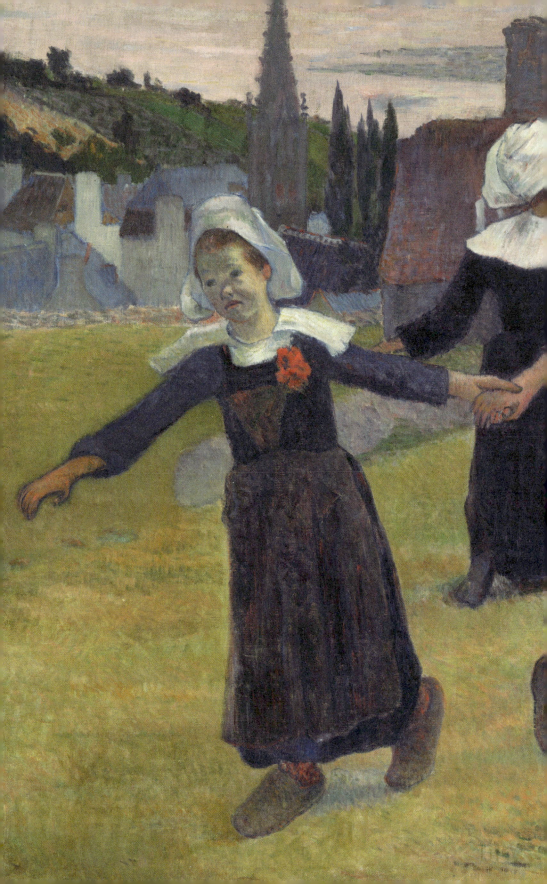

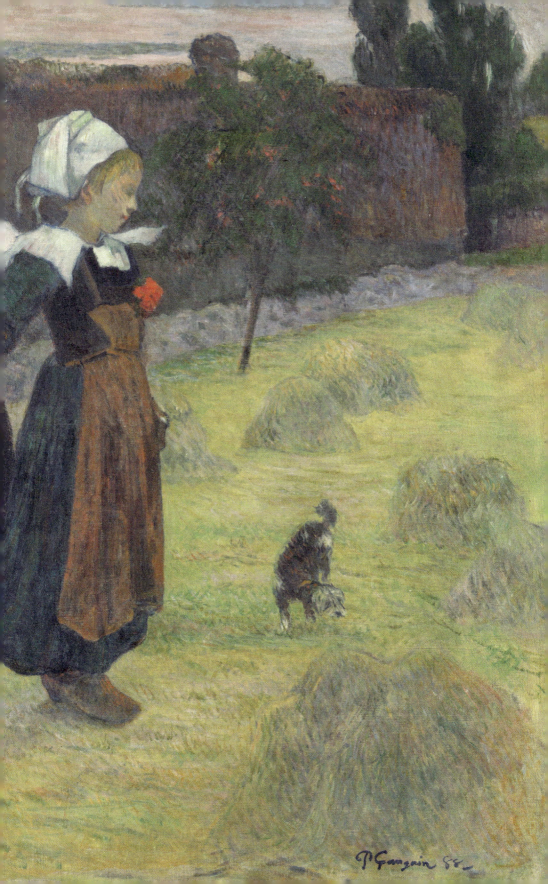

7

EVOLUTION OF A DREAM

'You have to remember', he wrote to Mette, 'that I have two natures, the savage and the sensitive. I am putting the sensitive on hold, to enable the savage to advance resolutely, unimpeded.'[1] He wished to retreat to the wildest possible corner of France, where he might refashion his ideas far from 'the prodigious pyramid we call civilisation'.

Neither the Enlightenment nor the French Revolution had made much impression on Brittany, the north-western peninsula of grey granite bulging out into the Atlantic Ocean. 'France' was a dirty word here, 'Paris', dirtier. The peasants of the land and the 'peasants of the sea', as the fisher-folk and seaweed gatherers called themselves, identified firmly as Celts. The year 52 BC, when Julius Caesar had defeated Vercingetorix, was only eclipsed in Breton tragedy by the year 1532, when the duchy was annexed by France. Apart from a few who traded with the outside world, the people neither spoke nor understood French. Breton was their language, crow-harsh and spiky, abounding in x's, z's k's and t's. Bretons were scorned as primitives by the rest of France; Gauguin anticipated Rousseauian rusticity where he would be able to reconnect with his Peruvian self, responding to the world around him instinctively, unhampered by having to talk to people or by experiencing the soul-withering pressure of unspoken expectation. How had he allowed society to get in the way of being his own authentic self, to inhibit his imagination, to imprison his creativity?

He heard of an inn called the Pension Gloanec, in a village called Pont-Aven, where they charged sixty francs a month for bed and board, including two generous meals a day washed down with as much of the local cider as you wanted. He calculated that 300 francs should support him throughout the whole summer. He borrowed the money.

Fourteen hours on the train brought him to Quimperlé, near the peninsula's southern coast. Eventually, a horse-drawn cart ambled up to the station

to collect the letters and parcels and passengers. Its axles squeaked and its iron-shod wheels rang as it lurched and swayed like a boat, an impression reinforced by the wind off the Atlantic filling the air with the smell of salt and iodine. They drove through an open landscape of much charm and unimaginable richness of colour. Every shade of green scumbled the woods, from absinthe-coloured poplars to almost black firs and the dull green-grey leaves of the cider orchards with their little pointillist fruits of green, yellow and orange apples bending their branches into rhythmically repeating curves. Orange earth fringed soft green meadows where Druidic left-behinds reared up randomly: dolmens, menhirs, mysterious stone circles and henges made from the same blue-grey granite that dropped sheer to the purple Atlantic. Gauguin would paint it all. Figures populated the landscape. Up till now he had been wary of poking people into pictures; it was difficult to make them look as though they belonged. But these figures were so much at one with their context that it was like looking at a Brueghel come to life. They dressed as if nothing had changed since the sixteenth century. The women in tight bodices and long, full skirts made inky, bell-shaped silhouettes. Broad white collars spread over their shoulders like folded wings. From their tall, snowy lace-trimmed *coiffe* headdresses, ribbons flickered like fugitive haloes. They might be flights of angels, recently alighted. The men wore their hair long, blowing in the wind beneath round felt hats. They wore sombre, woollen swallow-tailed coats, knee breeches, gaiters and wooden clogs as they worked the land with long-handled scythes and pitchforked the harvest on to horse-drawn carts. Gauguin saw his compositions laid out before him.

From Quimperlé to Pont-Aven is only seventeen kilometres as the crow flies but the winding deliveries of the post cart doubled the distance. The final stage led down a steep, wooded valley, loud with the sound of the river Aven. At the confluence of the gorge and the river, a tight cluster of fourteen houses and fifteen mills crowded together, in shades of beige, ochre and grey and pink. Pont-Aven, though small, had been an important working port since the time of Julius Caesar. It was the place to which Brittany's natural wealth of wood, stone, sand and cereals was transported on carts down two steep valleys that converged on the village, where they were milled (in the case of cereals), or simply loaded on to ships and sailed four miles down the

tidal Aven to Port Manec'h on the Atlantic coast, to be shipped to the wide world. The centre of Pont-Aven's village life was the medieval stone bridge over the river. Its parapet was exactly the right height for resting your bottom on while catching up with the day's gossip. Ten steps from the bridge was the Pension Gloanec, dominating the town square with its whitewashed walls dramatically contrasting with the heavy dark-grey granite quoins round its windows and doorway. This architectural flamboyance was part of Madame Gloanec's strategy to seduce visitors to her *pension* rather than Madame Julia's round the corner.

In all innocence, Gauguin had arrived at an artists' colony. Pont-Aven had been 'discovered' nearly fifty years previously in 1840 by the English travel writer Adolphus Trollope, brother of the more famous novelist Anthony. 'Here,' wrote Adolphus, 'the painter encounters the wild, the savage, the primitive, the majesty of humanity's unspoiled nature uncorrupted by even a trace of modernity, engulfed in Druidic ruins, religious and feudal relics, the living pages of a profound and forgotten history.'[2] Forty years later an English academician, Henry Blackburn, took up the theme in a lavishly illustrated guidebook, *Breton Folk: An Artistic Tour in Brittany* (1880). A series of articles in the *Philadelphia Evening Bulletin* unleashed a stampede of North American artists equipped with Blackburn's helpful book, which recommended the best spots to set up your easel for a picturesque view. Early mornings would see a stampede of artists competing to grab the best positions.

Arriving in late June 1886, Gauguin was in time to cheer on the Fourth of July baseball match between American artists. 'There are scarcely any French here,' he noted, wide-eyed. 'All foreigners. 1 Dane, 2 Danish women [*sic*], Hagborg's brother and a lot of Americans.'[3] About a hundred foreign artists had converged on Pont-Aven that summer. Gauguin's ignorance might seem naïve, but Pont-Aven was simply outside the spectrum of interest of his own circle of Impressionist artists, though Monet was already painting close by on Belle Île, a dramatic rocky islet visible from the mouth of the Aven.

The majority of painters gathered here had quite possibly never seen an Impressionist picture or met an Impressionist artist. They modelled their art on the style of the recently deceased Jules Bastien-Lepage whose agreeably

unchallenging pictures were popular in Scandinavia and the USA. A romantic realist of the Barbizon School, Bastien-Lepage insisted that painting be done *en plein air* to observe strict fidelity to nature. To this end, the artist must set up his easel in a location where the lighting conditions changed least during the time the artist was constructing the picture. This meant setting up in shade or semi-shade. Grey-toned canvases resulted, avoiding both the clear colours of the Impressionists and their dissolution of form, as well as their ambition to capture the essence of a fleeting moment. The landscape background often played servant to a pretty figure striking a sentimental pose, a handsome woodcutter, a comely milkmaid or maybe a picturesque child or two. At the time of Gauguin's arrival in Pont-Aven, Bastien-Lepage's followers there and worldwide were carrying on a long-running debate on whether the late Master had used large or small square brushes.

The leader of the Pont-Aven artists was Hubert Vos, a Dutchman, whose self-portrait shows a swaggering chap in the style of Frans Hals's *Laughing Cavalier*. Vos had visited China and Korea and his spookily photographic paintings of the people of those parts sold well.

'I well recall the attack made on the painter Gauguin by V. [Vos] a Dutch painter who on the strength of a medal in the Salon was more or less cock of the walk among the painters then in Pont-Aven,' wrote one of the group, the Scottish artist A. S. Hartrick. 'He [Vos] swaggered about the village with long, carroty locks, on the top of which was set a green beret of Rembrandt pattern, and laid down the law on everything, to everybody. Gauguin, shortly after his arrival, a stranger to most, came back for *déjeuner* one day and passed through the crowd at the door of the *auberge*. He was carrying a canvas on which he had been painting some boys bathing on a weir,[4] painted brilliantly, with spots of pure colour in the Impressionist manner.

'V. started by asking him, in the rudest way, what game he was playing? going on to quote Rembrandt, Bastien-Lepage and himself as witnesses of its futility, while the majority crowded round to enjoy the fun of the newcomer being baited. G. however only smiled grimly and elbowing his way through went about his business without explanation or retort. The sequel to all this was really funny. Within a fortnight V.'s special pupil P. [Puigaudeau] went off to Gauguin, leaving V. altogether. Within a month, V. was secretly

consulting his former student on Gauguin's methods and theories; finally, he went over a large canvas that he had just completed, taking out the blacks and the shadows and substituting pure colour . . . Six months later, he wrote to Cormon, whose pupil he had been . . . announcing that he had joined the camp of the "intransigents", as the "spot" painters at that time were labelled . . . I heard Cormon himself tell the story to his pupils at his studio. He spoke with some amusement and much contempt. Yet Gauguin did nothing in the matter himself; though I fancy he knew all about it and enjoyed the situation in his silent way.'[5]

Another painter who met Gauguin, admired him, and immediately began to paint like him was Henri Delavallée. He described Gauguin as very proud, somewhat naïve, very mystifying, a man of deadpan humour. 'No one who saw Gauguin in his prime is likely to forget him. Tall, dark-haired, swarthy of skin, heavy of eyelid and with handsome features, all combined with a powerful figure, Gauguin was at this time indeed a fine figure of a man. Later on, his low forehead with its suggestion of a *crétin* was a source of grave disappointment to Van Gogh, to Gauguin's vast amusement! He dressed like a Breton fisherman in a blue jersey and wore a beret jauntily on the side of his head. His general appearance, walk and all, was rather that of a Biscayan skipper of a coasting schooner; nothing could be further from madness or decadence . . . In manner, he was self-contained and confident, silent and almost dour, though he could unbend and be quite charming when he liked . . . [It] may now be considered strange that in spite of his later reputation for amorous adventures, I well remember how sardonic and sarcastic he could be about some transitory attachments of the kind.'[6]

Surprise at Gauguin's abstemiousness was widespread, particularly given his charisma, vigorous good looks and his avant-garde glamour, but Gauguin was as strait-laced about casual sex here in Pont-Aven as he had been in Paris when he was newly wed and ironically observing the sexual shenanigans of his Impressionist drinking companions at the café Nouvelle Athènes. He had noted then how fortunate he felt to have all his sexual and emotional wants satisfied by Mette. When he had left Denmark, he and Mette had agreed that it was to be a temporary arrangement until they had money to live reunited as a family. Gauguin was a man of his word. He took his honour

and his marriage vow seriously. If a vow was broken the contract was broken. Otherwise, there was no point. 'Lies and venality are crimes.'[7] 'The only sin [between us] would be adultery.'[8] 'What a pity we did not take up our abode in Brittany formerly . . . there is a house which could be had for 800 francs with stables, coach-house, studio and garden. I am sure that a family with 300 francs a month could live very happily . . .'[9] She wrote to tell him she had a tumour on her breast. He was desperately concerned; 'If I could be operated on for you, I would gladly suffer it.'

He missed the children terribly. His letters keep asking Mette for photographs so he could see how they had changed. His Pont-Aven sketchbooks are full of studies of the local children and it was a picture of children called *The Moulin du Bois d'Amour Bathing Place* (1886), which he painted during his first fortnight in Pont-Aven and carried back to the inn at lunchtime, that had caused the painter Vos to attack him, and the attack to elevate Gauguin to new leader of the artists' colony.

The Bois d'Amour, the 'wood of love', is just a short walk from the Pension Gloanec, on the path that runs beside the river Aven through an enchanting wood of oak, pine, mistletoe and enigmatic Druidic stones. A bathing place in a clearing presented Gauguin with the unexpected sight of nudes in a landscape. He had not painted a nude since *Woman Sewing* but that itself was not the spur. The nude boys in the Bois d'Amour presented him with the dream of innocence he had been seeking when he chose to come to Brittany. Here before him was the Virgilian idyll, a scene from the Golden Age. Nudes in the landscape had been painted down the ages by Raphael, Giorgione, Titian, Rembrandt and Poussin, more recently by Courbet and, notably, Manet in his magnificent *Luncheon on the Grass*. Gauguin was ready to take on the challenge. He set up his easel and divided the composition classically into three horizontal bands. The lowest is yellow: the late-summer grass of the riverbank where boys are undressing. A couple of seated girls lead the eye diagonally to the middle band where two boys standing on the bank are summoning up their courage to bathe in the river that rushes along in vivacious twinkling strokes of russet, mauve and green, every colour but blue. The diagonal is sped up by a weir (that still exists) running diagonally across the river, taking your eye to the further bank, where the final

WILD THING

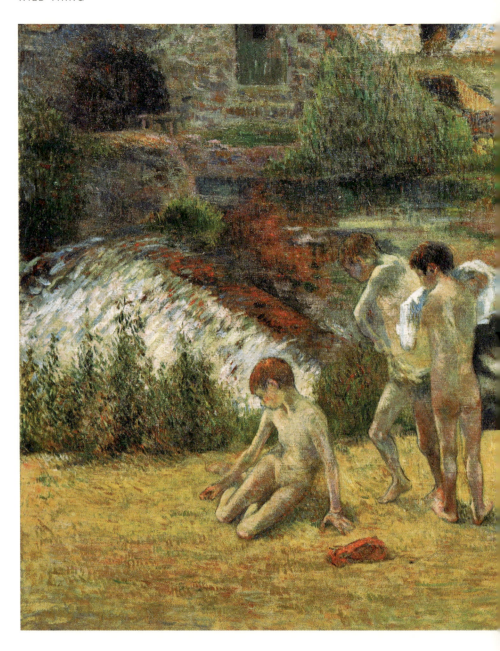

horizontal band consists of bushes massed around the stone-built mill (also still extant) and its subsidiary buildings. The bushes are constructed of a mass of vertical strokes that steer your glance down and round, leading you back to the centre-point of the composition, the boys undressing.

EVOLUTION OF A DREAM

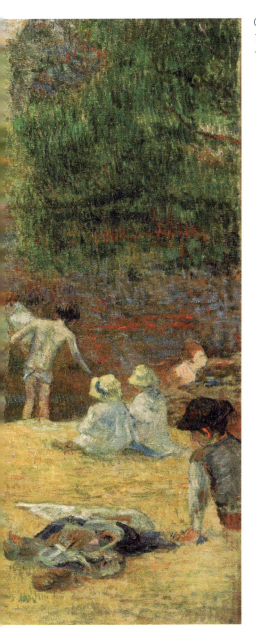

Gauguin,
The Moulin du Bois d'Amour Bathing Place,
1886

It was an unconventional treatment of the theme: Gauguin failed to 'place' the landscape by topping it conventionally with a horizon. It was certainly unlike anything the Pont-Aven gang had seen. Classical in concept, yet completely modern in execution. They marvelled. 'I am the best painter in

Pont-Aven,' he wrote to Mette, 'although of course that does not earn me a cent. Maybe in the future? In any case, everyone here (Americans, English, Swedes, Frenchmen) competes for my advice. And I am foolish enough to give it to them.'

A 'Gauguin gang' formed, headed up by Ferdinand Loyen du Puigaudeau, Henri Delavallée, Henry Moret and Charles Laval. Gauguin discovered that he loved to teach. He also loved to be seen as an outstanding artist but he disliked celebrity. His reaction to it in Pont-Aven was the same as in his stock exchange days. He remained apart. 'I am so uncertain and anxious,' he confided to Mette.[10] There was no way he could relax into popularity and a feeling of accomplishment. Delavallée confessed that even Gauguin's most devoted followers remained a little scared of him. He seemed to move within an invisible nimbus inscribed, '*Noli me tangere* unless you have a bloody good reason.' The only time they really saw him completely off-guard was when he stripped down to his shorts, grabbed a rope behind a rowboat and urged his friends to row as fast as they could, dragging him behind the boat, bodysurfing on the rope like a great porpoise. Then, he would laugh and laugh uproariously. Rumbunctious surfing provided bursts of release from the tension of the main job, which was to master pictorial composition as well as the peculiarly difficult task of depicting the bodies of humans and animals. In this we must remember that Gauguin was largely self-taught. These things would have come much more easily if he'd had years of life classes at an art school or academy.

He was still using the Rouen notebook in which he had written his speculations on the nature of art. Now he was filling it with studies of figures, faces and animals. He had always taken an exceptionally strong, but unsentimental, enjoyment in the existence of animals but he had never progressed to fitting them naturally into his pictures. If he were to succeed in representing the world in its entirety, animal inclusions were important. Dogs, pigs, chickens, horses, cows, sheep and goats galloped into his sketchbook. He became besotted by the geese with their white, bottle-shaped bodies, long, questing necks and interrogating eyes. Geese were pure pleasure; they made him laugh. The insertion of a goose or two acted as a general reminder of the foolishness of mankind as well as, on a more practical level, being immensely

useful as smaller white shapes to balance out the colour composition when he was making pictures of the women in their huge white headdresses that always threatened to unbalance the composition. *Breton Women Chatting* (1886) is an early collocation between Breton women and geese. Its composition is unconventional, the centre foreground occupied by a woman's back-view, and the four women treated as schematic shapes arranged in a compressed vertical space. It is typical of Gauguin's humour that the figure on the right, based on a Degas drawing of a dancer adjusting her slipper shown at the Impressionist exhibition of 1876, is delving into her clog maybe to scratch her foot or maybe to remove a pebble.

During three months in Pont-Aven, Gauguin made some forty paintings, and crammed his notebook with studies to be worked up in the studio at

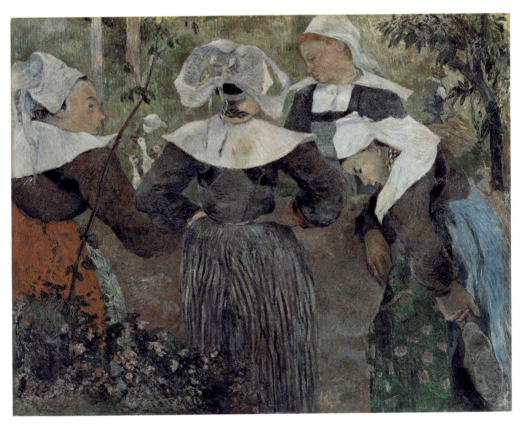

Gauguin, *Breton Women Chatting*, 1886

a later date. He had acquired a school of followers. To instruct them had given him confidence and self-affirmation. He had preached to them his gospel that the realm of the imagination played as great a part in art as the realm of observation. He had played boldly with space, experimented with multiple viewpoints, flattened or lengthened perspective, worked hard on complex composition and managed to place both human figures and animals comfortably in their picture space; they no longer looked like random pieces of furniture shoved in. He had managed to make his brushstrokes his own: small, vibrant and flickering.

It had been a useful period artistically. Three steady meals a day of Madame Gloanec's cooking had restored him to health. His energy and new-found optimism made him restless and impatient to strike a blow for his financial position. On 14 October he went back to Paris, where he had the promise of work.

A minor Impressionist painter called Félix Bracquemond wished Gauguin to spend the winter at the potter's wheel. He had exhibited alongside Gauguin in several Impressionist shows, but his real importance was as a tastemaker. On coming across one of Hokusai's albums, Bracquemond almost singlehandedly ignited the rage for *japonisme* that swept Paris. Older than Gauguin, Bracquemond had been on the periphery of Gustave Arosa's cultural circle, along with the art critic Philippe Burty, whom Gauguin had often met chez Arosa. Burty became infected by Bracquemond's passion for Hokusai. It was largely thanks to Bracquemond and Burty that Samuel Bing opened his historic exhibition on the art of engraving in Japan and founded a sumptuous magazine devoted to Japanese art, after which every fashionable Parisian apartment displayed a Japanese fan or a mask and no pretty *demi-mondaine* would be seen dead without a kimono, while respectable housewives contented themselves with stuffing chrysanthemums into vases of Kakiemon ware or *cloisonné* enamel.[11] Serious artists like Degas and Toulouse-Lautrec, Van Gogh and Gauguin devoted study to the spatial subtleties of this fascinating art that had no truck with the Western Renaissance perspective box but played with isometric and reverse perspective, that ignored shadows and volume, elevated the line, and didn't give a fig for realism. Bracquemond had been artistic director of two important French porcelain factories, Sèvres

and Auteuil, where he had brought *japonisme* into porcelain and ceramic design with considerable commercial success. Bracquemond had greatly admired Gauguin's wood relief *La Toilette* (1882) at the eighth Impressionist exhibition, and he was curious to see what Gauguin could achieve as a potter. Already artists such as Ingres and Delacroix had worked in the same capacity for the Sèvres factory, and Gauguin saw Bracquemond's proposal to work in ceramics as an exciting and flattering offer, particularly given his own passionate interest in Peruvian and pre-Columbian ceramics, though it was a shame there was no money to be had up front.

As usual, Gauguin had to raid his art collection to see him through the next few months. He sold a Jongkind for 350 francs, hoping it would keep him going over the winter. He instructed Schuff to find him a little hovel to live in, close to the workplace of Ernest Chaplet, the ceramicist that Bracquemond had chosen for Gauguin to work with. Chaplet's factory was in Rue Blomet; Schuff found a nearby apartment in 27 Rue Lecourbe. It was even worse than the previous winter's apartment, but at least he did not have Clovis to look after.

Initially, he decorated the pots that Chaplet threw, applying his favourite Breton women in their large white *coiffes* – and the odd goose. He enjoyed the richness of drenching coloured glazes and of drawing fine gold lines for emphasis but the very idea of creating an artwork collaboratively never sat well with Gauguin. Nor did the process of creating art on something as mechanical and by implication as decadent and industrial as the potter's wheel. 'God created man from a little mud . . . a little mud plus a little genius,' he wrote.[12] God certainly hadn't used a wheel; nor would he. Godlike, he would raise worlds by his own hands, moulding, modelling, pulling, stretching, compressing, slashing. With a lump of clay in his hands, three-dimensional creation took hold of him. He felt none of the intimidation of precedent that came with the medium of painting. The images of strange beings that had been brewing inside him for almost forty years poured from his hands. Ancient Peruvian archetypes rinsed through modern consciousness. He found their new forms in globular, asymmetrical imaginings awkwardly anthropomorphised, interrupted by faces, limbs and orifices. Handles looped like twisted intestines, blood-red glazes splashed

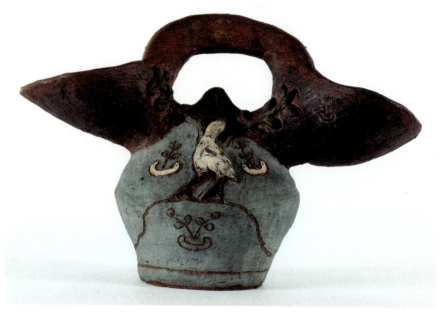

Gauguin, ceramic pots, 1886–8

and dripped. Powerful, puzzling, primeval, naïve, rustic, unlinked, like something glimpsed out of the corner of an eye. Mysterious, magical, secretive, a body of fetishistic work full of strange discontinuities unhinged from reality. The firing in the kiln took on for him the significance of the fires of hell itself. He worked intensely hard. He only had time to make fifty-five pieces before he became seriously ill, but during that time he harvested his unconscious of resonant images that contained the same disturbing, superstitious quality as his earlier Danish coffin.

Maybe it was psychic exhaustion from this great ransacking of his unconscious that induced sudden physical collapse, or maybe it was destitution and near-starvation. He was living on cheap brandy and tobacco. It staved off the hunger pangs. He noted with forensic interest that on this diet, you only needed to eat actual food every three or four days. 'I have known absolute poverty, that is, hunger and all the rest . . . You get used to it and with will enough you can laugh it off. But what's really terrible is that it stops you working, stops you developing your intellect . . . It's true that suffering sharpens the mind. But you mustn't have too much, or you die of it.'[13]

Chaplet and Bracquemond thought his pots were masterpieces, as did Gauguin himself. Bracquemond exerted himself hard to promote them, but nobody wanted to buy, or even exhibit them.

He fell ill with angina. In late November and December, he spent twenty-seven days in hospital. His parents' untimely deaths reminded him that mortality was merciless. When he came out of hospital, Gauguin closed the venture with a courteous note.

Dear M. Bracquemond,
 Thanks for all you have done, which at times must have been a nuisance to you. You once very truly said: it is not difficult to practise art, the thing is to sell it!
 Kind regards,
 Paul Gauguin[14]

Gauguin never stopped making ceramics throughout his life. His creativity could only be satisfied by a wide range of cultural activity that included

stone carving, wood carving, playing music and writing: the *Gesamtkunstwerk* that was his spiritual entirety. All helped him, in different ways, to explore the paradoxical relationship between the Finite and the Infinite. What he could not say in one medium, he would say in another. As Theo van Gogh wrote to his brother Vincent: 'It is obvious that Gauguin who is half Inca, half European, superstitious in his ideas like the former and advanced in his ideas like the latter, cannot work in the same way day after day.'[15]

Gauguin's ceramics were first exhibited in 1903, six months after his death, in Vollard's gallery. They were admired by Degas, Matisse and a young Picasso. Monet, who never had a good word to say about Gauguin's paintings, damning them as clamorous and vulgar compared to his own work, liked the ceramics, and praised them as 'of a lofty and poignant obscurity'. They were a springboard to Matisse and Picasso, to make their own freely modelled 'primitive' pieces.

The digging of the fifty-mile Panama Canal connecting the Atlantic Ocean to the Pacific was attracting all sorts of European adventurers, among them Gauguin's brother-in-law, Juan Uribe. He had gone out to South America to establish something that Gauguin's sister Marie vaguely described as a banking agency.

Gauguin leaped to the conclusion that Juan would badly need someone who understood banking, who could be relied upon not to rob him and who could take his place during his trips back to Europe to visit Marie and the children. Panama was no place for women and children with its gun-slinging desperadoes and death-dealing pestilential climate. Juan had left Marie and the children in Europe where she had gone to live in Germany and set up as a dressmaker, as her mother, Aline, had done before her. Gauguin booked a passage for Panama. This time, he told Mette gleefully, their fortune really would be made. This time it was foolproof. Quite soon he would have earned enough to ship the whole family over to join him in the glorious tropics where the children could grow strong and healthy, running around in the sunshine, living off fruit from the trees and fish from the sea.

When Gauguin felt moneyed and confident, he could act like the good bourgeois husband he had once been. With the prospect of a well-paid job

before him, he put his affairs in order before his departure. He set up power of attorney for Mette. His father's brother, Uncle Zizi, with whom Gauguin had lived in Orléans when he first came to France from Peru, was getting old. The power of attorney empowered Mette to act for Gauguin in the event of Zizi's death. He wrote to her formally requesting she use the money for the children, and he asked her to send somebody to Paris to collect Clovis from boarding school. He had used some of the money from the sale of the Jongkind to pay the school fees, but this could not go on. Clovis must re-join the family in Copenhagen.

The day before leaving Paris, he went round to Schuff's house to say goodbye, and to make sure Schuff would oversee the Clovis problem in his absence. His astonishment was immense on finding Mette sitting there. She had come to Paris to collect Clovis herself. An embarrassed Schuff left them alone to talk. Mette told him that she had kept her visit secret from him because she knew that if she saw him, they would make love, and she did not want to get pregnant again. He told her that he loved her. His only wish was that he could make money so they could live together as a family. Everything he had been doing up till now had been towards that end and now he was making another bid for fortune. He felt keenly his inability to give her any money. He had left instructions that if any of his ceramic pieces sold, the money was to go to her. He implored her not to reproach him for the past. The blows he had suffered had been difficult to recover from. Above everything, his greatest wish was for them to be reunited. He told her to go to his studio and take whatever she wished back to Denmark so that the sales of his works could release money to help her support the children.

It was a sad and stilted leave-taking. He left her there in Schuff's house. The following day, he embarked for Panama.

A few days later, Schuff was taken aback to discover that Mette had virtually emptied the studio.

8

'I'VE NEVER PAINTED SO CLEARLY'

The boat left for Panama on 10 April 1887. He was not travelling alone. Charles Laval, a devoted disciple from Pont-Aven, was eager to paint with the Master in the fabled light of the tropics. Thirteen years younger than Gauguin, Laval was 'very thin, very intelligent, very tall, hollow featured, exquisitely courteous, extremely well-bred'.[1] He had a near-sighted habit of peering at things and was almost too skilled at painting: he had first shown at the Salon at the age of eighteen. Originality was Laval's weakness: he could paint in any style. Finding his own was the problem he never solved. When he and Gauguin met at the Pension Gloanec, he was imitating Degas. By the end of Laval's sojourn with Gauguin in the tropics, he was turning out canvases so close to Gauguin's that disputes still rage over who painted what, leading to unscrupulous dealers scraping off Laval's signature to forge Gauguin's in its place.

Laval was not contemplating physical work in Panama. The plan was for Gauguin to earn his money clerking in his brother-in-law's financial operation while Laval would paint society portraits, a pastime he imagined easily achievable through his excellent connections: he had a relative who knew somebody who knew the secretary of 'le Grand Français' Ferdinand de Lesseps, who had been made president of the Panama Canal Company following his triumphant dig of the Suez Canal. Gauguin and Laval reckoned that, considering all the wealth and colonialist *gloire* involved in this French *grand projet*, company bigwigs would be standing in line to have their likenesses immortalised. As soon as they had made enough money, the two artists would leave Panama, to paint on the reputedly unspoiled island of Taboga, that promised to fulfil Gauguin's recurrent Arcadian dream of living off fish, fruit, authenticity and sunshine.

Lesseps's first cut of the Panama Canal in 1881 had been celebrated by marching bands, maidens in white dresses waving palm fronds, interminable speeches and a 400-million-franc share issue. The project was expected to

take eight years altogether, but seven years had already passed by the time Gauguin and Laval arrived, and it was floundering. Lesseps's triumphant Suez Canal had been an easy dig through sand on level ground. It was a different matter to cut a stable channel through the geological incompatibilities running between Colón and Panama City. Unstable rock, quicksand and saturated stony soil behaved like a flowing river slithering downhill or collapsing abruptly in landslips and mudslides. The dig was cutting across rivers so powerful that when they spated they laughingly washed away everything in their path. So far, the death toll from industrial accidents, malaria and yellow fever was around 22,000.

The two artists disembarked. 'This is Colón where the frogs frolic in the water of those greenish pools, rats infest the banks and snakes from the forest – which begins where Colón ends – come to hunt the frogs and rats; mosquitoes swarm up from this low-lying region and spread all through the houses.'[2] Juan Uribe's office was not here, but in Panama City, at the other end of the project. Though it took thirty-three years to complete the canal, it took Gauguin and Laval only three hours by train to travel from Colón to Panama City, breathing air vile with a cocktail of rotting vegetation, stagnant mud, latrines and decomposing corpses. Abandoned machines, flank-deep in mud, poked up rusty masts and funnels and other unguessable parts like arms not waving but drowning. Snakes watched their progress from abandoned rat holes. Sad, leaning coconut palms funnelled rain on to the roofs of workers' huts, velveting them with green rot.

Panama City was no more cheering. Uribe, 'my fool of a brother-in-law', was not, it turned out, running a bank, nor any sort of financial agency, but one of several general stores that vied to sell frontier necessities: boxes of matches, rope, tea, workwear, pots and pans, tinned food, drink and guns. Uribe was not pleased to see Gauguin. He offered neither welcome nor help. There was no question of a job. Gauguin had been the victim of face-saving bourgeois family pretence by Marie, who had talked up her husband's importance. Resentful of his own foolish gullibility, Gauguin stole an overcoat as he was leaving the store. He never saw or spoke to his brother-in-law again.

'Anyhow, the folly [of our journey] was committed. Tomorrow I am going to swing a pickaxe in the isthmus for cutting the canal in return for 150

piastres a month, and when I have *saved* 150 piastres, that is 600 francs (which will take two months), I will leave for Martinique.'³

It was a plan that might have worked, had it not coincided with the collapse of the Panama Canal Company. On the fifteenth day of his employment, the faltering management dismissed ninety workers including himself. To save its reputation, the company now brought in Gustave Eiffel, of Tower fame, under whose aegis it would stagger on for another two years before collapsing altogether, engulfed in financial scandal that ended in a prison sentence for Eiffel and a shredded reputation for Lesseps. The canal would finally be completed in 1914, not by the French, but by the Americans.

Gauguin and Laval left for the island of Taboga where, once more, Gauguin discovered himself the victim of misinformation. These days the island was far from unspoiled. It was dominated by an enormous sanatorium run by nuns caring for the sick workers of the canal company. Set within a complicated labyrinth of shallow channels dedicated to growing food to nourish the convalescents, the watery kitchen garden proved the ideal breeding ground for the anopheles mosquito. The link between the mosquito and malaria had not yet been made. Gauguin was bitten and infected. He and Laval were both ill. They must leave. They took a ship on 3 June.

The ship took them to the island of Martinique, a French colony since the 1660s grown prosperous on the murderous extermination of the original Carib inhabitants and the unspeakable humanitarian horrors of the sugar and slave trades. Its wealth fertilised with rivers of blood, by Gauguin's time the capital Saint-Pierre was known as the Paris of the Antilles for its cosmopolitan sophistication. It housed some 20,000 people in buildings of the local warm yellow stone topped by ochre-red roofs, giving the impression of a prosperous French provincial town accessorised by an unusual number of palm trees. The theatre played host to visiting stars from France. The main street was named after Victor Hugo; you could buy excellent croissants in the *boulangerie* on the Rue Longchamps. Cafés blazed. Tourists flocked. Gauguin was lightheaded and feverish, but his ideals had not been addled; he and Laval struck out from this hypocritical parody. A mere two kilometres from the capital they discovered a deserted workers' hut on the fringes of a fruit plantation.

'As soon as I reached Martinique I collapsed. In short, I have been down

with dysentery and marsh fever [malaria]. At the moment my body is a skeleton, and I can hardly whisper; after being so low that I expected to die every night, I have at length taken a turn for the better but I have suffered agonies of the stomach. The little that I eat gives me atrocious pains . . . I must end this letter as my head is swimming and my face is covered with perspiration and I have shivers down my back. Goodbye for the present, dear wife, I kiss you and I love you (I ought to hate you when I look back and see the vile tempers which parted us). Since that day everything has gone from bad to worse. A thousand kisses for the children, shall I ever see them again?'[4]

Laval was also desperately ill, with yellow fever. Pissarro had converted Gauguin to homeopathy, and he dosed Laval from his travelling tinctures. Laval appeared to make a good recovery but soon relapsed. The two artists led a pathetic existence, fighting their life-threatening diseases.

There was no furniture in their derelict hut but they gathered two piles of seaweed to sleep on. Above them the roof of woven leaves was alive with insects and small creatures that came out after dark to slither and scuttle and whine and buzz and bite. Nevertheless, Gauguin described it as a paradise.

They cooked over an open fire. Their combined budget per month was ninety francs. This meant existing on 1.50 francs each a day, a whisker more than the freed slaves were paid. It covered food but little else. The hut was situated on the Route du Carbet, a busy route running between the capital Saint-Pierre and the fishing village of Le Carbet. When they were up to it, Gauguin and Laval could walk ten minutes to the shore to buy fish and make studies of the fishermen dragging their heavy nets up the beach, but Gauguin's main joy and preoccupation lay with the traffic passing his door. He had only to drag himself off his mattress to see the *porteuses* coming and going along the Route du Carbet. A *porteuse* was a 'liberated' slave, who worked for a plantation owner from dawn till dusk, carrying produce to market and returning with other goods balanced on her head in a large tray or basket. She wore two headscarves of brightly coloured cotton, one to pad her head against the load, the other to tie it securely in place. *Porteuses* wore *douillettes*, colourful cotton dresses to the ground, which they hitched up with a belt to keep the long skirt out of the dusty road. The nobility of their upright carriage and the grace of their rippling drapery gave the women the

timelessness of the antique friezes that so deeply touched Gauguin's soul. He took up his position beside the road with his sketchbook, black chalk, charcoal, pencil and watercolour box. To see his pictures from Martinique, you would think the island was inhabited solely by *porteuses*, but this is because Gauguin was too ill to move far from the hut.[5]

Diarrhoea, malarial fevers, vomiting, shaking sweats and chills, muscular pains, and hallucinations prostrated Gauguin on his seaweed mattress for at least six of the nineteen weeks of his stay on the island. During the remaining weeks he worked prodigiously hard while also nursing Laval, even rescuing him from suicide when the younger painter tried to take his own life in a fit of delirium brought on by fever. Considering the physical circumstances, it is remarkable that Gauguin managed to complete sixteen paintings and fill three sketchbooks. All of them attest to the surge of creativity that may be generated at the end of the road, at the bottom of the existential barrel where the human soul may feel the overwhelming need to find scrapings of meaning.

The sketchbooks are full of quick studies quivering with life: heads, limbs, figures.[6] There are not many landscape details. This implies that he constructed the landscapes *en plein air* and then peopled the pictures with figures taken from the sketchbooks. This process was a question of necessity – he hardly had the wherewithal to pay a model to stand still for hours in front of the framing landscape – but Gauguin came to think of this way of constructing a picture as more liberating to the imagination than making a real live person stand like a statue for hours in front of a composed background and copying the whole thing slavishly. It became a favoured way of working, and it excited him. He knew that he was producing work 'far superior to my time at Pont-Aven, in spite of my physical weakness. I've never painted so clearly and so lucidly.'[7]

Fruit Porters at Turin Bight (1887) shows the imaginative breakthroughs he was talking about. In composition, it is not unlike *The Moulin du Bois d'Amour Bathing Place* of Pont-Aven with its horizontal divisions and empty foreground but now he uses the bent trunks of the sea-grape trees (*Coccoloba uvifera*) to form a screen through which you see the landscape, constructing pictorial depth while flattening the colour planes of both the beach and the sea, turning the picture into a satisfying decorative pattern rather than a

realistic depiction. The sea is abstract. The artist is not concerned with the anger, or otherwise, of the waves. It is a picture of a certain atmosphere, a certain mood. He changed the colour of the beach, too. The beach at Anse Turin is composed of dull grey volcanic sand but he painted it the same pale lemon as the sky, giving a unity to the whole composition. Try thinking of the beach as grey: the picture dies. The *porteuses* who have arrived at the sea with their baskets on their heads are taken from the sketchbooks. The figure in the foreground in the red *douillette* obviously pleased him mightily, as he uses her again in quite a few other pictures.

'Martinique was a decisive experience. It was only then that I felt like my real self, and if one wants to find me, one must look in the works I brought back from there, rather than those from Brittany.'[8] It had taken destitution verging on death to provoke the urgent need to express himself completely subjectively, to grasp the courage to simplify the form as he complicated the idea.[9]

But if the four months of malaria, dysentery, hepatitis, undernourishment and taking care of Laval released Gauguin's imaginative inhibitions, the night-sweats and dagger pains in his stomach, together with the continuing consciousness of his own material failure, unleashed neurotic marital anxiety. He kept writing letters to Mette and not receiving any answer. He begged her to write. The arrival of every post boat brought an agony of disappointment. Insecure, and suffering from that most undermining of problems, insomnia, he tortured himself with the thought that she was dead. If she were dead, what would happen to the children? Mette had, in fact, written but the delivery system was capricious; it could easily take five months for a letter to arrive.

In August, he received the news that a young businessman named Albert Dauprat had called in to Chaplet's factory to buy some pots. On seeing Gauguin's ceramics, he had become so enamoured that he was proposing to put up a sum of around 25,000 francs to buy Gauguin a partnership in Chaplet's business. It was imperative to get back to Paris as quickly as possible! He shot off a letter asking Schuff to send 250 francs for the fare. We do not know if the letter arrived, or the money arrived. Possibly, Gauguin fell back on his naval experience to work his passage home. Laval was too ill to travel, and so he was left behind.

WILD THING

It was mid-November and snowing when Gauguin arrived in Paris. He went straight to Schuff, who was now living comfortably on his investments in a delightful house in Rue Boulard with a billowing garden and an airy studio, happily painting his pedestrian pictures which fortunately he had no

'I'VE NEVER PAINTED SO CLEARLY'

Gauguin, *Fruit Porters at Turin Bight*, 1887

need to sell. He still idolised Gauguin, both as a man and as an artist, and he was happy to offer him a home and the use of his studio.

Bitter disappointment awaited Gauguin. Once more he discovered that he had made a journey halfway round the world on the promise of work that

failed to materialise. Chaplet had lost interest in ceramics, sold his studio, and moved away to indulge his new passion for experimenting with copper-red glazes on porcelain.

'Yet another thing slips through my fingers,' Gauguin wrote to Mette. 'I must find a situation where the work is sufficiently remunerative to support life *and* to enable me to help you a little.'[10]

The Schuffenecker household was not a happy one. Louise was taller than her husband and provocatively beautiful, with slanted eyes and masses of red-gold hair. She made no secret of looking down, in every way, on the gentle Schuff, seeing his habitual compassion and generosity as weakness and ineffectuality. Gauguin was infuriated at how she treated his friend and took to referring to her as 'the harpy'. The Moche Peruvians made portrait pots of their beheaded enemies and Gauguin made a similar beheaded portrait pot of Louise, her come-hither eyes peering up seductively from under long eyelashes. He wound a spotted snakeskin like a ribbon through her hair and round her throat. At the back of her head a dismembered hand grasps another snakeskin that slithers down the back of her neck, a motif often used in Peruvian Moche ceramics to symbolise the powerful, fertile woman. For Gauguin there was also a sly reference to Eve, whose acceptance of the apple from the snake made her the source of humanity's perpetual state of existential misery. Schuff's marriage did not last.

Gauguin had been away from Paris for eight months. He was keen to see how things had moved on. The latest avant-garde show was being held in the Restaurant du Chalet on the Avenue de Clichy, where Vincent van Gogh had persuaded the *patron* to give wall space to himself and the group with whom he was painting. They called themselves the Painters of the Petit Boulevard, a dig at the Impressionists who hung out on the bigger and more glamorous Boulevard Montmartre. Like the pointillists, the group was looking for a way forward from Impressionism. Like the pointillists, their art had been baptised by an art critic, Édouard Dujardin, who called it Cloisonnism, because they took their inspiration from Japanese *cloisonné* enamel vases and from stained-glass church windows, both of which used metal lines to separate areas of colour. This was a question of style. The important way they differed from both the pointillists and the Impressionists was in their urgent

conviction that the art of the future must bring back to the canvas those vital elements that both Impressionism and pointillism had purposely excluded: strong emotion and spirituality. Vincent's fellow travellers, Louis Anquetin, Henri de Toulouse-Lautrec, Émile Bernard and Arnold Koning, had all, like Van Gogh himself, studied under Fernand Cormon, a not overly spiritual Academy painter who painted gigantic pictures of prehistoric man with titles like *Return from a Bear Hunt in the Stone Age* and *Cain's Family*. He must have been puzzled by his pupils' direction of travel. The restaurateur who had allowed them to exhibit soon told them to take their pictures off his walls because they were putting the customers off their food, but not before Gauguin had visited, and greatly admired Vincent's work.

Vincent's brother, Theo van Gogh, was a successful and influential Paris art dealer, the manager of the Paris branch of Boussod, Valadon & Cie, where he traded in the works of established artists, including Degas, Monet and Pissarro. Schuff invited the Van Gogh brothers to his studio to take a look at Gauguin's Martinique canvases. They were thunderstruck. Theo instantly bought *Fruit-Picking* or *Mangoes* paying 400 francs, the largest sum he ever paid for a picture for his own collection. He hung it in his home, in pride of place over the sofa.

Vincent was financially completely reliant on Theo. He had never so far sold a picture, except for a few francs to the odd friend like Père Tanguy from whom he bought his paint supplies. Vincent was deeply religious, and when he saw Gauguin's Martinique pictures, he fixated on the idea that Gauguin might be the leader and teacher who would be the Saviour of the Art of the Future. Spellbound by Gauguin's use of colour and the poetic and emotional power of his works, but having no money to buy a picture, Vincent proposed to Gauguin that they swap Gauguin's *Riverside* (1887) for Vincent's *Still Life with Two Sunflowers* (1887). For Gauguin, it was wonderful to be back to exchanging pictures, to be adding a new work to his 'museum of the mind' rather than selling his mental stimulus off bit by bit for money to live on. And with the 400 francs from Theo, it was also wonderful to be able to send 100 to Mette.

The meeting with the Van Gogh brothers was a decisive turning point. Theo became Gauguin's agent. He would work hard to sell Gauguin's work

over the next two years, managing to sell several ceramic pieces and eleven paintings for a total of 4,450 francs of which Gauguin received 3,315 francs. By way of comparison, Theo was selling works by Monet for an average of 2,200 francs each and Degas for an average of 3,200 francs, so it was not a fortune, but it was money, and it was coming in steadily. Theo also showed Gauguin's paintings in the gallery he managed. In January, they caught the eye of the critic Félix Fénéon who had been the chief promoter of Seurat, with his meticulous frozen dots conveying a petrified state of monumental calm. Now he praised Gauguin for the opposite: his barbarism, irascibility and the force of his brushstrokes that fell 'like a rainstorm'. Octave Mirbeau described his pictures as very odd, very noble and very barbaric all at once. Gauguin was seen as a new force: original, intriguing, colouristically sumptuous, and more than a little transgressive in the way he was prepared to jettison technique in order to loosen the strings of the imagination. Jaded Parisian critics, craving change from scientific analysis of colour and light, were ready for Gauguin's dreamy suggestiveness. Fénéon picked out *Conversation (Tropics)* for special praise and Theo van Gogh held out for a good price for the picture. A year later he sold it for 300 francs to a collector friend of Degas, who held on to it until his death. 'Poor Gauguin,' Degas is supposed to have said, 'way off there on his island. I advised him to go to New Orleans, but it was too civilised. He had to have people around him with flowers on their heads and rings in their noses before he could feel at home.'[11]

In January 1888, Gauguin left Paris for Pont-Aven. He was still not well, and he felt that his best chance to recover his health was to stay at the Pension Gloanec, where he could live cheaply and calmly and be generously fed. Between January and April he spent the majority of the time in bed, feeling sorry for himself and fuming against fate. He was bored, the weather was atrocious; he painted a few snowscapes; he had searing stomach pains and he had no money. Not until July did he feel himself cured, though the gut ache persisted, as it would for the rest of his life. To restore his strength, he took lessons in the boxing *salle* and the fencing *salle*, swelling his reputation for cutting a dash. As Pont-Aven welcomed its customary summer migration, Laval joined him, back from Martinique and as devoted as ever. 'For my part, the more I go on, the

more I admire your talent, and I feel respect and affection for you. You made me understand the superior strength that permits me to make efforts to grow. I embrace you tenderly as a courageous elder brother who set the example for me.'[12] Laval never forgot that Gauguin had saved him from suicide.

Up until now, though Gauguin was concerned with infusing his work with spirituality, he had not introduced religious references. In Brittany they were inescapable. While much of France was succumbing to the moral anaesthesia of industrialised capitalism, Brittany still clung stubbornly to muddy-clogs ruralism and a deeply held Catholic faith. During his money-go-round in the City of Gold, Gauguin had hung a pair of wooden clogs on his wall. We see them from time to time in his Paris interiors, sneaky little invaders from pre-industrial times. Now, like the local Brittany peasants, he carved his own.

Spirituality was as strongly rooted in Brittany as in himself, though he had long turned away from organised religion and the established Church. Moche animism had laid the foundation. On to this, Bishop Dupanloup had grafted the idea that a universal religio-intellectual synthesis was necessary, and this fitted well with Gauguin's own synaesthetic nature. The Breton position was a synthesis of Catholicism, Celtic and Druidic legend, animism and superstition.

At the heart of every hamlet and village in the area was a small, squat church built of local stone. Most dated from around 1460 and were erected on the sites of Druid temples beside sacred springs that, according to Roman historians, were the place of Druidic human sacrifice. Following Christianisation, these sites absorbed the Christian symbolism of Jesus Christ the sacrificial victim through whose redeeming blood flowed the water of eternal life.

Once a year, on the feast day of its patron saint, each of these little village churches was the centre of a unique ceremony called a pardon. It was the most important day in the church's calendar. The pardon had its origins in the ancient Celtic Tailteann Games, dating from somewhere around 1600 BC. Funeral games for the dead, they had included wrestling contests and these had survived down the ages, becoming known in Breton as the *gouren*. Christianity had transformed the wrestling contest from a slugfest ending in the defeated having his throat cut by a Druid into the representation of a moral conflict at the end of which the victorious wrestler, having proven through

his strength that he was the most spiritually pure, was rewarded with a farm animal to swell his herd and his prosperity.

Human rivers streamed through woods and green meadows from miles around to witness the event, dressed in their best to receive God's pardon for their sins. Snowy coiffes floated above dark dresses like foam on inky water, their white ribbons dancing like spume on the wind. First, they received absolution from the priest. Then they danced a gavotte, a rather formal folk dance, on the levelled area of ground by the church where the wrestling match had always taken place. As they danced, their wooden clogs flattened the grass of the arena which they gathered round to watch the young men of the village renouncing the devil before engaging in the wrestling competition. The champion, in Christian times, was deemed to have proven himself the most spiritually pure young man in the village. His prize, the live heifer which we see in Gauguin's painting tied to a tree during the match, symbolised the conquered opponent of previous times, who had then been sacrificed at the sacred spring.

This is what Gauguin painted in *The Vision of the Sermon*. Past and present, reality and imagination, a fusion of the familiar with the magical and strange. Like in his portrait of Clovis asleep, Gauguin is attempting to show an outward and an inward state simultaneously. But he brings a further complexity to the picture as the *Vision* also tells the Bible story of Jacob wrestling with the angel, a story Gauguin identified with.

The Breton women gathered for the pardon, dressed in their regional costume, have just listened to the priest on the right (whose tonsured profile some believe to be a Gauguin self-portrait). He has delivered a sermon on Genesis 32:22–32, which tells how the prophet Jacob wrestled all night with a mysterious angel before receiving a blessing from God.

Gauguin wrote a letter describing the picture to Vincent van Gogh. The landscape and the fight, he explained, were taking place in the imagination of the people. The tree-trunk slashed diagonally across the space divided real space from imagined, the profane from the sacred. (This, if it really is a self-portrait, fixes Gauguin firmly in the spiritual space.) In the real space on the left, the prayerful Breton women stand in the circle to watch the contest. The heifer that is the victor's prize also occupies real space, tied to the tree-trunk. To the

'I'VE NEVER PAINTED SO CLEARLY'

right of the tree, the space occupied by the imagination, the vision appears. The boys are transformed into Jacob wrestling with the angel. The wrestlers also, Gauguin says, symbolise himself wrestling with the tough process of artistic creation, and wrestling for the redemption of his life through art.

The *Vision* shows Gauguin finally freeing himself from the subordination to appearances and committing to the inwardness of colour, as he had begun to do on *Fruit Porters at Turin Bight*. The whole scene, not only the imagined, takes place on vermillion ground, unifying the space while striking a fantastical and mystical note. Like the rest of the *Vision*, there are two ways of reading the red ground: literally and symbolically. Literally, the colour was not totally impossible: the pardon took place on the third Sunday in September, when the buckwheat in the fields turns red. Symbolically, red is the

Gauguin, *The Vision of the Sermon*, 1888

colour of blood and of life, and of intense emotion. The *Vision* also saw the further development of another motif that had fascinated him ever since his Impressionist days, the tree motif used in the Japanese manner as vertical screen to divide space, as in *Fruit Porters at Turin Bight*.

The letter describing the *Vision* to Vincent included a sketch of the picture,[13] and Vincent used exactly the same compositional device – the diagonal tree bisecting the canvas – in his famous *Sower with Setting Sun* (1888) which he painted some six weeks later. The *Sower* is also a religious allegory but one based on Christ's parable of the sower broadcasting the seeds of religious faith, which Vincent saw as symbolising the artist sowing the seeds of the new artistic truth.

Gauguin wanted the *Vision* to hang in one of the local churches whose deep history had inspired its creation. He said that he wished to see the synthetic effect the modern piece would have among the rustic Romanesque and Gothic forms within the chapels. He offered it first to the church at Pont-Aven, but the church was in the throes of modernising its interior, so he was not unduly downcast when the priest turned it down. Far more authentic was the Church of Saint-Amet at Nizon, with its deep, dark interior rich with pre-Christian figures and symbols, overlaid with later medieval paintings, sculptures and carvings. The canvas is quite large, seventy-three by ninety-two centimetres, and a group of his young pupils including Laval and Émile Bernard helped Gauguin to carry it four kilometres uphill through the fields to the Nizon church.[14] There they hoisted the picture up above the door where the vermillion ground darkened to the colour of rich soil, just as Gauguin had envisaged. Pleased at how it looked, he sent Bernard off to the presbytery to fetch the priest to receive the gift.

'I saw immediately that he would not accept,' Bernard says. 'It was very different of course from the surrounding liturgical furnishings. The first words he uttered were those of a polite refusal. Gauguin raised as an objection the old saints, the ancient church, the harmony there could be between all these artistic expressions . . . The priest questioned him about the subject and declared it not to be a religious interpretation. Perhaps if it had presented the famous struggle in a straightforward way! But these enormous bonnets, the way the backs of these peasant women filled the canvas, and the essential

element reduced, in the distance, to such insignificant proportions! . . . It was not possible, he would be held accountable, he would be blamed.'[15]

They hefted it back. Gauguin put on an iron face, carrying on as usual in Pont-Aven, boxing, fencing, swimming, making paintings and giving lessons to his followers, but he wrote to Vincent, 'There is a road to Calvary that all we artists must tread',[16] and he offered the picture to Vincent, who replied that it was too fine a gift, Gauguin should rather send it to Theo in Paris. Here it was seen by Gauguin's consistent admirer Degas, who suggested it be sent along to Brussels to be exhibited with the Belgian avant-garde group Les Vingts in their upcoming show in Brussels, where the picture was received with 'the greatest hilarity . . . In front of [it] an incessant buzz of human stupidity, breaking out from time to time in bursts of human laughter . . . people inferred from his *Vision of the Sermon* that the artist presumptuously intended to mock the visitors.'[17]

Desperately hurt, Gauguin did not risk putting the picture on public view again. Nobody saw it until 1891, when he was selling the contents of his studio to raise money to travel to Tahiti.

9

VINCENT. 'MY GOD, WHAT A DAY!!'[1]

Vincent van Gogh had become obsessed by the idea of painting with Gauguin. Between March and September 1888, he bombarded him with invitations to join him in Arles, in the south of France. Here they would form the Studio of the South, a group 'something along the lines of the . . . English Pre-Raphaelites', a spiritual as well as an artistic band of brothers who would, Vincent fervently believed, bring about 'the great revolution, art for the artists, my God, perhaps it's a utopia!'[2]

Vincent, who never had a penny and never gave a party in his life, bought twelve rush-bottomed chairs for the twelve hypothetical disciples to sit on – paid for by his brother Theo. Gauguin found all this a little hare-brained, but he did not turn the proposition down outright. Vincent was, after all, his agent's brother. Gauguin knew that the work he was producing was so good that with Theo to push it, there was every reason to expect success, in which case, when the great moment came, it would be commercial suicide to be holed up in Arles, rather than capitalising on attention in Paris.

However, following September's *Vision* debacle, Gauguin was staring misery and misunderstanding in the face. Finally, he prepared to commit to sharing a house in a place he had no desire to go, with a man whose mental stability was plainly in question. Vincent, meanwhile, was attributing Gauguin's prevarications to a conspiracy by Gauguin's erstwhile capitalist stockbroker associates, though what on earth they should gain by such a thing remains unfathomable. Theo eventually found a way around both his brother's paranoia and Gauguin's material needs by offering Gauguin 150 francs a month in exchange for paintings if he went to live with Vincent in Arles.

Vincent's psychotic episodes and mood swings had long been a problem for his family. His ups often took the form of religious mania. His downs, depression and masochistic religious guilt. Vincent's first ambition had been to become a clergyman like his father, but the Church had rejected him as unfit.

A spell as an itinerant evangelist bringing the Gospel to coal miners in Belgium came to an end because he frightened the children, who threw things at him, while the adults thought him a fanatic and a 'lunatic'. For a period, Vincent had managed to work at the international art-dealing firm Goupil et Cie, where his uncle, a partner, placed both Theo and Vincent until eventually Vincent's mental problems became too great. Their despairing father decided that Vincent should be committed to an asylum. When Vincent refused, Theo had taken on responsibility for him. By 1888, he had been lodging with Theo in Paris for two years, turning his life and his apartment upside down. It came as a great relief to Theo when Vincent conceived the plan of moving to Arles. The cost of renting the Yellow House and paying a monthly allowance to both Vincent and Gauguin came cheap at the price, if it got his brother out of his hair.

During the preliminary skirmishes, Vincent had suggested to Gauguin that they exchange portraits. 'For a long time, I've been touched by the fact that the Japanese artists very often exchanged works with one another. It shows that they loved and supported each other and that a degree of harmony prevailed among them; they lived precisely a sort of fraternal life, naturally, and without intrigue. The more like them we are in that respect, the better we will feel.'[3] An exchange of portraits would seal the brotherly bond.

Every portrait creates a myth; many form the foundation of legend. In a week, Gauguin dashed off the first Symbolist-Synthetist portrait in a canvas whose symbols and colours were full of coded messages. 'It's not a copy of a face . . . but a portrait as I understand the word . . . an abstraction.'[4] Above his signature, he had written *Les Misérables*, the title of Victor Hugo's popular novel and the clue that he was presenting himself as the novel's hero, Jean Valjean, convicted criminal, outcast, martyr and saint, a man of great physical and moral strength who was wronged and misunderstood by society. As in the *Vision*, Gauguin divided the canvas diagonally, setting up the symbolism and the tension between triangular areas of light and darkness. On the left, Gauguin himself forms the area of dark interiority. 'The face of a bandit, coloured with the reds, the violets scored with gleams of fire like the glow of a furnace in the eyes, which are the seat of the painter's struggling thoughts . . . the hot sexual blood floods the face while the furnace-like colours enveloping the eyes suggesting the fire that burns molten in the souls of painters

WILD THING

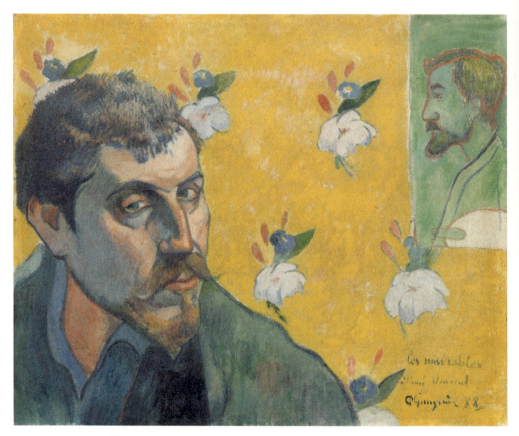

Gauguin, *Self-Portrait Dedicated to Van Gogh, Les Misérables*, 1888

like ourselves,'[5] read his covering note to Vincent. In the right-hand area, yellow wallpaper scattered with bouquets of flowers 'reminiscent of a young girl's bedroom' symbolised 'our artistic virginity' and the general principle of artistic blossoming. On this virginal wallpaper, as if thumbtacked on, was a portrait of Émile Bernard, a twenty-year-old painter whom Vincent hoped would join them in Arles to become one of the twelve disciples. Émile's sister, seventeen-year-old Madeleine Bernard, had met Gauguin in Pont-Aven, and worshipped him. She wrote to him that she was going to shout at the top of her voice that he was the greatest painter in the world. It would have been the easiest thing to seduce her, but Gauguin was forty years old and married. He kept the whole thing platonic, addressing her as 'sister' and advising her on life and on painting, for she too was an artist. The symbolism of portraying

124

VINCENT. 'MY GOD, WHAT A DAY!!'

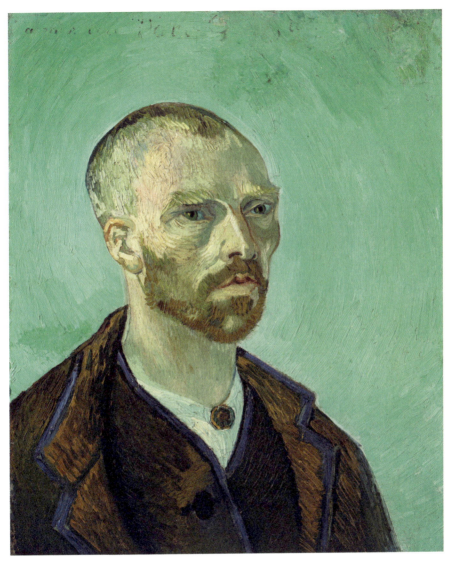

Van Gogh, *Self-Portrait Dedicated to Paul Gauguin*, 1888

himself with a seducer's sidelong glance and a sexual flush flooding his face in a virgin's bedroom, with her brother's portrait gazing sternly down at him from the wall, is complicated. Jacob wrestled with the angel. Was Gauguin showing himself wrestling sexual temptation?

Vincent, a man not given to restraint, was tremendously moved by the portrait. He saw a man crushed from within by the prodigious pyramid of

125

civilisation, a man led by affliction after affliction to believe that life is a war. Vincent was fighting the same war on many fronts, but he was having a great deal more sex than Gauguin. For all Vincent's fervent piety, he was committing the sin of fornication fortnightly on excursions to the brothels of Arles, paying two or three francs a time.

In exchange for Gauguin's self-portrait, Vincent sent *Self-Portrait Dedicated to Paul Gauguin* (October 1888), an image so ascetic as to verge on a death mask. Even the self-portrait after he had cut off his ear expresses more life, colour and vitality. He explained to Gauguin that it was a portrait of himself as a bonze, a Japanese monk, a simple worshipper of the eternal Buddha. Without wasting further words on symbolic meaning, Vincent charges straight into describing how he achieved the colour effect. 'All ash-coloured. The ashy colour that comes from mixing Veronese with orange lead, on a background of uniform Veronese, with a red-brown garment.'[6]

When Gauguin had the means, he was particular about paying off his debts. Theo sold one of his paintings for 300 francs. Gauguin paid what he owed in Pont-Aven and took the two-day train journey from France's Atlantic north to its extreme Mediterranean south. Arriving in Arles in the middle of the night of 23 October, he waited for dawn in a little all-night café run by Vincent's friends and often artistic models, Monsieur and Madame Ginoux. Their café was not a full-blown brothel, but it did rent rooms by the hour.

'The proprietor looked at me and exclaimed, "You are the pal, I recognise you!" A portrait of myself which I had sent to Vincent explains the proprietor's exclamation . . . Neither too early nor too late, I went to rouse Vincent out.'[7]

Vincent lived in half a tiny house on the Place Lamartine, a seedy part of town housing the brothels, the railway station, the police station, and the Roman amphitheatre where Sunday bullfights filled the air with bloodlust, sex-lust, sweat and wine. The Place Lamartine, now a car park, was then a park which, like Pont-Aven's Bois d'Amour, saw a certain amount of action. Vincent had painted his half of the house's exterior bright butter yellow, with shutters and door of vivid emerald green. The sun had not yet risen when Gauguin presented himself at the green door. His fencing foils and mask had not fitted into his suitcase, so he was carrying them under his arm. Silhouetted in the doorway, he presented a terrifying shape to Vincent, who had a horror of weapons.

Only after they had hastily been scrambled into a cupboard could he turn from frozen fear to boiling exuberance. Gauguin the longed-for had arrived! So much rode on this: the whole idea of the Studio of the South, the whole future direction of painting. He was wildly excited. He had confided to Theo that he was apprehensive in case the experience of painting with Gauguin would be more than his nerves could bear. Vincent was aware of his nervous crises. He described his violent fits as 'attacks of electricity' when he was overcome with anguish and terror and lost cognisance of what he was doing.

The street door led straight into Vincent's studio. Gauguin thought it looked as if a volcano had erupted, spouting pictures and paint tubes all over the place. Pictures stacked, rolled, pinned up, poked into corners had left coloured smudges on the walls from their careless passing while their paint was still wet. To his horror, the silvery paint tubes scattered about all over the place were uncapped, the colours drying out in their tubes. Paints were expensive and Gauguin screwed the tops carefully back onto his own. The total effect was chaotic, blindingly colourful and difficult to take in. Since arriving in the light of the south, so strong that every colour gives you back a vivid after-image, Vincent had become fascinated by the optical effect that complementary colours had on each other: orange and blue, red and green, yellow and violet. He called this behaviour 'colour gymnastics', and he ascribed sublime spiritual power to complementaries, believing that they corresponded to the highest ideal form of earthly love: each fulfilling its potential through action with its opposite.

When, in July, Gauguin had written a letter encouraging Vincent to expect him, Vincent had spent one frenzied week in August painting the Sunflowers series for which he is so famous. *Six Sunflowers, Fourteen Sunflowers, Fifteen Sunflowers*.[8] All achieved between 21 and 26 August.[9] All for Gauguin. All composed of complementary colours. To hang in Gauguin's room like a huge welcoming bouquet, as he wrote to Theo.

On one level, the Sunflowers are composite portraits of both men. They stand for Gauguin because they were the symbol of the Inca sun god of Peru and, following the return of the Spanish conquistadores in 1532, they had become the symbol of Peru in European iconography. But they were also a metaphorical self-portrait of Vincent himself. In Christian iconography, they

hold a double significance, standing both for Christ as the light of the world, and for the questing soul that turns to the light to seek out the divine, just as the sunflower turns its head throughout the day to follow the sun on its journey through the heavens. This fused the meaning of sunflowers into a unified soul-portrait of both men.

To reach Gauguin's bedroom, they had first to go through Vincent's. Their two tiny bedrooms occupied the entire upper floor. No bathroom, no running water. Washing facilities were available in the bathhouses close to them which were also used by the inhabitants of the nearby brothels. What with the smell of irregularly emptied chamber pots, and Vincent's total indifference to the need to wash, to clear up tobacco ash or to cap his paints, the Yellow House stank. Gauguin insisted they spend money on a cleaner.

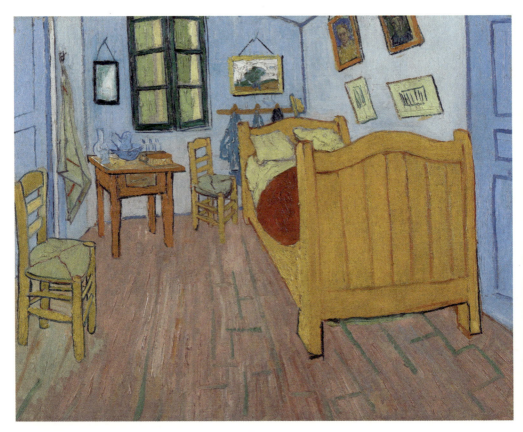

Van Gogh, *The Bedroom*, 1888

VINCENT. 'MY GOD, WHAT A DAY!!'

We can see exactly what Gauguin saw as he passed through Vincent's bedroom on the way to his own in *The Bedroom* (1888), painted a few days before Gauguin's arrival. Vincent described it to Theo. 'The walls are of a pale violet. The floor – is of red tiles. The bedstead and the chairs are of fresh butter yellow. The sheets and the pillows are of very bright lemon green. The blanket scarlet red. The windows green. The dressing table orange, the basin blue, the doors lilac . . . [all] coloured in flat plain tints.'[10] We must remember that, as in all the Arles paintings, *Sunflowers* included, Vincent was using paints whose colours have faded and deteriorated badly. Everything was much brighter than we see it today.

They passed on to Gauguin's own small bedroom, 2.25 metres by 3.4 metres. You had to squeeze round the grand and expensive bed of walnut wood Vincent had bought for him to sleep on. Vincent's own bedstead was cheap and basic, made of plain yellow deal. He had plans to paint it with a naked woman and maybe a child in a cradle; he longed for both. He had no such plans for Gauguin's: you didn't spoil expensive walnut wood by painting it. He had badly misjudged Gauguin if he thought he would care for an oversized, highly polished status symbol to sleep on.

The walls were newly whitewashed and crammed with pictures. Unfortunately, we have neither a painting nor an inventoried description of Gauguin's bedroom, but we do know that Vincent had arranged six very large canvases in the small space, 'the way the Japanese do', and that the pictures included *Fourteen Sunflowers*, *Fifteen Sunflowers* and a version of the *Sower*.

Having hung his masterpieces on Gauguin's bedroom walls, Vincent was in a state of desperate anxiety for his guest's opinion. Any response was going to be inadequate. Tired from the train ride, punch-drunk from the colour overload, eyes vibrating with after-images, Gauguin coped badly. When agitated, Vincent 'had an extraordinary way of pouring out sentences, if he got started, in Dutch, English and French, then glancing back at you over his shoulder, and hissing through his teeth. In fact, when thus excited, he looked more than a little mad; at other times he was apt to be morose, as if suspicious.'[11]

Gauguin only managed to produce the remark that Vincent's sunflowers were better than Monet's. Vincent purported to be delighted by this true, but hardly ecstatic, observation. Modestly he bridled that he was not worthy of

such high praise but later he wrote miserably to Theo that Gauguin had given him no clue as to what he really thought.

The first day was devoted to getting settled, to a great deal of talking and walking about so Gauguin might admire the beauties of Arles, including Vincent's favourite brothel and the Arlesian women, about whom Gauguin could not get up much enthusiasm.

The following day they went out painting in the countryside. Normally, this was the cue for the local boys to shout and throw cabbage stalks at Vincent, who frightened them. One thirteen-year-old described him as very ugly, ungracious, impolite, crazy and bad-smelling.[12] Gauguin's burly figure by his side discouraged the boys from hurling missiles.

The two artists went to work, Vincent 'continuing what he had begun and I starting something new. I must tell you that I have never had the mental faculty that others find, without any trouble, at the tips of their brushes. These fellows get off the train, pick up their palette and turn you off a sunlight effect at once . . . They so confident, so calm. I so uncertain, so uneasy. Wherever I go I need a period of incubation, so that I may learn every time the essence of the plants and trees, of all nature, in short, which never wishes to be understood or yield itself up easily to me.'[13]

Vincent was a devotee of painting *en plein air*. The weather was good. The first subject they tackled was the Alyscamps.

Arles is full of Roman remains. Alyscamps is the local word for the Latin *Elysii campii*, the Elysian Fields, in this case referring to the Roman necropolis a short walk from the Yellow House, where the carved columbaria, mausolea and sarcophagi are sinking slowly and picturesquely into the earth between the roots of overhanging trees. Vincent's picture, *Falling Leaves* (*Les Alyscamps*) simplifies the Alyscamps into the scene of a horror story. A man with unmistakeable threatening intention advances on a female between the line of tombs.

Gauguin was inspired to a different interpretation: he builds up an impossible space of *cloisonné* areas of colour realised in vertical and diagonal strokes. The ruined Roman temple that in reality stands sad, sunken and derelict in front of the railway line is moved to a hilltop where it looks like a space rocket about to take off – and who are the three uniformed men? Vincent waxed lyrical over Gauguin's 'Japanese' interpretation. He was reading *Madame*

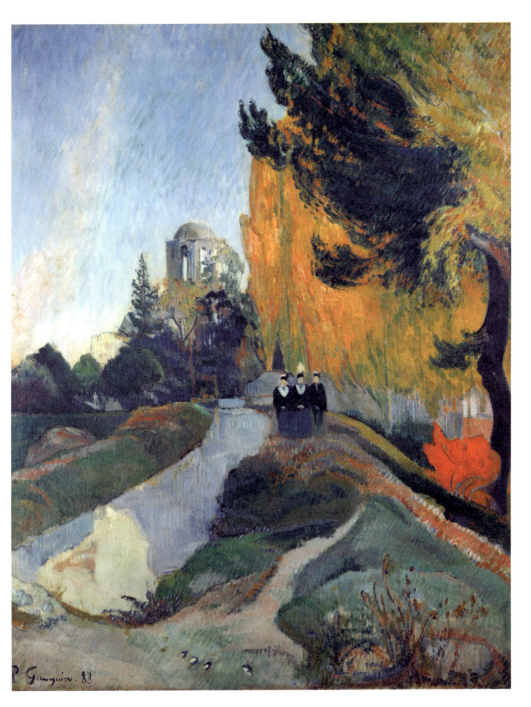

Gauguin, *Les Alyscamps*, 1888

WILD THING

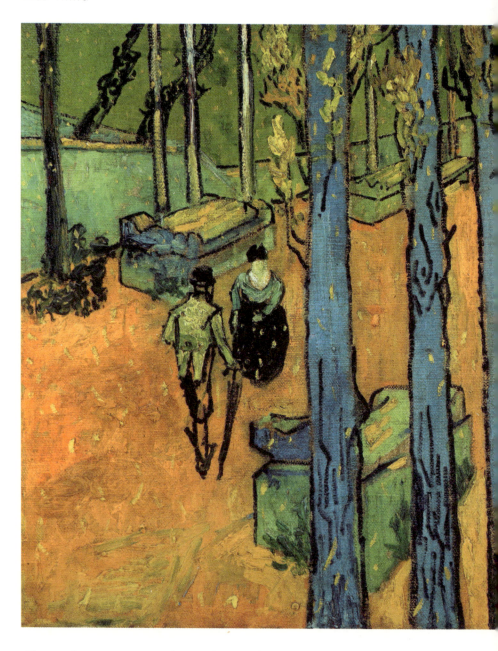

Chrysanthème, Pierre Loti's popular novel set in Japan that was heavily influencing European perception of the place. Vincent was as obsessed with Japan as Gauguin was with Peru. In Vincent's mind, the Studio of the South in Arles was merely a rehearsal, a preliminary, for Japan. When a sufficient

VINCENT. 'MY GOD, WHAT A DAY!!'

Van Gogh, *Falling Leaves* (*Les Alyscamps*), 1888

number of artists had been attracted to fill all the chairs he had bought, they would travel there together as a group, to practise art. Gauguin, who had visited Japan as a sailor, found both Loti's book and Vincent's vision of Japan wholly unrealistic, but what was the point of removing the scales from his friend's eyes? Vincent was not amenable to reason. Even mild criticism provoked a storm. Meanwhile, Gauguin gained both pleasure and technical insights from studying Vincent's large collection of Japanese prints. Gauguin seems not to have stopped to think how closely his own Peru-of-the-mind, so necessary to his self-mythology, rhymed with Vincent's wholly impossible notion of Japan.

In the Yellow House, Gauguin was finding 'a disorder that shocked me. His colour box could hardly contain all those squeezed tubes, which were never closed . . . In spite of all my efforts to disentangle from this disordered brain a reasoned logic I could not explain to myself the utter contradiction between his paintings and his opinions.'[14]

Seeing their finances taking on the same chaos as his friend's colour box, Gauguin proceeded cautiously. He knew the situation was delicate, 'at the risk of wounding that very great sensitivity. It was thus with many precautions and much gentle coaxing, of a sort very foreign to my nature, that I approached the subject. I must confess that I succeeded far more easily than I should

133

have supposed.'[15] He installed a cash box. On top of it lay a scrap of paper and a pencil for them to write down what they took from it. They economised on eating out. Gauguin took on the cooking.

'Gauguin knows how to cook *perfectly*,' Vincent wrote to Theo, awestruck.[16]

One day Vincent volunteered to make the soup. 'I do not know how he mixed up things – surely as he mixed his colours in his pictures – at any rate, we couldn't eat it. And my Vincent burst out laughing.'[17]

'I didn't know that Gauguin had been a real topman on the topmast, a real sailor. That gives me a tremendous respect for him and an even more absolute confidence.'[18]

'Gauguin gives me courage to imagine, and the things of the imagination do indeed take on a more mysterious character.'[19]

From Vincent's letters to Theo, we can see that he genuinely thought he was acting as a bonze, a humble monk submitting to Gauguin's abbot, but Vincent had never had the slightest idea of what submission meant, and this was one of the reasons Theo had been so pleased to export him from his Paris flat to Arles. If Vincent was in an exalted mood, he would not stop talking, day or night. He would follow Theo into his bedroom talking at him all the time while he undressed, went to bed, and blew out the candle, whereupon Vincent would draw up a chair close to Theo's pillow and keep talking while Theo first pretended to go to sleep, then, with luck, actually did manage to drop off. But even then, Vincent was not above shaking the poor man awake to drive home the argument. Presumably he behaved the same way in Arles. Dialogue was unknown to Vincent. His convictions were so firm that he could only proselytise.

In the summer leading up to Gauguin's visit, Madeleine's brother Émile Bernard had been sending Vincent sketches of brothels and prostitutes. A couple of weeks before Gauguin arrived, Bernard sent 'Au Bordel', a whole portfolio that increased Vincent's long-standing eagerness to tackle the subject. Unlike for Gauguin, brothels had long been part of the fabric of Vincent's life. This was complicated by his religious feelings. In response to Bernard's pictures, Vincent wrote him long letters opening his heart on the nature of God in relation to brothel-visiting and prostitutes. Sex outside marriage is a

Christian sin. However, Vincent's characteristically illogical sense of moral clarity reconciled his 'sin' by seeing it as the cause and reason for deep submission to God's forgiveness, leading to his own redemption. He was, in effect, doing God a favour by giving Him a sin to forgive. Further, he was doing the 'fallen woman' he sinned with a favour by giving her the opportunity to bring about her redemption through the cycle of sin and forgiveness. He set out his tortured logic as clearly as he ever managed to do in a letter to Émile Bernard concerning the transfiguration of the sinner. 'See that meat from the market, notice how all the same, despite everything, it can still be electrified for a moment by the stimulus of a refined and unexpected love. Like the sated caterpillar that no longer eats, that crawls on a wall instead of crawling on a cabbage leaf, this sated female can no longer love either, even though she goes about it – she seeks, seeks, seeks, does she herself know what for? . . . The butterfly, where does the butterfly emerge from that sated caterpillar – the cockchafer from that white grub?' The letter ends in an odd aside on his mother, a super-respectable clergyman's wife; 'I'd very much like to know a little bit about the thing I am myself perhaps the larva of.'[20]

There were six brothels in Arles. Vincent frequented the cheapest. While he had no problem going there for the regular fortnightly transaction, he was too timid to enter alone to make pictures. What if they threw him out? He would wait till Gauguin had arrived. Then they would go together. Gauguin would be his protector and bodyguard.

Gauguin had always disliked the whole idea of brothels. We remember his stockbroker days when he rejoiced in going contentedly home to Mette while the other artists went brothel-crawling. Gauguin and Vincent had already painted the Alyscamps together. Now they tackled the subject of the brothel together. 'I've done a café too but which Vincent really likes and I like less . . . Basically it's not my cup of tea and the low-life local colour doesn't suit me. I like it in other people but I'm always apprehensive. It's how I was brought up and you can't change that . . . Oh well.'[21]

Gauguin centred his picture on a portrait of Madame Ginoux fronting the night café looking mellow and a little squiffy, probably because she's been at the absinthe whose paraphernalia sits on the table in front of her: bottle, glass, sugar cubes, soda water, spoon. Behind her, we recognise Vincent's great friend,

Gauguin, *Night Café, Arles*, 1888

the postman Monsieur Roulin, sitting among the women. Drifts of smoke curl lightly across the canvas, a Japanese device that turns the scene into a dreamy abstraction. Might everything be happening in Madame Ginoux's head?

Vincent's *The Night Café* is visceral. The same room is seen in exaggerated perspective. There is nowhere for the eye to rest; a war is going on between green and red. Three lamps hanging from the ceiling are like three eyes interrogating you as you enter the transgressive space. 'Everywhere it's a battle and an antithesis. I've tried to express the idea that the café is a place where you can ruin yourself, go mad, commit crimes.'[22]

Vincent's work was getting more vivid, more hectic, more agitated with the passing weeks. 'He was furiously mad. I had to suffer for a month all the fears of a mortal tragic incident.'[23] Gauguin was drinking with his usual degree of

VINCENT. 'MY GOD, WHAT A DAY!!'

control, but Vincent was drinking enormously. To stupefy himself, he said, in the furnace of creation. He was aware that 'the electricity' in his brain was building towards crisis.

November brought rain. Continuously for twenty days. No more painting *en plein air*. Imprisoned in the tiny Yellow House, Vincent was becoming increasingly agitated, but Gauguin did not want to alarm Theo so he wrote gently, 'Your brother is in effect a little agitated and I hope to calm him down bit by bit . . . This blessed rain is a terrible nuisance for outdoors and we're doing paintings *de chic*' (painting from the imagination, also called *à la tête*).[24]

Gauguin had enjoyed painting chairs during his Impressionist days in Paris and in Rouen, when he had made chairs the subject of still lifes. It was a witty way of telling a story, rousing curiosity through objects placed

Van Gogh, *The Night Café*, 1888

on their seats: a bouquet of flowers or his mysteriously stringless mandolin. The Yellow House suffered from no lack of chairs. Might this make a good indoor subject for the agitated Vincent? The results were two of Van Gogh's most famous paintings, *Van Gogh's Chair* and *Gauguin's Chair*. Van Gogh's is straw-bottomed, uncomfortably upright, with a pipe and a screw of tobacco on the seat. Gauguin's is a much grander affair, of walnut wood like his bed, with curved arms and a broad seat, a chair for lounging. On the seat are two modern novels and a candlestick to read them by.

What appallingly claustrophobic evenings those two chairs conjure. Vincent poker-backed on his mortificatory chair, stupefied with drink, puffing on his smelly pipe, not reading, eyes boring intensely into Gauguin who pretends to read his book, hoping to avoid a tirade. The rain continues for hours.

'In the latter part of my stay, Vincent became excessively hasty and noisy, and then silent. Some nights I caught him standing up and coming over to my bed.' An unnerving experience conjuring the childhood memory of Peru when the madman chained on the roof broke free and stole down the staircase to stand gazing at Gauguin and his sister Marie in their beds while they, terrified, pretended to be asleep.

'To what can I attribute waking up just at that moment? At all events, it was enough to tell him quite sternly: "What's the matter with you, Vincent?" for him to go back to bed without a word and fall into a heavy sleep.' The idea occurred to Gauguin to paint Vincent's portrait in his state of mental disequilibrium, to catch the net of insanity closing in on his friend. He painted *The Painter of Sunflowers* (1888), a portrait in which Vincent's face is deconstructed, as blurred as his mind. At first Vincent could not see the likeness but later, when his mental crisis had peaked and he was confined to the madhouse, he recognised it as an accurate portrait: 'It was indeed me, extremely tired and charged with electricity as I was then.'[25]

On 22 December, they went to the café, where Vincent ordered an absinthe. Suddenly he threw the glass and its contents at Gauguin who ducked the missile, took him firmly by the arm and conducted him home. Vincent was soon in bed. In a few seconds, he was asleep. 'When he awoke, he said to me very calmly, "My dear Gauguin, I have a vague memory that I offended you last night."

VINCENT. 'MY GOD, WHAT A DAY!!'

'I forgive you gladly and with all my heart, but yesterday's scene might occur again and if I were struck I might lose control of myself and strangle you. So allow me to write to your brother and tell him that I am going back.'[26]

The following evening, Gauguin felt the need to go for a walk to escape the claustrophobic atmosphere of the tiny house. Outside, he delighted in the deliciously fresh air. As he ambled across the square, he heard quick, irregular footsteps behind him. Turning, he saw Vincent rushing towards him with an open razor in his hand. 'My gaze at that moment must have been quite powerful, for he stopped and, lowering his head, set off running towards home.' For years later, Gauguin would continue to question himself; might the outcome have been different if he had disarmed Vincent and tried to calm him down? 'I have often examined my conscience about this.' But he was frightened. He didn't dare go back to the Yellow House. Instead, he went to a hotel where he didn't manage to get to sleep until three in the morning. He woke at half past seven. Going straight to the square, he saw a great crowd gathered round the Yellow House, and gendarmes trying to keep order. Elbowing his way through, he learned that Vincent had gone back to the house and cut off his ear close to the head. When he had staunched the flow of blood he pulled on a Basque beret and went to the brothel, where he gave the person on duty his ear in an envelope, saying, 'Here is a souvenir of me.' Then he ran home and up the stairs to his bedroom where he shut the shutters, lit an oil lamp, placed it on the table, and went to sleep.

At the door of the Yellow House, a small man in a bowler hat grasped Gauguin's arm. He was the chief of police. He asked Gauguin, 'What have you done to your friend?'

'I don't know.'

'Oh yes . . . you know very well . . . he is dead.'

Gauguin insisted on seeing. Entering the house, the little downstairs room was strewn with wet towels stained red. The floor tiles and the walls were splashed with blood. They ascended the bloody stairs. Vincent lay on his bed, 'humped up like a gun dog'. Gently, very gently, Gauguin touched the body, whose heat announced he was very much alive. Gauguin asked the chief of police to wake Vincent gently, and if he asked for Gauguin, to say that he had

left for Paris. 'I must admit that from this moment the police chief was as reasonable as possible.'

Gauguin did not in fact leave for Paris straightaway. He telegraphed Theo, who arrived by train the next morning. It was Christmas Day. Gauguin was waiting for Theo at the hospital. Nobody was certain if Vincent would live or die. Gauguin now revealed to Theo what he had been concealing in his letters, that Vincent had been showing signs of madness for some time leading up to the self-mutilation.

The first things Vincent asked for, when he regained the power of speech, were his pipe and his friend Gauguin. Gauguin excused himself: 'Tell him I'm in Paris.' Gauguin explained in his memoir that he said this because he did not want to agitate Vincent further, and also because he did not know whether he could maintain his self-control in Vincent's presence. He could not trust himself completely because he did not lightly or immediately get over being arrested, however briefly, for murder.

Vincent was hovering between life and death, but Theo only stayed a few hours by his bedside, returning to Paris that evening, on the same train as Gauguin. This was the first and only time that Theo had visited his brother in Arles. It would be understandable for Theo to hasten back to Paris as a newly engaged man eager to spend Christmas with his fiancée, but his fiancée was not in Paris; she had returned to her family in Holland.

What had given rise to Vincent cutting off his ear? The blame is most often attributed to Gauguin, in a vague, non-specific way. Neither Vincent nor Theo ever wrote a line to support this, but there are two ways in which Gauguin might be accountable.

First, Gauguin's affirmative answer when Vincent asked him outright if he was going back to Paris. Gauguin answered, 'Yes.' His answer meant the ruin of hope, the end of Vincent's dream of the Studio of the South. Second, Vincent's miserable feelings of commercial failure and inferiority set against Gauguin's comparative artistic success. On the day that Gauguin had arrived in Arles, Theo had sent Gauguin 500 francs from the sale of a single picture. During their subsequent weeks together, more had been sold, including one to Degas, who then had engineered an invitation to exhibit with Les Vingts. Vincent had never received an invitation to exhibit with anyone. It is possible

that Vincent sold only one canvas in his lifetime; in any event his sales were meagre indeed, and his miserable feelings of inferiority in comparison to Gauguin are completely understandable.

Why that specific day? Why 23 December?

It was raining. That was nothing special. They had spent the day together painting as usual. Gauguin notes that they had quarrelled about art and their favourite artists but that too was usual, and Gauguin probably calmed his friend down with the formula he fell back on in such moments: 'Corporal, you're right.' The immediate cause that presents itself is the letter Vincent received in the post that day from Theo, with the news that he had become engaged to be married. For Vincent, this came like a sentence of execution. What would become of him when Theo had a wife and maybe even children to love and support? Who would love him? What would put bread in his mouth?

Why the ear? Theories proliferate.

Vincent tells us that the attacks were accompanied by voices in his head. Maybe he wanted to cut off the voices? In Orthodox religious iconography, the ear is a sacred organ. In icons it must never be covered because the ear is the channel through which the voice of God is heard. Maybe Vincent wished to shut off the voice of God? Maybe it related to the last week of Jesus Christ's life, when one of the twelve disciples, defending Christ, cut off the ear of one of His attackers in the Garden of Gethsemane.

Or maybe, closer to home, it had to do with the bullfight.

The Yellow House was only a few steps away from Arles's Roman amphitheatre, where bullfights were held. At the end of the bullfight, when the bull is dead, if the matador is deemed to have done a good job, an ear may be severed and awarded to him as a prize. The cocky matador might then toss the bloody ear to a pretty girl in the crowd as an unmistakeable gesture of intent.

Gauguin's account has Vincent giving the ear to the concierge in the brothel, but Gauguin was not actually there to witness it. A long-standing version of the story has Vincent wrapping the ear, or maybe putting it in an envelope, and delivering it direct to his favourite prostitute Rachel, with the words, 'You might find this useful', upon which she fainted dead away, leading Vincent to flee as chaos broke out in the brothel. Later research has revealed the recipient to

be not Rachel but Gabrielle Berlatier, who was too young to be registered as a prostitute and was nominally working as a maid in the brothel.[27]

Further theories of causation run with castration displacement and even with Vincent taking his reverence for Japan rather far by mutilating himself in imitation of the behaviour of geishas in Japanese brothels. Some theories seem more credible than others but taken within the context, any or all might have a bearing. Vincent himself never gave a reason. 'In my mental or nervous fever or madness, I don't quite know what to say or how to name it, my thoughts sailed over many seas.'[28]

Right up to Vincent's death, his relationship with Gauguin would continue. It was enormously important to him. In all the many letters he wrote, there is never the smallest hint of blame or implication that Gauguin was in any way responsible. The first letter was written from the asylum, twelve days after the ear-cutting:

> My dear friend Gauguin,
> I'm taking advantage of my first trip out of hospital to write you a few most sincere and profound words of friendship. I have thought of you a great deal in the hospital, even in the midst of fever and relative weakness. Tell me. Was my brother Theo's journey really necessary – my friend? Now at least reassure him completely . . . I wish you prosperity in Paris.[29]

As he gets stronger, his letters go on to resume discussion on colours as if their ongoing conversation had never been interrupted. He apologises that Gauguin's things have not yet been sent back from the Yellow House, including his fencing masks and gloves, 'childish engines of war of which I wish you would make the least possible use'.[30] He writes intimately and affectionately; no hint of blame, accusation or reproach. He names no cause but his own wandering mind. He ends, 'It would please me greatly if you would write to me again.'

A prompt response would reassure his friend, and Gauguin found a way to reply within two weeks without referring to anything that might be upsetting.

Gauguin, *Sunflowers on a Chair*, 1901

Instead, his letter focused on the urgent issue of the white paint they had been using in Arles. It was of poor quality and already flaking badly. *The Grape Harvests* was totally covered in dandruffy scales. If Vincent had similar canvases the thing to do was to stick the back down using a process shown to Gauguin by a re-liner. 'If I tell you about it, it's because the thing is easy to do.' Vincent must stick newspaper on to the canvas with flour paste. When the paste was dry he must put it on a smooth board and press down hard on it with a very hot iron. Then he must soak the newspaper well and peel it off. The scales would be stuck back down; the result would be 'perfect'. One shudders. The letter ends breezily, 'Thank Roulin for thinking of me. Friendly wishes from me to everyone.'[31]

The letters never dip below the surface. So far as he referred to the episode at all, Vincent named it 'an everyday artistic aberration', though his first letter

to Theo dictated from the clinic on 2 January admits that he knew it was something rather more. 'Let's talk about our friend Gauguin. Did I terrify him?'

Gauguin would never contradict Vincent's mild description of the episode as an aberration, though he saw it as a great deal more than that: a crisis in the cycle of sin, guilt and repentance that he had witnessed during their time of living together, the most extreme instance of Vincent's deep, masochistic religious guilt resulting in biblical mortifications.

Living at such close quarters had been useful to Gauguin in one profound respect: there was no chance of him falling for the contemporarily fashionable notion of the emancipatory nature of insanity.

Gauguin continued to love and respect Vincent, to write to him and about him with deep affection, even writing one of his rare short stories about him, called 'The Pink Shrimps', in which he praises Vincent's unworldly goodness. But he could not bear to see him ever again. Gauguin repulsed all Vincent's eager suggestions that they resume the artistic struggle together painting side by side but in his refusals Gauguin was consistently careful in fending him off considerately to preserve his fragile feelings and self-respect.

Gauguin saw through the smell and the mess and the impractical fanaticism to a luminous spirit whose ecstasies were Vincent's way – not Gauguin's way – but, for Vincent, the only sure road to comprehension. Many years later, when Vincent was long dead and Gauguin was living in Polynesia, he sent to France for sunflower seeds. He planted them in his garden, tended them carefully and brought them to flower. Then he painted them stuffed into a vase and sitting on a chair, in memory of his gentle friend.

10

THE MARCH OF SCIENCE

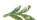

If Vincent had bled to death, there would have been no witness for Gauguin's defence. He had been arrested. He would have faced a trial for murder, followed by the guillotine if found guilty.

Arriving in Paris two days later, he found the city convulsed in guillotine frenzy, looking forward to the bloody spectacle of the public execution of a notorious murderer whose horrible misdemeanours had the newspaper-reading public around the world aboil with prurient interest. In Arles, Gauguin and Van Gogh had followed the case closely. The criminal persisted in protesting his innocence. Debate ran high on whether he was rightly or wrongly accused. Gauguin and Van Gogh believed him innocent. Arriving back in Paris, Gauguin resolved to attend the execution. Not, he wrote, in a spirit of bloodlust but to bear witness to a martyrdom.

The murderer said his name was Prado. A man of mystery, he refused to give his real name or origin, but the newspapers gave out that he was a Spanish nobleman called Count Linska de Castillon, and that he had lived in Peru – making him especially interesting to Gauguin. Wherever he had really come from, he left a trail of besotted women in his wake, robbed of their money, their jewels and their illusions. But his successful international career as a conman and jewel thief took a more serious turn when he murdered a prostitute.

Newspapers all over the world ran the sensational story like one of Poe's tales of mystery and imagination so popular at the time. Prado was a 'Son of Satan', a 'serial Don Juan'. An ex-mistress asked to identify him 'shuddered with terror' and 'until the moment of her death she had 'feverish fits, paroxysms and nightmares, during which she frequently pronounced the name of the alleged murderer . . . sometimes starting up from her bed, her eyes gleaming with terror and fixed on some phantom before her'.[1] The detective in charge of the case demonstrated all the ingenuity of Poe's detective Dupin,

the very first in the long line of literary sleuths (Conan Doyle acknowledged Dupin as the predecessor of Sherlock Holmes), who resolved labyrinthine mysteries by means of his ice-cold powers of deduction. Prado was reported to be 'very cool and cynical' in prison, spending his time composing verse in French and Spanish. He was also replying to a great number of fan letters.

His court appearances were celebrity occasions. Society women, dressed to the nines, passed him love-notes. Prado was elegant, silver-tongued, charismatic. He let it be known that he was spending his time reading Victor Hugo, now dead three years and soaring in iconic status. Hugo had championed the abolition of the death penalty when he created the ultimate falsely accused outsider in the character of Jean Valjean in *Les Misérables*, given life imprisonment for stealing a loaf of bread. Prado threw himself wholeheartedly into encouraging his audience to identify him with the martyr-hero.

At half past two in the morning of 28 December, five days after the Van Gogh horror, Gauguin joined the large crowd on the Place de la Roquette. The December night was cold. He stamped his feet for warmth. He had brought his sketchbook to record what he saw. A faint gleam announcing sunrise, allowed him to catch a glimpse of the square. He saw a great semi-circle round the guillotine, formed of soldiers, the police, the wagon and the hearse.

The prison gates opened. Silence fell. The men in the crowd removed their hats. Gauguin caught a glimpse of a small but sturdy man, with a handsome, proud head. He was too far back in the press of the crowd to see the execution itself, but he could see the top of the guillotine. The blade fell twice. The first time, instead of severing Prado's neck, it took off part of the front of his face. The second time, the head was severed. Gauguin saw the bloody head lifted up. It disappeared to be taken to a place to have water poured over it. Lifted up again, the blood ran down the head in watery streams. He wondered why the blade had fallen twice. Also, why did they not have a tap under the box to wash the head? Word reached him through the crowd explaining the appalling reason for the two falls of the blade. He was revolted. The State could not be bothered to measure the prisoner so he might be placed in the proper position for the first blow. He was disgusted, too, by the State's encouragement of human degradation in pandering to the crowd's bloodlust by making a public spectacle in the name of justice. 'I have

now described the famous spectacle that gives such satisfaction to society,'[2] his account ends.

Nocturnal creatures spring from the sleeping brain: a few weeks later Gauguin made a ceramic jug in the form of a self-portrait. It is almost life-size. The head is cut off at the neck. The ears have been severed and the hair arranged over them as Vincent's bandages were arranged. Blood-coloured glaze flows from the crown of the head, running down the cheeks and neck, pooling red at the base. The eyes are closed as in death and his features wear an air of ineffable sadness, as if he is carrying the collective martyrdom of the tragedies he has witnessed.

Gauguin suffered long from the emotional after-effects of his time in Arles but, however heavy the burden, it did not include the burden of guilt.

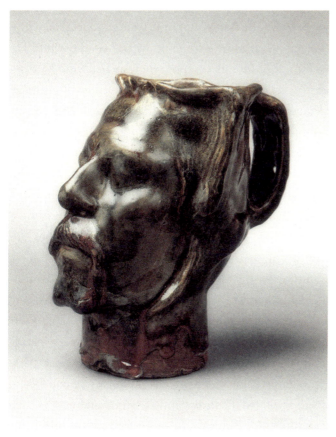

Gauguin, *Self-Portrait in the Form of a Jug*, 1889

Throughout the remainder of the Van Gogh brothers' short lifespans letters flew between them and these, together with the letters they wrote to Gauguin, never blamed him. It must have been a consolation to Gauguin that Vincent, whom he knew to be incapable of pretence, continued to write regularly and fondly to him right up to his death.

And Theo kept up his payment of Gauguin's allowance. The money enabled him to rent a studio on Rue du Saint-Gotthard. Prints were becoming very popular with collectors, and Theo suggested he try printmaking. Gauguin was always happy to find new things to make with his hands, new ways of making art. Typically, when it came to printmaking, he thought it out from base principles. Rather than starting by drawing the image on wood, or stone, or copperplate, he drew on zinc, the dirt-cheap, slightly brittle, soft silvery metal widely used on the counters of bars and the tops of café tables. Printing with experimental mixes of oil, water and crayon produced an unusually rich range of tones. By tradition, prints were produced on white or cream paper, but Gauguin was always troubled by the colour white. He could only bring himself to print his zincographs when he had found a store of bright yellow paper: the yellow of advertisements, the yellow of cigarette papers, the yellow of Vincent's sunflowers. He made ten zincographs revisiting favourite themes, simplifying them for the small format: Breton women, Martinique *porteuses*, seascapes and landscapes. The black lines leap out from the bright yellow. His close study of Vincent's large collection of Japanese prints comes through in the theatrical use of silhouetted figures and the fantastically aberrant treatment of space. Fifty sets were printed, each set put into a cardboard portfolio folder, some decorated with a further zincograph of *Leda and the Swan*.

They were finished in time for the opening of the 1889 Exposition Universelle, a vast trade fair held to celebrate the centenary of the French Revolution. The Eiffel Tower, built for the celebration, famously overtook the Great Pyramid at Giza in height. Lit up by electric light, soaring heavenward like a blazing arrow, it symbolised France's industrial power to enlighten the Stygian darkness of the rest of the pre-industrial world, particularly the French colonies.

Since Napoleon III had ascended the throne in 1852, the number of French overseas territories had tripled. An impressive proportion of the expo was

devoted to displays from France's widespread colonies and protectorates in Asia, the Pacific, Indochina and Africa, glorifying France's *mission civilisatrice*, her 'civilising mission' to spread the French language and the Roman Catholic faith to unenlightened places – by force when necessary. 'The higher races have a duty to civilise the inferior races,' said Jules Ferry,[3] the leading proponent of colonialism whose writings, backed by the Catholic Church, gave the green light for French priests, magistrates, civil administrators and gendarmes to act with all the brutality of latter-day conquistadores. The idea of France's civilising mission originated, strangely enough, in the French Revolution, which one thinks of as overwhelmingly powered by democracy rather than by nationalism, but it was the Revolution that invented the myth of the universal nation charged with educating other peoples. Colonising on behalf of the universal values of the French Republic and the Declaration of the Rights of Man gave legitimacy to overseas expansion. The dependencies were, in French eyes, impeding the march of science, human progress and human rights, through their inherent resistance to representative democracy. Speaking at the foot of the Eiffel Tower, President Sadi Carnot opened the exhibition by proclaiming that France was 'celebrating the dawn of a great century which had opened a fresh era in the history of humanity. When given its freedom, the human spirit gathers energy and science takes wing; today, steam and electricity are transforming the world.'[4] A transformation abhorred by Gauguin.

Exhibitors came from everywhere except the European monarchies, who felt that regicide was not something to celebrate. Two miles of railway track were laid to transport the thirty-two million visitors around the site. In the Galerie des Machines, working machines played the clatter-and-clank hymn to the steam and electricity that were transforming the world, watched by a crowd who were shifted along like parts in a production line on a 'moving bridge', suspended from overhead wires. The spectacle hardened everything Gauguin had previously felt about a world that called itself civilised while privileging machines over men, logic over intuition, reason over instinct, and constraint over liberty.

To his further irritation, the expo was celebrating the forward-lookingness of everything except art. The Palais des Beaux Arts, a vaguely 'oriental' fantasia of polychrome tiles, was given over to showing a retrospective of French

art from 1789–1879. Why stop ten years ago? Gauguin wrote a furious article. He began deceptively mildly, saying how much he enjoyed seeing so many pictures by Corot, Millet, Daumier and Manet, before he leaped into an attack on the State. Here was an opportunity for thirty-two million pairs of eyes to see Impressionism and its lively offshoots; the State had ignored it. How were France's living artists to put bread in their mouths if their work could not be seen? His boiling words were published in an avant-garde magazine of short life and small readership that is mainly remembered for one of the earliest ever reviews of Van Gogh.[5]

Schuffenecker discovered a space where Gauguin and his excluded contemporaries might display their works. Good old Schuff. A certain Signor Volpini, the manager of one of the large temporary cafés that had sprung up on the expo site, had been let down by the company that was to cover his walls with mirrors. Desperate to avoid blank walls, Volpini told Schuff that he had room for a hundred pictures. Gauguin swung into action, marshalling his friends and disciples from Pont-Aven. Quickly baptising them the Groupe Impressioniste et Synthésiste, Gauguin mounted a scratch exhibition of a hundred pictures. It is quite difficult to get to the bottom of what actually hung on the walls as it was organised in a mighty rush, and Gauguin printed the exhibition posters and catalogues before anything was finalised. Van Gogh's name appears among the exhibitors along with Charles Laval, Léon Fauché, Schuffenecker, Louis Anquetin, Émile Bernard, George-Daniel de Monfreid and Louis Roy but we know that – probably for dealership reasons – Theo did not allow his brother's work to be hung, nor was he keen that Gauguin should participate in the exhibition. Ever since becoming Gauguin's agent, Theo had been carefully curating the sales of his works to suitable buyers, driving up the price as he released selected pieces on to the market. A harum-scarum show in which Gauguin exhibited with a bunch of mostly unknowns was not going to enhance the artist's reputation or the value of his pictures. Gauguin was impatient with such circumspection. He wanted his work to be seen. Disregarding Theo's advice, he went ahead and exhibited paintings from Arles and Martinique. The zincographs, too fragile to be hung on the walls, remained in their portfolios. They could be viewed on request. Quite possibly nobody knew they were there.

The café was big, busy and noisy. It enjoyed great success, largely thanks to the Russian Princess Dolgorouki, leader and conductor of an orchestra of a dozen female violinists dressed in colourful Russian folk costume as they sawed away at their instruments. The princess wielding her baton was a sight to behold. The orchestra took up quite a lot of room in the café and the pictures behind them on the walls were impossible to see. It was difficult, too, to discern the rest, what with the milling customers, tailcoated waiters skimming like swallows between closely packed tables, and the thick fog of cigar smoke. Despite being sited opposite the expo's press office, the exhibition received only one insignificant little review. Not one of the hundred works on the wall was sold. The print portfolios remained unrequested, apart from Gauguin's fellow exhibitors who admired them immensely. Gauguin ended up giving them away to his friends. Theo had been right, and Gauguin had been wrong.

One of the great hits of the expo was Buffalo Bill's Wild West show, complete with a group of Native American Sioux in feather headdresses and beaded buckskins. Ululating impressively, they re-enacted horseback skirmishes against cowboys, who were always victorious. Annie Oakley, lightly moustached, displayed her devastating skill at sharpshooting. Rumour had it she had smuggled her favourite brand of gunpowder into France in her knickers. Gauguin loved the show and went several times. (As did Edvard Munch. They never met.) Gauguin bought a revolver, a Buffalo Bill Stetson hat and yellow high-heeled cowboy boots, and practised shooting at tin cans.

But it was the colonial exhibits that made the deepest and most lasting impression upon Gauguin. Round the feet of the Eiffel Tower sprang grass huts, pagodas, stupas, temples, pyramids and whole villages shipped from all over the world along with their people and animals, brought over for authenticity. A recreated Cairo street boasted genuine Egyptian donkeys, though surely there were donkeys enough in France? In sundry bamboo huts, you could sample unfamiliar foods or buy straw hats from straw hatmakers as they demonstrated their skills. In the Afro-Caribbean village you could watch four hundred people cooking, eating, praying, practising crafts, dancing and singing. Once a week all the 'inferior races' were marshalled into a 'festive' procession, to be gawped at. Nothing demonstrated the benefits of colonialism so much as this procession of the 'backward' and 'inferior' peoples.

His mind already in thrall to Peruvian and Japanese art, Gauguin was enchanted by the treasures on display. 'The West is corrupt at the present time, and whatever is Herculean can, like Anteus, gain new strength in touching the soil of the East,'[6] he wrote after walking through the full-sized plaster-cast replica of one of the three towered stupas of the temple of Angkor Wat. Gauguin filled his sketchbook with its ornamentation, reliefs and statues of Buddhas, goddesses, spirits, demons, saints and temple dancers, their bodies frozen in hieratic poses. Coming across a small, broken-off statuette of a temple dancer, he stole it. In the Javanese pavilion next door, he watched a group of living temple dancers recreating the fluid hand and arm movements and the balanced poses of the Angkor friezes and statues. Processions of shaven- headed bonzes, chanting and banging gongs, brought Vincent to mind.

In the Egyptian pavilion, artists were recreating pharaonic temple art. He discovered to his delight that the ancient Egyptians had been as obsessed by geese as himself. He sketched their interpretation of the comical birds, as well as the Egyptian stylisation of human figures: side-posed, stiff, un-emotional and solidly rooted to the ground by their big flat feet, so different in every way to Graeco-Roman individualised fleet-footed figures. He studied the technique of the Egyptian artists brought over to recreate the wall paintings using the wet fresco technique. Later in the year, he would try it for himself. He observed and wrote at length about the making of *cloisonné* vases, describing the technique of creating the design by pasting or soldering copper or bronze wires onto a metal vessel and then placing different colours of glass paste within each wired enclosure (*cloison*). When the vessel was fired, each colour imprisoned in its metal boundary melted, forming enamel, resulting in the overall multicoloured design. This appealed both to Gauguin the potter, as a technique to be experimented with on pots, and to Gauguin the painter, who still hadn't found the answer to his discontent with the Old Masters' method of blending light and shadow, and how to handle colour transitions in a fresh and more satisfying way.

Pissarro, among others, deplored Gauguin's habit of picking up bits and pieces from here and there and incorporating them into his art. Pissarro called him a *bricoleur*, a cobbler-together of second-hand ideas. For Gauguin, this

was a deliberate strategy. Like his sketches of the *porteuses* in Martinique and the coiffed women of Brittany, the motifs he picked up at the expo became an important part of his reference book of archetypes that he would use and reuse in his compositions, as he deliberately synthesised motifs from disparate races, countries, historical periods and cultures.

The expo confirmed Gauguin's vision of world art as a unity. Just as the tides of time flowed backwards and forwards, fluid and inseparable, so the melding of Eastern and Western art presented another lovely manifestation of *Gesamtkunstwerk*. Why put art into little boxes? Why categorise into 'periods', 'schools', 'movements', 'nationalities'? That way of thinking was as artificial as the *cloisons* on Chinese vases. It served only to separate. All art belonged together, nourished by the perpetual exchange of human connection mysteriously linked through history. 'Sometimes I have gone far back, farther back than the horses of the Parthenon . . . as far back as the horsey of my childhood, the good wooden rocking horse.'[7]

Tahiti had been a French colony for less than ten years. The expo was the first time anything from there had been seen. France was afire with interest. The island had loomed large in French imagination ever since the Comte de Bougainville had landed there in 1768. So taken was he by the uninhibited welcome of its naked maidens, that he named it Nouvelle-Cythère, New Cythera, in honour of Aphrodite's birthplace. De Bougainville's legend had recently been given new oomph by the author 'Pierre Loti', the nom de plume of Julien Viaud, a French naval officer who wrote bestselling page-turners telling ostensibly true tales of his own experiences of enjoying a nubile girl in every port as he sailed around the world in the service of his country. In Arles, Gauguin and Vincent had devoured Loti's latest, *Madame Chrysanthème*, set in Japan. An earlier book, *Le Mariage de Loti*, told a Tahitian variation of Loti's standard romantic tale set in assorted exotic locations, each providing local background colour to plots running along the same simple storyline. Arriving in an unspoiled Arcadia brimming with voluptuous 'nymphs' of unbridled sexual skills and appetite, Loti would marry one of them. Somehow, he always ended up marrying a 'nymph' of thirteen or fourteen. The age of consent in France and the colonies was thirteen, so

nobody minded. The nymph would then fall desperately in love with him. Alas! his ship must sail! Loti must abandon his fragrant bride! Heartbroken, she invariably declined for love of him and died in whatever was the picturesque fashion of her nation. In *Le Mariage de Loti*, Loti sails to Tahiti, finds it awash with willing nymphs who have nothing to do but sing and dance and make love. He spends a lot of time being delightfully massaged, marries fourteen-year-old Rarahu, and the usual fate follows.

The world took Loti's autobiographical fantasies for fact. His books were widely admired, as well as hugely successful; they made him a celebrity, and very rich. He built a Japanese pagoda and a mosque in his garden and he loved to be photographed swanking about in Eastern robes or in his naval uniform topped by outrageous foreign headgear. Henry James called him a man of genius. His book *La Livre de la pitié et de la mort* (1891) is said to have influenced Proust. In 1891, he ascended to the realm of the immortals by election to the Académie Française, an honour never accorded his contemporary Zola, who described the real poverty and social injustice of the time. When Loti died, in 1923, he was honoured with a State funeral.

Like the expo itself, Loti was committed to the 'science of race', a pseudo-science invented and upheld by European writers, artists and intellectuals such as the notorious Arthur de Gobineau whose *Essai sur l'inégalité des races humaines* (*Essay on the Inequality of Human Races*) was a primer for racists that was to become important for Hitler and his Nazis. Engels implicitly supported the idea in *The Origin of the Family, Private Property and the State* Gustave Le Bon published extensively on the subject and invented the portable cephalometer, a handy device for taking the cranial measurements of the peoples you might encounter in out-of-the-way places, classifying as you went along. Cranial measurements were considered precise tools for revealing race, character, moral tendencies, mental capacity, potential criminality, 'idiocy' and 'racial unconscious', thus 'proving' scientific racism. Phrenology heads became the fashionable ornament popping up on every 'civilised' gentleman's desk or library.

The Tahitian 'village' at the expo was a modest affair. Just three traditional oval huts disappointingly short of bare-breasted maidens, or indeed inhabitants of any kind. Its principal exhibits were a collection of palm-frond hats,

and a skull improbably described as a drinking vessel. The few Polynesians who had been persuaded to come over insisted on dressing in Western-style clothes and refused to be exhibited like spectacles in a human zoo or to join the 'festive' procession on the grounds that they were French citizens. The resulting minimalism of the underpopulated huts had the accidental effect of reinforcing the Loti fantasy. Empty walls had to be filled somehow, and they were filled by photographs taken by Charles Spitz, one of the great early photographers, who lived and worked in Tahiti in the 1870s and 1880s. His gorgeously composed pictures of the palm-fringed island with its bare-breasted young women and bare-chested men strongly reinforced the Loti fantasy. The Spitz photographs were stolen in such great numbers from the Tahitian huts that they had constantly to be reprinted and were eventually displayed in securely locked glass cases. Gauguin does not seem to have stolen any, but he did browse the promotional literature, where he learned that Tahiti was short of colonial administrators, gendarmes and traders. One of the many advantages of emigrating was that you could apparently live pretty much for free. Hungry? You just had to reach a lazy arm to pick a banana off the tree. Drop a line into the water and fish practically queued to get on to your hook. This looked like a Martinique without the problems, a place to relocate the Studio of the South. However, Tahiti did not seem to provide much brain-food, and Gauguin was far more attracted to the ravishing artworks from Cambodia, north Vietnam and Java, notably Angkor Wat and the Buddhist temple of Borobudur.

The thought of exploring such artistic marvels was overwhelming. But he knew that for his own sake he must go nowhere for a while. He was empty. The last year had taken its toll. He must take time to recover and re-centre following the disturbing time in Arles. He must also take time to digest everything he had seen at the expo before he could absorb it into his art.

Pont-Aven had become the nearest thing to a home. He went back to the Pension Gloanec. This time, a feeling of discomfort crept over him as he saw himself as part of the band of exploiters, the hypocrites, the colonising artists whose sentimental expectations were pushing the peasants into inauthenticity. Going to work in the fields in huge starched white *coiffes* was

undeniably picturesque, but he now knew it as a show put on for money. He did not blame them for mounting a performance for the visiting artists, but he could not feel comfortable within it. He moved to Le Pouldu, a rougher, undiscovered village on the coast. Only some forty kilometres from Pont-Aven, mentally it was a world away: harsh, and indubitably authentic.

'Imagine a country of gigantic sand dunes like mountainous waves of a solid sea, between which appear glimpses of the Bay of Biscay and Atlantic rollers. All this, peopled by a savage-looking race, who seemed to do nothing but search for driftwood or collect seaweed with strange sledges drawn by shaggy ponies and with women, who wear the great black coif (like a huge black sun bonnet).'[8]

Sand hauling was a major source of income, shovelling sand from the dunes to be transported by wagon to other places in France where it would be dug into heavy agricultural soil to lighten it. Seaweed was another important crop, harvested for fertiliser to put on the soil. This was the work of the sombrely clad women bent double as they waded knee deep in the icy shallows. Little girls, skinny and strong, dressed in rags, herded the animals on the steep black cliffs. Life was not decorative; it was not a performance. With existence so hard, no credit was extended here, as there was in comfortable Pont-Aven. He had to pay for every single thing as he went along. Fortunately, Gauguin had disciples, willing to pay for lessons.

The previous October, just before Gauguin had left Pont-Aven to join Vincent in Arles, he had given a painting lesson to twenty-five-year-old Paul Sérusier in the Bois d'Amour, the Wood of Love, where Gauguin himself had found inspiration for several pictures. Setting up the easel on a bend in the little river that ran through the wood, he had challenged Sérusier to capture the spirit of the place by quickly putting down the basic structure of colour and shapes, exaggerating the colours and simplifying the natural shapes. 'If you see red, take your best red.' Gauguin steered his young pupil away from literalism and objectivism towards the art of ideas and subjectivity. On a wooden panel no larger than a cigar box, Sérusier quickly executed the scene in bold tones of three colours: blue for the river and the tree-trunks, yellow for the autumn leaves, and bright vermillion (his 'best' red) for the dull rust-coloured bracken covering the slope that falls down to the river.

The next stage, Gauguin instructed, was to take the sketch to the studio where the observed landscape structure would be transformed into a picture through the artist's emotional response to the sketch he had made. The second part never happened, because Sérusier had to hurry for a train back to Paris. Here he showed the little panel to his painting companions who were stunned by the highly individual interpretation of nature through the use of non-realistic heightened colour, linear rhythms, decorative shapes, and the jettisoning of traditional perspective, shading and scale. The picture was so admired by his Paris painting circle that they named it *The Talisman*. It was their inspiration, the lens through which they wanted to interpret the world. The tiny picture has later risen to great fame, being seen as the springboard for the extraordinary upheaval in Post-Impressionism, leading to Symbolism, Cubism and abstract art by giving artists the freedom to depart from the limitations of seen reality, to exaggerate the colour contrast in nature and to simplify its forms, producing a synthesis that described, expressed and directly communicated the artist's creative dream.

The group included Charles Laval, Léon Fauché, Charles Filiger, Schuffenecker, Louis Anquetin, Émile Bernard, Daniel de Monfreid, Louis Roy and Paul Ranson. They called themselves the Synthetists, taking the word from Gauguin's title for the Volpini exhibition, implying not only a melding of form but a broad evocation of symbolic resonances opening up spiritual realms far removed from the realms of realism. The group made their headquarters in Ranson's studio, which they renamed 'The Temple'. Here *The Talisman* was displayed in a shrine-like contrivance round which the life of the temple revolved. As adepts of *The Talisman*'s invisible realm, they had a fondness for dressing up in robes to perform made-up ceremonies, freewheeling through prayers and incantations, Egyptian spells for the dead, reciting poetry by Mallarmé, Huysmans and Baudelaire, frightening themselves with the creepy tales of Edgar Allan Poe, conjuring spirits and devils, consulting sacred numbers and, in their lighter moments, holding louche cross-dressing parties. Later, renamed the Nabis (Prophets), they would become famous, being joined by Pierre Bonnard and Édouard Vuillard, and they moved from the wilder shores of necromancy into abstract symbolism, still based on Gauguin's principle of subjectivism, and still venerating *The Talisman*.

WILD THING

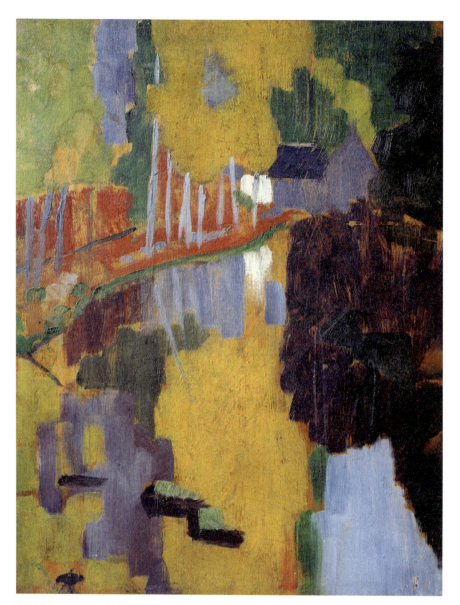

Paul Sérusier, *The Talisman*, 1888

When Sérusier heard that Gauguin was in Le Pouldu, he followed him there with Charles Filiger, a painter who then promised greatness but later sadly lost himself in a maze of occultism and drugs.

The writer André Gide, on a walking tour of Brittany, described the trio:

'At the end of the day I arrived in a little village, called Le Pouldu if I remember rightly. The village didn't have more than four houses and two inns. The most modest seemed to me the most pleasant. I was very thirsty so I went in. A maid led me into a lime-plastered room, and left me face to face with a big glass of cider. The lack of furniture and wall hangings contrasted strangely to the large number of painted canvases stacked against the walls. I leafed through them one after the other. I was stupefied. They seemed to me childish, but what children, what tones, what colours, so joyful I didn't want to leave the inn. I wanted to meet these artists capable of such life-enhancing vision. I abandoned my plan to reach Pont-Aven that evening and I engaged a room. Come the dinner hour, the maid asked me if I would like to eat by myself or with "Ceux messieurs", by which she meant the creators of these marvels. Soon they entered with their paint boxes and their easels. It goes without saying that I asked to eat with them, if they didn't mind. They didn't mind at all. They were all three barefoot, superbly dishevelled, deep-voiced. During dinner I hung on their words, tormented by the desire to talk to them, to make myself known, to know them. The big man with the piercing eye was the leader, the others were the chorus . . . I met him later chez Mallarmé: it was Gauguin. The other was Sérusier. I'm not sure about the third (Filiger, I think).'[9]

Sérusier and Filiger found Gauguin drained, introspective and difficult. He had even lost his usual tough, ironic humour. On seeing a group of Englishmen playing football in a meadow, rather than joining in and kicking the ball to hell, he grumbled sourly at such idiots who followed a little round ball around while they ignored eternity.

He was depressed by the failure of the Volpini exhibition. 'What can we do but fume and grapple with these difficulties; when beaten, get up and go on again. For ever and ever. At bottom painting is like man, and mortal living is always in conflict with its own flesh. If I thought of the absolute, I should cease to make any effort even to live.'[10] More important even than past failure, present lack of recognition and lack of money, was his present mental state. Gauguin was forty-two, and he was floundering.

The self-portrait he had given Vincent had shown him identifying with the misunderstood outsider Jean Valjean. Now he went one step further,

identifying his suffering and rejection with Jesus Christ, the spurned god. He painted a group of pictures depicting himself as Jesus.

The Vision of the Sermon had been rejected by the Trémalo Chapel in Pont-Aven. Within Trémalo Chapel hung a polychrome wooden Crucifixion. Now he made a painting of it, *The Yellow Christ* (1889), giving the crucified Christ his own face. He also painted *Self-Portrait with Yellow Christ* (1890–1) showing himself between his previously created *Yellow Christ* (1889) and another of his unappreciated and unsold artworks, the ceramic *Anthropomorphic Pot* (1889) which also bears his own features. Another complex self-portrait is *The Green Christ* (1888/9?) a picture of the thirteenth-century sculpted calvary that stands outside the church at Nizon, the other church near Pont-Aven that had rejected the *Vision*. The painting shows the church's calvary relocated to where he is living in Le Pouldu, set in a recognisable landscape, as if to say that the landscape may have changed but the rejection continues. Finally, *Christ in the Garden of Olives* (1889) depicts the melancholy Christ on the eve of His betrayal praying alone while His disciples sleep. Later that night, Christ's treacherous disciple Judas will betray Him, leading to Jesus's arrest. In the scuffle following the arrest Malchus will have his ear cut off by Jesus's disciple Simon Peter and Jesus will reach out to heal the ear. The reference to Vincent is obvious. Gauguin relocates Christ's Garden of Gethsemane to Le Pouldu, and Christ's features are, once more, a self-portrait, but this time Gauguin crowns his own face with Vincent's blazing red hair.

In describing the picture to Vincent, Gauguin explained that he had painted his own portrait, but that it also represented the crushing of an ideal and a pain that was both divine and human. Christ, too, had been totally abandoned; his disciples had left him in a setting as sad as his soul. The picture expressed the lack of encouragement that scourged one with thorns.

Other pictures from this transitional year include *Ictus*, a small oil-and-watercolour sketch showing an androgynous nude seated with legs crossed in the position the Egyptian artists had taken up at the expo to reproduce their ancient art, though the arms of the figure have been rearranged in the flowing gestures of Khmer religious statuary. Behind the figure is drawn a large fish, the early symbol of Christianity, beneath which is written the word

Ictus, the Greek acrostic for 'Jesus Christ, Son of God the Saviour', a favourite word of Vincent's.

Another small picture, *Exotic Eve*, shows a female nude in the swaying attitude of a statue of the Buddha that he had seen on the façade of the Javanese Borobudur temple. He gave the figure breasts and a dark-skinned body and placed it in a Martinique landscape, but the strangest element of this synthesised image is the face: it is a portrait of his mother, taken from a photograph of her. This was the first of Gauguin's many pictures that do two things: first, reinterpret photographs into paintings, something that would become commonplace but at that time was pioneering; second, to move Western Christian iconography into a Caribbean world. *Exotic Eve* was possibly the first Western portrayal of an indigenous Eve. When Gauguin sent *Exotic Eve* to Paris for Theo to sell, it was criticised on racial grounds, upon which Gauguin commented ironically that such critics obviously thought Eve and the serpent had conducted their world-changing conversation in fluent French.[11]

Rumour was buzzing round Paris that Gauguin had founded a monastery in Le Pouldu and was spending his time walking along the beach like Jesus Christ, proselytising to a band of devoted disciples. He responded sarcastically: 'The only disciples I know of are de Haan, who is working outdoors, and Filiger, who is working in the house. I myself walk about like a savage, with long hair, and do nothing. I have not even brought colours or palette. I have cut some arrows and amuse myself on the sands by shooting them just like Buffalo Bill. Behold your self-styled Jesus Christ.'[12] So he told Émile Bernard, who had become a devoted disciple the previous year in Pont-Aven, as had his sister Madeleine when he had painted her portrait in Pont-Aven – after which Papa Bernard (who held the purse strings tight) had become paranoid over the spell Gauguin had cast over his children and forbade them to see or correspond with him. He should not have worried. Gauguin recognised the immaturity of Madeleine's feelings for him, while acknowledging her talent and encouraging her potential. He wrote her a remarkably advanced letter for a man to write at that time, when women were given little respect, let alone independence, being seen as chattels of husband or father. In the eyes of his contemporaries, Gauguin was disrespecting Mette for allowing her independence within their marriage, but this was rooted in his

Gauguin, *Exotic Eve*, 1889–90

feeling that society's most appalling theft from women, apart from stealing from them the right to develop their gifts and talents, was the fact of women's forced material dependency on the male sex, depriving them of any means to act on personal conscience, in effect nullifying them as moral beings.

'Dear Sister,' began his letter to Madeleine, before plunging straight into the advice that she would go through life without aim, and without power, unless she started to think of herself as 'Androgyne, without sex'. This was the only way to escape the female fate of being tossed about by fortune in a world governed by men. 'If, on the other hand, you want to be *someone*, to find happiness solely in your independence and your conscience, it is now time to think about things . . . Do in a proud spirit all that would help you to win the right to be proud, and do your best to earn your own living, which is the pathway to that right . . . Do not be afraid.'[13]

In love with Gauguin but obeying her father's dictate never to see or correspond with him again, Madeleine became engaged, more out of compassion than love, to Laval, the weak-willed, procrastinating painter who had accompanied Gauguin to Martinique. Following Laval's death in 1894, she went to join her brother in Cairo where, aged only twenty-four, she died of consumption. How different her life might have been had she followed Gauguin's advice.

In Le Pouldu, Gauguin had been joined in the autumn by a new disciple, Meyer de Haan. He was the thirty-seven-year-old son of a wealthy Jewish family with a factory making matzos in Amsterdam. De Haan was the indulged younger-son artist whose old-fashioned genre paintings look like misconceived Rembrandts: lakes of brown treacle out of which over-lit faces jump out at you. His family belonged to the Nederlands Israelitisch denomination of the Orthodox Ashkenazi community. He was intelligent, intellectual and highly versed in Jewish theology, philosophy and mysticism. He had spent the last ten years working on a four-by-five-metre canvas on the subject of the interrogation of Uriel Acosta, a sixteenth-century Jewish mystic and philosopher, said to have influenced Spinoza. Acosta's books had been burned and Acosta himself trampled (though not to death) by the congregation in the synagogue as punishment for his heretical writings. Raised in a strictly observant family, de Haan had already painted *Is This Chicken Kosher?* (1880) and *The*

Talmudic Dispute (1878). The gigantic *Uriel Acosta* (1878–88), that had cost him so many years of effort, was received with laughter from the critics and rancour from the rabbis, who didn't like the subject matter at all. Feeling the need to get right away from the Amsterdam goldfish bowl, he sold his share of the family business to his brothers in return for an allowance of 300 francs a month which supported him in a move to Paris where he lodged with fellow Dutchman Theo van Gogh. Once more saddled with a troubled painter, Theo saw the same solution: foist him off on to Gauguin. Send him down to Le Pouldu where Gauguin could give him lessons.

Not short of money, de Haan grandly hired the top floor of the only large house in the area, Castel Tréaz, a stark horror-movie edifice of four storeys gloomily dominating a glassy black cliff. Their studio window overlooked Atlantic rollers, shivering seaweed gatherers and straining sand haulers. Almost exactly a year after the ear-cutting, Gauguin wrote to Vincent describing and sketching the painting he was working on, *The Kelp Gatherers* (1889), a picture of resigned and weary figures plodding up the beach transporting their loads of seaweed. Their blue clothing and black coifs are set off against the idyllic setting of pink sands and a turquoise seascape whose beauty mocks their lives of drudgery. 'Seeing this every day I get a kind of gust of wind for life, of sadness and obedience to unfortunate laws. I try to put this gust of wind on to the canvas, not haphazardly, but rationally, perhaps exaggerating a certain rigidity of pose, certain sombre colours etc. . . . All of this is *mannered* perhaps, but where's the natural in painting?'[14]

After three months painting in their top-floor studio in Castel Tréaz, Gauguin and de Haan were thrown out for making too much noise. This was probably due to Gauguin's devotion to wooden clogs. He had carved himself several pairs, and de Haan had copied him. Clogs were a matter of political solidarity with the locals, but the tenants on the floor below objected to the castanet clatter overhead.

They moved to the Buvette de la Plage, a small inn a little below the Castel Tréaz, that had been opened by Marie Henry, universally known as Marie Poupée for her doll-like beauty. Marie had worked as a lingerie embroiderer in Paris but on finding herself pregnant, she had used her savings

to buy two small plots of land in Le Pouldu, where she built the tiny *buvette* with a bar and restaurant on the ground floor and a steep, narrow staircase leading up to three tiny bedrooms, her own and two she rented out.

Marie Poupée recalled: 'They got up early and had breakfast at seven o'clock. Coffee, bread and butter. Then they left to paint outdoors while the light was still good. They came back about eleven, to eat at midday. At about one or half past they went out again to renew their labours, coming back about five. Dinner was at seven. After that, chat and maybe painting in the studio. They went to bed very early, around nine, after a game of lotto or chequers, with Gauguin drawing up the game boards on newspaper. Often, they just sat, drawing. They read neither books nor newspapers, but music was central to their lives. Meyer de Haan didn't play an instrument. Gauguin played the mandolin and the piano.'[15]

December days were short and blustery. Atlantic gales played havoc with their easels. They moved indoors where Gauguin and de Haan took on what Gauguin described to Vincent as 'rather a large job, a decoration for the inn where we eat. You begin with one wall, then you end up doing all four.' Not only all four walls but the windows too. Blank panes of glass must not be allowed to interrupt the painted illusion. As was his custom in letters to Vincent, he enclosed a sketch.[16]

De Haan painted a large panel in the manner of the ancient Egyptians as seen at the expo, straight onto fresh plaster. It showed the local women sorting hemp against a background of straw ricks. It is remarkable to see how quickly de Haan's art had changed from treacle-dipped realism to Gauguin's ideas-led deformation of form and emotion-led use of colour. With his interest in Jewish mysticism, de Haan understood Gauguin's ideas on the suitability of the 'primitive' art of Cloisonnism to represent the 'primitive' peasant life of Le Pouldu. By dividing the narrative space into sections, like stained-glass windows or the *cloisons* on a vase, 'real' space could be placed beside imagined space. Plenty of symbols were included to suggest truths hidden behind the visible world. Gauguin knew that, in terms of sincerity to peasant life, he was cheating in applying such a sophisticated concept and yet, as he had written to Vincent, 'All of this is mannered perhaps, but where's the natural in a painting?'

Summer came. They extended decoration of the dining room to the ceiling, painting it blue-grey and transforming it into a parody of a ceiling of a medieval castle, with onions and Egyptian geese taking the part of heraldic symbols, and the famous chivalric motto *Honi soit qui mal y pense* spelled out phonetically in the local accent: *Oni soi ki mâl y panse*.[17] It was probably Sérusier who added 'I love fried onions', but the most important words in the room were written in all seriousness by Gauguin, quoting Richard Wagner, who stood for them all as the paragon of artistic conviction. 'I believe in a Last Judgement where all who have dared to profit from chaste and holy art shall be condemned to terrible suffering.'[18]

On the two doors in the room, Gauguin painted their two portraits. The symbolism of doors is self-evident: exits and entrances, progression and regression, the door to heaven and the door to hell.

Portraits on the doors of the Buvette de la Plage, both by Gauguin, 1889. Meyer de Haan left, Gauguin right.

In *Self-Portrait with Halo and Snake* (1889), Gauguin stylised his features into the harsh geometry of an Inca idol. Above his head floats a golden halo. Apples from the tree of knowledge of good and evil hang close to his face. To taste them confers occult knowledge, the price of which is lost innocence. In front of him on an Arlesian yellow field, the Buddhist lotus spreads its flowers of enlightenment. Caught in the space between, Gauguin holds the snake, the tempter and engineer of the Fall but also, in contemporary Symbolist and decadent thinking, the one source of creative power. Gauguin believed, like Wagner, that the true artist was endowed with divine power. It came with the Faustian price. You can only become a true creator once you have taken the terrifying step of asserting your independence from God the Creator by eating the apple. And so, this little portrait on the door shows Gauguin as a new Faust. The subtext of spiritual initiation and the deliberate (and isolating) choice to taste the forbidden fruit are continued in Gauguin's twin portrait of de Haan, painted on the other door.

In this picture, Gauguin portrays de Haan as the dominant intellect: the initiated magus, the seer. The forbidden apples have now been plucked from the tree of knowledge. They sit on the table in front of him. He is placed halfway along the steep diagonal running through the picture, materially representing the table-top but symbolically indicating spiritual progress. He holds his finger up to his lips in the timeless gesture of the initiate who must keep silence, as he gazes with unseeing eyes at, and beyond, two books on the table. De Haan had been instructing Gauguin in these two books over the past year: Milton's *Paradise Lost*, whose most mesmerising character is the fallen angel Lucifer, whose trajectory through time led him into the embracing arms of the Paris avant-garde, Charles Baudelaire, Madame Blavatsky and the growing groups of occultists and decadents, leading to a sharp revival in Satanism, *fleurs du mal* hashish-fuelled mysticism, and magic; and *Sartor Resartus* ('the tailor re-made') by Thomas Carlyle, a most unusual book even among occultists. *Sartor Resartus* was not yet published in French, and Gauguin's English being what it was, de Haan must have had to translate it for him verbally, discussing as they went along. As a work of philosophy, it takes the form, like Voltaire's *Candide*, of an absurdist tale. Herr Diogenes Teufelsdröckh (God-Born Devil's Dung), Professor of Things in General

at the University of Know Not Where, gives his children 'earthly hulls and garnitures', suits of clothes (symbolic of religious beliefs) which they must never alter. They do alter them of course, according to fashion, and this leads them to pass into 'the howling desert of infidelity', enduring the agonies and anguish of nihilism, scepticism and empty despair. Carlyle was the great historian of the French Revolution and at the heart of this book is his sad disillusionment at the fact that Utopia had not been realised through the Revolution. The book was a spiritual autobiography of his generation 'caught between two worlds, one dead, the other powerless to be born'. It raises spiritual perplexities which, in Carlyle's case, drove him into the arms of Kant – Nietzsche had not yet been born while he was writing it or it might have been a different story. The science of Carlyle's time proclaimed that since the universe is governed by natural laws, miracles are impossible and the supernatural is a myth. But Carlyle, wedded to the supernatural, fought back with total conviction and magnificent illogicality in the same spirit as his contemporary anti-scientists who insisted that God had placed fossils in the new-made rock when He created the world. The thought of the rigorous Hebraic God pursuing the dishonest course of faking up fossils surely goes against all that god's fundamental principles but to Carlyle and his ilk, who supported the idea that natural laws are only outward manifestations of the spiritual force, it somehow made sense taken in the spirit that the miraculous is everywhere and all nature is supernatural. God reveals Himself through symbols. The wise man sees the symbol, knows that it is a symbol and penetrates it to find the ultimate fact or spirituality which it symbolises. This was a fascinating line of thought for Gauguin and de Haan to pursue. It echoed Wagner's Schopenhauerian belief that the world consisted of will (*Wille*) and representation (*Vorstell*). What we take for reality in this world is only 'representation', the visible equivalent that falls far short of the ultimate reality, the 'will'. This conformed to Baudelaire's view of the world as expressed in his essay 'The Painter of Modern Life' published in 1863. Further, it affirmed what had come up in conversations with Vincent and with Sérusier, both of whom had taught Gauguin about Buddhist enlightenment and nirvana, which state may be called the Buddhist equivalent of 'will'. This

complicated intellectual trail synthesising so many trains of thought led to Gauguin calling the portrait of de Haan on the door *Nirvana*.

The portrait carries another message as well. De Haan's face was well proportioned and averagely handsome. Dutch-looking in colouring, he had milky skin, blue eyes and red-gold hair. Nothing exceptional. But Gauguin subtly manipulated his friend's features, melting them into the sly face of the Moche dog fox, the Peruvian symbol of sensual perversity. Long after de Haan was dead, Gauguin would put the hybrid de Haan dog fox into paintings when he wanted to suggest sensuality.

When they had come to lodge in the *buvette* with Marie Poupée, the prettiest woman in the village, she had quickly taken de Haan as her lover. He slept with her in the biggest bedroom at the top of the cramped wooden stair. Gauguin slept alone in the very small bedroom next door, only a paper-thin partition wall between them. This was humiliating. De Haan suffered from skeletal dysplasia, or dwarfism, one shoulder was hunched high above the other and he had scoliosis, severe curvature of the spine but, for all this, Marie had chosen him above Gauguin. Gauguin the virile savage, Gauguin the superbly dishevelled, Gauguin the leader of men who made tin cans jump, like Buffalo Bill. Night after night he had to lie in bed, his male pride wounded as he listened to de Haan and Marie Poupée making love.

11

A THROW OF THE DICE

Thoroughly alarmed at the course de Haan's life was taking, his family reduced his allowance. This left Gauguin periodically without the means to pay for bed and board chez Marie Poupée, who did not extend credit. When Gauguin's pockets were empty, he would go back to Pont-Aven, where Madame Gloanec was more relaxed about rent, and he was welcomed with open arms by the summer painters who flatteringly begged for lessons. He missed the hardness of life in Le Pouldu. 'Its inhabitants supplied a frame for the primitive and the romantic . . . angular people with boldly cut features, whose expression bore the stamp of their religious ideas, a blend of Christianity and pagan superstition, in which the deity was rather the just but cruel judge who demands human life than the white, gentle Christ who promises eternal life.'[1]

He went back to Paris a couple of times, usually staying with Schuff and taking the opportunity to paint from a nude model. The Bretons being extremely reluctant to take off their clothes for art, Gauguin had painted comparatively few nudes to date, all with the suggestion of a posed life-class drawing, but now at last he produced a lyrical nude that took flight from physicality: *In the Waves/Ondine* (1889). A naked woman, seen from behind, ecstatically surfs a glassy-green wave. Japanese-inspired, the composition relates to some words of Wagner's that Gauguin had inscribed in the visitor's book at the Pension Gloanec: she 'only achieves the fullness of her individuality in the moment when she gives herself; she is the Ondine who floats murmuring across the waves that are her element'.[2] In esoteric lore, Ondine is the spirit of the water, one of the four elemental spirits. Gauguin used the same model to pose for *Life and Death* (1889), a picture of two female nudes on a beach. Life has been for a swim and is sitting drying herself; her body is flesh-coloured and a little sunburned. Death is recognisably the same model placed behind and a little to the side of Life. Death's body is bloodless, ghostly white, and she raises one hand to cover her ear in the

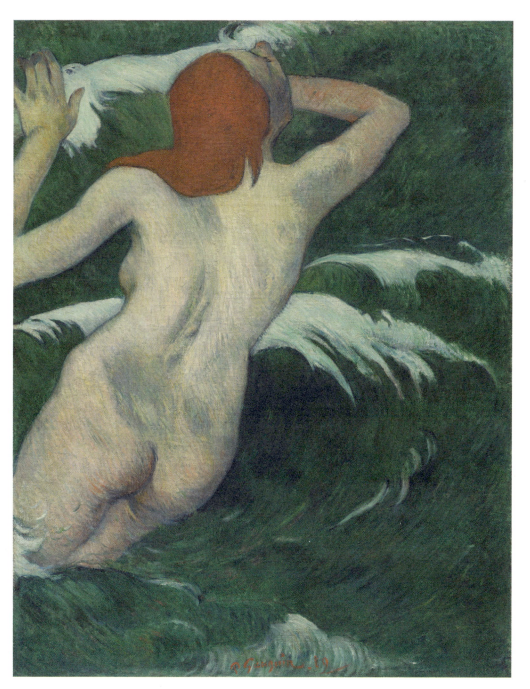

Gauguin, *In the Waves/Ondine*, 1889

gesture reminiscent of Vincent. Her other hand is raised to her mouth in the same gesture as in Gauguin's portrait of de Haan, signifying initiation into a forbidden world. In Death, Gauguin produced the figure he believed truly represented the state of death to the world's vanities: the closing of your ears to the noise of the world as you open your mind. While they were never used together in the same canvas again, both the Life figure and the Death figure would be used and reused in Gauguin's pictures as part of the vocabulary of his symbolic language. The Ondine figure would be reused too. Her sinuous surfing back becomes an enduring symbol of female delight in abandonment, recurring in later sculptures and paintings.

Gauguin's social life appeared to be burgeoning. He writes about a countess, whom he never names, being much smitten with him and by the large wood panel he had carved in the absence of money for paints and canvas. *Be Amorous and You Will Be Happy* (1889) is a seduction-verging-on-rape fantasy in which Gauguin depicts himself as a monster grasping the hand of a resisting woman. The words 'be amorous and you will be happy' issue from the Gauguin monster's mouth. The remaining space is taken up with carvings of the Moche dog fox symbol of perversity and other figures playing their part in this updated narrative of the Fall of Eve in which Gauguin has cast himself as tempter, Satan and serpent. The smitten countess returned to Paris promising to show the carving to Maurice Rouvier, the Minister of Finance who, she said, was bound to buy it. Gauguin wrapped it carefully to arrive in Paris in good condition. The venture ended in nothing but postal expense for Gauguin.

Things looked up again in the month of May, when he met Charles Charlopin, a charming man of many parts: art teacher, inventor, ship's doctor, art collector. Charlopin was about to come into a great deal of money through his latest invention, a steam engine far superior to any already manufactured. As soon as the patent came through, he would buy thirty-eight of Gauguin's paintings for the sum of 5,000 francs. The money should be available in a month or so.

Gauguin was temporarily distracted from this and everything else by a letter from Vincent announcing yet another plan to come and paint with him, this time proposing to join him and de Haan in Le Pouldu.[3] Panicked, Gauguin instructed Marie Poupée to write saying there was no room at the

buvette. Gauguin himself wrote that it would be a very bad idea, Vincent being in fragile health and there being neither doctor nor hospital in Le Pouldu. Besides, they would not be there long. De Haan was planning to go back to Holland and he was making plans, he said, to leave for Madagascar.[4] Vincent wrote to Theo saying he would much prefer to see Gauguin leave for Tonkin than Madagascar but if he persisted in going there 'I'd be able to follow him there. For one *should* go there in twos or threes.'[5]

Vincent would never get to Madagascar or Brittany or anywhere else. A little over a month after writing that letter, he walked into a field carrying a gun. Ostensibly out to shoot rooks, instead he pointed it at his own stomach, and shot himself. He died two days later in Theo's arms. It was a sombre shock to all, including Gauguin, but he took comfort in the conclusion that it was probably the best way out of suffering for his troubled friend 'and if he returns in another life he will bring with him the fruit of his fine conduct in this world, according to the law of the Buddha',[6] whose spiritual teaching, Gauguin knew, had meant so much to Vincent.

Gauguin had been applying to the Ministry of the Marine and the French Emigration Society who had the power to pay the fares and provide jobs for 'useful' emigrants to the colonies. Gauguin's first destination of choice was the French protectorate of Tonkin, home of the Khmer art that had so enchanted him. He wished to fill the lowliest possible office job there, to leave himself plenty of time for travel, studying the temples and monuments. His application was turned down. Artists were not 'useful'. This was infuriating but did not detain him long. A conversation with Camille, wife of the Symbolist artist Odilon Redon, refocused his attention on the French colony of Madagascar. She told him that 5,000 francs could support him there for thirty years if he wished. Therefore, 'Irrevocably I will go to Madagascar – I will buy a clay house in the country that I will enlarge myself, grow plants and lead a simple life. One can easily obtain all one's food from hunting alone. I will found the workshop of the tropics – whoever wishes can come there to meet me.'[7]

Charles Laval, Gauguin's companion on the adventure in Panama and Martinique, remained a devoted disciple but Gauguin was ambivalent about including him. Laval was suffering from tuberculosis. Since returning to France he had lapsed into lassitude; nothing ever got finished. Another

possibility was Sérusier, who had painted *The Talisman* and was at the centre of the cult around the picture. Sérusier needed shaking up. Choking incense and cod-religious rituals were harmless enough in themselves, but his art was starting to suffer, becoming stilted and inflexible as he applied set religious principles to it. Sérusier was another who thought he had discovered art-by-formula. He believed he had worked out the sacred measurements of proportion and he was also in the creative throes of formulating a rigid colour theory.[8] Vincent, while alive, had not been impressed; his brisk opinion had been that Sérusier was reverting to medieval tapestries.[9] Gauguin, as we have seen from his reaction to pointillism, believed that any definite programme imposed upon art was nonsense. Art must be totally free to roam wild, uncorseted. Though he was hailed as the leader of Sérusier's Symbolist-Synthetists, 'he hated to hear the word synthetist and it gave him a cold sweat to be taken symbolically'.[10] However, Sérusier did have private means. The money would be useful if he came.

Émile Bernard was the most promising artist of the young disciples. Gauguin very much wanted to paint with him, but lack of money stood in Bernard's way. He came from a rich family, but he was being held on a tight rein by his father, who wished his son to go into business rather than become an artist. Gauguin offered to pay Bernard's passage, to which Bernard responded full of joy and rapture. 'How glorious to get far, far away . . . To abandon this loathsome European life; all these dolts, misers and fat swindlers; all this pestilential scum . . . How grand to drink freedom to the full, admire the sea, imbibe the void . . .'[11] But Bernard, like Laval, was an eternal waverer. All his life he was easily influenced and he had been reading *The Marriage of Loti*. Forget Madagascar, he told Gauguin, Tahiti was the place!

Gauguin scolded Bernard. Didn't he realise that Loti's books were works of romantic fiction? But Bernard was not to be put off. He sent Gauguin the government handbook for emigrants, a work concocted of ignorance, fantasy and a lot of Loti, designed to encourage *émigrés* to go out to the young colony as merchants, administrators, magistrates and gendarmes, their job to exploit and subjugate the local population, thus destroying the very way of life the booklet hymned.

'In Oceania toil is a thing unknown. The forests produce spontaneously

everything necessary for the nourishment of those carefree tribes; the fruit of the breadtree and bananas grow for everybody and suffice for all. The years slip by for the Tahitians in utter idleness and perpetual dreams . . . Hospitality is offered, warmly and without charge, everywhere . . . In general, a magnificent race with beautiful figures . . . remarkable for affability, gentleness and hospitality . . . One needs neither weapons, supplies, nor money . . . Theft and murder in Tahiti are almost unknown . . . A Tahitian woman is usually a perfect model for a sculptor. Her features can occasionally be a little too Malayan [sic] but with her large dark eyes, so wonderfully fine and clear, her almost excessively full lips, she looks so sweet and innocently voluptuous that it is impossible not to share in the general admiration which she arouses . . . While men and women on the opposite side of the globe toil to earn their living, content with cold and hunger and suffer constant privation, the lucky inhabitants of the remote South Sea paradise of Tahiti know life only at its brightest. For them, to live is to sing and love.'[12]

Bernard wouldn't budge. Gauguin gave in. And so his fate was decided by the effect of a bad book upon an impressionable mind, and by a dishonest government handbook.

In October Theo van Gogh offered to co-finance the trip. Gauguin's spirits soared, only to plummet a week later, on learning that Theo had gone mad, and the money was a figment of the poor man's imagination. Theo had long suffered from syphilis and the disease was reaching its final stages, dissolving the whorls of his brain, and collapsing its hemispheres. Theo was admitted into an asylum in November, and in January he died, six months after Vincent's death.

Gauguin's castles in the air were fast tumbling into ruins. His last source of steady income, Meyer de Haan, had been recalled to Holland to account for himself to his hard-working brothers, who held the purse strings. The brothers objected to Meyer's nice, Rembrandtian art being transformed into newfangled psychological nonsense. On discovering that Meyer had impregnated Marie Poupée, it was a short step to conclude that Gauguin had pulverised their brother's moral sense as well as his art. Marie Poupée already had an illegitimate daughter who had been living with the three of them in the tiny *buvette*, sleeping in the cradle on the floor beside the bed where

Marie and de Haan were making her new sibling. The de Haan brothers concluded that Marie Poupée was no better than a whore. Meyer remained in Holland, claiming to be ill. Given his health record, this might be true. Or it might have been a way to evade his obligations. Marie Poupée would bring into the world a second child deserted by its father.

The inventor Charlopin had first approached Gauguin in the month of May. When November came around, Gauguin reached the unwelcome conclusion that the man was a charlatan. Time to take control: pick up the purse strings, move back to Paris, raise money for Tahiti by selling the stored paintings, find a new agent to take Theo's place. This last was vital. Gauguin did not imagine there would be a market for avant-garde pictures in the colony itself. He envisaged shipping his pictures back to Paris, whose artistic milieu was the yardstick he wished to measure himself against. On a less exalted plane, he also realised that he had to organise the trip himself, rather than instruct Schuff and Émile Bernard to do the legwork for him. A full-frontal assault on the emigration authorities would have to be made in person. His plans hit a hard obstacle: Marie Poupée would not let him leave Le Pouldu without paying his bill. Weeks passed with Marie Poupée tense and implacable and Gauguin, who couldn't afford painting materials or even tobacco, strumming his mandolin on the bleak November beach, and carving bits of wood into clogs, narrative panels and a figure of a black, kneeling Virgin Mary.

Stalemate was resolved by Émile Bernard, who brokered the sale of five of Gauguin's paintings for a hundred francs each to Eugène Boch, the well-heeled scion of the (still-thriving) porcelain manufacturer Villeroy and Boch. A poet and a painter, Boch had been close to Vincent, whose tendency to idolise his friends had led him to paint *The Poet: Eugène Boch* (1888) portraying him as mystic and seer, luminously radiant in a chrome yellow coat vibrating against a cobalt sky swirly with stars. Gauguin used the Boch money to pay off part of the debt to Marie Poupée, whereupon she allowed him to leave, on condition he left all his paintings with her. He would be free to redeem them whenever he could afford to pay the rest of his bill. It was a tough bargain, and one he would regret, as it tied up a major source of income from potential sales, but he had no choice.

In late November, he left for Paris, where he moved in with Schuff, as usual,

and tried to persuade him to join the Tahiti expedition. Schuff could finance the whole thing. Surely he would be delighted to get away from his harpy of a wife? Schuff did not see it the same way and they quarrelled. Gauguin moved out, into one of those mouldy rat-and-cockroach-riddled flophouses immortalised as romantic garrets in opera and literature. At 35 Rue Delambre, he was close by the studio of one of his young admirers, George-Daniel de Monfreid. Twelve years Gauguin's junior, de Monfreid had been painting agreeable landscapes in the pre-Impressionist style of the Barbizon School before becoming drawn into Sérusier's Temple. Delighted to have the Master come and paint in his studio, de Monfreid took on the role of Gauguin's business manager, and threw himself into a money-raising campaign.

Gauguin had been a long time away from Paris. His old haunt, La Nouvelle Athènes, was as passé as the subjects they had discussed around its tables: Impressionism, pointillism and the science of seeing. Today's men met at the Café Voltaire in the Place de l'Odéon, at the table presided over by Paul Verlaine, where discussion was anything but scientific, centring instead on the unseen as expressed by symbolism and occultism, the two being inextricably intertwined. The occult was the gate to the subconscious labyrinth that was the key to the ultimate truth: the psychology of the soul, which it was the task of the artist to render into art.

Their leader, Verlaine, once great, was now raddled beyond coherence. Long years of drink and drugs limited him to rare, gnomic utterances that intensified his mystique for the younger artists setting sail on the seas of unreason.

Verlaine had been chief of the press bureau during the Paris Commune. He had been the lover of the poet Rimbaud, wild child of French *décadence*, the literary movement that metamorphosed into Symbolism and Surrealism as well as much else in literature and art. During a lovers' quarrel Verlaine had shot Rimbaud in the wrist (how symbolic to shoot a writer more important than yourself in the wrist). Beneath Verlaine's high, domed forehead that was presumed to contain infinite sagacity, his mysterious outbursts were taken seriously by the group that included Jean Moréas, author of the impenetrable Symbolist manifesto of 1886;[13] Albert Aurier, the critic who would write the first important essays on the art of Gauguin and Van Gogh that

same year;[14] Charles Morice, the poet and critic who never made the front rank in either field but knew everybody who was anybody and would be helpful in promoting Gauguin's art, though he would also cheat him out of lots of money; the Symbolist painter Eugène Carrière, whose dreamy pictures would inspire Picasso's Blue Period; and the sculptor Rodin, whom Gauguin already knew from his time sculpting with Bouillot. Rodin was still working on *The Gates of Hell* whose crowning *Thinker* symbolised for them all the tortured subjectivism of the modern individual.

If the task of art was to represent reality, what reality were you talking about? It was accepted that verbal art and visual art each created its own reality, but which was the more truthful medium? Visual art's capacity for straightforward equivalence made it deceptive, possibly it made it the least truthful form of art, of least value to 'truth' when compared to the arts of writing and music which appealed to the imaginative understanding precisely because they had no real objects to imitate.

Hence, visual art was the one branch of the arts that embodied the Platonic delusion. Like the shadows on the walls of Plato's cave, it presented as substantial and true objects that were only a copy. Visual art must follow the example of music and literature. Take from music and literature the task of conveying inward qualities: moods, thoughts, intangible states. Concentrate on conveying rather than describing. The art of the mind rather than the art of the eye would activate the projective capacity of the beholder to 'read' into the depiction the 'meaning' of the artist, who had been dipping his brush into his subconscious. Successfully dipped, the brush would have extracted the artist's own subconscious symbols, shapes and colours, which then would form an instant connection with the subconscious of the beholder, who would be more deeply moved by the artwork because of being involved at a subconscious level, as well as enjoying the mere delight of the eye.

This led on to interest in art produced in 'heightened states': drink, drugs, séances, magic rituals, conjurings, Satanism, Mesmerism and hypnotism. There rose a new interest in the art produced by the patients in the hospitals for the insane, such as Paris's La Salpêtrière, presided over by Dr Charcot who became known as 'the Napoleon of neuroses' for his lectures exploiting

his poor mental patients in public performances of hypnosis, 'animal magnetism' and induced hysteria; his lectures were attended by a young Sigmund Freud, gaining Charcot the title of the father of modern psychiatry, and the Symbolist painters the status of the interpreters of the mind.

In a large part, all this had developed from Baudelaire's 1863 essay 'The Painter of Modern Life', which proposed that the visible world only exists as a kind of storehouse waiting to be transformed by the imagination into sense, into narrative and into works of art. A conclusion concerning permeability that Gauguin had already arrived at, written about and taught to his disciples, though his particular perception of this sentiment differed from his contemporaries'. His own longings for connection involved his modern, 'civilised self' rummaging about in a different storehouse of images and signs, connecting to his 'savage Peruvian' self. While the French Symbolists were collectively mining archetypal Western cultural references, it was connection to the archetypal pre-modern Other that Gauguin was seeking to rediscover in Tahiti.

Symbolism was hardly a new concept. Enshrined in art down through the ages, symbols had proved extraordinarily useful in conveying ideas. Symbols taken from well-known myth, allegory or religious texts had built up a dictionary of symbolic language over the centuries, easily deciphered. A fish means Christ. An apple means temptation. A bird in a cage signifies the stifling of freedom of some sort. The recent loss of female virginity was traditionally conveyed by the inclusion of smashed eggs, broken vessels, cracked mirrors or teacups and the like. Rummaging through his own subconscious, Gauguin painted *The Loss of Virginity* in which the dog fox de Haan perches on the chest of the newly deflowered girl. A strikingly more affecting and appropriate image than a cracked teacup.

Hours at the Café Voltaire bore fruit when Charles Morice introduced Gauguin to Stéphane Mallarmé, the latest poet navigating the subconscious seas sailed by Baudelaire and Rimbaud. Mallarmé's *Mardis*, his Tuesday salons in his tiny flat in the Rue de Rome, were Paris's current centre of cultural influence. Mallarmé, now forty-eight, was 'not very tall, and rather sickly-looking with a solemn and melancholy face, conveying a slight bitterness upon which were already etched the ravages of anxiety and

disappointment. He had tiny, delicate hands and his gestures of a rather affected nature were awkward and faintly annoying. But his eyes were bright and clear like those of a little child, with a distant, transparent look, and his voice, which was fluent and accentuated in rather a deliberate way, was very warm and caressing.'[15]

In the struggle between the real and the invisible, Mallarmé was haunted by man's powerlessness to overcome fate, summed up in his poem *Un coup de dés jamais n'abolira le hasard* (*A Throw of the Dice Will Never Abolish Chance*). Another poem compares human beings to swans, longing to soar into the sky while trapped in the frozen waters of a lake. Gauguin, who had so far willed every step of his unorthodox life, was unmoved by the argument privileging fate over free will, but he was profoundly interested in discussing Mallarmé's angle on *Gesamtkunstwerk*.

Mallarmé's concept of symbolism was built on this idea. Rather than articulating art in a limited language of specific symbols, Mallarmé was interested in simultaneous perceptions into universality, 'the prismatic subdivisions of the Idea' which, however fleetingly, seemed to articulate the inarticulable as they overcame the apparent barriers between the arts. Mallarmé was, like Wagner, Rimbaud and Gauguin himself, gifted with synaesthesia. Senses overlapped. Gauguin does not write about his own synaesthesia directly but refers to it in passing every now and then. For Gauguin music had colours and pictures had sounds.

Mallarmé's synaesthesia was the grapheme variant. Letters were his instrument in unleashing the involuntary simultaneous stimulus of the brain connecting the prismatic subdivisions of the Idea in that maddeningly ungraspable and incommunicable moment when the doors of perception are opened to reveal a blissful whole, such as Verlaine described in his drug-induced revelations. Mallarmé was no painter. His stairway to heaven worked through playing with typography on the page; his subconscious reflex was released by the arrangement of words and letters on the white rectangle. Placed to his precise instructions, freed from the convention of linear narrative, they triggered in him and (he hoped) the reader the release of the further (synaesthetic) dimension of comprehension. In this he, like Gauguin, was seeking to reach right back to prehistory, to the origin of letters, words

and language as symbolic embodiments of comprehension and, as such, magical symbols in their own right.

Mallarmé was interested to meet Gauguin as the reputed leader of the Symbolist-Synthetist painters. Music, as the abstract, conjurative art, played a large part in both Gauguin and Mallarmé's compositional processes. It so happened that the leading Symbolist composer was Claude Debussy, who had been the 'ward' (i.e. the son of the mistress) of the elder Arosa brother. Unconscious of each other, both Debussy's and Gauguin's creative lives were entwined as they grew up. At the 1889 expo, they had dreamed the same dream of synthesising Eastern and Western art. Debussy was inspired by the gamelan music he heard in the Khmer pavilions, Gauguin by the temple troupes who, dancing to the gamelan, imitated their forerunners frozen in stone. Debussy connected closely to Mallarmé, whose *L'Après-midi d'un*

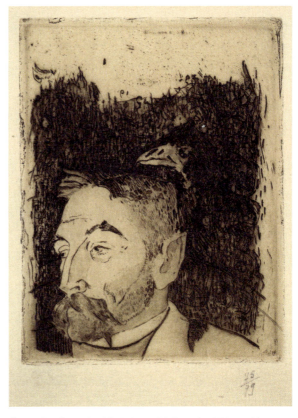

Gauguin, *Portrait of Stéphane Mallarmé*, 1891, etching

faune he set to music. Debussy was a welcome guest at Mallarmé's *Mardis*, but he was shy, and seldom came along. Fate's roll of the dice decreed that the two never met as adults.

Mallarmé had translated Edgar Allan Poe's poem *The Raven* into French. In homage, Gauguin made a portrait of the poet with Poe's raven alighted on his shoulder, as though flown in from Hades to croak the secrets of the grave into his ear. Mallarmé liked the picture very much.

When Gauguin had been attending the *Mardis* for a couple of months, and was secure in Mallarmé's favour, Charles Morice broached the subject of someone writing an article on Gauguin. Mallarmé thought this was a good idea, but he had no illusions as to the limits of his own sphere of influence. He knew that his own writings were too obscure to release francs from the wallets of the art-buying public. Octave Mirbeau was the man! His clever writing reached both the intellectual high ground and the newspaper reader. Mallarmé wrote to Mirbeau, who responded with a sumptuously over-egged article extolling Gauguin's tawny golds, poisonous greens, hallucinatory statuettes, sexual flowers, tempting convolutions, the whims of his imagination and the dreams of this man who had seen everything, mourned everything. It was published in *L'Écho de Paris* a week before the sale. Delighted, Gauguin used the article to preface the auction catalogue.

On 23 February 1891, the sale of thirty works took place in the Hôtel Drouot. It was well attended. Mallarmé was there with the Mardistes. Degas came. Apart from one picture, which Gauguin bought himself to drive the bidding up, everything sold at between 250 and 900 francs, totalling 7,350 francs after expenses. Feeling it should have raised more, he characterised it as more a moral success than a financial one, but it would be enough to buy his passage to Tahiti.

He would now be going alone.

A flurry of articles in the press describing Gauguin as the leader of the Symbolist-Synthetists had roused Émile Bernard to fury. He thought the title belonged to himself. On the eve of the sale, he stormed into the saleroom, publicly denounced Gauguin as an imposter, and flounced out of Gauguin's life for ever in a flurry of resentment and jealousy. Gauguin responded coolly that putting labels – any labels – on artists was as restrictive

as putting corsets on women. Programmes and manifestos placed senseless restriction on the freedom of expression that must be the first condition of any creative artist.

Mette wrote to him with two pieces of alarming news: their eldest son Emil wished to train as an officer in the Danish navy, and Clovis had fallen out of a window. Mette said that Clovis was not much harmed by the fall, but Gauguin was terribly anxious for Clovis, and the news of Emil horrified him. Gauguin hated the officer class as much as he hated stuck-up Danes, and if Emil were to join the Danish navy, he would have to give up his French citizenship.

During their six years apart, Gauguin and Mette wrote to each other constantly. His letters are complicated by guilt at his failure to support the family. Mette's anger at the same made for poisonous exchanges but passion still boiled between them. Their full-bloodedly quarrelsome letters brim with unreasonableness and aggression but underlying is the absolute assumption that they are welded together as a couple, and the outcome will be that they somehow will manage to come together as a family.

Mette's letters are practical and tough. They reflect both her fatalism and her confidence in her capacity to cope with whatever the world threw at her, born of her responsibility as a ten-year-old taking charge following the death of her father. Gauguin found her letters dry and unemotional. Repeatedly he urged her to sign them off more warmly than 'your devoted wife' but she never did, regarding such effusions as showy, silly and unnecessary within the framework of the marriage vow. Gauguin's letters and his signoffs reflect all the passions ranging from jealousy, adoration, reproach and threats to self-pity. Longing to ignite reaction in her, he was ignoring the fact that it was Mette's unswerving, and often unnerving, independent steadiness of principle that had enchanted him in the first place, and still kept him in thrall.

Mette's family were urging her to divorce. Her brother Aage was preparing the documents even as she and Gauguin were secretly planning for Gauguin to visit her. Mette found it immoral and incomprehensible that a mother of five children should sever ties from their father. 'His letters upset her, but she never complained to the people who looked down on him but hid her sorrow

and her trouble. So long as Paul took full responsibility for his actions, and she had done nothing to hinder that, she did not see herself as a victim. So long as she was mother to his children and lived her own life, she did not see her life as purposeless or diminished.'[16]

When Gauguin had returned to France from Denmark, she had refused to move back to live with members of her own family in Copenhagen but stayed in the apartment where they had lived together. Her French lessons blossomed into an unexpected advantage when a wealthy builder joined her pupils and found her a better apartment on favourable terms in the best part of town. Like Gauguin, Mette was fond of good things, and she lived there very comfortably, even employing a maid. French lessons did not cover all the bills, and when she found herself short, she asked Gauguin for money. If the only thing forthcoming was a guilty excuse, she followed up by asking him which picture from his collection she should sell next. The thought of his collection, a precious part of his 'museum of the mind', being dispersed one after another was agony for Gauguin, but it salved his conscience, and he advised her well. He gave further good advice when he told her that she should extend her French lessons into translation work, which resulted in her translating Zola's novels into Danish. Zola was all the rage. Mette's apartment with its French furniture and Gauguin's ravishing collection of French art hanging on the walls became the centre of Denmark's avant-garde, for whom Paris was the centre of the world as they dripped water into their absinthe in Copenhagen's Café Bernina. After the Bernina closed, everybody went on to Mette's. She loved an all-night party, was quick with repartee, and her utter disregard of nonsense reached legendary status when one night an intruder appeared in her bedroom, and she jumped out of bed naked and chased him out. After that she appropriated a cavalry sword belonging to an ancestor and slept with it on the wall above her bed. The only thing that frightened Mette was sleeping in the dark. She always kept a light on.

'Within the context of femininity defined as missishness and artifice, she in her way also saw herself as a noble savage. A tendency to arrogance, never insinuating, never bowing to the superior male, or female, she could be as tactless as her husband,' observed Pola, their son. 'She didn't much care how she brought up her children, there was no strict rule of right or wrong so

long as they took responsibility for their actions and had sufficient strength to cope with things if they went wrong. There wasn't much punishment or praise. She held herself away from petty and, to her, unimportant issues, and so she seemed remote and was called cold.'[17]

She cut her hair short. Taken together with her husbandless state, assumptions of suffragettism and lesbianism followed. When she met Princess Marie of Denmark, the Princess remarked, 'One can see you are one of Denmark's emancipated women from your hairstyle.'

'Your Royal Highness is mistaken,' Mette replied. 'When I cut my hair it was the better to display my sculptural head.'[18]

She did have a good head, as we see from Gauguin's marble bust. It was he who had advised her to cut her hair short.

At forty, her figure was thickening. With Gauguin's visit impending, she asked him to bring her some corsets from Paris when he came over. His ardent response anticipated his removal of the corsets, but it also set up anxiety about how she would find his own forty-two-year-old self.

'Your photographs show you all so smart. I wouldn't dare be seen with you in my old clothes.'[19] He bought a new pair of shoes and a beret. Otherwise, his old clothes must be content with pressing. The two of them agreed it would be best for him to come incognito and stay in a hotel. It suited both their unspoken agendas: his to avoid meeting her disapproving family; hers to avoid sleeping with him. Mette had always found him sexually irresistible. The last thing she wanted was another pregnancy.[20]

At the railway station, a few empty seconds of non-recognition refocused on their new reality. At forty-two, Gauguin had turned into a grizzled eagle, his longish black hair threaded with white, his great hooked beak of a nose more imposing in the lined face. He was wearing his now-habitual, very distinctive dress: white shirt beneath an embroidered Breton waistcoat beneath a black woollen jacket adorned with silver buttons. Mette's own dress had not deviated from the style she had adopted before she had even met him: frill-free tailormade clothes, neat and well kept; ankle boots buckled rather than laced, saving time. She had taken up the Danish habit of smoking cigars. Their pungency rendered her personal scent, which he remembered well, even more intriguing to him. Beside her stood two lanky adolescents:

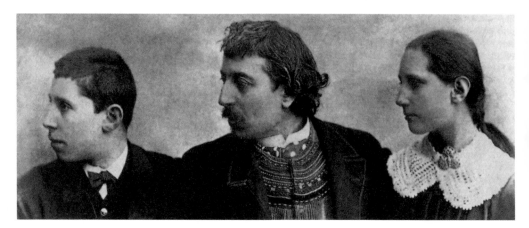

Emil, Gauguin and Aline in Copenhagen, 1891

his two eldest children, Emil, seventeen, and Aline, thirteen. Gauguin saw nothing of himself in Emil, the would-be Danish naval officer whose rounded face and militarily short hair gave him a stolid air.[21] Aline enchanted him. She was Flora Tristan, his mother, himself; the generations synthesised in her dark colouring, tough little body, coarse black hair, inky eyes and her quality of being aboil with intensity. A *coup de foudre* took place on the station platform. Aline and her father were simultaneously struck. Before the week was out, she said that when she grew up, she wanted to marry him.[22]

His luggage was deposited at the Dagmar Hotel in Vestre Boulevard, and they went on to Mette's flat, where the other three boys were lined up to greet him in chorus.

'Bonjour, Papa.'

They had no other words in French. Clovis, whom Gauguin especially loved, could not even say *bonjour*. He hid behind the others, hanging his head in shame. Clovis had been problematic ever since coming back from France. Unco-operative at school, he was now twelve, and had been taken out of school to become an apprentice in the Titan Machine Factory, a hard course of life but it made him happier than the classroom.

It was an appalling reunion for Gauguin on realising that he and his children had no common language. Mette had to act as interpreter. March is a cold month in Denmark, and the majority of the family's time was spent indoors in Mette's flat. 'She pitied him as much as she pitied herself. Being

practical rather than amatory, she did not let her feelings run away with her but reviewed all the consequences that might ensue. He interpreted this as treachery towards him, a plan concocted by her correct and unimaginative family, which always put duty first.'[23]

They discussed the preparations her brother had made for their divorce. She said she did not want to take responsibility for such a course of action but would leave it up to him. He was strongly against it. He would be certain to make enough money in Tahiti to send for them in a couple of years.

The children remembered the time as happy. Aware of the tone and timbre of the words, if not the meaning, their impression was of discussions passing peaceably as their parents decided on the future. The week's high point came when Gauguin extravagantly hired a horse-drawn carriage to take the children to ride round the streets of Copenhagen like royalty. Everyone stared. The children waved. They never forgot the pride of that flamboyant carriage ride with their father.

He could not stay longer than a week. His Paris friends had planned a farewell at the Café Voltaire. Gauguin and Mette parted amicably with good intentions on both sides.

Back in Paris, he returned to twenty-year-old Juliette Huet who had modelled for *Ondine, Life and Death* and *The Loss of Virginity* and had become his mistress. She is the first mistress we know by name, possibly the first in fact. His sexual abstinence through the Pont-Aven period had been much discussed among the artists, most of whom saw their summer school as an opportunity to have affairs. Gauguin exuded virility. Celibacy added to his mystique in the promiscuous artists' colony. In Le Pouldu, things had changed and he had sneaked down the narrow stairs to have sex with the welcoming maid. Maybe his stern resolution had cracked as he lay in bed night after night listening to de Haan and Marie Poupée making love in the next-door bedroom through the cardboard-thin wall.

Juliette Huet was too thin to be popular as a life model and this had made her cheaper for him to employ. While he was fond of Juliette, she does not seem to have made any impression on him as an individual, a character or a person.

On his return from Copenhagen, he was confronted with the fact that

Juliette was two months pregnant. He might abandon her, as de Haan had abandoned Marie Poupée in the same circumstances. Instead, he gave her a small lump sum from the proceeds of the art sale, installed her in a room of her own and bought her a sewing machine. This was the honourable way of going about things: you set your mistress up with a source of income as a seamstress until she found her next 'protector'. Not much had changed for single women in Paris's merciless society since Aline's day as a seamstress. What a lucky roll of the dice for Aline to turn up Gustave Arosa!

During his absence from Paris, his friends had been continuing to lobby the Minister of Education for some sort of official recognition, preferably attached to a fee, to acknowledge his 'artistic mission' to Tahiti. A piece of paper with an official stamp would be invaluable to impress Tahitian authorities. Through gritted teeth, Gauguin wrote a begging letter to the director of the Beaux Arts. It produced the requisite piece of paper giving him a 15 per cent discount on the price of the voyage and a commitment on behalf of the State to purchase a picture for 3,000 francs on his return. Charles Morice, who had accompanied Gauguin on the mission, was cock-a-hoop at their success, but on the way home, Gauguin remained silent.

'I observed that now his long period of painful struggle was over and that now, at long last, he could accomplish his task without distractions. Glancing at him as I spoke, I too in my turn fell silent, astonished by the despair on his face. His colour, naturally a leaden grey, had suddenly turned pallid; his features were distorted, his eyes unseeing, his gait shambling. I took him by the arm. He started, and pointing to the nearest café said: "Let's go in there."'[24]

When they had seated themselves, Gauguin buried his face in his hands and began to weep.

'"I've never been so unhappy . . . I have failed to support both my vocation and my family. I chose to pursue my vocation, but I haven't even succeeded there. And today, when I have good reason for hope, I am more than ever tormented by the terrible sacrifice I have made and can never retrieve."'

Before they parted he asked Morice to forgive him for troubling him with his tears.

When they next met, a few days later, on 24 March, Gauguin had repaired the crack in his carapace. Morice saw the old Gauguin swaggering into the

Café Voltaire for the banquet in honour of his departure. Over forty guests attended: Symbolists and Synthetists, artists and writers, literary critics and Mallarmé's Mardistes. Notably absent were Émile Bernard and Schuffenecker.

MENU

Potages
Saint-Germain. Tapioca.
Hors d'œuvre
Beurre. Olives. Saucisson.

*

Filet de barbue sauce dieppoise

*

Salmis de faisan aux champignons
Gigot d'agneau rôti
Flageolets maître d'hôtel

*

Fromage Brie

*

Corbeille de fruits
Petits fours glacés

*

Vin Beaujolais

Mallarmé proposed the first toast: 'Let us drink to the return of Paul Gauguin, but not before we express our admiration for his superb conscience, which, at the height of his talent, summons him to exile, so that he may re-immerse himself in those distant lands and in himself.' Morice read a poem composed for the occasion. Heavily indebted to Loti, he hymned the idyll that awaited Gauguin in the land of sweet desire, peopled by living statues from man's primeval age, delightfully clad only in sunbeams and fragrant flowers. A younger symbolist poet, Julien Leclercq, paid a formulaic tribute, its dullness

Overleaf: Gauguin, *Arearea*, 1892

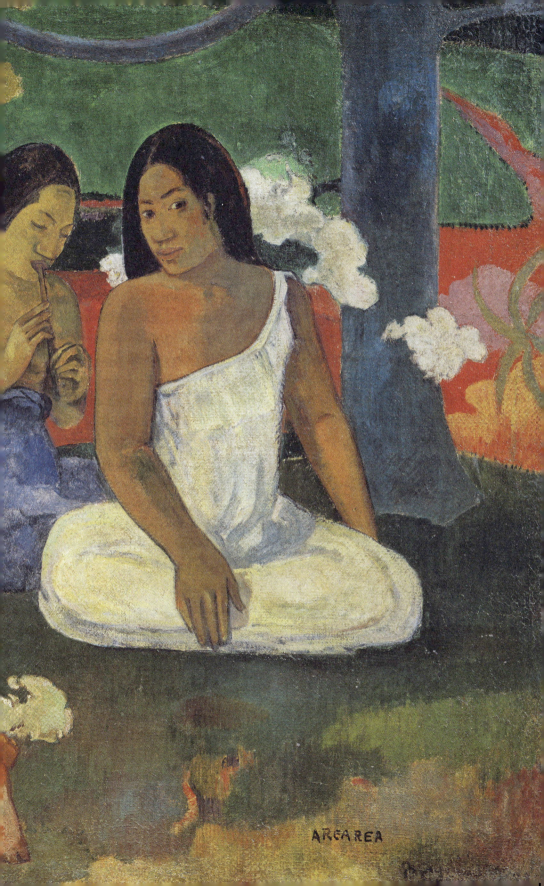

prompted by his overwhelming awe of the distinguished company and the occasion. Mallarmé read his poem 'The Tomb of Edgar Poe'. Finally, Gauguin rose to speak. 'I love you all,' he said, 'and I am very moved. I therefore cannot say much or even speak well. Several among us have produced great masterpieces. I drink to them, together with all great artworks still to come.'[25]

The next day he wrote to Mette, promising that within three years she would no longer have to work and then,

'In the absence of passion, let us go together into the future white-haired, entering an epoch of peace and spiritual happiness surrounded by our children, flesh of our flesh . . . Goodbye dear Mette, dear children, love me well. And when I return, we will be re-married. It is therefore a betrothal kiss that I send today.

'Your, Paul.'[26]

He would never see Mette or any of his children again.

12

POISONED PARADISE

A hundred metres of canvas, a large collection of paint tubes from Lefranc & Cie, a rifle to shoot the wild game he would eat, a French horn, two mandolins, a guitar, a pile of music by Schubert and Schumann, at least a hundred postcards and photographs that he sometimes called his 'little friends' and sometimes his 'museum of the mind'. The temple friezes of Borobudur, Javanese dancers striking attitudes at the expo, an album of collotypes of Arosa's picture collection immortalised with the help of Nadar, Raphaels, Corots, Dürers, Degas, Manet's *Olympia*, and of course many Cézannes. They were to act as the springboards for his imagination, as well as providing the standards to measure his new work against.

At the Gare de Lyon, Gauguin's friends helped him load his luggage onto the train to take him to Marseilles. There, he boarded the steamer *Océanien*, newly appointed and so luxurious that he noted regretfully that third class would have been perfectly adequate and would have saved him 500 francs. The voyage raised no nostalgia for his seafaring days. It was an interlude of almost idiotic mental passivity; 'I stare stupidly at the horizon.' The porpoises shooting up from the waves to bid him good morning were far more amusing than the passengers, 'all of them employees of the Government, this benevolent Government which foots the bill for all these little outings, with removal expenses for women and children thrown in. They are worthy people at heart and have only one drawback, a fairly common one, that of being absolute mediocrities.'¹ Gauguin was not in good humour; he saw nothing to please him as he skimmed through the Suez Canal, Aden, Mauritius and Madagascar. Australia displeased him most of all for its 'stupid burlesque of grandiose English style'.

Heading into the Pacific, he arrived at the little island of Nouméa, a French penal colony. 'What a funny colony Nouméa is! Both pretty and amusing . . .

the released convicts are the richest . . . their wives ride around in carriages . . . this makes me truly envious of those who commit crimes . . .'[2]

Here he had to change ships to the *Vire*, a three-masted schooner past its best. Rotting, patched and crawling with cockroaches, the ship's job was not to impress newly signed immigrants but to shuttle existing military and administrative cogs in the colonial machine. Gauguin was crammed in with thirty marines, a selection of gendarmes, soldiers and one, lone Tahitian woman, Miss Fanny Faatauria. Thankfully, she seems to have been granted safety and dignity throughout the voyage. The officers invited him to dine with them, and he enjoyed it. His hatred of the officer class didn't debar him from liking them as individuals and he struck up a particular friendship with Captain Swaton who was travelling out to take charge of the garrison in Tahiti. There is a portrait of Swaton looking rather like Goethe in the famous portrait by Tischbein, dashingly romantic in a wide-brimmed hat. It used to be thought that Gauguin painted it, but it has since been reattributed to Paulin Jénot (to whom Gauguin later gave painting lessons when they arrived in Tahiti), thus confirming Gauguin's words that between departure and destination, his mind simply floated, blank.

On 6 June 1891 he celebrated his forty-third birthday. Two nights later, 'on the night of 8 June, after a voyage of sixty-three days from place to place, days which for me were full of impatient dreaming, of feverish longing for the promised land, we caught sight of some strange specks of light moving in zigzag fashion on the sea. A black cone detached itself from the dark sky.'[3]

The zigzagging specks were outrigger fishing canoes bobbing about on the choppy water, carrying little lanterns to trick flying-fish to jump into their nets. The black cone was the island of Tahiti, a conjoined cluster of extinct volcanoes rising sheer from the sea like battlemented castles silhouetted against a blue-black sky thickly sprinkled with an unfamiliar pattern of stars.

They dropped anchor off Point Venus, named not by de Bougainville in honour of his erotic encounters of 1768, but by Captain Cook, who had arrived the following year on a scientific mission to observe the transit of the planet Venus across the sun, an event that only happened every 243 years. Nobody had actually seen the transit of course but if Cook observed it, the world would be the richer for being able to measure the distance of the earth from the sun and, by extrapolation, the size of the solar system. Transit day,

fortunately, was cloudless. Cook observed the event. Enlightenment science marched on, as did the fairy-tale legend of Tahiti's tropical paradise of free love, first reported by de Bougainville, later confirmed by Cook.

'As we came nearer the shore, all the people came crying out *tayo*, which means friend, and gave a thousand signs of friendship; they all asked nails and ear-rings of us. The periaguas [canoes] were full of females who, for agreeable features, are not inferior to most European women and who, in point of beauty of the body might, with much reason, vie with them all. Most of the fair females were naked, for the men and old women that accompanied them, had stripped them of their garments . . . The men . . . soon explained their meaning very clearly. They pressed us to choose a woman, and to come on shore with her; and their gestures, which were nothing less than equivocal, denoted in what manner we should form an acquaintance with her. It was very difficult, amidst such a sight, to keep at their work four hundred French young sailors, who had seen no women for six months. In spite of all our precautions, a young girl came on board and placed herself upon the quarter-deck, near one of the hatchways, which was open, in order to give air to those who were heaving at the capstern below it. The girl carelessly dropt a cloth, which covered her, and appeared to the eyes of all beholders, such as Venus shewed herself to the Phrygian shepherd, having, indeed, the celestial form of that goddess. Both sailors and soldiers endeavoured to come to the hatchway . . . At last our cares succeeded in keeping the bewitched fellows in order, though it was no less difficult to keep command of ourselves.'[4]

De Bougainville had no alternative but to permit his overheated crew to obey the welcoming gesticulations into the canoes. Frail vessels bobbing with lustful men made the short journey to beaches as the longer mental journey transported them aeons back to the Golden Age before sex became problematical. Lightened from the burden of original sin, they anticipated total freedom but, just as they felt themselves free of all moral constraints, de Bougainville's crew detumesced. Sex in this Eden was not a private affair. Stripped naked and examined in excruciating detail before being urged to go ahead with the girl while surrounded by a watching circle, many could not manage it and fled back to the boat. The cook confessed to de Bougainville that nothing in his life had frightened him so much as what had just occurred.

Having claimed Tahiti for France, de Bougainville sailed away with an islander named Ahutoro on board. Ahutoro was presented to Louis XV at Versailles and singled out as a favourite of the Duchesse de Choiseul. He enjoyed terrific success in Paris, becoming the social sensation of 1769, but sadly he died during his voyage home.

Cook stayed longer than de Bougainville. He reported that his ship, the *Endeavour*, was almost falling apart due to the Tahitians' hunger for metal, a substance 'unknown to them before he landed'. Cook's accounts of what he coyly referred to as the 'rites of Venus' confirmed de Bougainville's. Cook returned to Tahiti twice. A true son of the Age of Reason, Cook was interested in questions of comparative morality. He had found himself profoundly shocked by a public display of sexual intercourse between 'a girl of eleven or twelve' and a fully adult man, put on for the pleasure not only of Cook and his crew but also of a large Polynesian audience that included 'several women of superior rank, who may properly be said to have assisted at the ceremony; for they gave instructions to the girl how to perform her part, which, young as she was, she did not seem much to stand in need of. This incident is not mentioned as an object of idle curiosity, but as [one that] deserves consideration in determining a question which has long been debated in philosophy: whether the shame attending certain actions, which are allowed on all sides to be in themselves innocent, is implanted in nature, or superinduced by custom? If it has its origin in custom, it will, perhaps, be difficult to trace that custom, however general, to its source; if an instinct, it will be equally difficult to discover from what cause it is subdued, or at least over-ruled among these people, in whose manners not the least trace of it is to be found.'[5]

Like de Bougainville, Cook also brought back to Europe a willing and attractive young man in his twenties. 'How do, King Tosh,' Mai is supposed to have said on introduction to George III. London's hearts were won. Mai became the darling of fashionable society, where English interest in their visitor proved rather less libidinous than French – in public, at least. Whereas Paris had marked the occasion of their distinguished visitor with a famous brothel entertainment, London commemorated his visit with an instructive play at the Theatre Royal, Covent Garden, called *Omai; or a Trip around the World*. We don't know from Mai himself how he experienced his English welcome.

Unsurprisingly, he left no account. Did he feel like a guest or a curiosity as doors flew open to him? Invitations rained down, born surely of social competition, condescension and curiosity, but the man himself shamed and confounded such unworthy motives. Reports of the time say he was liked for his natural good manners which gained him the respect of the highest in the land. Dukes invited him to shoot game birds on the moors (today the British royal family extend similar invitations to honoured guests). Following the avian slaughter, they watched him cooking the birds the Polynesian way in an *umu*, an earth oven, and professed it delicious. On a more serious note, he was taken to the bosom of Enlightenment as he participated in the pioneering programme of inoculation against smallpox and had his portrait painted by Sir Joshua Reynolds, the first president of the Royal Academy, who depicts Mai as an admired fellow member of the human race rather than an alien curiosity. Draped like a Roman senator in toga-like cream robes, standing in the pose of the Apollo Belvedere, the 'savage' is placed for the first time securely within the European Enlightenment canon, but the artist does not omit the tattoo on the hand holding the toga in place. Seen through today's political lens, Reynolds's portrayal of a Polynesian as an idealised ancient Roman is patronising and insulting and qualifies as colonial appropriation. However, at the time, Reynolds was taking a brave stand in displaying a non-European figure in the place that since 1523 (when the first classical statue had been publicly displayed in Renaissance Italy)[6] had embodied the humanist ideal. Reynolds's portrait shows Mai as the personification of intrinsic noble simplicity and quiet, self-confident grandeur.[7]

In 1776, Mai returned home with Cook on his third voyage. He was laden down with all sorts of gifts that in themselves illustrate the vast gulf of misunderstanding that can just as easily be generated by goodwill as ill will. Port wine, gunpowder, muskets, tin soldiers, a globe of the world, a horse and a suit of armour.

It was through these romanticised accounts embroidered upon in Loti's novels that Western eyes still saw Tahiti.

A coral reef running round Tahiti forms a jagged ring just below the surface of the sea. To hit it means shipwreck. Swaying at anchor, Gauguin's ship had to wait until daylight when they would be able to see the narrow gap in the

reef, and shoot for it. He said that excitement kept him awake all night, and he heard his heart reverberating to the beating of the waves. Spume curled from their tops like a Hokusai print, and the little fishing lanterns bobbing on the dark surface of the sea looked like one of Vincent's cartwheeling skies.

Soon after five o'clock, a line of pale green washed the horizon. The sky flushed lemon, pink, magenta. The black turrets resolved into thickly forested peaks. With dawn came the particular fragrance of the island wafting across the water. *Noa noa*, they called it, the narcotic scent of wild orange blossom, frangipani, jasmine and *tiare*, the Tahitian gardenia. As the boat glided into the Papeete channel and cast anchor, he gazed with deep emotion.

Papeete's mile-long bay curved like the virgin moon. No house in sight. The water in the lagoon was glassily transparent, faintly washed with turquoise. A glittering line of blackish-brown volcanic sand rimmed the scalloped shoreline. Above it bulged a blowsy band of scarlet flame trees in flower. Palm trees, giraffe-necked and tousle-headed, rose out of the billowing red.

As their boat shot the gap in the reef a fleet of fast black beetles scuttled towards them. Pirogue canoes: their job to bring the passengers and their luggage ashore.

Ecstatic on arrival, his elation lasted as long as the push through the flame trees. Where the scarlet blossoms petered out, he saw a landscape of loneliness and submission, shaped by eleven years of French colonial rule.

In 1842, Tahiti had become a French protectorate, with its capital Papeete the seat of the administration. By 1880 it was a full-blown colony. Four years later, Papeete had burned down. This was a local event that happened every so often. The latest conflagration would be greeted calmly and unfussily by the inhabitants, who simply walked into the forest to gather materials to build replacement houses. Bamboo formed the basic skeleton into which pandanus leaves were woven and braided to make walls and roofs. But, following the fire of 1884, the French banned houses built of these local materials and walls had to be constructed of imported brick, roofs of imported sheets of iron. The terrible idea of material permanence had been imposed upon this non-materialistic people. Gauguin found the sight of Papeete both aesthetically appalling and culturally offensive.

France's 'civilising mission' looked like a cheap, half-finished European

building site. Unplastered brick houses rose in straight lines that had no relation to the topography of the place but had plainly been inspired by French town planners' Haussmannesque mania for grids. Two church spires stuck up from the sprawl, one Roman Catholic, one Protestant, glaring at each other across rusting tin roofs. Roused by de Bougainville's and Captain Cook's libidinous accounts, missionaries had arrived from France and from England. Catholic and Protestant had been playing tug-of-war for Tahitian souls ever since.

As in the Garden of Eden, so in French Polynesia. Bare flesh was the first victim to fall to the fatal impact of Biblical Truth. Both sets of missionaries, though agreeing on little else, were in unison on the sinfulness of nudity and the moral necessity for clothing. The only female flesh Gauguin glimpsed on Papeete's depressing main street consisted of faces and hands sticking out from all-enveloping shape-concealing missionary dresses made of imported cotton, reaching from chin to floor, universally known as 'Mother Hubbards'. The men wore equally bulky lengths of imported cotton wrapped around their loins. Above this, a white shirt, and a straw hat.

Gauguin came ashore dressed in a purple suit over his embroidered Breton waistcoat, with his Buffalo Bill cowboy hat on his head, and his cowboy boots. This made a strong, indeed unique, contrast to the French ruling class who wore either military uniform or, if they were traders and businessmen, black tailcoats for work and white linen suits for recreation. Beneath Gauguin's wide-brimmed Buffalo Bill, his long salt-and-pepper hair waved freely in the coastal wind. As he stepped out of the canoe on to Tahiti's shore, Tahitian men and women on the quay pointed at him, raised their hands to their mouths, tittered behind their fingers, and rolled their eyes. They had never seen anything like this.

It was his hair. '*Taata vahine*,' they giggled, '*mahu*' – 'man-woman'. Only *mahus* wore hair that long, and they had never seen a European *mahu* before.

Mahus were individuals born male but brought up as females from an early age in a household that decided it needed a daughter rather than a son, or a village that needed a *mahu*. As far as memory stretched, Polynesian society had been rigidly divided into sexual roles. Women's roles were limited by strict taboos that kept them in a constant state of subjection. Domestic work and

family order were their realm. Women were not thought of as fully human. It was *tabu* for them to enter the sacred sites of worship. This worked to their advantage in that they were not valuable enough to be sacrificed to the gods on these sites, an honour reserved for males, whose higher status made them worthy sacrifice. The last recorded human sacrifice had taken place forty years before Gauguin's landing. As honorary women, the same *tabus* applied to *mahus* as to women. *Mahus* wore their hair long, dressed as women and undertook the same home chores, handicrafts and arts that, in their turn, were *tabu* for men. *Mahus* were not necessarily homosexual, though they might be. One of their unwritten roles (Polynesia had no written language until the missionaries arrived, before which everything was transmitted orally and written in carvings and tattoos, which the missionaries banned) was to initiate boys sexually if the *mahu* was so inclined, but equally the *mahu* might marry and father children if so inclined. Socially, *mahus* stood in an uneasy place. Created by a rigidly organised society, they were allowed fluidity of being, and this pushed them out to the edge. *Mahus* were the butt of jokes, as objects of fear often are. Gauguin understood none of this until much later.

He remained on the quay feeling uncomfortable and wondering what he was meant to do next. A man in uniform hurried up, panting. It was Lieutenant Jénot, whose job was to welcome the two important Europeans, Gauguin and Captain Swaton, the new garrison commander. He conducted them both to his nearby house, which was promptly surrounded by a clamouring crowd wanting to catch sight of the foreign *mahu*. Lieutenant Jénot had to resort to driving them away, while maintaining the fiction of a dignified reception.[8] He told Gauguin that the first thing he must do was present his credentials to Governor Étienne Théodore Mondésir Lacascade, the man whose duty was to enforce French rule and the French 'civilising mission' popularised by the propagandists of colonial expansion in the name of upholding the myth of universal values of the French Republic and the Declaration of the Rights of Man. The republican principle of assimilation insisted that French colonies should be integrated into the judicial and administrative framework that prevailed in the mother country. However, under the Third Republic a way round this had been discovered. A legal distinction was drawn between subjects and citizens. The indigenous

populations were excluded from citizenship. This restricted their legal status and subjected them to extraordinary judicial regulation according to the Code de l'Indigénat, enacted in Algeria in 1881. It assigned a separate legal status to the native population and created new offences that did not apply in France itself. With the new offences came new penalties.

Gauguin was not the first to be unimpressed by the man representing the Rights of Man in Tahiti. Another visitor described Lacascade's manner as 'a sort of Japanese mixture of deference, patronage and suspiciousness'.[9] Lacascade received Gauguin in a black frock coat and a nimbus of self-importance. His round face would have been much more dignified had he not succumbed to the fashion for outsize muttonchop whiskers which made his face broader than it was long: a gift to Gauguin the caricaturist, who disliked the man at first sight. The dislike was returned. The governor found the artist's dress and hair disrespectful, and his presence suspicious. Before Gauguin's arrival, Lacascade had received a letter from the Colonial Department alerting him to Gauguin's arrival on an 'official artistic mission'. No artist had been sent on such a mission before and this led Lacascade to conclude that Gauguin's real official mission was to spy on him and to report back to Paris on how he was governing the colony. During the interview, Lacascade was all smoothness and courtesy. Gauguin found this both insincere and amusing, but he had no scruples in accepting the offer of accommodation in a government guest house until he should find something to suit him better.

The population of Tahiti at the time was about three thousand, of whom a couple of hundred were French. Gossip travelled fast. If Gauguin was an undercover agent, he would report back to Paris, not only on Lacascade, but on all the French. Before twenty-four hours had elapsed, he had become an object of suspicion not only in the eyes of the Polynesians for his novel status as the first European *mahu*, but also among the Europeans for his suspected role as a spy. The Director of the Interior, the second most important official on the island and no fool, invited Gauguin to lunch. Oblivious of any reason to suspect this flattering attention as anything but friendly encouragement, Gauguin wrote complacently to Mette: 'I think I shall obtain some well-paid commissions for portraits. I am constantly being asked by all manner of people to paint them. I think I shall be able to make money here, something I did

not expect. Tomorrow I meet the entire royal family, which will be excellent publicity, however tiresome . . .'[10]

On his first evening, Lieutenant Jénot invited him to the club for French officers, the Cercle Militaire. The island fragrance of *noa noa* rose heavy on the air as they joined the stream of festively dressed Tahitians flocking up the hill to enjoy the night's entertainment, with flowers garlanded around their necks and woven into crowns on their hair. The club itself was for whites only. It was housed in a swanky building on the edge of the municipal park which, like all good French parks, boasted a bandstand of curlicue wrought iron (imported in bits and reassembled) where a band played every Wednesday and Saturday nights. The French officers had a staircase constructed up into the crown of a nearby banyan tree and a platform wide enough to accommodate chairs and a bar in its high branches, like a children's tree house or a tiger hunter's *machan*. Here they sat on dance nights in their uniforms, drinking their absinthe and smoking their cigars while enjoying the excellent bird's-eye view of the whirling *vahines* and their handsome escorts flinging themselves into the dance. When the evening's entertainment was brought to a decorous close by the playing of the Marseillaise, those so inclined repaired to Papeete's Chinatown to drink tea and make private arrangements.

The Chinese formed the third racial segment of Tahiti. They had been brought in following the abolition of slavery in 1852, when the French realised that forced labour remained indispensable. The main influx of Chinese happened in 1865 when a British entrepreneur named William Stewart decided to create a Tahitian cotton industry. Three hundred Chinese were shipped in to work as cheap labour. Cotton refused to grow in the climatic conditions and so the unfortunate Chinese were moved on to other French colonial projects, like digging the Panama Canal. Those few who stayed on ran bars, restaurants, general stores and other little businesses. The Chinese were resented by both the French and the Tahitians. They were seen as exploiters: too enterprising, too successful. They made it too obvious that they had no intention of assimilation or pay-back. Their ultimate interest lay not in the prosperity of Tahiti itself but in making sufficient money to go back home to China to lie in an impressively expensive tomb. Chinatown, however, was

popular, particularly after dark, when it provided an unbuttoned no-man's-land, an interval between the organised musical evenings overseen by the French with their uniforms fastened high to the chin, and the nearby market which by day sold fish and fruit and very little meat, though it was universally known as the meat market.

Soon Gauguin became tired of sitting on the platform with the officers watching the dancing. He climbed down the ladder to join in the fun. His fellow Frenchmen did not approve of his social descent.

His first day on the island had been far from Arcadian. Innocence had been absent throughout.

Loud booms brought him back to consciousness the next morning. Canons were being fired. Was this how every day started in Papeete? No. King Pomare V, the last royal ruler of Tahiti, had died. Gauguin would not now be meeting the royal family. Curious, he made his way to the palace, another building with nothing Tahitian about it. Prefabricated in France and shipped over in parts, the palace might easily pass for the villa of a wealthy plantation owner in any French colony. Symmetrical, two-storeyed, four-square, it was constructed of clapboard and painted wedding-cake white. A fretwork veranda ran all the way round both levels. A raked roof ran up to a point topped by a central lantern. The flagpole was impressively tall.

King Pomare V had acceded to the throne in 1877 and abdicated in 1880, when he had signed away his constitutional rights and the rights of his descendants to France in perpetuity in exchange for a pension of 5,000 francs a month. It went mostly on drink. When Gauguin arrived at the palace, he found the dead monarch laid out in the uniform of a French admiral, and the French Director of Public Works fussing about, organising the obsequies. On spying the maybe-spy Gauguin, he decided to flatter him by suggesting he take charge of decorating the funeral parlour. Gauguin was horrified at such insensitivity. He had been watching the widowed queen arranging flowers and greenery according to tradition and he had no intention of imposing inauthentic decorations upon this historic scene.

The cortège left the palace with King Pomare's coffin enclosed in what looked like a curtained four-poster bed swagged in black draperies, its bullion fringes swaying with every step taken by the mules drawing it, also

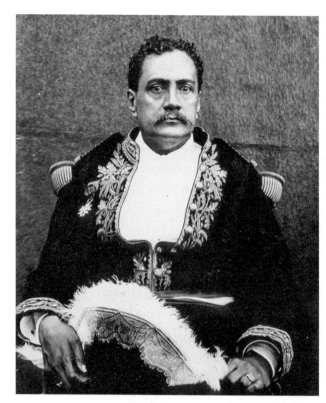

King Pomare V

The handover of the flag of the protectorate to Governor Lacascade by Prince Hinoi on 18 June 1881

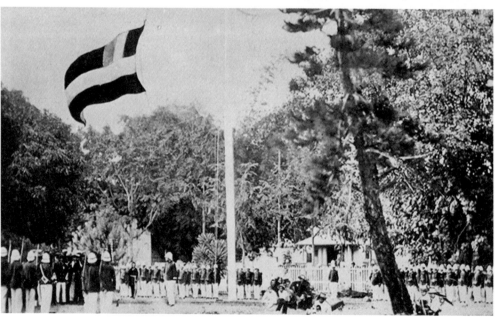

draped in black. Behind marched French troops and officials in black, with white helmets. Behind them marched the Tahitians organised into districts, each led by its chief bearing the French flag. They processed three miles to the royal grave where Gauguin's hopes of timeless ritual and an ancestral vault were dashed by a recently constructed mound of formless lumps of coral hastily cemented together. Priests and chiefs stood around as awkwardly as performers at a school concert. Their speeches given in Tahitian were ponderously translated into French. Lacascade delivered a short eulogy of non-stop clichés. This done, the French piled into carriages. Gauguin thought they looked like crowds returning from the races at Longchamps as they travelled back to take comfort in the officers' bar. Gauguin remained with the Tahitians who returned more slowly, first cleansing themselves from the dust and the past in the nearby river.

"'*Teine merahi noa noa* (now very fragrant)," they said. That was all – everything went back to normal. We were only a king the less. With him there vanished the last trace of former customs and former greatness . . . It was all over – nothing but civilised people left. A profound melancholy came over me. Here I had come this long way for the very thing I had fled from. The dream that had brought me to Tahiti had been cruelly unmasked by actuality. It was the old Tahiti I loved. But I could not bring myself to believe it was completely wiped out, that this beautiful race had not preserved its old glory somewhere or other. But how was I alone to find the traces of that distant and mysterious past, if they still existed? . . . My decision was soon made. I would leave Papeete, go far away from the European centre. I had a feeling that if I adopted the natives' life outright, living among them in the bush, I might at last through patience overcome their distrust and get to know what I wanted.'[11]

To achieve this, he first had to learn at least rudimentary Tahitian. He would ask his new friend Jénot to teach him.

Gauguin began visiting Jénot nearly every day. Language lessons were exchanged for painting lessons. Gauguin taught Jénot to play the mandolin. It was good to have someone to play duets with. Jénot found Gauguin a modest lodging, enabling him to move out of State accommodation and live on his own terms. Gauguin knew his fundamental difficulties with

learning languages. He took his lessons very seriously. He compiled a Tahitian dictionary, and he organised further lessons from the colony's official interpreter, Monsieur Cadousteau, who also told him what he could of the subject of the island's history and culture.[12] Jénot advised Gauguin that if he really wished to demolish the barrier between himself and the locals, he must cut his hair. And if he wished to demolish the distrust of the French and gain painterly commissions, he must turn up at their houses in a white suit. Gauguin saw the sense in both pieces of advice. He cut his hair. On 'civilised' occasions he wore a white suit. Otherwise, he simply went around with a bare chest and a *pareu*, a length of flowered cloth, knotted round his hips.

During the king's funeral, he had noted down some quick impressions in his sketchbook but otherwise he had made little art in the first weeks, as he absorbed the influences and the place. This notable lack of artistic activity lent substance to the rumour that he was a spy. However, once he had smartened up a commission followed.

Suzanne Bambridge was the forty-four-year-old daughter of an English father and a Polynesian mother.[13] A woman of standing in Papeete's small social circle, Suzanne was no conventional beauty, but she was an interesting woman whose appeal lay in her strong character, shrewd gaze and evident intelligence. Gauguin painted all this, but the portrait was not flattering. Suzanne's horrified father paid the agreed fee of 200 francs, and the painting magically disappeared into a cupboard.

Word spread through Papeete that you did not want your nearest and dearest painted by the official artist. Further commissions came there none.

Two fruitless months in Papeete's gilded cage recalled being imprisoned by convention in Copenhagen. He must get away from the rigid colonialism and capitalist modernity of Papeete. He must find a place close to nature, free from economic and moral oppression.

A schoolteacher called Gaston Pia invited him to stay in the village of Paea, down the coast from Papeete. Gaston Pia was an amusing fellow and an amateur painter. Not for the first time, Gauguin's rent would mostly be paid in giving lessons. Soon he chafed. The place was too close to Papeete; there was no wildness about it. He borrowed a horse and carriage and went

Gauguin, *Suzanne Bambridge*, 1891

questing for an unspoilt place where he could exist alongside the people of this place, living beside them, as one of them.

There was only one road running round Tahiti. Less road than optimistic track, it rimmed the island hugging the coast. Gauguin decided to take it anticlockwise, striking out westerly.

'My *vahine* went with me.'

The girl from the meat market who seemed the most kindred spirit and the most willing to join her fate to his was known as Titi (Breast). Gauguin liked her for her vivacity and *joie de vivre*. She dressed for the journey in a

beautiful dress, a necklace of gold-painted shells, a flower behind her ear, and her hair flowing loose beneath a plaited sugar cane hat. 'I well knew that all her mercenary love was composed of things that, in our European eyes, make a *whore*, but to this observer there was more . . .' He respected her innate dignity and her generosity in giving of her love. 'In short, the journey passed pretty quickly – a little insignificant conversation, and scenery that was rich all the time but not very varied. Always to the right the sea, the coral reefs and expanses of water which sometimes rose in smoke when the encounter with the rocks was too violent . . . At the end, I found rather a fine hut which the owner consented to let to me.'[14]

He dropped Titi back in Papeete. She told him she would like to come and live with him in his hut, and when he had it organised to his liking, he picked her up as promised. All too soon he regretted his misjudgement. 'I realised that this half-white girl, glossy from contact with all those Europeans, would not fulfil the aim I had set before me.' It was not Titi's fault that she drove him mad with her chatter, or that her incorrigibly cheerful company coincided with the longed-for arrival of his creativity. The blind period was behind him. The vision was at last unfolding of how he wished to make pictures of this place that he had travelled halfway around the earth to discover.

Titi's energising personality, which he had found so refreshing within the strict colonial behavioural code of Papeete's absurdity, struck false in the deep quiet of the rural agricultural community. Titi liked gossip, dancing and pretty things. She found the country people dull. They found her showy and trashy. In the confined space of the little hut, she resented having to keep quiet while Gauguin worked, and he found her chatter exasperating. By mutual consent, he took her back to the bright lights of Papeete. She was as glad to leave as he was glad to be rid of her distraction.

His rented hut was in the village of Mataiea. The flat ribbon of land edging Tahiti's coastline is mostly so narrow that views are cramped but at Mataiea the coastal plain widens out about half a mile, giving long views in all directions. It is almost as far as you can get from Papeete, situated on the long curve of a south-facing bay nearing the southerly point of the island. Approximately 500 people lived here in a scattering of about 150 huts, mostly hidden from each other among trees. The Christian mission had extended

this far, and Gauguin's hut had a church to either side. Catholic and Protestant. Competitive bellringing punctuated the never-ending boom of surf breaking on the protective coral reef. Gauguin rented the hut from a prominent villager called Anani (Orange), who had made his fortune through the tough business of harvesting and selling the wild oranges that grew high up in Tahiti's volcanic crevasses. The precious fruit made the perilous journey down the mountain in wire cages balanced on a carrying pole across the shoulders. Anani shipped millions of oranges per annum to America, where they became so popular and so highly valued that they prompted the creation of the huge American orange industry. Anani had made sufficient money from exporting oranges to build himself an elaborate European house which he did not like living in, and so he offered it to Gauguin, who said he would rather rent Anani's hut. The deal was done. Anani remained uncomfortable in his Western-style splendour while the white man settled contentedly into the hut.

It stood on the sand among a scattering of palms and breadfruit trees, a typical oval hut located a couple of hundred yards inland. Directly in front, the long south-facing beach of shimmering black sand gave on to glass-clear lapping shallows that gradually coloured from palest aquamarine to deepest turquoise, breaking on the reef in glittering, cream-coloured crests beyond which 'I let my eyes wander to the great abyss of the ocean which swallowed up the swarm of the living, guilty of having meddled with the tree of knowledge, guilty of the great sin of understanding'.[15]

As he looked to his left, dawn broke over Tahiti Iti (Little Tahiti), the small blob of island attached to the main island by a narrow isthmus.

Looking to the right, the view stretched westward fifty miles over the water to the spectacularly jagged turrets and chimneys of the island of Moorea, behind which the sun set. It soon became a habit to walk down to the edge of the sea every morning and every evening, to mark the procession of the sun.

Behind his hut, to the north, Mataiea's plain sloped uncharacteristically gently into cool refreshing foothills lush in elephants' ears, tree ferns, ground orchids and jade vines, rich in springs and waterfalls, and skeined with narrow, hidden, sacred paths that traditionally were trodden to attain spiritual purification.

Once he had sent Titi away, Gauguin relished a quiet, lonely, hard-working few months, introverted and happy. At first, the startling colours produced by the overhead equatorial sun seemed impossible. There were no transitions. 'Everything in the landscape blinded me, dazzled me. Coming from Europe, I was constantly uncertain of some colour [and kept] beating about the bush: and yet it was so simple to put on my canvas a red and a blue. In the brooks, forms of gold enchanted me – why did I hesitate to pour that gold and all that rejoicing and sunshine on to my canvas? Old habits from Europe, probably – all this timidity of expression of our bastardised races.'[16]

He was enchanted by the people but he knew, as he had known in Pont-Aven, how important it was not to disturb, not to impose his presence while looking for the vocabulary to express what he was seeing. This was even more complicated here than in his native France. Apart from trying to discover the pictorial language to express the ethnographical mystery of the place and its people, he needed to discover how these foreign colours, whose behaviour in this glaring sunlight was so new to him, behaved in relation to each other when they were placed together. Further, there was the human aspect: how to convey the nuances of light and shade on Polynesian skin? He could by no means ask the inhabitants of this settled and stable community to strip off their clothes and model for him to help him understand. Tahitians did not make paintings of any sort. The Western concept of life study simply did not exist here. And so these early pictures made in Mataiea in late summer to autumn 1891 are, like his early Pont-Aven paintings, genre landscapes inhabited by small figures going about their rural business, chopping wood, mending fishing nets, dancing round a fire or sitting gossiping. The figures are seen from a distance; the subtlety of their skin tones is not depicted in any detail. But he did snatch quick sketches of heads, in charcoal or chalk, sometimes enlivened with touches of watercolour. It is characteristic of this group of his early studies of Tahitians that the eyes remain blank, unfilled by iris or pupil, like the eyes of ancient Greek statues. The point was to understand the sculptural quality of the whole head and, through that structural understanding, to convey internal psychic states, rather than taking the easy route of conveying emotion and expression by the fleeting positioning of iris and pupil. Colour was irrelevant to these early studies: skin colour did not constitute the essence.

POISONED PARADISE

He first managed synthesis when a neighbour called on him in his hut one day. She was interested in the pictures, the 'little friends' that he had pinned up to the wall. She examined *Olympia* with special interest. After a bit, she asked him if Olympia was his wife. 'Yes,' he lied, not knowing why. During the encounter, he had been making quick sketches of her. When she saw what he was doing, she made a face, said, '*Aita*' (no), and left. He was downcast, but greatly surprised when she came back an hour later dressed in a Mother Hubbard with her hair carefully arranged and caught at the back with a fragrant white flower. 'I painted passionately and in greatest haste for I had a feeling that she might change her mind at any moment. I have put into her portrait all that the heart revealed to my eye and, above all, that the eye would have been incapable of seeing, the glowing wealth of latent forces . . . Her noble forehead with its prominent lines made me think of Edgar Allan Poe's saying that there is no perfect beauty without a certain singularity in its proportions. And the flower behind her ear was listening to its scent.'[17] He called the portrait *Vahine no te tiare* (*Woman with a Flower*, 1891). A portrait of an inner state, quickly executed, intent on reflecting what he saw in her face.

Is it an accident that the melancholy in the face of this, his first Tahitian portrait, reflects the melancholy he saw in the vanished paradise of her race? The speed of the successful execution of this portrait must have surprised and reassured him that, without thinking of externals such as skin colour, he had found the key, the universal. Maybe this was what he was communicating in the background he gives her, which bears no relation to the real background inside his hut. Behind her, red and yellow colour planes divided horizontally, dotted with flowers, recall the background of his self-portrait with halo and snake. All portraits are, to a large degree, self-portraits.

Gauguin's creative impulse was running full flow, but his body was having difficulty keeping up. He was finding life physically difficult as he discovered the big lie that both Pierre Loti and the French government had been guilty of telling. It was impossible to live off the land in this place. There was no such thing as free housing or free food. With inhabitable land so scarce, every hut belonged to somebody, every precious fruit-bearing tree belonged to somebody. To pick was to steal. As for existing off free fish, you could not just go out and cast a line as you could in a placid French river. Fishing was a tricky and

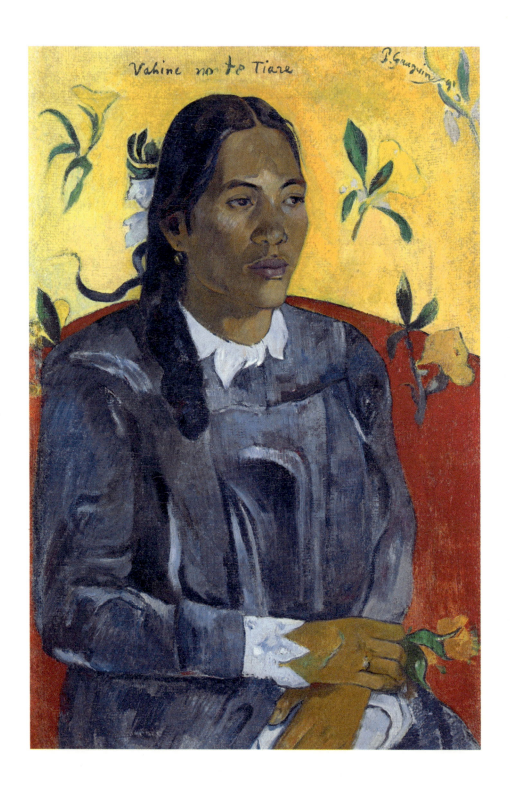

time-consuming affair. Either you stood stock-still for hours on a rock with your weapon poised to spear the quick fish, or you went out in your canoe, and you could not purchase a canoe. You made your own by hollowing out a tree-trunk. This was work that took months. As for shooting animals to eat? The chickens and goats scratching about the place all belonged to someone. The thickly forested volcano with its razor ridges and well-disguised precipices played home to wild boar, but you did not go killing wild boar alone. Hunting parties were organised involving dogs and spears but even so, it was a notoriously dangerous pursuit. Living off coconuts and bananas was also a dream. Coconut trees belonged to people, and if you scavenged the fruit off the ground, you had to understand the arcane law of whether it would feed you or poison you. They all looked the same, but bad ones whose milk had fermented would do you a great deal of harm. The wild bananas he had hoped for grew only in inaccessible places high on the mountain for historic reasons, to protect them from marauding parties of the peripatetic Ariois who trashed all crops in their path as a matter of principle. For Gauguin to go hunting bananas was almost as perilous as hunting boar. You needed to undertake a day's expedition to collect them, and even if you did, a stem that was worth dragging down, that could keep you going for weeks, was enormous. Locals gathered bananas in pairs, carrying them down slung on a pole over their shoulders. There was no way Gauguin could bring back a heavy stem without tripping over tree roots, or blundering into thorny or poisonous plants, or falling into a precipice, or offending a wild boar. 'I've grown very thin . . . am losing my strength and ruining my stomach. [But] If I went to hunt bananas in the mountains, or to fish, I could not work, and, besides, would probably get sunstroke. Oh how much misery on account of this accursed money!'[18]

His neighbours, noticing what was going on, invited him to share their meals and eat with them. They would not take payment. To be paid for food went against the local principle of hospitality. Gauguin saw it from the different end of the telescope. To accept their food without paying would turn him into a beggar, an outcast in his own eyes. He had not come here to live off the people but to live *with* them. He refused their hospitality on principle,

Gauguin, *Vahine no te tiare* (*Woman with a Flower*), 1891

though when neighbours turned up with a bowl of food, he would accept it with gratitude. And so another misunderstanding was added to the catalogue of misunderstandings that had accumulated since his landing on the island.

The solution to feeding himself lay in the Chinese convenience store. Apart from Gauguin, nobody needed to buy fresh food and so it did not sell fresh fruit or vegetables, fresh meat, fish, milk or eggs but tinned and dried food, sugar, preserved butter, wine, absinthe and tobacco at rates that reflected the cost of having these things shipped to a faraway island. Tinned corned beef became Gauguin's staple. At 2.50–3.50 francs per small tin, it was an expensive diet, and far from healthy. His heart, that he had heard beating with excitement on arrival at the island, now began a different, troubling, rhythm, but he ignored its signals as he lay in his hut, looking up at the moonlight filtering through the spaced row of woven leaves and 'listening to the pattern of the light through the leaves like an instrument of music' playing in time to the unnaturally loud beating of his heart.[19]

Having failed to make any close relationships in the village, he developed a great fondness for a coconut palm. It became a sort of inanimate pet. Evidently diseased, it subsided crookedly into a shape resembling a crouching parrot, with its head cocked curiously, and a bunch of coconuts grasped in its claws. Some dying fronds collapsed droopily, mimicking a tail. The breeze from the sea made its tail sway. One day a young man arrived with an axe and started chopping it down. Nearby a woman, unconcerned, was stowing nets in a pirogue. Gauguin learned that the man's name was Totefa or Jotepha (Tahitian for Joseph), and he made a painting of him cutting down the tree. Jotepha became his Everyman, an individual figure to follow as he went about his daily life. He painted him in the same pose in *Matamoe* (*Death*, 1892), an allegory of cutting down and regeneration: life and death. He also painted Jotepha joyfully riding his horse along the beach. Cautiously Jotepha observed Gauguin making pictures but when Gauguin encouraged him to take up a pencil Jotepha shook his head. It was not for him to make men. Gauguin had made his first local friend.

Jotepha became so interested in Gauguin's art that he came to visit him

Gauguin, *The Man with the Axe*, 1891

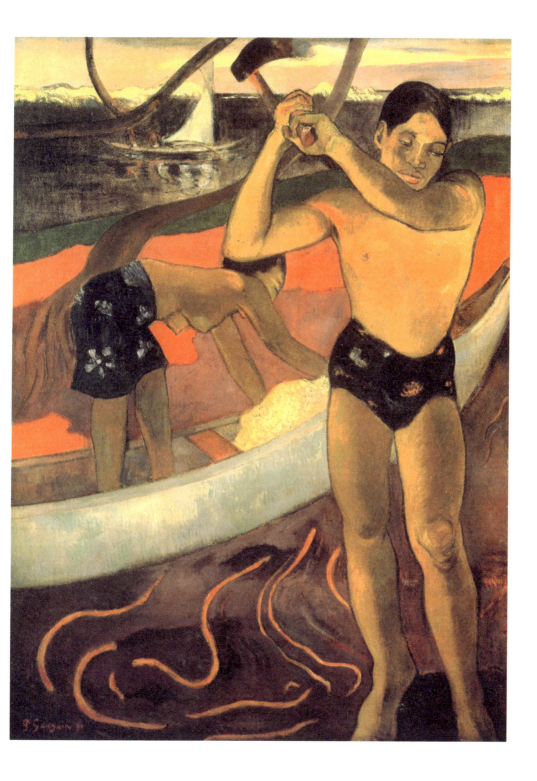

every day. On arrival, it had been a terrible disappointment to Gauguin to confirm that there was no picture-making on the island. However, there was a tradition of carving, and Gauguin asked Jotepha where he might find wood to carve without committing a theft from his neighbours. Gauguin had brought his carving tools from France, eagerly anticipating the opportunity to create a sculpted body of work inspired by Polynesian tradition, just as in Paris he had referenced and reinterpreted the body of Moche ceramics when he had been working in Ernest Chaplet's studio. But now that he was here, he found almost nothing to work on. The missionaries who had destroyed the old religion and its icons and artefacts had, it seemed, succeeded in killing the creative artistic urge. The fact that Tahitian had never been a written language had made it peculiarly easy to destroy all vestiges of ancient days. The missionaries had concocted a phonetic written equivalent to the spoken language. This they taught in their ubiquitous church schools. When Gauguin arrived, the only book that had been printed in the Tahitian language was written according to the Latin alphabet, and was the missionary translation of the Bible. Among this brainwashed generation, the few clues that Gauguin could find to connect to the ancient civilisation were some shallowly carved petroglyphs incised on monumental sacred boulders that were buried too deep in the jungle to destroy. Unfortunately, these petroglyphs reached so far back in time as to be indecipherable, rendering them innocuous to missionaries and incomprehensible to Polynesians and Europeans alike. Even today nobody knows if the shadowy scratched four-limbed beings represent lizards, humans or even large-finned fish. Occasionally a freestanding god, a tiki, had escaped total erasure. Roughly hewn in stone the tiki stood between the two platforms of the ancient ritual: the dancing platform where dance played prelude, and the platform of sacrifice, where human throats were slit using a sharpened stone, iron being unknown.

In response to Gauguin's request for wood, Jotepha said that he knew of trees growing so high up on the mountain that they belonged to nobody. If they went looking for them, they must start early in the morning. They set off, each carrying an axe and wearing a *pareu*, a length of cloth wrapped round the waist like a sarong. The sacred path towards the interior ran between two unscalable cliffs, in a ravine so deep it lay in perpetual night. Looking up,

they could see stars in the sky even after dawn had broken. They followed a fast watercourse bubbling between boulders, disappearing and reappearing, falling sometimes in loud cascades. Jotepha's 'lithe animal body had graceful contours, he walked in front of me sexless. From all this youth, from this perfect harmony with the nature that surrounded us there emanated a beauty, a fragrance (*noa noa*) that enchanted my artist soul. From this friendship, so well-cemented by the mutual attraction between simple and composite, love took power to blossom in me. And we were only the two of us.

'I had a sort of presentiment of crime, the desire for the unknown, the awakening of evil. Then – weariness of the male rôle, having always to be strong, protective; broad shoulders may be a heavy load. To be for a minute the weak being who loves and obeys.

'I drew close, without fear of laws, my temples throbbing.

'The path had come to an end . . . we had to cross the river, my companion turned at that moment so that his chest was towards me. The hermaphrodite had vanished, it was a young man after all; his innocent eyes resembled the limpidity of the water. Calm suddenly came back into my soul, and this time I enjoyed the coolness of the stream deliciously, plunging into it with delight.

'"*Toe toe*," he said to me. ("It's cold.")

'"Oh no," I answered, and this denial, answering my previous desire, drove in among the cliffs like an echo. Fiercely I thrust my way with energy into the thicket [which had] become more and more wild; the boy went on his way, still limpid-eyed. He had not understood. I alone carried the burden of an evil thought, a whole civilisation had been before me in evil and had educated me.

'We were reaching our destination. At that point the crags of the mountain drew apart, and behind a curtain of tangled trees a semblance of a plateau [lay] hidden but not unknown. There several trees of rosewood extended their huge branches. Savages both of us, we attacked with the axe a magnificent tree which had to be destroyed to get a branch suitable to my desires. I struck furiously and, my hands covered with blood, hacked away with the pleasure of sating one's brutality and of destroying something . . . Well and truly was destroyed all the old remnant of civilised man in me. I returned at peace, feeling myself thenceforward a different man . . . The two of us carried

our heavy load cheerfully and I could again admire the graceful curves of my young friend – and calmly: curves robust like the tree we were carrying. The tree smelt of rose and *noa noa* . . . I was definitely at peace from then on. I gave not a single blow of the chisel to that piece of wood without having memories of a sweet quietude, a fragrance, a victory and a rejuvenation.'[20]

Gauguin tells this story in *Noa Noa*, the booklet he wrote back in Paris in 1893, to accompany the first exhibition of his Tahitian paintings at Durand-Ruel's gallery. Well aware that he was presenting something altogether new to Paris, Gauguin wrote *Noa Noa* to publicise the show, to intrigue Paris's sophisticated avant-garde, and to draw them into his own fascination with the fallen-away paradise. The tales he recounts are part experience, part fantasy, part conclusion spun forward from events. Whether the Jotepha story is 'true' literally, whether it really told of his feelings on the expedition to cut down the tree (the tree of knowledge of good and evil?) seems less important than the moral and ethical question he puts before us as he turns the real-life expedition into a Garden of Eden myth where he places himself as a modern Adam, the corrupt Adam of today, who contemplates and resists the temptation of imposing his own corruption upon the prelapsarian colonised people, as symbolised by Jotepha. The myth he makes echoes several: Christ's harrowing of hell, Dante's descent to Inferno, Odysseus' adventures. Maybe most of all, the tale of Orpheus. The journey to the Underworld symbolised by the deep chasmic ravine engulfed in eternal night where the sight of stars in the daytime signals a magical realm, and the stars themselves perhaps hold out the possibility of hope and salvation. Beside him and Jotepha runs the ambiguous river, the path of the waters of life, of death and of knowledge, disappearing, reappearing, as the two of them tread the Orphean path of forbidden adventure. Temptation resolves into salvation when Jotepha/Orpheus looks back. The backward glance, the transformative moment that condemned Eurydice to the Underworld for ever, releases Gauguin from the role of the sexually predatory white male. In that moment of interaction, he becomes a new Adam. He and his friend cut down the tree of temptation together. 'I hacked until it was just as dead as the old civilisation within me.' Sweat runs from his body, and blood from his hands. He rinses them in the sacred spring. He is cleansed, purified, reborn. They return together carrying

the wood he will carve. 'I returned at peace, feeling myself thenceforward a different man, a Tahitian.'

Was he writing a made-up story to titillate world-weary Parisian consumers and to stimulate sales? Where Gauguin's tale differs from Loti-style colonial tales is in the choice he makes, the redemptive outcome. Gauguin has denied his white-conqueror-related grabbing burst of lust. Purity has triumphed over experience. He has acted on his real belief in sacral innocence. There would be no going back from the choice he made on the path through the woods.

Autumn crept over Mataiea as Gauguin continued his cautious approach towards the community. The villagers observed him to be markedly timid. Elders offered him girls, as was the custom, but he refused. The well-structured laws of the community frightened him. Ignorant of the rules, he felt he was bound to behave badly and upset everybody.

On Sundays he joined his neighbours in the House of Hymns, as they called the Catholic church where they sang the well-known anthems that had played soundtrack to his reverence for Jesus Christ since Bishop Dupanloup had first awakened it at school in Orléans. Gauguin made a drawing of one of the nuns, Sister Louise, who taught at the mission school; he became close to her in some way, and he painted *Ia orana Maria* (*Hail Mary*), in which the Virgin Mary is a contemporary Polynesian girl. Standing on the near bank of a river, she has a red *pareu* knotted round her body. The Christ child is balanced on her shoulder, as children were carried locally. Christ is naked, and Polynesian. His golden halo merges with hers. Around her feet spread fans of red bananas. Behind her, a blue river runs in a horizontal line. Two bare-breasted *vahines* take the place of the traditional three wise men, as they cross the river to worship, coming towards her with their hands clasped in prayer. On the far bank of the river, the Angel of the Annunciation, dressed in a lavender-coloured Mother Hubbard, swoops down through a flowery jungle that tangles round her outsize gold and blue wings. Gauguin had taken the foundational legend of Christianity and synthesised it through a multi-racial lens.

The picture is divided horizontally into three spaces – the near bank, the river and the far bank – describing three different spiritual states and realms.

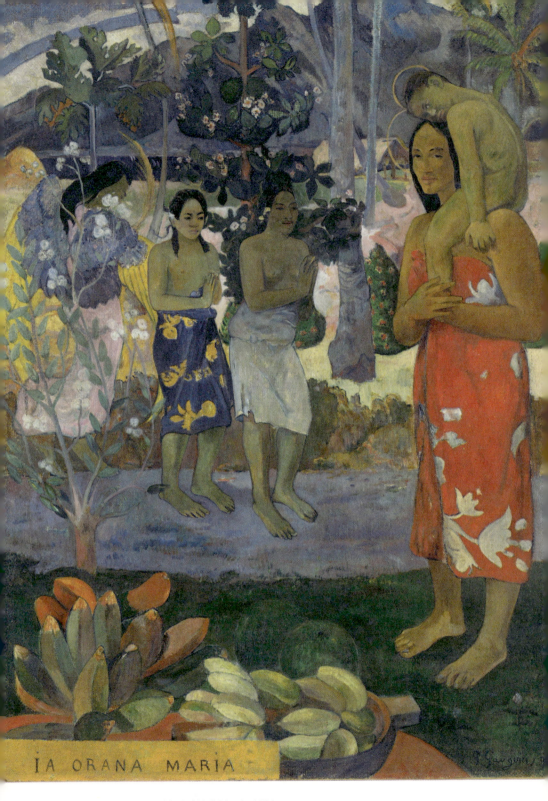

Gauguin, *Ia orana Maria* (*Hail Mary*), 1891

The influence of Gauguin's sympathetic, and synthetic, vision may be seen in the (later) stained-glass windows in the Catholic Cathedral of Papeete, where the window depicting the three wise men shows them arriving to pay homage to the Holy Family in a pirogue and Christ being baptised in the river Jordan where swims a Polynesian whale.

When it was seen in Europe, Gauguin's localising of the nativity tale resulted in *Ia orana Maria* being hailed as blasphemous for over half a century. It was not until 1951 that a papal encyclical made it permissible to represent indigenous people as biblical characters.

13

TEHAMANA

November brought the rainy season. Winds swept down from the mountain through the openwork hut. Chills ran through Gauguin's ill-nourished body, and he heard his heart hammering. Pains shot through his chest and fear through his soul. When he began to cough up clots of blood, he ignored the problem. Finally, in the New Year, his lungs haemorrhaged. He had no choice but to climb laboriously into the public coach that took him to Papeete, where he was admitted to the military hospital. To relieve his chest pains, he was cupped, an ancient remedy close to witchcraft involving placing a cupping vessel on the affected part to create a vacuum: when the vessel is pulled off it 'draws out the malevolent humours'. Equally witch-doctory mustard plasters were applied to his legs to 'draw out impurities'. He credited his recovery to the digitalis they gave him for his heart. Decent food probably helped too. But it was costing him twelve francs a day, and the expense troubled him.

Despite the numerous letters he had written to Mette and his friends in France, no money had arrived. Before he left Paris, he had loaned Charles Morice 500 francs. The repayment would have made all the difference, but it never came. Whenever a mail boat moored in Papeete, Gauguin purchased a coach ticket to take him the thirty miles there and back. Repeated disappointment was mitigated by the company of Lieutenant Jénot, with whom he got on famously. Gauguin used Jénot's studio to paint in, gave him painting lessons, and they had fun making music together. Jénot gave, or lent, him small sums of money. Gauguin formed other local friendships, too. He was always welcome to share a meal with a confectioner named Sosthène Drollet, and with Jean-Jacques Suhas, a nurse and pharmacist who worked in the military hospital where Gauguin had been a patient. Suhas had a two-year-old son, Aristide, known as Atiti.

Gauguin enjoyed the company of small children; he liked having them running about, and Atiti loved to watch him in the studio. Gauguin encouraged

Atiti to pick up a brush and join in. He gave Atiti's parents two pictures to decorate the walls of the boy's nursery. The March following Gauguin's release from hospital, Atiti became ill, and quickly died. Gauguin painted a funerary portrait of the little one on his deathbed. He lies among white funeral flowers with an expression of mysterious serenity on his face, a Catholic rosary in his hand and religious medal round his neck. It was a Polynesian custom to bury the dead with objects, and the two pictures Gauguin had painted for the nursery went with him into the grave, but his parents kept, and treasured, the posthumous portrait. They had a special box made for it, and when their posting to Tahiti was over, they took it back with them to France.

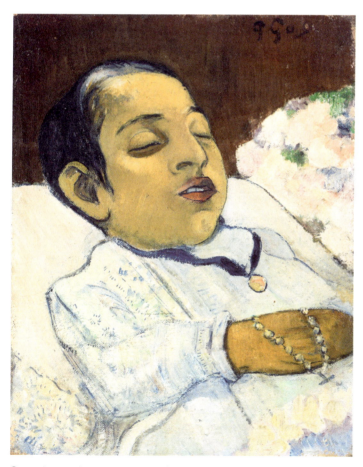

Gauguin, posthumous portrati of Atiti, 1892

Lack of money led Gauguin to discharge himself from the hospital before he was fully recovered. When he got back to Mataiea, his kind landlord Anani insisted that Gauguin move to the comfort of his own European house to recover his strength within warm, dry walls, rather than in the damp hut. Gauguin recompensed his generous host by working, as he had worked in Marie Poupée's *buvette*, on a scheme of interior decoration. As in the *buvette*, the exuberant wall paintings spilled on to the glass panels of the door, where the light shone through a lovely Tahitian Eve who anticipates Matisse in the minimalist free sketching of her body in a few sweeping lines. Her tree of knowledge is a breadfruit tree, the forbidden fruit in her hand a breadfruit. Once more, Gauguin was undermining the exclusively white, Western iconography that had grown around the Christian myth. We don't know what was on the walls because the Eve painted on the glass panel of the door was all that was left in 1917, when the English author Somerset Maugham visited the house and purchased the door from Anani's son.

Gauguin was getting very low on money. This way of life without an income could not continue. Hearing that there was a vacancy for a magistrate's job on Hiva Oa, a tiny island 900 miles away in the Marquesan archipelago, he decided to apply for the job. The Marquesas Islands had the advantage of being about as far from civilisation as one could get, while still being a French colony. The job of magistrate carried the salary of 500 francs per annum, and his passage would be paid.

He called on Lacascade in his governor's palace.

Lacascade was no longer afraid of Gauguin. He had discovered that Gauguin was not a government spy and so he had no power to sabotage his career. How Lacascade must have enjoyed widening his eyes in theatrical astonishment when Gauguin presented him with what Lacascade called his 'wild idea', before going on to deliver a lecture on the special qualifications and character required to fill such an important and responsible post. His homily ended 'with great civility' (in Gauguin's words) by describing what a very poor impression Gauguin would make as a magistrate.

Gauguin was furious. Lacascade was undoubtedly right, but that was no compensation. Gauguin sketched a quick, insulting cartoon referencing Darwin, depicting Lacascade, who was of mixed race, as a monkey, low on

the ladder of evolution. But when Gauguin got down to his last forty-five francs he had, once more, to tread the path to the palace, this time to petition Lacascade for free repatriation to France.

'I raged like a furious fool. Just at the entrance to Government House I met a captain who sails about the islands in his own brigantine, who is believed to be a pirate. I made his acquaintance a couple of months ago.

'"What the devil are you doing in this galley?" he asked me.

'"*Ma foie*, I'm going to do the most disagreeable thing possible. To beg my passage home from the Governor. My ship is adrift and I'm on the rocks."

'Then the rascal slipped 400 francs into my hand. "You give me a picture and we'll call it square."

'So I did not go to the Governor and here I am once more hoping for money from France.

'Possibly I shall do a portrait of the pirate's wife and then he will give me 1,300 francs more. But for that we must exercise great diplomacy with the lady who is not always easy to manage, so he says. Then I can raise my top-gallant sail and have ten months of peaceful work. It's only to me that such things happen . . . It has been that way my whole life; I stand on the edge of the abyss, yet I do not fall in. When Van Gogh went insane, I was just about done for. Well, I got over it. It forced me to exert myself. All the same my life has been a queer mix-up.'[1]

The pirate, Captain Charles Arnaud by name, told him the commission must wait until he had taken a round trip to Mangareva Island, a thousand miles away. Arnaud had a reputation for being all talk and no trousers, and Gauguin did not count on the money. He knew the ways of pirates, both on land and on sea, but there was always a possibility it might be a real deal. Meanwhile, he might tide himself over by selling his gun. It had been no use to him anyway since he brought it out from France.

On the way home from Papeete, he stopped at Punaauia where Auguste Goupil, the island's leading lawyer and entrepreneur, had built one of the biggest, grandest and oddest mansions on the island. Gothic crockets poked up prettily between Goupil's shock-headed coconut palms. He was the island's king of desiccated coconut, which he exported at great profit to the United States. He also owned a local newspaper, *L'Océanie française*. A learned man,

he kept an excellent library. He bought the gun, and Gauguin was greatly delighted to leave the mansion not only with money in his pocket but having had a stimulating conversation with probably the island's brightest intellect. Goupil lent Gauguin a rare publication that he had long been wanting to read.

The two-volume *Voyages aux îles du Grand Océan*, by Jacques-Antoine Moerenhout (1837), was the Bible of Polynesian history, covering its mythology, sociology, archaeology and anthropology, written by a historian with a passion for recording Polynesian folk memory as far back as it could reach.

Between 1829 and 1879, Moerenhout had travelled widely throughout the South Pacific islands trading in pearls and, oddly, horseradish. This financed his real interest, which lay in what he could discover of the ancient civilisation, to record it for posterity. The oral tradition allowed for wide regional variations within the vast area of the loosely linked triangle between Hawaii, Easter Island and New Zealand that Polynesians considered, and still consider, their homeland. Undaunted by the enormous task in hand, Moerenhout interviewed chiefs, priests and elders, visited sacred and profane sites, described what was on the ground as well as what he was told. He recorded myths, legends, religious rituals, magic, customs, objects, architecture and archaeology. The variations of the Polynesian languages between islands and archipelagos came easily to Moerenhout, but he seems to have had no talent for art, and so his compendious work was inadequately illustrated by a few misleading lithographic plates that made Polynesia look like Switzerland with palm trees.

Knowing he must return the book, Gauguin copied out chunks that he found meaningful, illustrating them with quick sketches of how he thought Polynesian gods and people and places and artefacts might have looked. He brought to these suppositions his own assumptions of a common anthropological past, raiding his references to Peruvian Moche artefacts and his collection of postcards from the expo and the British Museum, and synthesising them with his own experience of this place to construct his own visual 'Polynesian' vocabulary. Eventually he would work the texts he had copied out into an illustrated book that he titled *Ancien culte mahorie*, the word *mahori* being Polynesian for human being.[2]

Gauguin must immediately have been struck by the similarity of the Polynesian myths to the German, which he knew so well from Wagner's *Ring* cycle. In both mythologies, trouble starts with male sexual frustration when the chief god – German Wotan and Polynesian Oro – is thwarted by a grumpy wife. Seeking sexual release, both chief gods travel to the earth where Oro finds the beautiful Vairaumati, just as Wotan finds Erda. Here the myths and their consequences diverge. Oro's brothers follow him down to earth to chastise him for his bad behaviour but on seeing the beauty of Vairaumati, the brothers are overcome. One changes into a pig and the other into a bunch of red feathers, to worship the couple. Oro turns his back on the tiresome wife and the old religion. He declares the birth of a new religious cult, the Arioi, which will be dedicated to free love. The Arioi will have nothing to do with domestic responsibility. They are wholly dedicated to dance, song and worship. Their sacred symbols are the pig and the bunch of red feathers. Upon the Arioi cult rests the European idea of Polynesia as the realm of unbridled sensual liberty and epicurean delight. Unlike the old Polynesian religion and society, which was largely settled on one single island and strictly segregated sexually (one might almost call it bourgeois in this context), the Arioi equalised the status of men and women, both of whom were free to make love to whomever they pleased. Neither incest nor child rape was *tabu*. If and when children were born within this extraordinarily promiscuous cult, they were murdered. The Arioi had no fixed home among the islands. They were a sacred band roving from place to place, roaring and revelling and wreaking holy havoc materially, societally and surely psychically. Founded in the fifteenth century, the Arioi resembled nothing so much as a Dionysian cult, very similar to those in Greece based on the Eleusinian mysteries, and those in ancient Egypt, based on the Osirian mysteries: both cheating normal bourgeois laws by journeying to the forbidden realm of the underworld. Moerenhout reported that at its peak the cult had grown so great that the travelling parties comprised between seven hundred and a couple of thousand people. When you consider that Tahiti, the most populous island in the group, had three thousand people in Gauguin's time, the arrival of two thousand Arioi would have been monumentally disruptive.

'A flower-decked flotilla with *arioi* on board wearing their festal finery was

an imposing spectacle. All were arrayed in yellow leaf-girdles and red cloaks; their bodies shone, and the women's hair streamed loose in the wind. On board the largest canoes, nude dancers swayed on raised platforms in time to the dull beating of the sharkskin drums. In the stern of the leading canoe stood the grand master with a huge adornment of red feathers on his head, steering the flotilla by signals on his shell trumpet, and at his feet black Polynesian sacrificial swine lay with their feet bound together.'[3]

Welcomed as divine emissaries from higher powers, the Arioi were believed to be able to induce gods to come down to earth and bring advantage to the places they visited. Passing their time in luxurious idleness, perfuming their hair with fragrant oils, singing and playing on the flute, they would change in an instant to destructive furies, killing livestock, uprooting crops, sleeping with men, women and children, carrying off the most beautiful women, and eating the good islanders out of home (it was due to these privileged marauders that crops like bananas were planted in high, out-of-the-way places that were difficult to access by such as Gauguin). The Arioi were anarchists who destroyed property as a matter of principle. Householders might pay the price of the visit from the Arioi in malnutrition throughout the following year but what was the dribble of long-drawn-out hardship set against the glamour and glory of the visitation? The community felt itself chosen, favoured, blessed, sacralised through submission to the orgiastic release of the non-stop public demonstrations of sex that whipped the visit of the Arioi into the transcendental realm that, for a short time at least, liberated the individual to imagine a return to a natural state of domestic irresponsibility and unlimited sex.

'Among theAriois, prostitution was the principle and infanticide the obligation,' Gauguin noted.[4]

'Who', Moerenhout concluded rather surprisingly, 'would not have wished to belong to a society, whose members only seemed to live and die to be happy?'

'What a religion the ancient oceanic religion is!' wrote Gauguin. 'My brain is buzzing. The ideas it suggests to me are terrifying.'[5] The principle of Arcadian freedom from responsibility in this place, where guilt-free sexual freedom – 'a glance, an orange offered' – had been founded on the widespread custom

of infanticide and approval of abortion as a life choice, was profoundly disturbing to Gauguin who revered the state of childhood for its own sake. It was the clear-eyed innocent condition – unsmudged by civilised accretions – with which he wished to see the world and present it through his art. Though the cult of the Arioi had died out by Gauguin's time, learning of their previous presence in the perceived Arcadian realm posed harsh moral questions.

Calling in on Goupil's gothic mansion, maybe to return the books, Gauguin had nothing to sell this time. Goupil was not terribly interested in art, so he did not commission a painting, but he was a decent man and, seeing Gauguin's need, he proposed a temporary job as a caretaker for a property that was the subject of a lawsuit. Guarding the property of a bankrupt Chinese shopkeeper for eleven days, for the sum of thirty-seven francs and seventy-five centimes, was probably as low a moment for Gauguin as his time pasting posters in Paris.

After this, he steeled himself for yet another interview with Lacascade to apply for repatriation. Lacascade had a legal obligation to pay the return passage for immigrants whose passage out had been paid by the French government if they applied within a year of arriving in the colony. Dragging his dispirited feet towards the governor's palace, who should Gauguin bump into but Captain Arnaud, freshly returned from his long voyage. The captain once more pressed money into his hand, enabling Gauguin to avoid the interview and return to Mataiea, but it did nothing to relieve his depression concerning his beggarly status. Worse, he knew he had grown stale for lack of stimulus. The width of knowledge and history contained in Moerenhout's book had pinpointed how domesticated, how civilised, how inauthentic his life was in this place.

'I decided to go away, to set out on a tour of the island without making any fixed plan. While I was making parcels of things I might want on the tour and putting all my studies in order, the friendly Anani stood watching me uneasily. At last he made up his mind to ask if I was preparing to leave. I answered no, I was only getting ready for a few days' trip and I should soon be back.

'"You Europeans," added Anani's wife, "you always promise to stay and when at last we have grown fond of you, you go away! You assure us you will come back but you never do!"

"'But I can swear that I intend to come back in a few days. Afterwards" – for I dare not lie – "afterwards we shall see."'[6]

Gauguin struck out. Just as he had struck out in Orléans as a little boy with his possessions in a knotted handkerchief. Tramping along an unfamiliar track leading into the interior, he came across a small cluster of huts that he imagined must be an undisturbed remnant of the civilisation he had read about in Moerenhout. Into their small, hard lives, he projected the *luxe, calme et volupté* he had read about and idealised. He imagined the inhabitants worshipping Hina the moon goddess and celebrating festivals in her honour. Fired up to a state of high excitement by the mere sight of a few poor dwellings clinging to the mountainside, when he got back, he painted *Matamua (In Olden Times*, 1892), a picture of the mytho-historical past he imagined into the place. *Matamua* unleashes the visual language he would use to attempt to recreate the lost history that existed before missionaries and colonialism. With, after all, no historic iconography to follow and no artistic predecessors to work from, it was perfectly legitimate for 'the dream' to take over. The Tahitian pastorals take their model from the balanced figured landscapes that come down from Roman wall paintings, Egyptian tomb friezes and the great pastorals of Poussin and Pierre Puvis de Chavannes, peopled by figures frozen in aeons of time on the Borobudur temple. The pastorals share with these a sense of stopped time and mythic duration. Where Gauguin upsets the classical vision is in his shocking use of colour, reverberant luminosity, and the weird geometry of his deliberately unrealistic scale, suggestive of the distortion of dreams: a surreal subjectivity of vision privileging the importance of object over scale, and the flatness of planes in which shadows have no place. The iconography shows how free he felt to disregard what he had read about in Moerenhout. He would have known that Polynesian idols never stood on a square plinth. He would also have known that sacred sites would never have played host to graceful maidens in long white dresses, sacred sites being *tabu* to women. No matter. If the balanced shape of a carved idol demanded a square base, he would give it one. And what was a temple site without worshipping maidens in white dresses?

Realisation of his vision brought with it the zest for mental, spiritual and physical adventure. He travelled to Taravao, the southernmost tip of the island.

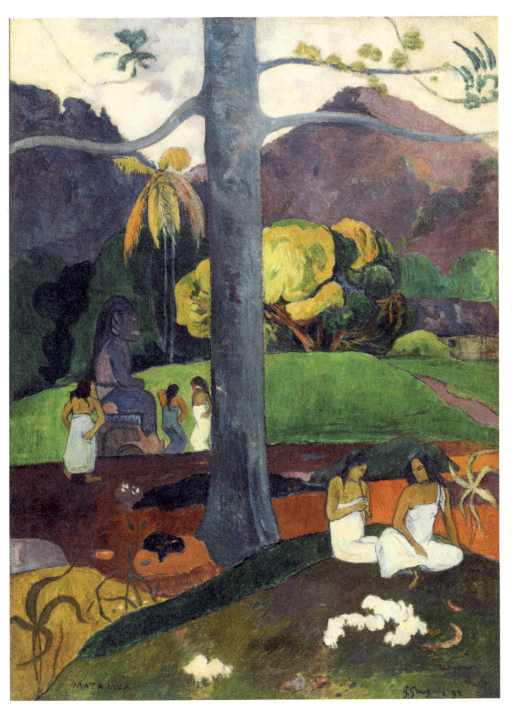

Gauguin, *Matamua* (*In Olden Times*), 1892

Here he borrowed a horse from a gendarme and struck northward to explore the track up Tahiti's east coast, the island's wild side that was little visited by Europeans. On reaching Faaone, a few huts scattered on bronze soil beneath jungle, bulging out between the long silvery threads of a spectacularly tall waterfall, a man called out to him; 'Hey! You man who makes men! Come and eat with us.'

After the man had helped Gauguin tie his horse to the branch of a tree, they went into a hut where men, women and children were chatting and smoking.

A handsome woman of about forty asked him where he was going. When he told her he was going to Itia, she asked what he wanted there. He confessed himself surprised by his own answer when he heard himself say he was going there to look for a wife. The woman's answer surprised him even more. She offered him her daughter.

There was no obvious indication whether any of the girls in the room was this daughter. He looked around, wondering. The woman left the room. A quarter of an hour later she came back accompanied by a tall girl carrying a small parcel containing her belongings hastily packed up to go away with a complete stranger. He was told that her name was Tehamana.

She was dressed in very transparent pink muslin. He could see her nipples through the gauze. He had never seen skin so luminously, richly golden. He longed to paint it. They sat down to talk. Her features were not typically Tahitian, and he asked her about this. She told him that her forebears had come from the island of Tonga. He asked if she was afraid of him. She said no. Then he asked if she would come and live with him, and she said yes.

A piece of paper was hastily produced. He signed the pseudo contract full of puzzled misgiving. No money changed hands.

And that was it.

They rode back towards Mataiea accompanied by her mother and a man whose identity was unclear, as well as two young women whom she said were her aunts. When they had ridden about half a mile, a voice called out for them to stop. They dismounted and entered the man's hut. It showed all the signs of a prosperous and well-ordered life. The young couple who seemed to be the householders were friendly, calm, and hospitable. They

poured a drink. It was passed round like a loving cup for them all to sip in turn, solemnly. After this ritual the woman householder turned to Gauguin with tears in her eyes and asked him if he was kind. Would he make her daughter happy? He searched his heart and hoped he gave a truthful response when he answered that he was kind and he would try to make her happy. She said that when eight days had passed he must let Tehamana return to her and then, if she was not happy, she would leave him. This seemed sensible and Gauguin assented but when they remounted to continue the journey home his suspicion grew. The process by which he found himself in this situation had seemed both measured and dignified. There was no evidence it had been driven by criminal motives or financial desperation. And yet how could it be that Tehamana had two mothers? He asked Tehamana why she had lied to him? When she explained that one was her birth mother and one her nursing mother, he was repentant of his mistrust.

When they reached Taravao he gave the horse back to the gendarme. His wife, a Frenchwoman, shouted out, '"What! Have you brought back a trollop with you?" And her eyes undressed the impassive girl, now grown haughty . . . the virtue of the law was breathing impurely upon that native but pure unashamedness of trust, faith . . . I felt ashamed of my race.'[7]

The words of the gendarme's wife hung like a witch's curse in the air. The dream, the willing suspension of disbelief, had been shattered by the cold eye of civilisation. He had never wished to enter the exploitative world of Loti but now he had done exactly that. However, by the end of the trial week living with Tehamana, he did not care. He loved her and he told her so as he put her on to the coach to return to her family to decide whether she wished to come back to him or not. She merely looked back at him quizzically. He waited on tenterhooks.

She came back.

Tehamana released a great flood of creativity in him. She synthesised his vision of Tahiti. The place and the people came together in the 1891–2 canvases, more than sixty of them, unleashing colour with astonishing new freedom and power to riot over entirely unnaturalistic landscapes peopled with figures that now belonged within the idealisation as naturally as the clouds and the trees. The pictures could all be run together as a frieze

around a giant gallery forming a collective hymn of love for her and, through her, for the place and its people. The life of the village was more than sufficient subject matter. He did not need to go far from his hut. The locations are identifiable: real but unreal, 'the same but not the same', using his base vocabulary of heightened colour, and a truly Japanese contempt for realistic perspective and depiction of rounded form. The whole stylised Tahitian panorama is ultimately made credible by his understanding of light under the equatorial sun, so much closer to the earth in Tahiti than in France. Light effects are flatter and the complementary colours that make up after-images are strengthened, while midday gives an opposite but equally dramatic effect by bleaching out all colours.

Gauguin had never ceased, and never would cease, to describe himself as a savage, by which he meant unspoiled by civilisation. Brittany had come

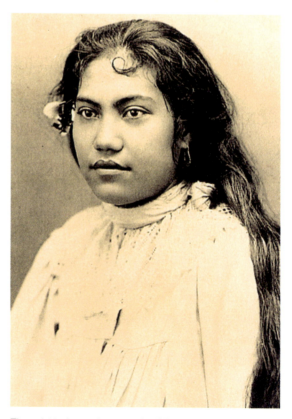

Thought to be a photograph of Tehamana

close to synthesising the inner and the outer but only now had this actually occurred. He gave the pictures Tahitian titles, often writing them on the canvas itself. They tell the everyday unpretentious tale of people going about their lives. *Mahana maa – Saturday*; *Haere mai – Come Here*; *Parau api – News*; *Nafea faaipoipo – When Will You Marry?*; *Aha oe feii – Are You Jealous?*; *Te raau rahi – The Great Tree*; *Pape mo – Mysterious Waters*; and so on.[8]

Little is known about Tehamana, the girl who inspired this great artistic outpouring. She was never interviewed. We have only Gauguin's account of their relationship. Today some doubt whether Tehamana even existed, or if she is a fictional character created by Gauguin, *à la* Loti, in *Noa Noa*, a slim volume of traveller's tales he wrote on his return to France in 1893 to rouse interest in his first Parisian exhibition of Polynesian paintings. The counter to this theory lies in the writings of Bengt Danielsson (1921–97) the Swedish anthropologist who was a crew member of the 1947 *Kon-Tiki* expedition on which a handful of absurdly brave Scandinavian anthropologists and scientists drifted for 101 days across 4,300 miles of the Pacific Ocean on a tiny raft to test their theory that the Polynesian islands had been settled in pre-Columbian times by people from South America. *Kon-Tiki*'s successful landfall was followed by Danielsson devoting the rest of his life to Polynesia, working there as an anthropologist and writer, and campaigning against atomic testing in the Pacific. He was the closest in time to research Tehamana's life, finding out what he could, mostly through interviews. He says she lived from around 1878 to 1918 when she died in the flu pandemic sweeping the world.[9] Her parents came from Rarotonga in the Cook Islands, a point misunderstood by Gauguin when he writes that she came from Tonga.

The fact that Tehamana was not living with her birth family was unremarkable within the customs of the islands though this too was imperfectly understood by Gauguin whose suspicion of the tangle of mothers encountered on the journey home reinforced his unease roused by the too-hastily produced 'contract', a worthless piece of paper that was neither legally nor religiously binding. Real marriages were by now conducted in church and registered in the town hall.

Tehamana was doubly a victim: trafficked by her family for an advantageous connection, and victim to the lust of the much older European man.

The situation was far from unusual in Tahiti where an agreed arrangement with a white man was considered materially advantageous to the family. At thirteen Tehamana had reached the legal age of consent. Parents arranged such matches, and children submitted. Tehamana's family could not know that Gauguin would not gain them the advantage they hoped for, being neither as rich nor as influential as most other Frenchmen. What her family would not have approved of, had they known, was a relationship with a married man. Before signing the paper that so temptingly appeared at the *moment critique*, Gauguin ought to have told them he was already married.

What Tehamana truly thought of Gauguin and how she experienced the relationship we will never know. Gauguin reports in *Avant et après* that she had the gift of silence. It is hard to know whether that was indeed her natural way or a reaction to her situation. Alone on the western side of the island with a strange man, she was far from her extended family on the east coast. She was further isolated within the village because she was not Tahitian; she came from another island and her different ethnicity was apparent in her features. We can only guess at her loneliness.

That she returned to Gauguin after the first trial week together might speak of the obedient girl obeying family orders but crucially when Gauguin came back from Paris in 1895, having been away for two years, by which time Tehamana was married to another man, she came back to live with him for a couple of weeks. She had no obligation to do so. It argues affection.

Gauguin was not a man to admit to feelings but now he abandoned inhibitions to confess that, for the first time since Mette, he had fallen precipitately, vertiginously, in love. He pondered Tehamana's inner qualities, little realising how his admiration for her echoed his earlier admiration of the same qualities in Mette and, indeed, the same qualities in his mother and grandmother, all women strongly independent of thought. He writes of Tehamana that he had never known a woman so self-contained. He marvelled at her inner strength, her subtlety and tact. Sometimes it frightened him.

Lyrically he describes their life together. Each day at dawn they bathed in the nearby stream. Cleansed, wrapped in his *pareu*, he would begin work. She knew instinctively when to speak to him without disturbing the creative process. When the hard-working day was over, he would go down to the

beach to watch the sun sinking in a blaze of glory. After darkness had fallen, they talked in bed. She wanted to know all about where he came from, about European gods and beliefs. He told her. She found European scientific thinking hard. How difficult to imagine the earth travelling round the sun. What was the French name of the morning star? the evening star? She told him the names of the stars in her language, and she told him her local version of the creation myth.

Everything started with the god Roua. He slept with his wife, the dark earth. She gave birth to the first king, the soil. Then she gave birth to twilight. Next, she birthed dusk. Roua then left his first wife, to sleep with the woman called The Great Meeting. She gave birth to the stars who were the queens of the heavens. She gave birth to the evening star called Faiti.

Roua then slept with Faouni who gave birth to the morning star. He was called Tauroua, and he became king. King Tauroua guided the mariners of the islands throughout all the long times when the people believed that they were the only people on earth and their islands were the only land on earth, set in the vast ocean. This was before the arrival of the Europeans, who told them otherwise.

King Tauroua gave laws to the night and to the day, to the stars, to Hina the moon, and to Rehoua the sun. When he had given laws, King Tauroua set sail north. Here he slept with his wife who gave birth to the red star that rises in the evening. The red star became 'the god who flies in the west'. He made ready his pirogue, the pirogue of broad day which sets sail at the rising of the sun. He slept with his wife Oura Tanaipa who gave birth to twins. The twins were the nearby island of Bora Bora with its sharp twin-peaked volcanoes. When the twins Bora Bora heard their parents talk of separating them, they fled together, first to the nearby island of Raiatea, next to Outamé, then to Eimo and finally to Tahiti Iti, the island closing the eastwards view across the sea on the left of Gauguin's hut. Their mother sought them anxiously, but she always arrived too late, just as they had left. Arriving in Little Tahiti, she heard that they were hiding in the mountains. When they saw their mother coming, dreading separation, they fled to the summit of the highest mountain and flew off into the stars where they can still be seen in the constellations among the *tupapaus*, the shooting stars

who are the heavenly emblem of the ghosts, the malign spirits and terrifying spectres who lurk on earth in the dark, ever ready to seize the unwary in the blackness of night.

This did not seem too outlandish to Gauguin within the context of the new waves and rays and transmissions being discovered in the Western world where he and his generation were being told that invisible things like electricity, wireless radio telegraphic waves, cosmic rays and X-rays existed. They were told that they saw what they saw because they had eyes that were constructed just so. If, he pondered, their eyes were differently constructed, might they see the skeleton, might they see the invisible forms that have populated myth from the dawn of time? Might they see Bora Bora flying up to the stars, the *tupapaus* that haunt the darkness, Edgar Allan Poe's creations that existed on the double edge of reality and symbolism? Jacob's struggle, as reported by earlier eyes, had not been merely symbolic. Jacob had actually seen the angel and wrestled with it. Tehamana saw *tupapaus* in shooting stars, in the glimmer of phosphorescence in the sea, in lightning and in other bursts of light. The jealous *tupapaus* take vengeance on the living for the fact that they are dead. They can only seize you in the dark. For this reason, Tehamana kept a little oil lamp burning.

With Tehamana in his hut, her legends in his ears, and his own mind open to her world of symbols and stories, rites and rituals, lore and law, which together formed the powerful and deeply rooted ethnocultural identity, Gauguin became integrated into the life of the community.

By the time of the seasonal arrival of shoals of tuna and bonito in the open sea on the other side of the reef, it was taken for granted that Gauguin was part of the village. Clouds of flies announced the arrival of the fish. On this annoying, biting, stinging signal, the whole village mobilised. The men checked their fishing hooks and lines, while the women and children walked into the sea in close formation, dragging coconut leaves to entrap small fish in their serrated fronds. The small fish would act as bait. Two large pirogues were tied together and launched into the sea. Five men on each side wielded their paddles. The steersman at the stern used his paddle as a rudder and chanted to keep time. A long rod was fixed to the prow, stout enough to land fish larger and heavier than a man. They paddled through the gap in the reef,

far out and further, to reach the Tunny Hole, a very deep undersea cave. Here, legend had it, the tuna slept at night, out of reach of the sharks. 'Why', asked Gauguin, 'not then simply let down a line into the cave?' Because the cave was the abode of the god of the sea, it was a sacred place: the location of the Tahitian version of the legend of the Flood.

One day in the distant past, a fisherman had let down his line into the Tunny Hole. The line had got entangled with the god's hair, tugging at it, waking him up and annoying him. This made the god so furious that he decided the whole human race should be destroyed as a punishment for disturbing his peace. Only the fisherman himself would be spared – if he obeyed the god. He must take all his family to the Toa Marama, which means Warrior of the Moon. It is unclear exactly what this is – a ship, or a mountain, or maybe even a star – but when they had reached it, the flood waters rose to cover the whole earth, leaving only those on the Toa Marama alive, after which they repopulated the earth.

Hence, the reluctance of all subsequent fishermen to sink a line down into the Tunny Hole. Instead, they sprinkled the water with the small fish, to bring up the tuna. The surfacing tuna brought the circling sharks. The churning sea browning with blood, the air turned chaotic with screaming frigate birds diving to pierce fish flesh at random. Calmly, the captain of the pirogue chose a man to cast the first hook from the long line attached to the prow. Time passed without a bite. Another man was called. A superb tuna bit. As they were hauling it on board, a swift shark demolished the hooked fish with a few slashes of its teeth. Only the head was landed on board. This was unlucky. The fishing had begun badly.

Gauguin was chosen to fling the next hook. This time the fish was landed. The Frenchman was lucky. He got to fling the hook again. Another good fish was hooked and landed. But this second success was accompanied by sniggers and laughs, similar to the sniggers and laughs that had greeted him when he had first landed ashore in Papeete with his long hair and been mocked as a *mahu*. Why did they laugh at him? He would ask, but first they must get home. It was hard work. Twenty arms paddled for two hours to get the heavily laden pirogues through the tricky gap in the reef in the dusk. 'The powdery wake phosphoresced, and it felt to me like some mad race, pursued

by the mysterious spirits of the ocean and by the schools of curious fish that kept us company, leaping.'[10]

On the shore the women greeted them with fires to feast on the fish. He asked one of the crew what was the cause of the laughter and whispers? It was because Gauguin had hooked the fish in the lower jaw. This meant that his *vahine* was being unfaithful while he was away.

After they had feasted on the beach and were sleepy with food and drink, he asked Tehamana if her lover had been nice today. She told him that she had no lover. He told her that the fish had spoken. She fell into a long prayer to her god before telling him to beat her, to strike her hard. He refused.

'May my hands ever be for ever cursed if they strike a masterpiece of creation.'

'Beat me, I tell you, or you'll be angry for a long time, and you'll be ill.'

He kissed her instead 'and my eyes spoke these words of the Buddha; it is by gentleness that anger must be conquered and by good that evil must be conquered'.[11]

The page on which he writes this story is illustrated with a picture of the two of them entwined making love inside the petals of a sacred Buddhist lotus flower. The following morning one of Tehamana's mothers made it quite plain to him that Tehamana had slept with another man in his absence. It caused him no pain. This was how life was conducted here, and ought to be. A relationship was not a prison. Her sexual freedom trailed clouds of glory from the vanished paradise.

'One day I was obliged to go to Papeete. I had promised to be back the same evening but the carriage I took only brought me halfway, so I had to walk the rest and it was one o'clock at night when I reached home. We happened to be very short of oil; I was just going to get in a fresh supply.

'When I opened the door the oil lamp was extinguished, the room was in darkness ... I struck a match, and then I saw ... Motionless, naked, lying at full length on her stomach, Tehamana stared at me with terror-stricken eyes and seemed not to recognise me.[12] I stood still for a few moments in strange uncertainty. Tehamana's terror infected me, it was as though a phosphorescent light radiated from her fixed, staring eyes. I had never seen her so beautiful, never had her beauty appeared so impressive. And in this

semi-darkness that was undoubtedly peopled with dangerous apparitions, with obscure imaginations, I was afraid of making any movement that might change her terror into paroxysm. Could I tell what she took me for at that moment? With my agitated face might I not be one of the demons or spectres, one of the *tupapau* with which the legends of her race fill sleepless nights? So violent was the feeling that had seized her under the physical and mental sway of her superstition, that it converted her into a being utterly strange to me from all I had seen before. At last she came to herself and I did my utmost to calm her and restore her confidence. She listened to me sulkily and said in a voice shaken by sobs:

"'Don't ever leave me alone again without a light.'"[13]

Ever since Gauguin had painted the picture of Clovis asleep, he had been fascinated by the idea of making portraits that would move between dream and reality, giving equal weight to the outer and the inner life, the physical presence and the imagined. This was part of the Symbolist-Synthetist agenda of privileging the unseen over the seen. He details in a letter to Mette how he strengthened the fearful atmosphere of *Manaò tupapaú* (*Spirit of the Dead Watching*), through use of colour in the picture, constructing it like an Edgar Allan Poe tale: 'sombre, mournful and muffled like a funeral knell' using violet, dark blue and complementary orange.[14] Wanting to avoid the effect of lamplight, but to suggest the artificial light cast by the *tupapau*, he coloured the white bed linen a sickly greenish-yellow. Clear yellow binds this and the orange to the dark blues and violets, completing the 'musical chord' that he describes as running through the picture. The light explosions in the background are not real; they are the *tupapau*, the cause of Tehamana's terror. Knowing that Western eyes would not comprehend the degree of horror that could be aroused by mere explosions of light, Gauguin invented an embodied *tupapau*, giving it human shape to explain Tehamana's fear to the Western mind.

The picture is one in a cluster of major paintings developing the personification of the *tupapau*,[15] giving it the chillingly banal shape of a hooded, human figure. Watching at the foot of Tehamana's bed, the *tupapau* links the conscious and the unconscious in the same way that the creatures on the wallpaper in the picture of Clovis asleep link dream and reality, as does

WILD THING

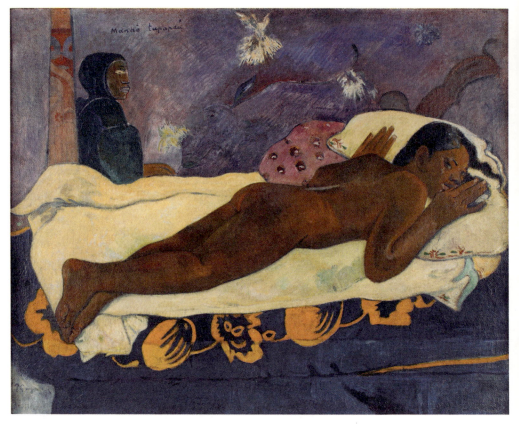

Gauguin, *Manaò tupapaú* (*Spirit of the Dead Watching*), 1892

Poe's watchful raven flown in from the occult realm to alight on Mallarmé's shoulder.

When he sent the consignment of pictures back to Mette in December 1892 for an exhibition she was organising, they were accompanied by a long letter explaining all this. Understandably nervous about the reception of 'the most questionable . . . *Le Manao tupapau* [sic] I have painted a young girl in the nude. In this position, a trifle more and she becomes indecent.' He hoped his explanation of the picture 'will arm you against the critics when they bombard you with their malicious questions'.[16] Pornographic interpretation being all too easy then, as now, he trusted Mette to recognise the real meaning of the picture as an icon of existential terror, paralysis in the face of the horror of the void that strikes most forcibly when we are alone and vulnerable. (It was

242

a preoccupation of the time; Edvard Munch painted his *Scream* the following year.) Gauguin knew that Mette for all her pragmatism was terrified of the dark; like Tehamana, she had to sleep with the light always on.

Gauguin trusted Mette to fix the prices on all of the pictures except three, which he valued above the others. *Manaò tupapaú* was the canvas he priced most highly at 1,500 francs. He also gave her strict instructions to exhibit the pictures with only their Tahitian titles. Spectators must be given the chance to dream. He did, however, provide her with translations, should people insist on knowing, though he would prefer the mystery to be maintained.

The list of pictures he sent comprised:
Parau parau (Word, Word)
Aha oe feii? (Are You Jealous?) 'not less than 800 francs'
Manaò tupapaú (Spirit of the Dead Watches) – 'not less than 1,500 francs'
Parahi te marae (Temple place reserved for worship of the gods and human sacrifice) – 'not less than 700 francs'
Te Faaturuma (Silence or Mournful Spirit)
Te raau rahi (The Great Tree)
I raro te oviri (Under the Pandanus)
Te fare maorie (The Maorie Dwelling)
Vahine no te tiare (Woman with a Flower)
He also included a couple of landscapes, titles unspecified.[17]

The idea of an exhibition of Gauguin's work in Denmark was born in the brain of the painter Theodor Philipsen. He had become Gauguin's friend on his first, miserable visit to Copenhagen in 1884–5. On Gauguin's second, and final, short visit to say goodbye to Mette and the children, Gauguin had invited Philipsen for a cup of tea and a catch-up in the flat in Vimmelskaftet. It was Philipsen who had bought the picture *Woman Sewing*, paying 900 francs. The other moving spirit behind the exhibition was the artist Johan Rohde, who set up the Frie Udstilling, the independent exhibition space that broke the stranglehold of the Academy in Denmark, introducing and pioneering exhibitions of the avant-garde.

'It seems obvious', Rohde wrote in 1892, 'that Gauguin was the most prominent figure in this circle, the leader, and the one who had contributed

the greatest fund of work and talent. At Schuffenecker's there were works by him that will probably be reckoned among the finest achievements in the art of the century.'[18]

To swell the exhibition, Mette asked Schuffenecker to send pictures from Paris, where he was continuing to store them, despite the *froideur* that now existed between himself and Gauguin. When Gauguin's latest pictures arrived, Mette told Schuffenecker that she found them very beautiful, something she never told Gauguin. She had them framed, and she sold four for 1,500 francs. On 21 January 1893, she sent Gauguin 700 francs.

By February that year, Philipsen, Rohde and Mette were discussing what would be on the walls when the exhibition opened in March. Rohde travelled to The Hague to see a large exhibition of Van Gogh at the Haagse Kunstkring, the local art association. Bowled over, he wrote to Theo's widow, Johanna van Gogh-Bonger, to ask if she would lend pictures to be exhibited alongside Gauguin's. The widow gave her blessing. Rohde crated up twenty-five paintings and sent them to Copenhagen by boat. Come 25 March, the opening date, the Van Goghs had not yet arrived, though Gauguin's paintings had, by a whisker. At last, on 30 March, the walls of the Frie Udstilling blazed with the first ever two-man show of Gauguin and Van Gogh. Copenhagen's reaction was 'vociferously enthusiastic'.[19]

It was an exhibition of masterpieces: forty-nine Gauguins, ranging from his early marble busts of Mette and Emil, through *Woman Sewing*, Rouen landscapes, the red-nosed self-portrait in the Danish attic, Symbolist-Synthetist landscapes from Brittany and Arles, *Life and Death*, Martinique landscapes and the paintings he had sent from Tahiti.

The twenty-five Van Goghs included the graphic *Sorrow*, early Impressionist landscapes, *The White Orchard*, *The Langlois Bridge*, two portraits of Doctor Gachet, *Poplars* from Saint-Rémy, two paintings of poppy fields, the *Twelve Sunflowers* he had painted for Gauguin's room in the Yellow House, and *Fourteen Sunflowers*.

There were over 1,200 visitors on the first day. The conservative papers wrote critically, as expected, but the commentary in forward-looking international papers like the Danish *Politiken* (started by Georg Brandes) and the French *Mercure de France* were ecstatic in their praise of the 'radiant

monstrosities . . . the frenzied riot of colour rampaging through the pictures . . . art as rich and various as the jewelled splendour of fairy tales . . . the landscapes with their brilliant colours, the trees with their oddly twisted forms that are no slavish imitation of reality but the reflection of the artist's own – strange – nature . . . incomprehensibly wonderful . . . not just representations of reality: they are poems, fantasias, symphonies where the incidental, diffuse phenomena of nature sound together in a richer, stronger and more beautiful harmony than each possesses singly'.[20]

Mette, de Monfreid and even Joyant, his neglectful agent who had taken over from Theo at Goupil's, wrote to Gauguin to inform him that the exhibition was a sensation and that his reputation was growing Europe-wide. With so much critical attention focused upon him, it was urgent Gauguin take advantage of the moment. He must get back to Europe as quickly as possible. He now learned that Joyant had sold 1,000 francs' worth of paintings while he had been in Tahiti and Gauguin had never seen a penny of it. Joyant wrote to him, 'You can't imagine how the spirit has changed and to what extent your crowd has arrived.'[21] His time had come and he was half a world away, powerless to capitalise on the moment. 'My god, how I rage! It is really anger that keeps me going.'

In March, two further things happened: Tehamana told him that she was pregnant, and Lacascade told him that his ticket had been approved by the ministry. He would be travelling third class (which made him furious) on the French warship the *Duchauffault*, leaving on 4 June. Three months to chafe! There was at least a little humour to be harvested from the fact that Lacascade would be leaving Tahiti at the same time as himself, and in disgrace. Complaints and reports of Lacascade's ineffectual governorship had led to his demotion. He would be sailing away to take charge of Mayotte, a smudge of an island off the coast of Mozambique.

Gauguin was not going to worry about leaving Tehamana. Since the arrival of Europeans, measles, influenza, pneumonia and syphilis had more than decimated the population. In 1769, Captain Cook estimated the population at around 200,000. In 1797 it stood at 16,000. A mere fifty years later in 1848, it had fallen to 8,000. With numbers declining so drastically, babies were so welcome that it had become the custom for every newborn to be adopted as

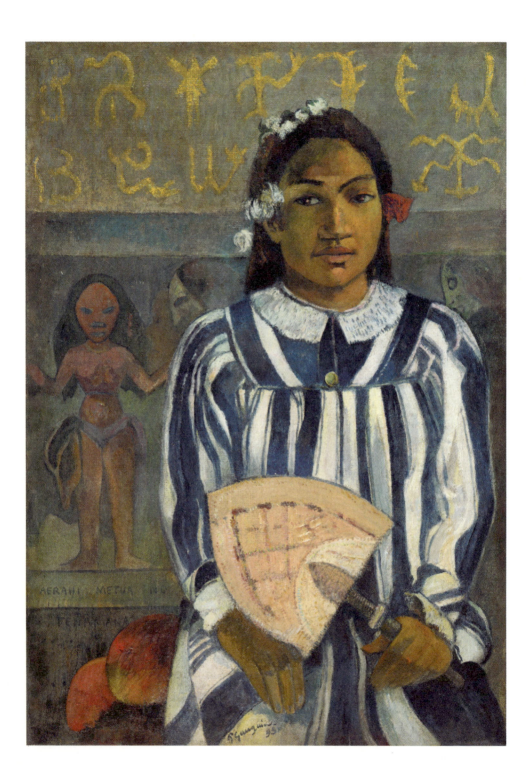

a matter of course by the whole community who became its family for life. Gauguin reported correctly if cynically, 'I shall soon be a father again in Oceania. Good heavens, I seem to sow seed everywhere! But here it does no harm for children are welcome and spoken for in advance by all the relatives. It's a competition as to who should be the mother and father nurses. For you must know that in Tahiti, a child is the most beautiful present one can give. So I do not worry as to its fate.'[22]

Merahi metua no Tehamana (*Tehamana Has Many Parents*, 1893) is the only ascertainable picture of Tehamana. He painted her name on the canvas. We know that Tehamana had 'many parents' in the literal sense of being part of a wide adoptive family, but the portrait's title draws attention to her abstract parents, her parents in time, the historic and imaginative forces that went into her creation. Just as Gauguin saw his nursery rocking horse as a later manifestation of something that had begun in the Parthenon frieze, so the attributes he gives Tehamana stretch far back into prehistory. Above her head runs an indecipherable runic inscription, like a magic spell, which Gauguin copied from a photograph of Easter Island petroglyphs. Behind her stands the figure of a goddess, probably Hina, the goddess of moon and creation. Behind her flit sinister *tupapaus*. The flowers in her hair are the eternal *noa noa* of the delicious isle. The striped Mother Hubbard covering her body is the clothing of an imposed religion that leaves her soul, and her essential self, untouched. She sits by mangoes, symbolising fruitfulness. The plaited palm fan in her hand symbolises her innate nobility. Gauguin might deny the label Symbolist-Synthetist, but this is surely the ultimate Symbolist-Synthetist portrait, delving into the complexity of identity, a family tree reaching back to ancient scripts and symbols, taking in religious antagonisms, colonial impositions, cultural and cross-cultural mysteries. He looked forward to coming back to Tahiti when he would meet all these complexities embodied in their child.

Gauguin, *Merahi metua no Tehamana* (*Tehamana Has Many Parents*), 1893

14

'I HATE NULLITY, THE HALFWAY'

> You drag your double along with you, and yet the two contrive to get on together . . . Saint Augustine and Fortunatus the Manichean, face to face, are each of them right and wrong, for here nothing can be proved . . .
> It is such a small thing the life of a man, and yet there is time to do great things, the fragments of the common task . . . Everything is serious and ridiculous as well . . . The feudal castle, the thatched cottage, the cathedral, the brothel. What is one to do about it? Nothing. All this must be; and, after all, it's of no consequence. The earth still turns round; everyone defecates; only Zola bothers about it.[1]

In mid-June Gauguin set off back to the Eurocentric world on board Lacascade's promised ship, the *Duchauffault*, with sixty-six Tahitian canvases stowed in his luggage. What Lacascade had not told him was that it would take him only as far as New Caledonia, where he would have to spend three weeks at his own expense before changing to the *Armand Béhic* for Marseilles. Gauguin's purse was bleeding dry, but pride took over when he saw Lacascade himself boarding the *Béhic* to return to France before taking up his new colonial governorship. Gauguin paid to upgrade himself from third class to second; he would not give Lacascade the satisfaction of seeing him among the lowest of the low.

The voyage was miserable. A cold spell in Sydney was followed by furnace-like conditions in the Red Sea where three passengers died of heatstroke and their corpses were flung overboard. When the boat arrived in Marseilles on 31 August, Gauguin had only three francs and some centimes in his pocket. He called in at the central post office where he discovered a warmly supportive letter from Sérusier offering to lend him 250 francs. Gauguin spent his last francs telegraphing to say he needed the money immediately. When it arrived the following day, he bought a train ticket to Paris, and bamboozled

his way past the concierge of de Monfreid's studio, dropped his bags, and went on to the gallery Boussod et Valadon to check on sales. There he discovered that Joyant had left six months previously. The gallery, unwilling to clutter up its premises with Gauguin's unsaleable pictures, had sent them along to de Monfreid. Gauguin's despair would have been complete had it not been for Degas, who had always admired his pictures and who, on hearing that Gauguin was back, wished to see his latest work properly displayed and used his considerable influence to bring about a solo exhibition at Durand-Ruel's famous gallery in November.

To accomplish this, Gauguin had to get the paintings back from the Copenhagen exhibition. While this was being arranged with Mette, Gauguin's uncle Isidore (Uncle Zizi) died in Orléans, leaving his money divided equally between Gauguin and his sister Marie, now living in Colombia with her husband Juan Uribe, who had been so extremely unwelcoming when Gauguin had arrived in Panama. There had been little contact between them since. The inheritance comprised about 22,000 francs. Mette considered she was due half of Gauguin's half. He disagreed. His reason was that while he had been in Tahiti, Mette had sold some pictures by him, and others from his collection of Impressionists, to two Danish friends: her brother-in-law Edvard Brandes and her doctor, Kristian Caröe. Mette had not sought his permission to sell his pictures, and she had kept the proceeds to support herself and the children. She considered this fair and let him know that if he ever wanted to buy them back, he was free to do so. Gauguin raged. Mette had no idea of their importance to his creativity. They were the sacred source of inspiration. She had no right to sell them. Self-righteousness bristled on both sides. Gauguin demanded a full list of the pictures she still had in her possession, as well as a list of the pictures she had sold. She never furnished him with either. He was desperate, not knowing what remained, and what was gone for ever. He was particularly concerned for his beloved Cézannes. On ascertaining that she had sold 'a Cézanne with Red Roofs' to Edvard Brandes, Gauguin wrote directly to Brandes, offering to swap it for one of his own canvases.

Brandes replied briskly: 'Over the last two years I have bought pictures from Mette to the value of 10,000 francs. I like my little collection and have

no intention of selling anything to you.'² From this, Gauguin learned two things. Firstly, that there were probably many pictures that he would never see again. Secondly, that while he had been in Tahiti, Mette had realised 10,000 francs from the sale of his paintings to Brandes alone. How much more had she kept secret from him? She had not sent him any money from the sales, even while she had known he was living in poverty, ill health and distress. Mette had cheated him.

Mette saw it differently. Gauguin had been such a poor breadwinner that all the money from the pictures rightfully belonged to her. Now *he* would probably cheat *her* over Uncle Zizi's inheritance. Gauguin's share of the inheritance and Mette's profit from the pictures were worth the same amount: 10,000 francs, give or take. They might have decided to call it quits and move on. Each did, in fact, make a tentative move towards reconciliation. Mette invited him to Denmark, but he refused on the grounds that he was too busy preparing for the exhibition. He countered with an invitation for her to come to Paris, maybe bringing one of the children? All might have been resolved if they had met face to face. Instead, there ensued an escalating epistolatory war, fuelled by grudges, resentment, self-righteousness and misunderstandings. Their correspondence was further complicated on Gauguin's side by his need to coax Mette into sending him the pictures by him that had been exhibited in Denmark. From her point of view, if she kept the pictures, they would be a continuing source of income for her and the children. If, on the other hand, she sent them to Paris and the exhibition proved a success, their value would increase, and, as a result, she and the children would profit. Finally, she came down on the side of speculation for accumulation. The pictures arrived a couple of weeks before the exhibition was due to open, but his bad temper increased on discovering that two of his favourite pictures were missing. He sent her a self-justificatory inventory detailing the expenses he had incurred since his return to France, amounting to 2,490 francs. Icily he pointed out that he had had to borrow this sum, with interest, against the day Uncle Zizi's money would come through. To have to account to Mette in this pettifogging way was distasteful to him but it did not interfere with his sincere wish, and indeed central purpose, that when he had made the large sum that would undoubtedly result from sales at the exhibition, he would use

it to finance his return to Polynesia accompanied by Mette and the children. They would all live happily ever after there, though he was a little concerned that their son Emil, who had joined the Danish navy and who already, in photographs, looked like a jut-jawed stereotypical Nordic officer, was unlikely to fit into the Arcadian adventure.

Naïve in many ways, Gauguin had no inkling of the effect that the long-drawn-out duel over the pictures and the inheritance money was having on Mette. She unloaded her feelings in a letter to Schuff, saying that the question of the inheritance had opened a rift in her heart; that 'he'll never think of anyone but himself . . . Maybe, Schuff, you find me cold, strict and at fault, as Paul says I am, but he makes no mention of giving me a share . . . I've written all this to unload my feelings. If you think I'm wrong – no, don't tell me. Don't show this letter to a soul, promise me that.'[3] Previously, she said, she had respected her husband for his integrity in placing art above all the world's concerns but now, with Zizi's inheritance coming to him, she first perceived his artistic mission as a manifestation of egotism, and egotism was something she could neither understand nor condone.

Zizi's executors needed Marie's signature on documents before they could sell securities to realise the cash. A single exchange of letters with Marie in Colombia took months, and few issues were settled in a single exchange. Pieces of paper shuttled halfway across the globe and back, leaving Mette suspecting deliberate prevarication, and Gauguin fuming at having to borrow with interest against the eventual payout. His first expense was the preparation of the Tahitian pictures he had brought back. They had been rolled up on the voyage home, ergo there was travel damage to repair, touching up to be done, and stretching preparatory to framing. Durand-Ruel was not himself in Paris at this time, being in New York on his tremendously successful gamble to make America wake up to French Impressionist painting. Gauguin had to deal with his subordinates who, in the boss's absence, imposed harsh terms. The exhibition was to last a fortnight. Gauguin had to pay all costs. He also had to make all arrangements, including transport, the printing of posters, catalogues, invitation cards, and arrange the framing of more than forty pictures. Gauguin might have saved a lot of money if he could buy standard-sized ready-made frames to tack the canvases into but, because

he had taken a hundred metre roll of canvas to Tahiti and cut pieces off to suit the size and proportion of each individual subject as he saw it, there was nothing standard-sized about the pictures he brought back. The Paris avant-garde had a passion for plain white frames. Gauguin followed the fashion. White paint was, after all, a great deal cheaper than the traditional carved and gilded alternative. But stark white was a colour he seldom, if ever, used, finding it sterile and deadening. Nevertheless, he followed the fashionable formula, though the pictures that completely revolted against existing within a rectangle of stark white he framed in cobalt blue or chrome yellow.

'I shall soon know whether it was an act of lunacy to go to Tahiti,'[4] he told Mette, betraying his trepidation.

The show opened on 9 November, a freezing day in Paris. Gauguin hurried to the gallery, looking dashing in a dark cloak held together at the throat with a big brass clasp. Somewhere he had found a karakul astrakhan fur hat that perched on his head like a small, furry, upside-down canoe. Thus dressed, his exotic figure at the door made a surprising prelude to Durand-Ruel's stately establishment. Durand-Ruel had built his reputation by boosting the market in Impressionist pictures with the millionaires of Paris, among whom they had become status symbols, particularly Monet and Renoir. American millionaires would not be far behind. Durand-Ruel understood the insecurities of the very rich. He did not frighten them with too much modernism but gently moved their taste forward in canvases that were not presented aggressively framed in plain, white-painted frames but in the old-fashioned carved and gilded frames that fitted well into the cluttered abundance of his clients' homes, that clung to the Rothschildian aesthetic of Gauguin's stockbroker days. Flattering his clients' taste, Durand-Ruel's gallery exuded an air of luxury and resplendence that could scarcely be less appropriate to Gauguin's raw canvases glorifying a pre-European civilisation powerful in alien, mystical spirituality. The gallery's oil-burning arc lights that did such a splendid job of bringing to life the flickering brushwork of the Impressionists flooded Gauguin's flatter and more solid colours with a tough harshness that made them look crude and garish.

Gauguin showed forty-two Tahitian paintings and several of his carvings, including *Idol with Shell*, *Idol with Pearl* (1892–3) and a wooden cylinder

form of Hina and Fatu (c.1892), the mother god and her son carved in the style of tikis with large heads and claw-like hands. The carvings were possibly the most offensive and incomprehensible items in the show. Conservative critics spluttered. However, two critics wrote warmly. Octave Mirbeau pointed out that Gauguin empathised and sympathised far more with the remote place than Loti, in whose books 'we search in vain for the soul of this curious race, its mysterious and terrible past, the strange voluptuousness of its sun, nor do we find the thrill of its exceptional and unique character as we do in Gauguin's exhibition'.[5] Thadée Natanson also approved, while questioning why Gauguin was so transparently using Western models such as Manet, Poussin and Puvis de Chavannes, and why he took the poses of Eastern temple friezes and classical statues on which to base his Polynesian pictures. Natanson was missing Gauguin's point that worldwide historical references were designed to infer universal human interconnection.

Mallarmé, whose opinion he valued most of all, said, 'It is extraordinary that so much mystery can be put into so much splendour.'[6] Degas followed up his unswerving admiration of Gauguin's art by purchasing two pictures at the opening, *Hina Tefatou* (*The Moon and the Earth*, 1893) and *Te Faaturuma* (*Silence*, 1891), the latter having much in common with Degas's quiet pictures of resting dancers. Degas's purchase was a gesture of public support that Gauguin much appreciated. As the older artist was leaving, Gauguin accompanied him to the door and, reaching up, he took one of his carved ornamental walking sticks from the display on the wall. He handed it to the older artist with the words, 'Monsieur Degas, you have forgotten your cane.' Smiling, Degas accepted the gift and the tribute.

Only eleven paintings were sold. Disheartened, Gauguin decided to write an explanatory book. He would call it *Noa Noa*, and it would describe his experiences of Tahiti. Almost as soon as he had decided on this, he started to sabotage his own idea. Yes, he would put down his Tahitian experiences in words, but he was not going to write either an apology or a straightforward explanation. Nor was he going to turn his experiences into a novella along the lines of Loti. He wished to create the opposite of a sentimental South Sea adventure story. After all, what was the point of writing if he was not brave enough to try to produce in words what he was trying to produce on

canvas? The challenge was to juxtapose incongruities on the page to trigger thought-explosions in his readers' brains that would create as great a shock as the *tupapau* ghost explosions in the Polynesian night. To achieve this, he would follow the obscure symbolist path taken by Mallarmé, Baudelaire and Edgar Allan Poe in literature, rather than the popular path taken by Loti. He would avoid linearity, the literary equivalent of painterly realism. Gauguin understood that his talent lay in synthesis, suggestion and disjointedness rather than in description and organisation. Showing a surprising humility and practicality, he realised that he needed help from a professional writer to pull off such a complicated concept.

Gauguin had long forgiven the symbolist poet and journalist Charles Morice for borrowing 500 francs from him and never paying it back. While in Tahiti, Gauguin had fumed at Morice who, had he honoured his debt, would have made all the difference to Gauguin's everyday existence. But Gauguin was not one for bearing grudges when the cause for resentment was past. Since his return to France, Morice had been extremely friendly. Maybe it was his guilty conscience, or maybe he sniffed the air and deduced that *Noa Noa*'s intoxicating perfume might become the next Paris fashion. Morice's career had been promising when Gauguin had departed from Tahiti; it had been faltering ever since. His symbolist poetry and playwriting fell short of brilliant. However, he had a talent for promotion; he was a networker, he had buzz, he had useful pull with editors of newspapers and magazines, and he owed Gauguin a favour. As Gauguin completed sections of *Noa Noa*, he sent them on to Morice, sometimes only a couple of pages at a time. Morice's task was to write a response to each short section in the voice of 'civilised' man commenting on Gauguin's 'savage' anecdotes and observations. How on earth this would clarify Gauguin's paintings remains unclear, but the net result might easily have become a popular book, as Gauguin's love of the 'disjointed' form and his inclination towards verbal and visual hybridity hit the contemporary spot during the final period of handwritten books, when autograph books, albums and illustrated 'journals' still held their own alongside the mass-produced printed book. Gauguin put a great deal of effort into the project. He completed his pages quickly and scattered them with sketches and watercolours and sent them on.

But Gauguin had always overestimated Morice, who lacked the depth of thought for the task Gauguin had set him. Unaccustomed to sustained effort, Morice did not complete his part of the bargain during the time frame necessary to tweak interest in the immediate aftermath of the exhibition; indeed, he took more than a decade to complete his few pages. By the time he did, in 1901, Gauguin was back in Polynesia, and the idea of explaining Polynesia to Paris sophisticates was both time-expired and a supreme irrelevance. When, in 1901, Morice wrote to say that *Noa Noa* was printed and he would send Gauguin a hundred copies, Gauguin wrote back saying not to bother, they would only be so much wastepaper.

Morice had, however, been useful in writing the short introduction to the Durand-Ruel exhibition, completing it in time for the public opening on 10 November. Gauguin says that he priced the pictures between 1,000 and 4,000 francs each.[7] At these prices, with eleven works sold, the exhibition was not a disaster, but it was far from supporting a trip back to Tahiti with the family. When the show closed, he turned his energy to hiring a studio and turning it into an exhibition space and a social *salon* at 6 Rue Vercingétorix, a courtyard snuggled in the little network of streets between the railway station and the Cimitière de Montparnasse in an area that had been up-and-coming for the last twenty years but had never quite arrived. It was rackety, but not dangerous. The buildings that made up Gauguin's courtyard had been cobbled together from bits of pavilions dismantled after the 1889 Exposition Universelle. He purchased rolls of cheap, bright, chrome yellow paper, and glued them to the walls. He painted the glass of the high-up, west-facing window and the glass panels of the entrance door the same refulgent colour, turning the space into a glowing, golden cave. As he lived there, too, he needed furniture. The local flea market provided a curvaceous sofa, an iron bedstead and an upright piano. Music would sound so deliciously *yellow* in this space. His Tahitian carvings looked stunningly barbaric in the unearthly glow. So did the paintings when he got them back, but their white frames looked awful on the yellow. He repainted them in colours which brought them to life. This made him wonder how much the frames had contributed to the exhibition's disappointing sales. He hung his guitar and mandolin between the canvases along with connective artworks giving clues to quotations and indebtedness:

Japanese prints, photographs of older works by Cranach, Holbein, Botticelli and more modern ones by Puvis de Chavannes, Manet and Degas.[8]

Madame Charlotte's Crèmerie in the Rue de la Grande Chaumière was the social centre of the little district. Charlotte Futterer was another landlady who, like Madame Gloanec in Pont-Aven, loved art and artists. Her Crèmerie was a small unpretentious place, seating about ten customers. A meal generally cost one franc or one franc fifty with coffee included. On either side of its entrance stood two large painted panels by two artists, then unknown. One depicted a ravishing maiden who has apparently fluttered down from nowhere with her hair and draperies flying, like an angel of the Annunciation, but what she is announcing is the arrival of art nouveau borne on the paintbrush of the Czech artist Alphonse Mucha, whose style would take off the following year when he was chosen to design Sarah Bernhardt's publicity posters, after which his glamorous fluidity would permeate decorative art throughout the world, called art nouveau in France, Britain and America, *Jugendstil* in Germany, *Sezessionstil* in Austria, *Stile Liberty* in Italy, *arte joven* in Spain, and modern style in Russia. The corresponding large panel on the other side of the entrance was painted by Władysław Ślewiński, one of Gauguin's disciples from Pont-Aven and Le Pouldu. Mucha's studio was at 13 Rue de la Grande Chaumière. Before Gauguin found his own studio space, the easy-going and sociable Mucha had been happy for Gauguin to share his studio while he was preparing his paintings for the Durand-Ruel show. If Madame Charlotte liked you – and she liked both Mucha and Gauguin very much – she would take payment for meals in pictures rather than in money. Little wonder Gauguin was a favourite, described, not for the first time, as being built like a Hercules (this seems to have been a stock compliment of the time). 'His hair is curly, his features are energetic, his eyes clear; and when he smiles in his characteristic way, he seems alike gentle, shy and ironical.'[9] It was a sociable circle. He entered into a period of *joie de vivre* in a milieu of high jinks, singing, dancing, dressing up, playing charades and just being silly. On the other side of the road from Mucha and Madame Charlotte stood Colarossi's Académie, one of the small, independent art schools that were breaking the academic stranglehold on French art. Gauguin and Mucha both taught at Colarossi's, where

lessons were excellent value at fifty centimes, and students could work direct from the nude model.

Gauguin's studio occupied the top floor of the rickety ex-expo building. A wooden staircase ran up to his entrance doorway, on which he painted in flowing script *Te faruru* (*Here We Make Love*). The Scandinavian couple on the floor below were far from averse to the sentiment. William and Ida Molard were extremely bohemian and sociable. William was twenty-five years old, half Norwegian and half French. His father had been a church organist and William's ambition was to become a successful composer, but he sadly lacked both money and drive. William took a job at the French Ministry of Agriculture which paid for his pipe dreams and his little love affairs, both of which were scorned and resented by his wife Ida, a muscular sculptress approaching forty. William played the piano well and he shared Gauguin's passion for Wagner. Strains of the *Ring* cycle drifting up through the floorboards were an unexpected delight. The Molards' long studio, directly beneath Gauguin's, was tramlined by Ida's busts and body parts. She had studied sculpture at the Royal Academy of Art in Stockholm before giving birth in 1881 to an illegitimate daughter, Judith, fathered by the Swedish opera singer Fritz Arlberg. Subsequently a nameless 'wealthy supporter' (Fritz Arlberg's family? A later lover?) had paid for Ida to leave Sweden and continue her studies in Paris, where she married William, cut her hair short, smoked cigars and dressed in the feminist uniform of her day, a man's suit and tie. Her daughter Judith was now thirteen and growing breasts, in which her stepfather showed an indecent interest. Poor Judith had no refuge; she slept in a bed behind a screen in the long studio, while William and Ida slept behind another screen. Neither Ida nor Judith made any secret of their irritation that William failed to put his back into the Noble Cause of Art, and that he had a wandering eye for ladies other than his wife. Beneath the earthy scent of wet clay, the bohemian air of the Molards' studio was scented with jealousy and resentment. When Gauguin moved in upstairs, Judith flung herself at him – maybe to spite her stepfather? She offered him her breasts and was continually lunging to kiss him on the mouth and making a great nuisance of herself when he was trying to work. It reminded him of Titi. However, this was not the only irritating thing about her. Maybe we can deduce why Gauguin kept the over-willing teenager at arm's

length when we read her memoir. She is seldom rational, never charitable, and often unnecessarily unkind. She described her mother's face as nondescript, and her hair the colour of a washcloth. She is equally damning of the Swedish playwright August Strindberg, one of her parents' friends who ran in and out of the studio, and was vitally important to them intellectually, as he was to Mucha and Gauguin and to the wider circle, by introducing them to the fascinating and imaginative use of photography, such as ghost effects achieved through deliberate double exposures. But Judith saw only Strindberg's externals: 'his mouth pursed like the backside of a hen over the grimy mystery of his decayed teeth, the contrived and always identical disorder of his pretentious old lion's shock of hair, his grimy, chapped hands'.[10] Another member of the circle was Julien Leclercq, a hopeful symbolist poet aged twenty-eight with long, dark hair and burning eyes who worshipped Gauguin and began to haunt the building where they all lived. He had the misfortune to fall in love with the lurking Judith who wrote him off as 'speaking with a great deal of the supreme incompetence and marvellous intuition, that for him took the place of erudition'. When the badly smitten Leclercq told her he had wept all night for love of her, she answered tartly, 'Weep on, you'll piss less.'[11] The erotic currents flowing through the Molard studio provide another reminder of the accepted attitudes of French society where thirteen-year-olds were considered independent beings in their own right, and sex with them was not only permissible but unremarkable.[12] Whether thirteen-year-old Judith slept with twenty-eight-year-old Leclercq or with forty-six-year-old Gauguin was up to her. It was not her age that made Gauguin flee her advances, but her personality.

With his studio interior decorated to his satisfaction, and the paintings back from Durand-Ruel, Gauguin started a weekly Thursday *salon* along the lines of Mallarmé's *Mardis*, but a lot less solemn. Wine flowed. The Molards scuttled up and down the stairs with trays of homemade food and cakes. Guests entered through the door inscribed 'Here we make love'.

The Studio of the South Seas, as it became known, was a chaotic carnival of contemporary thought. Beneath his highly coloured paintings leaping off the yellow walls, Gauguin acted as both shaman and storyteller. It was performance art. Dressed in flea-market exotica he told his traveller's tales

and gave readings from *Noa Noa*. He played Western and Polynesian music on his various instruments and demonstrated Polynesian dances. Once he frightened Judith Molard almost to death when he dressed up as a Tahitian chieftain in a tight blue sarong, with a bare chest and his arms painted in imitation of tattoos: 'He had assumed a terrible look, – half Inca, half cannibal. They didn't pay any attention to me, so I stayed, dumbfounded before the milky skin, the curve of his torso like a Japanese wrestler.'[13]

Music mattered enormously. He sang, played his guitar, his mandolin and his upright piano. Molard performed Wagner and his own compositions, now sadly lost. The English composer Frederick Delius was the most accomplished musician. A close friend of Molard, Delius had enough money not to have to take a job but to be able to devote himself to music. Much of Delius's wealth came from a citrus grove in Florida, doubtless seeded by Tahitian oranges. Like Gauguin, Delius was entranced by the melancholy task of recording a vanishing paradise, in Delius's case the land of Native Americans who were being degraded and pushed out by, among others, plantation owners such as himself. While mourning the decline of the indigenous peoples and their landscape in his romantic music, Delius was also possibly the first front-rank white European classical composer to bring African American slave songs into his own compositions: an attitude which conjures the revolting image of him lounging on the veranda of his plantation in his immaculately cut linen suit with a julep in one hand and a scorebook in the other noting down the songs of his workers who not long ago had been enslaved.

Another regular performer was the playwright August Strindberg, whom Judith had described so cruelly. He contributed anarchy to the musical evenings as he demonstrated his belief that one must be utterly open to the occult and invisible forces, both bad and good, that are constantly besieging the visible world and our selves. These forces, he believed, direct our fate, making free will a delusion and a fairy tale. To illustrate this, Strindberg (an accomplished musician) gave performances playing and singing to a guitar that he refused to tune, considering that he was giving his audience a demonstration of the role of chance in creation. His concerts usually ended in hysterical laughter.

As so often in Gauguin's life, he had landed at the sharp end of the avant-garde. Throughout 1893–4, the skies of Paris were brilliantly lit by

the Northern Lights. Things Scandinavian were all the rage. Eleven plays by the Scandinavian authors Ibsen, Bjørnson and Strindberg stormed the Paris stage, mostly directed by the theatrical man of the moment, Aurelien Lugné-Poë, at his newly opened experimental Théâtre de l'Œuvre, which was devoted to symbolist works. France was producing no native revolutionary playwrights that hit the contemporary nerve like Norway's Henrik Ibsen with his examinations of the moral foundations of society and denunciations of social conventions, or Strindberg, whose closely focused psychodramas predated Freud. Bjørnson was more of a realist but popular, nonetheless.

Strindberg's play *Creditors* had been an enormous hit in Vienna, where it had a run of seventy-one performances. The great Lugné-Poë brought it to Paris in June. A psychological thriller, the play concerns a divorced husband who begins, ostensibly benevolently, a relationship with his ex-wife's new husband. The relationship darkens until eventually, he kills the new husband by *envoûtement*, bewitchment. Both Vienna and Paris were in a spasm of interest in the supernatural. Mesmerism, hypnotism, 'suggestion' and made-up religions like Aleister Crowley's Thelema that incorporated Satanism, drugs, Egyptology and black magic, and Madame Blavatsky's newly founded Theosophy whose *Secret Doctrine* centred on mysterious Masters of Wisdom who lived in Tibet. A play on the theme of murder by magic hit the spot in Paris, as it had in Vienna.

Strindberg had come to Paris to take advantage of his potential fifteen minutes of fame. 'In Paris, in the headquarters of the world, 500 people are sitting like mice in an auditorium, and foolishly exposing their brains to my suggestions. Some revolt, but many leave there with my spores in their grey matter; they go home pregnant with the seed of my mind,' he wrote home, happy to have achieved major intellectual influence.[14]

Gauguin's South Sea shenanigans had not noticeably impregnated Paris's grey matter, but despite this he was not overtaken by jealousy. Strindberg became a good friend. They had much in common. An accomplished painter, as well as a writer, Strindberg was also, like Gauguin, naïve when it came to trusting doubtful characters. His trip to Paris had been undertaken on the promise of being put up rent-free in a luxurious apartment in return for his paintings. The man who made the offer was a conman named Willy Grétor.

By the end of Strindberg's first month in Paris, Grétor told Strindberg that he had sold 900 francs' worth of his paintings. Cheerfully, Strindberg anticipated a bountiful money-stream that would support his playwriting. But, while Grétor showed him the bills and receipts, he never showed him the money. Grétor was signing Strindberg's pictures, selling them on as his own work, and keeping the money himself. The luxurious apartment where he housed Strindberg did not, in fact, belong to Grétor but to one of his mistresses, who was by no means keen to share it with Strindberg when she found him living there on her return.

Strindberg and Gauguin shared more than naïveté. Both were fugitive fathers and husbands consumed with guilt at putting their art above their family obligations. Both hated the established Church but loved Jesus Christ who, woven into the fabric of their lives from their earliest days, remained the spiritual foundation of both men. They fell into the habit of walking together to the Church of Saint-Sulpice to contemplate Delacroix's mural of *Jacob Wrestling with the Angel*. Each identified with both wrestlers, as they endured the great struggle between the sacred and the profane, the ideal and the real, between art and life.

Some, but not all, of Gauguin's old friends attended his Thursdays. Schuff came along with Louise, to whom he was still married, and with whom he was still quarrelling. Charles Morice attended, as did de Monfreid and his wife Annette. Absent were Émile Bernard, who was ramping up his baseless grudge against Gauguin, and Charles Laval, who had accompanied Gauguin to the muddy hell of Panama and Martinique and would have come to Tahiti had it not been for his tuberculosis. De Haan was also absent. Never robust, he was mortally ill and would die in Holland in October 1895. Absent also were the Nabis, the group of younger artists who had made *The Talisman* the centrepiece of their Temple, and Gauguin their god. The direction their god had taken on going to Tahiti diverged drastically from their central preoccupations which were essentially Eurocentric and concerned with marrying early Christian Byzantine and monastic traditions with folk art. Not even Sérusier attended Gauguin's *salon*. But Mucha, the rising star of art nouveau, brought along Władysław Ślewiński, whose panel stood on the other side from Mucha's at the entrance to Madame Charlotte's Crèmerie.

Ślewiński became an artistic disciple and lifelong friend. The young poet Julien Leclercq attended the *salons*, as did the cellist Fritz Schneklud whom Gauguin painted. Another young devotee was Paco Durrio, a Spanish sculptor, ceramicist and jeweller who would further the line of succession coming down from Gauguin, by helping Picasso to produce his savage, primitive ceramics after Picasso had been inspired by seeing Gauguin's.

The gallerist and agent Ambroise Vollard also came. He and Gauguin were conducting the preliminary dance steps between artist and agent as neither was yet confident enough to completely trust his future to the other. Vollard claimed to have introduced Gauguin to Annah la Javanaise, Annah the Javanese, a figure of some mystery. The legend ran that Annah had been trafficked into France to fulfil the whim of an opera singer who wanted a black girl as an accessory to show off the whiteness of her own skin (like the black maid in Manet's *Olympia*). Many black girls were employed as maids by high-class courtesans for the same purpose. Annah was feisty and uncompromising. Her habit of making rude faces, sticking out her tongue and coldly staring when she felt her space invaded made her unsuitable for the opera singer's decorative purposes. The singer regretted her whim and expressed the wish to move Annah on. Probably it was Vollard who steered Annah towards modelling at Colarossi's, where she became a popular sitter. 'Annah, despite her difficult position, was nobody's slave, she had a mind of her own and was potentially dangerous.'[15] Like Olympia, and like Gauguin's mother Aline, Annah was a survivor in the Paris demi-monde that was such a tough place for women. Possibly it was Vollard who suggested that Gauguin incorporate her in his Tahitian evenings, where the presence of a black girl would greatly add to the exoticism, particularly as Annah adored dressing up and seldom appeared without her parrot and her pet monkey. Her age is uncertain; she was either still in her teens or in her early twenties. One of the places Annah modelled was the Académie Vitti, a small art school, offshoot of Colarossi's,[16] where Gauguin began to teach in February. She became his mistress on an understanding of non-exclusivity on both sides.

Since arriving in Paris, Gauguin had not felt attracted to painting the city. His usual reason, needing time to accustom himself to a place before he could produce work representing it, surely did not apply in this familiar

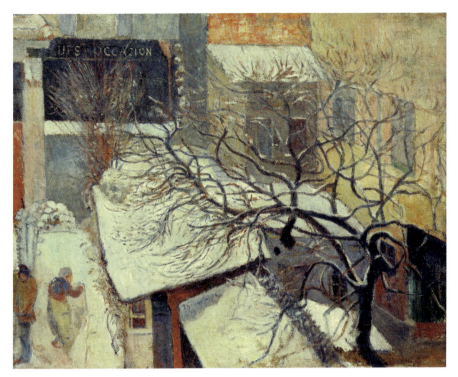

Gauguin, *Paris in the Snow*, 1894

place? He already understood Paris perfectly. Maybe there was a mental disengagement, or even revulsion? His most notable landscape, *Paris in the Snow* (1894), is a melancholy reverie constructed round a bare, snow-covered tree reminiscent of Vincent's wind-sculpted tree in the *Sower*. He sent it to the widow of Theo van Gogh in gratitude for paintings by Vincent that she had sent to him.

Plainly less preoccupied by Paris than by the Polynesian subjects that he had not yet fully worked out, he bought ten boxwood blocks, and carved them to create three vertical and seven horizontal prints, all of which are translations rather than reproductions of paintings, sculptures or drawings he made while in Tahiti. Known as the *Noa Noa Suite*, they were intended as a visual accompaniment to the book *Noa Noa*, that Morice would so disappointingly fail to finish. The project morphed into an independent work of imagination that is dense, dark and difficult. The only way the woodcuts echo the construction of the book is in their apparent randomness and obscurity.

WILD THING

Cataloguers and commentators have proposed different orders in which to present them as a sequence to fit into the book's text, or as a sequence to represent the cycle of life and death, but, as with the text of the book, it seems likely that there is no prescribed narrative order, no linearity. You might as well throw them in the air and see where they land. The texts take place in human time, and by day. The woodcuts take place in occult time, in the crepuscular zone when ghosts and spirits are taking hold of Gauguin's subconscious and the Tahitian night. 'Dark, unendurable worlds populated by prehistoric fish, barely tangible figures, desperate lovers, hooded women, and nameless, culturally ambiguous idols. These forms are illuminated not by the sun but by oil lamps, fire and phosphorescent light.'[17] Some of the images, such as *Nave Nave Fenua* and *Maruru*, read like the photographic negative of a previously made painting showing the obverse and very dark side of an image that in colour has been idyllic and optimistic.

Printed on Japan paper, the dominant colour of the prints is black on the beloved yellow, but there are elective highlights of water-based paint in orange, green, blue and ochre. Increasing the nightmare tension of the image Gauguin would double-print the same woodcut on a single piece of paper, deliberately

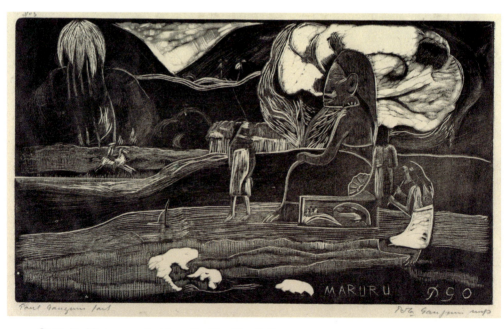

Gauguin, *Maruru* woodcut from the *Noa Noa Suite*

failing to line up the second printing so as to produce an out-of-focus image that forcefully propels us out of the realm of certainty. Out-of-focus is a cliché today. It no longer has the capacity to surprise or even carry a deeper meaning but in Gauguin's day, when one of the great aims of art over the past 400 years had been to produce relatable representation in clear focus, images that were deliberately out of focus threatened Enlightenment orderliness. In literary terms, the *Noa Noa Suite* connects to the writings and photographs of Strindberg and Edgar Allan Poe, borders blurred between the occult and the phenomenal; it also relates to Mallarmé and his fellow symbolist poets and painters, as well as the Nabis, all of whom placed great importance on the invisible tentacles connecting us to the half-glimpsed world beyond. In the *Noa Noa Suite*, Gauguin enlarges on the world he had first tried to represent in *Clovis Asleep* where his son's dreams splurge across the walls.

The sincere intention of the *Noa Noa Suite* was not to obfuscate but to promote understanding of the extraordinary faraway world with which he had fallen in love. To this end, he would give demonstrations of printing the woodcuts on studio evenings, recounting tales the while, but there is no doubt that, while true to his dream, and true to the enlargement of the images haunting his imagination, the woodcuts did not help Paris to understand what he was trying to communicate.

In March, with spring breaking, Władysław Ślewiński invited him to come to Le Pouldu. What a delight it would be to exchange the pavements of Paris for the sharp black rocks of Brittany! But there was more than mere nostalgia to the trip. When he had quit Le Pouldu, he had left two years' worth of work with Marie Poupée against the hotel bill he owed her. Gauguin was now in a position to settle the outstanding amount and get his pictures back. In Paris, he had been sleeping (separately) both with Annah, and with his previous mistress Juliette Huet, whom he had set up as a seamstress before leaving for Tahiti. He was still fond of Juliette, and he took an affectionate interest in both her and their daughter Germaine, who had been born when he was in Tahiti. On his return to Paris, he had invited them to come and live with him, but Juliette had refused to be his permanent companion. Instead, she preferred to show up in his studio from time to time for friendly and amorous encounters. One day she arrived in the studio to find Annah, whereupon

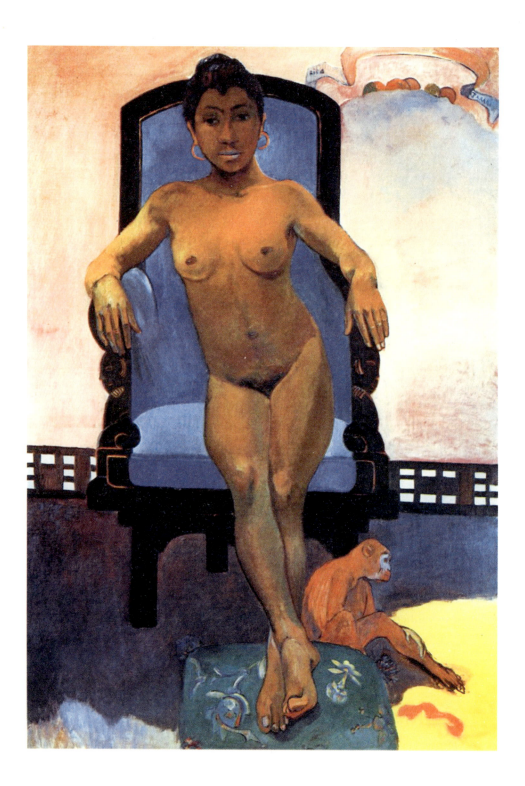

Juliette let fly a tirade of racist vitriol, at the end of which Annah coolly responded, '*Alors, madame est fini?*' after which Juliette broke off relations.[18]

Gauguin painted a full-length nude of Annah, giving it a most illogical title: *Aita tamari vahine Judith te parari (The Child-Woman Judith Is Not Yet Breached)*. Annah sits naked on a magnificent chair like a queen on a throne, her head held high, and her legs crossed, her pet monkey Taoa at her feet. Why did Gauguin give a picture of Annah a title relating to Judith Molard's virgin state? The story goes, and one can choose to believe it or not, that Judith Molard's mother Ida gave permission for Judith to go upstairs to be painted by Gauguin but, on venturing into his apartment and seeing the beginnings of the full-length nude of her daughter, Ida withdrew permission. Gauguin then reused the canvas for the nude of Annah.

The two self-portraits he produced during this Paris period are both unglamorous and uncharacteristically drably coloured. He is not portraying himself as a symbol, merely as himself. In *Self-Portrait with Idol* (1893–4), he wears a red-and-blue striped Breton fisherman's jumper under a nondescript khaki jacket; his chin is in his hand and his expression is thoughtful, contemplative and a little impish as he turns his eyes towards the large wooden tiki that lurks over his shoulder. *Self-Portrait with Hat* (1894) revisits the idea of the artist as saint and martyr to Art's sacred calling, but it strikes no attitudes. Now it is the battered Buffalo Bill Stetson that draws a shabby halo round his timeworn head. On the wall behind him, over his shoulder, in the same space occupied by the tiki in *Self-Portrait with Idol*, he has hung his painting *Manaò tupapaú*, as though he knows this picture, which he considered his most important to date, would be the cause of his sainthood or martyrdom. A further complexity is that he has painted a portrait of William Molard on the recto, the back of the canvas. This was unusual for Gauguin who, however impoverished he was, seldom produced two pictures on one canvas using both recto and verso. He must have valued both or he would have painted one out to make way for the other. He gave the canvas to Molard.

At the end of April, when he returned to Le Pouldu, Gauguin discovered

Gauguin, *Aita tamari vahine Judith te parari*
(*The Child-Woman Judith Is Not Yet Breached*), 1893

the perils of revisiting a beloved place. Marie Poupée's *buvette* had vanished. She had married and moved on. Gauguin tracked her down to a nearby village where she was living with her husband and children. Marie seemed to have given up on both her feminist principles and her artistic sympathies. Her reception of Gauguin was hostile, her husband's more so. Gauguin made them an offer for the pictures, but the very naming of a sum made them greedy, suspecting they were worth more. When, eventually they simply refused to sell to him, Gauguin found himself in exactly the same situation as Mette had been with the paintings that she had sold in Denmark to tide her over her financial difficulties. Both Mette and Gauguin had relied on the hazy, benevolent and completely unrealistic understanding that a sale could be reversed at will, despite nothing being put in writing and no buyback price agreed. As a result, everybody felt cheated, aggrieved and grew self-righteous. Marie Poupée eventually declared that she would never give up the pictures. Gauguin concluded that the only way he could get them back was to go to the law for their recovery.

Le Pouldu now stank in his nostrils. To lose the two years' work he had done in this place was appalling. He left, taking Annah and her beloved monkey, now an alter ego of his impish 'savage' self, the short distance to Pont-Aven, the delightful place where he had first found his painterly and political voice. Here things had also changed. One could no longer pretend it was an unspoiled corner of the world. Another paradise had taken the capitalist shilling. Madame Gloanec had opened a second hotel on the town square to accommodate the swelling artists' colony. There was consolation in discovering that he was still revered as the figurehead, the founder of the Pont-Aven school of art. A dubious compliment within the context but there was genuine pleasure to be taken from the nascent talent of two promising new disciples. In the end, neither amounted to a major talent but at this stage they were showing originality. Armand Séguin, twenty-four years old, had admired Gauguin's work from afar ever since the Volpini exhibition. Roderic O'Conor, thirty-four, was an Irish artist, whose canvases are on the rise today.

Gauguin experienced a burst of creativity, painting eight major landscapes in the first month in Pont-Aven. His brush flows fluently describing the area he knew so well, showing a dreamier vision, ignoring social reportage, and simply

relaxing into the beauty of the place. Led by the inner eye, rules of scale and perspective are even more imaginatively bent than hitherto, colours used more freely and non-realistically expressively than ever before. The overall mood is contemplative, almost abstract. The figures in their peasant dresses that had been such an important part of his earlier Brittany pictures are seldom included. And if they are, they take second place to the glory of the earth itself.

With his painting going well, and his social life satisfactory, on 25 May, he decided with a group of friends to make a trip to Concarneau, a fourteenth-century fortified port a few miles down the coast, famed for its historic beauty. Its fishing fleet landed France's major catch of tuna and bonito, which arrived cyclically in great shoals, just as they had in Tahiti. But here they were not caught and killed in canoes with drumming and gleaming machetes and superstitions about fish hooked in the lower jaw, but by a neat fleet of white-sailed fishing smacks bobbing decorously on the blue harbour.

It was a colourful party of eight that sunny breezy day in May. The artists Roderic O'Conor, Armand Séguin and Émile Jourdan brought their mistresses; Gauguin brought Annah and Taoa, her little monkey. A lovely long walk along the beach took them to the mossy bridge of roughly dressed stone connecting the mainland to the Ville Close, the medieval fortified island in the middle of the harbour. In Pont-Aven, where dressing up was a competitive game, the noisy group would not have turned a head, but in Concarneau's stolid fishing community, exotic apparitions were not appreciated. A group of boys started following them, laughing, pointing and making rude gestures and obscene remarks. The party ignored them until a boy picked up a stone and threw it at them. Séguin went over to remonstrate; he pulled the boy's ear. At a nearby café table a group of about fifteen men witnessed the incident. The group included the boy's father. Rising to their feet with unmistakeable purpose, they made a rush towards the artists. The drumroll of their wooden clogs on the cobbles sent a white flurry of gulls screaming into the air. Annah's parrot beat her wings in fear and panic. Séguin ran away from the advancing mob and jumped fully clothed into the harbour. Gauguin had not forgotten his boxing skills. With one blow he sent an attacker flying into the harbour. This was exciting. He dispatched several more into the water. And then he fell. Agony shot up his leg. It was impossible to get up. The thugs thundered towards his

prone body to give him a kicking. He thought he must have fallen into a hole but in fact what had happened was that one of his assailants' wooden clogs had shattered his shinbone and splintered several small bones in his ankle. They continued to kick him as he lay there. He put his arms up to shelter his head. All he could hear was stamping on the cobbles like pistol shots. The arrival of the gendarmes prevented Gauguin being kicked to death. He was lifted insensible on to a cart and taken back to Pont-Aven. The shinbone was sticking out of his leg through the skin. In the hospital they gave him morphine and set the leg as best they could.

He moved from the hospital to the Pension Gloanec as soon as was feasible. Through the months of August and September Gauguin lay there in bed in terrible pain, in a haze dulled by morphine. Taoa, the little monkey, cheered him; she was his playmate, companion and alter ego, and had even used to follow Gauguin into the water when he went swimming. But she ate the white flower of a yucca plant, poisonous to her kind, and she died. Soon after Taoa's death, Annah left for Paris.

His painter friends entertained him with visits and gossip as he lay in bed, and he devised an original way of making bedbound art, using small sheets of paper. First, he made an original matrix drawing, using water-soluble pigments like watercolour, gouache or pastel. Then he dampened a second piece of paper and laid it on top of the matrix. Using the bowl of one of Madame Gloanec's metal spoons he transferred the design on to the second piece. We can imagine him lying in bed, moving the spoon back and forth. The prints are small, about A4 size,[19] but they differ from the *Noa Noa* series in another way. *Noa Noa* is set at night; these are set in daytime. Mostly they depict Tahitian women doing not very much, exuding an air of lassitude verging on depression. Listless and purposeless despite their sunlit context, they drift across the page like disconsolate ghosts of a vanished age. He also produced some woodcuts, which he printed by using the full weight of his bed to press upon the block. Painfully he had to struggle to the floor with his damaged leg extended straight out behind him, exerting his considerable upper body strength to lift the bed and push the papered woodblock beneath.

A much-needed moment of pleasure arrived with a visit from a star-struck young writer, twenty-one-year-old Alfred Jarry, already working on *Ubu Roi*,

the play that paved the way for Dadaism, Surrealism and Futurism. Earnest pioneer of the logic of the absurd, Jarry called himself the inventor of 'the science of pataphysics': a world based on exceptions, paradoxes and all that lay outside the fixed habits of conventional thought. Jarry's jubilantly illogical imagination had been captivated by the incomprehensibility of what he had seen in the Durand-Ruel exhibition. He came to Pont-Aven to read aloud to Gauguin three poems he had written inspired by three pictures: *Ia orana Maria*, *Manaò tupapaú* and *The Man with the Axe*.[20] Hungry as Gauguin was for attention, he was not in the mood to be impressed by the young man who lived with an owl and thrived on self-conscious paradox.

The date of the trial of Gauguin's attackers in the district court at Quimper was 23 August. Gauguin endured thirty-six jolting kilometres on country roads only to hear them given a nominal sentence, and himself awarded a paltry 600 francs in damages – less than he had already spent on medical bills. 'Apparently people have the right to assassinate or lame for life an innocent man because he is a stranger in Concarneau. His illness, his suffering, and his lost time count for nothing – because the Concarneau brigands are *voters*, and my attacker is a friend of the Republican authorities.'[21]

Bitter and still very weak, he returned to his bedbound existence at the Pension Gloanec, where taking morphine every night for two months had reduced him to sleeping four hours a night. In the daytime he deadened the pain with alcohol. 'This weakens and disgusts me. Yes, I can manage to limp with a stick, but it is most disappointing not to be able to limp far enough to paint a landscape.'[22]

He suffered a second blow when the lawsuit against Marie Poupée resulted in the judgement going against him. It was ruled that as he had not demanded a written receipt for the paintings, this showed he was not really interested in them. She would keep the pictures for ever. He loved those pictures as he loved his children. His dreams and his blood were in them.

'What a foolish existence European life is!'[23] he raged. As soon as he was fit enough – and this did not happen until three further months had slowly passed in bed in Pont-Aven and December had come around – he would go back to Paris, sell everything, and return to Polynesia.

'Nothing will stop me going, and this time it will be for good.'[24]

15

PENT UP IN PARIS

His badly broken leg and ankle were poorly set, causing a malformation of the bone that left him with a limp and often needing the help of a stick to walk. It would give him disabling pain throughout the rest of his life. Where the bone had torn through the skin, the wound was wide, and incapable of healing due to the atrophy of the surrounding skin. The open sore would often become infected and start suppurating. He developed eczema, a chronic skin complaint that may be exacerbated by stress.

In excruciating pain, still high on morphine, humiliated and frustrated by the court cases, Gauguin fled Brittany as soon as he was able, to seek solace in his beautiful golden haven, the studio on Rue Vercingétorix. On unlocking the door, he beheld rummage and ruin. Annah had ransacked the place and stolen anything she could carry away. Only the large pieces of furniture and the paintings on the walls remained. It was another slap in the face that she had not thought the pictures worth stealing.

His friends rallied round to comfort him. The Molards ran up and down stairs with food and drink. Charles Morice collected the faithful friends to hold a banquet in his honour at the Café des Variétés, a charming gesture but scant consolation for a collapsed life. His legs hurt and itched abominably, but lying in bed was not going to get him any further forward. Annah had left him a couple of assets: the paintings, and a studio so devoid of furnishing that it made the perfect exhibition space. He would show his pictures here.

He set to work on preparations: framing, touching in, repairing and rehanging. He mounted the graphic works on mottled blue paper so they could be handled by visitors without damage. When he was not in the studio, he limped about Paris, calling in favours and talking to journalists as he focused on getting the maximum publicity for his gallery. It opened on 2 December. This time he took a far less madcap, arrogant approach than last time. He gave patient, explanatory talks, and demonstrations of printing, and he

passed round the graphic works from hand to hand. He was conciliatory rather than challenging or defiant. His young artist admirers such as Sérusier and O'Conor came to look and learn but they never had the money to buy, and nobody else had the inclination.

At night, morphine gave him snatches of sleep and monstrous druggy dreams. Oviri, the Tahitian goddess of mourning, pursued him in and out of his dreams, commanding he give her concrete shape. A painting would not do. He must make a three-dimensional representation of her: a statue, a tiki imbued with all the awe, majesty and *terribilità* of the primitive godhood that demands human sacrifice. When he had given her physical shape, he would take her back with him to stand on his grave in the place of a cross, on the island that he now determined would hold his fate for ever. The rest of his life would be dedicated to reviving and memorialising her fast-disappearing culture. 'Reviving the fire', he called it.

Oviri had long been banished by the missionaries, but she remained present and darkly all-powerful in the Polynesian collective consciousness, and in secret rituals re-enacted on the old sites deep in the jungle. To speak her name was unwise. She was 'she who lives in the forest', the most terrifying of all *tupapau*. Like her followers the Arioi, Oviri killed her children. Gauguin showed her as a figure from nightmare – savage, ugly, terrifying, semi-human, with an oversized, toad-like head on which her eyes are set too far apart. The grotesque head pokes forward from the twisted, clumsy, squat body. She is trampling to death the body of a wolf. With one hand she is killing a wolf-cub by crushing it against her hip. Red glaze runs from the dead wolves in gouts of blood, echoing Gauguin's use of red glaze in the self-portrait jug he had made after the beheading of Prado.

Degas had once described Gauguin as a 'hungry wolf without a collar', after which Gauguin had taken to referring to himself as a wolf. After creating the *Oviri* statue, he took on Oviri as another alter ego: he signed a self-portrait with her name and he brought her statue into subsequent pictures,[1] where she stands inscrutable, impartial as fate, invisible to the protagonists, her looming presence a threat, a murderous judgement or an omen of doom to come. She meant many things to Gauguin. He told Odilon Redon that the theme of *Oviri* is life in death and death in life. He sometimes called his

statue of her *The Murderess*. Who is murdering whom? we wonder. As Oviri murders the wolf, one of his alter egos is murdering another. Is one meaning of the statue, then, the image of the 'savage' Gauguin murdering the 'civilised' man, and so freeing his spirit?

Oviri became a kind of battle cry for him, an interchangeable symbol of self, the others being the wolf and the tiaré flower of Tahiti with its suggestively prominent pistil. He used all three as second signatures on pictures or sculptures, as Whistler used a butterfly. If we think of Oviri as death, the tiaré flower as sex, and the wolf as his untamed 'savage' nature, the inclusion of each lends a different subtext to the artworks on which they appear.

Iconographically, *Oviri* is completely original. There was no question of him copying any Tahitian carving or written description; none remained. She is a figure sprung purely from his synthesising mind. At seventy-four centimetres, she is the tallest ceramic he ever made. In coarse stoneware, her unglazed figure is greyish-purple but her hair, protected by a transparent glaze, is sandy in colour. On the base he wrote OVIRI and alongside the dead wolf's head he signed it with the signature P G O which can be read phonetically as the first part of his name but also – a joke he tremendously enjoyed – *pego* is French sailors' slang for penis.

Oviri took hold. He made at least one drawing, two colour transfers and two related prints, one of which survives in at least seventeen impressions. Also, around the time he was making the statue, he created *Self-Portrait Oviri*, a bas-relief and his first work in plaster. The idea came to him one day when he was acting as model for Ida Molard downstairs, surrounded by her plaster busts and bas-reliefs. Gauguin loved to experiment, and he made the bas-relief using a double mirror which enabled him

Gauguin, *Oviri*, goddess of mourning, 1894

to capture his profile. The bronze version that we see in exhibitions was cast after his death, probably in the 1920s.

August Strindberg was still enlivening life in Rue Vercingétorix with his eccentric musical recitals and extravagant amateur theatricals that included a South Sea musical with 'decorations' by Gauguin and dances choreographed by the artistic director of the Folies Bergère. Strindberg was also the group's expert on photography, a subject that had interested Gauguin since Nadar and Arosa's pioneering collotypes. Gauguin bought a big box camera. Knowing his dislike of realist art, it is not surprising to discover that he did not use it for any serious purpose at all, certainly not in relation to his art, but simply to take jokey photographs of the bohemians dressing up and having fun. Mucha had also bought a camera, which he did use to more serious purpose, photographing the poses of models and using the photos as source material for his pictures.

Strindberg's latest play, *The Father*, opened on 13 December. *Le tout-Paris* was there. Gentlemen's top hats were brushed to a blinding refulgence. Paris's first couturier, Worth, did brisk business in slinky satin gowns true to the symbolist tenet to 'clothe the ideal in sensuous form'. Rodin made a notable entry. Gauguin was photographed in his long cloak and karakul hat.

The Father concerned the burning subject of the New Woman, in the shape of an extended argument between a couple about the future of their daughter. The father is progressive. He wishes the daughter to become independent, to take up a career as a teacher. The mother wishes her to stay at home and become an artist, though as far as we can see, the girl has no outstanding talent in that direction. The mother's wish is fuelled by perpetuating the traditionalist attitude that women should be ornamental rather than useful. The play was super-revolutionary at the time because it was the mother who represented the backward-looking wish to keep the dependent woman in the gilded cage, while it was the father who wished to liberate her into self-sufficiency. The wife triumphs, the father dies, and the curtain goes down on the daughter enfolded in her mother's embrace. An ending that Strindberg and Gauguin, both stout believers in the independence of women, saw as a tragedy, but their opinion was not shared by the majority of the audience. The play was a hit. Paris continued its love affair with *la Norderie*.

While Gauguin was in the theatre witnessing Strindberg's enviable triumph, the playwright himself was sitting in his little room in Madame Charlotte's gazing suicidally at the revolver on his desk, contemplating his poverty and his desertion of his wife and baby daughter, whom he had left behind in his father-in-law's castle in Austria. His misery was increased because he was also, like Gauguin, suffering from a horrible skin complaint, psoriasis, that erupted in painful burning blisters. Strindberg and Gauguin saw each other every day. They took their free meals chez Madame Charlotte, who had conceived an unrequited passion for Strindberg and made no secret of her wish to marry him, causing him to walk a narrow tightrope between keeping her at arm's length and keeping the free meals coming. The two men played duets on the guitar and the mandolin in the yellow studio. They took their daily walks together around Montmartre and they held long conversations on the subject of Balzac's book *Séraphita*, which was creating a great stir. Gauguin read the book first, and lent it to Strindberg. In *Séraphita* Balzac swerved from his customary realism into the fashionable realm of symbolism to write a fairy-tale-cum-allegory set uncharacteristically but very fashionably in Norway. Séraphitus, a willowy youth of melancholic disposition, dwells in a castle on Norway's remote Stromfjord. The pale maiden Minna is in love with him. He returns her love, but he is also loved by Wilfred, who believes Séraphitus to be Séraphita, a girl – which, indeed, turns out to be the case. The dilemma is resolved through long tracts of Swedenborgian doctrine. Emanuel Swedenborg was a Swedish mystic whose followers founded the New Church based on revelations given to him by angels. He also practised as a scientist and was lucky enough to receive his scientific revelations directly from angels as well. The character Séraphitus-Séraphita is, in fact, the perfect Swedenborgian androgyne whose transcendence of sexual category symbolises the transcendence of the narrow limits of humanity that must be overcome in order to achieve human perfection. Very much a period piece, the book was of interest to Paris's occult and symbolist circles for its extended argument concerning the relationship between matter and spirit, as expressed in Swedenborg's founding statement of his doctrine of correspondence (which in effect was symbolism by another name).

'The whole natural world is responsive to the spiritual world – the natural world not just in general, but in detail. So whatever arises in the natural

world out of the spiritual one is called "something that corresponds". It needs to be realised that the natural world arises from and is sustained in being by the spiritual world, exactly the way an effect relates to its efficient cause . . . This is the origin of correspondence.'[2]

How interesting it would have been to eavesdrop on Gauguin and Strindberg's discussions of the book, but as they saw each other every day, there was no need to write anything down. A puzzling and intriguing fragment indicating that Gauguin traced 'correspondence' between Oviri and Séraphitus-Séraphita remains on paper in a drawing he made of his *Oviri* figure on which he wrote: *Et le monstre, étreignant sa créature, féconde de sa semence des flancs généreux pour engendrer Séraphitus-Séraphita.* (And the monster, embracing its creation, filled her fertile womb with seed and fathered Séraphitus-Séraphita.)[3]

Balzac's book seems to be the only wisp of the ectoplasmic fog engulfing Paris that succeeded in clouding Gauguin's brain. This marked him out as an unusually rational being. It has been recorded that there were no fewer than 50,000 alchemists in Paris in 1893,[4] of whom Strindberg was one. There is no specific figure for 1894–5, the year of their close friendship, but the number cannot have been much different the following year when the Symbolist and Nabi movements flourished, preoccupied as they were with Swedenborgian 'correspondences' between the higher world and the lower that could be put on to the canvas encoded, and decoded through knowledge of alchemy, magic, numerology, palmistry, mythology, mysticism and other alleyways of esotericism.

'Towards the end of the nineteenth century a tide of mysticism swept across the world,' wrote the Danish mystic and poet Johannes Jörgensen, a close associate of Georg Brandes, '. . . a reaction against the all-powerfulness of science which had ruled Europe in the second half of the century. Tables turned. Spirits revealed themselves by means of slates and chalk. They tapped at us with chair legs or spoke through the creaking of old chests of drawers – all our nursery tales were reawakened under another name . . . Thus was announced the reaction against naturalism. It expressed itself through a distrust of science, and through a penchant for the subject, romantic and fantastical, for what was called "The Dream" . . . In Paris, all

these tides and eddies, all these attractions to the occult and the mysterious, to what was forbidden, miraculous and terrifying, spun around like some spiritual whirlpool. Like ghosts emerging from their graves, astrology and the Kabbala, fortune-telling, incantation, magic and alchemy suddenly marched out of obscure corners and joined in the whole dance.'[5]

The Sorbonne University granted Strindberg space in their analytical laboratory to work on experiments in alchemy, the ancient magic art of turning base matter into gold that has appealed to mankind as a way to achieve wealth beyond the dreams of avarice since the time of Hermes Trismegistus. Like Swedenborg's doctrine of correspondence, the processes of alchemy represent an allegorical journey. If you follow a righteous path, transcending the narrow limits of humanity, you will emerge an enlightened example of human perfection like Séraphitus-Séraphita. When you have achieved this, you can make gold. The porous borders between science and magic being explored by Strindberg in the Sorbonne were not confined to him. Pierre and Marie Curie darted between discovering radium and spiritualist séances conducted by a stout medium named Eusapia Palladino whom they defended in print against charges of charlatanism. Within Paris's magico-scientific, ghost-hunting alleyways, Gauguin did not find it outrageous when his daily walk together with Strindberg took them to the Jardin des Plantes, where Strindberg would pause to inject apples with morphine 'to discover whether they had nervous systems'. They liked to visit the Zoological Gardens where they felt great pity for the monkeys, so almost-human, so speechless and so unfree, but they also enjoyed laughing at the likenesses between the uglier animals and people of their acquaintance.

One evening in early February 1895 when the two men were in the yellow studio, Gauguin decided that Strindberg was the man to write a preface to the catalogue of the sale of his paintings to raise funds for his return to Polynesia. 'The idea of asking you . . . occurred to me . . . when I saw you in my studio the other day, playing the guitar and singing,' Gauguin wrote, 'your Northern blue eyes studying the pictures hung on the walls. I felt your revulsion: a clash between your civilisation and my barbarism . . . A civilisation from which you are suffering; a barbarism which spells rejuvenation for me.'[6]

Strindberg accepted the commission. Typically mischievous, he did not write the expected encomium. Instead, his preface took the form of a long letter written to Gauguin, in which aversion for Gauguin's art changes subtly to admiration. It became one of Gauguin's favourite pieces of writing on his art. He copied it out and pasted it into his autobiographical *Avant et après*.

'My dear Gauguin,' began Strindberg,

> . . . I cannot understand your art and cannot like it. (I have no comprehension of your art, which is now entirely Tahitian.) However, I know that this admission will neither surprise nor offend you, as you seem rather to be fortified by other people's hatred, at the same time as your personality, concerned to remain free, thrives on it. Probably you are right, for as soon as people begin to appreciate and admire you, follow your example and group and classify you, a label will have been affixed to your art – a label which in five years' time will have become to the young an epithet for an obsolete art, which they will do all they can to make even more old-fashioned.
>
> I have myself made serious efforts to classify you, to fit you as a link in the chain, in order to understand the history of your evolution – but in vain . . .
>
> My thoughts turned last night, when to the southern sounds of mandolin and guitar I studied the sun-drenched pictures on the walls of your studio and the memory of them pursued me all night in my sleep. I saw trees no botanist would ever find, beasts Cuvier would never have dreamed of, and people you alone could have created. I saw a sea which appeared to flow out of a volcano, and a sky inhabitable by no God. 'Monsieur,' I said in my dream, 'you have created a new earth and a new heaven, but I do not feel easy in your new universe; for me, a lover of *chiaroscuro*, it is too ablaze with sunlight. And in your paradise dwells an Eve who is not my ideal; for I also have a feminine ideal – or two! . . .'

Who is Gauguin? He is Gauguin the savage who hates civilisation's restrictions; rather a Titan, jealous of the Creator and wanting in his

leisure to make his own little Creation. He is a child taking his toys to pieces to make new ones, rejecting and defying and preferring a red sky to everybody else's blue one.

Upon my word, it looks as if, in working myself up while writing, I begin in some measure to understand Gauguin's art!

A modern author [Strindberg himself] has been reproached for not painting real people but quite simply inventing his characters. Quite simply!

Bon voyage, master! But come back again and look me up. Perhaps by then I may have learned to understand your art better, which will enable me to write a real foreword to a new catalogue in a new Hôtel Drouot: for I, too, begin to feel a great need to turn savage and make a new world.

August Strindberg[7]

The auction took place on 18 February 1895, at the Hôtel Drouot. The room was sparsely attended. Forty-seven works went up for sale. Nine sold. Degas bought two paintings and six drawings, including *Vahine no te vi* (*Woman with a Mango*, 1892) and Gauguin's copy of *Olympia*, which he had made in Paris in 1891, working for eight days in the Luxembourg gallery trying to unlock its mystery before giving up, admitting he was constitutionally incapable of copying another painter. Indeed, Gauguin's copy is far from faithful, it has a character all of its own: the girl selling herself is harsher and more despairing than Manet's polished, self-sufficient original. Degas obviously found the work sufficiently interesting to want to own it. Gauguin tried to keep up the prices by putting in bids under a variety of pseudonyms, a tactic that only resulted in him being the highest bidder and stuck with buying back his own pictures. The final total of the sale came to 2,200 francs, but he had spent 840 francs on his pseudonymous bids. After expenses, he only made 464 francs and 80 centimes. When Mette read a report of the auction, she wrote demanding a share of the money. This was the first letter Gauguin had received from her in a year. He had been very sad at Christmas, when he had not received a word from her, or from the children. In his reply to Mette's demand for money, he had to admit to the

humiliating truth of what had really happened at the auction – but why should she believe him?

Fortunately he was not completely dependent on the money from the auction to get him to Tahiti. Enough remained of Uncle Zizi's legacy that if he was careful (though he was never careful) it should see him through the first year.

Before his departure, the immediate task in hand was to find an agent or gallery that would handle the pictures he sent back from Polynesia. This proved difficult. Following the twin fiascos of the Durand-Ruel show and the Drouot auction, Gauguin was not a bankable proposition. He settled on dividing the honour between a dealer called Lévy in the Rue Saint-Lazare, who fades out of Gauguin's life as quickly as he comes into it, and Georges Chaudet, an artist acquaintance of the Pont-Aven school whose style was heavily influenced by Gauguin and who did a little dealing on the side. It was a foolishly casual set-up. In terms of a trustworthy agent, Molard would have been the leading candidate, but Gauguin knew that for all his warm friendship, Molard's lethargic nature would hardly lead to keen sales and good prices. However, he did award Molard power of attorney to act for him concerning the publication of *Noa Noa*, should the procrastinator Morice ever get round to finishing his part of the book.

An unsuccessful artist leaving the 'civilised' world for the second time was hardly headline news. But the journalist Eugène Tardieu thought it worth an interview. It appeared on 13 May 1895 in *L'Écho de Paris*. In it, Gauguin spoke of what he believed art is, and what his own art is.

The Art of Painting and the Painters[8]
M. Paul Gauguin

He is the wildest of all the innovators, and of all the 'misunderstood' artists the one least inclined to compromise. A number of his *discoverers* have forsaken him. To the great majority of people he is just a humbug. Yet he calmly goes on painting his orange rivers and red dogs, and for every day that passes, adheres more and more to this personal *manner*.

Gauguin is built like a Hercules: his greying hair is curly, his features are energetic, his eyes clear; and when he smiles in his characteristic way he seems alike gentle, shy and ironical.

'What exactly does it mean, this expression "to copy nature"?' he asks me, stretching himself defiantly. '"Follow the example of the masters," we are advised. But what for? Why should we follow their example? They are masters for the sole reason that they refused to follow anybody else's example. Bouguereau has talked of women glowing in all the colours of the rainbow and denied the existence of blue shadows. One can just as well deny the existence of brown shadows such as he paints . . . After all, it matters little whether blue shadows do or do not exist. If a painter tomorrow decides that shadows are pink or violet, there is no reason why he should have to defend his decision, assuming that his work is harmonious and thought-provoking.'

'Then your red dogs and pink skies . . .'

'Are deliberate. Absolutely deliberate. They are necessary. Every feature in my paintings is carefully considered and calculated in advance. Just as in a musical composition, if you like. My simple object, which I take from daily life or nature, is merely a pretext which helps me by a definite arrangement of lines and colours to create symphonies and harmonies. They have no counterparts at all in reality, in the vulgar sense of that word; they do not give direct expression to any idea, their only purpose being to stimulate the imagination – just as music does without the aid of ideas or pictures – simply by that mysterious affinity that exists between certain arrangements of colours and lines in our minds.'

'These are rather novel theories!'

'They are not at all novel!' Monsieur Gauguin exclaimed emphatically and with some feeling. 'All great artists have always done exactly the same. Raphael, Rembrandt, Velasquez, Botticelli, Cranach, they all distorted nature. Go to the Louvre and look at their pictures and you will see how different they are. According to your theory, one of them must be right and the rest wrong. Unless they have all been deceiving us. If you demand that a work should be true to nature, then neither Rembrandt nor Raphael succeeded, any more than Botticelli or Bouguereau.

Shall I tell you what will soon be the most faithful work of art? A photograph, when it can render colours, as it will soon be able to do. And you would have an intelligent being sweat away for months to achieve the same illusion of reality as an ingenious little machine? It is the same with sculpture. It is possible already to make perfect casts. A skilled moulder can make a Falguière statue for you with ease whenever you like.'

'So you do not wish to be called revolutionary?'

'I find the expression ridiculous. Monsieur Roujon [Henri Roujon, director of the Société Nationale des Beaux Arts, who had refused to authorise payment for Gauguin's repatriation from Tahiti and who more recently had rejected *Oviri* for the Spring Salon] has applied it to me. I told him that all artists whose work differs from their predecessors' work have merited it. Indeed, it is for that reason alone that they are masters. Manet is a master, and Delacroix. At first their work was considered atrocious, and people laughed at Delacroix's violet horses – which, incidentally, I have looked for in vain in his pictures. But such is the public. I have become reconciled to the idea that I shall remain misunderstood for a long time to come. If I only did what others have done before me I should in my own estimation be just a worthless plagiarist. But whenever I strive to conceive something new I am called wretched. In that case I would rather be a wretch than a plagiarist.'

'There are many cultivated people who think that, as the Greeks achieved sculpture of ideal perfection and purity and the Renaissance did the same in painting, nothing now remains but to emulate their works. The same people would even say that the plastic arts have exhausted their potentialities!'

'That is an absolute mistake. Beauty is eternal and can have a thousand forms. The Middle Ages had one ideal of beauty, Egypt another. The Greeks strove for complete harmony of the human body, and Raphael had very beautiful models. But you can equally well produce a valid work of art from a model that is ugly as sin. There are plenty of such works in the Louvre.'

'Why did you make your journey to Tahiti?'

'I had once been fascinated by this idyllic island and its primitive

and simple people. That is why I returned and why I am now going back there again. In order to achieve something new you have to go back to the sources, to man's childhood. My Eve . . . is chaste for all her nakedness. But all the Venuses in the Salon are indecent and disgracefully lewd . . .'

Monsieur Gauguin fell silent, and with a rather ecstatic expression on his face turned to regard a picture on the wall of some Tahitian women in the jungle. A few moments after he continued.

'Before leaving I shall publish with my friend Charles Morice a book about my life in Tahiti and my views on art. Morice comments in verse on the works I have brought back with me. In short, the book will be a statement about why and how I made the journey.'

'What will be its title?'

'*Noa Noa* – a Tahitian word meaning "fragrant". In other words, the book will be about what Tahiti exhales.'

<p style="text-align:right">Eugène Tardieu</p>

Gauguin planned to leave Paris in February but May came around with no relief from the unhealed wound on his leg. It would be madness to embark on a long sea voyage in this physical condition. In addition, he hints at having picked up an embarrassing dose of venereal disease. He would postpone his departure until it had cleared up.

On 3 July 1895, cured of his temporary embarrassment, Gauguin shook the dust of Paris off his high-heeled cowboy boots and embarked a second time for Tahiti.

16

RETURN TO TAHITI

The steamer *L'Australien* passed through the Suez Canal to Sydney, Australia, where he caught the *Tarawera* to Auckland, New Zealand, where he missed his connection to Tahiti, and had to wait a couple of weeks. He was miserable. It was midwinter, the hotel was unheated, and he couldn't talk to anybody on account of his execrable English. Bored and cold, he disliked the city for its inauthenticity, its imitation European streets bustling with white bourgeoisie. Nowhere did he see any reference to indigenous culture: no hint that this was the capital of the largest island of the Polynesian triangle. Life was so dull that he went out spending money just for something to do. Eventually he thought he might as well poke his head into the Auckland Institute and Museum, a double cube of heavily rusticated stone modelled on the Palazzo Medici in Florence, behind whose unpromising façade 'a delight distilled from some indescribable sacred horror. A glimpse of far-off things. The odour of an antique joy which I am breathing in the present. Animal shapes of a statuesque rigidity: indescribably antique, august and religious in the rhythm of their gesture, in their singular immobility. Their dreaming eyes are the overcast surface of an unfathomable enigma.'[1]

Photographs taken in the museum in the 1880s and '90s show an enormous collection of all four categories of Polynesian culture: *whakairo* (carving), *tā moke* (tattooing), *raranga* (weaving) and *peitatanga* (painting). In contrast to the French, the colonising British had not seen it important to obliterate indigenous cultural and religious artefacts. On the contrary, they had honoured them in a museum. Spread before Gauguin's eyes was a marvellous, incomprehensible pantheon, a whole culture and belief system that he related to the fragments he had seen and read about in Tahiti. Tikis big and small, gods composed of mythological hybrids between men and creatures, complex interwoven narrative patterns of communication and mysterious dots dancing decoratively along the surfaces of fabrics, wood, stone, bone and human skin.

285

One hall was occupied by two complete houses with every inch of wooden fascia and barge board encrusted with carved gods and symbols as intricate as any piece of European High Baroque architecture. Another hall housed *Te Toki a Tapiri*, a great war canoe twenty-five metres long, built from a single trunk of the totara tree. It must have been a truly terrifying sight when it entered the enemy's bay, its prow carved with the goggle-eyed likeness of the god of war and a hundred tattooed warriors chanting and paddling in time to the drum.

He took a sketchbook into the museum, and he must have made many sketches in the few days remaining to him but only a few pages survive.[2] Before he left, he bought a collection of postcards of the Māori works of art to add to his collection of 'little friends'. On 29 August, he boarded the *Richmond*, which reached Papeete in eleven days.

Already incensed at the mass destruction wrought on the indigenous people of New Zealand in the name of civilisation, he was in sour mood to witness the changes in Tahiti. During the two years he had been away, civilisation had spread fresh tentacles through Papeete's streets in the form of electric cables. Harsh yellow light hardened and flattened everything: faces, houses, streets. Ambiguity was cancelled. Night was no longer blurred and mysterious beneath the gliding heavenly bodies that had given a silvery sheen

Auckland Museum, *c.*1880

to the white-plumed sea, whose waters now were splodged with artificial reflections, like a bad pointillist painting. The animals that had been used to wander about unrestrained, adding an Edenic air, were now behind fences. The French had gone sports mad. They wobbled beneath the palms in knickerbocker cycling suits and changed into whites to dash about the tennis courts that had sprung up in the grounds of the late King Pomare's royal palace, alongside a steam-driven merry-go-round with spotted horses revolving like damned souls in the seven circles of hell for ever condemned to banal fairground tunes. He might as well have been in Deauville or Trouville. It hardened his resolution to shake Tahiti's dust off his feet as soon as possible. But before that could happen, he received an intriguing invitation from the new commissioner, General Isidore Chessé, to join a large party on the battleship *Aube* on a diplomatic mission to the islands of Huahine, Bora Bora and Raiatea-Tahaa. Why Gauguin was invited is anybody's guess but he was certainly not one to refuse an adventure. The submissive colonies of Huahine and Bora Bora greeted the visiting ship with feasting on the beaches, the queen of Bora Bora apparently even annulling all marriages so their visitors could enjoy an unrestrained welcome. By contrast, Raiatea-Tahaa was hostile and sullen. Here was the real purpose of the voyage. Since France's annexation of the island in 1887, the brave Chief Teraupoo had conducted a determined resistance campaign, and he welcomed the French ship by flying the Union Jack rather than the French tricolour, implying they'd rather be ruled by the British – anyone other than the French – and the ship left the rebellious island with nothing diplomatic accomplished. Gauguin was back on Tahiti in October. The defiant islanders of Raiatea-Tahaa kept up their resistance for another two years until, in 1897, the French sent troops and warships who conquered the island after six weeks of fierce fighting. Chief Teraupoo was exiled to New Caledonia and the courageous queen of Raiatea to the remote Eiao Island in the Marquesas.

Firm in his resolve to leave over-civilised Tahiti, Gauguin took furnished lodgings in Papeete while he waited for a boat to take him off the island. On the previous visit he would have stayed with Lieutenant Jénot, who had always been happy to offer him a bed, but Jénot was no longer in Tahiti, having been posted to another colony. In late October and early November, several

boats left Papeete for the Marquesas Islands but, for all his often-expressed intention to leave, Gauguin was never on board.

What had changed? One can only conjecture from his letters that he realised how much he needed to live nearby Papeete's French hospital, by far the most sophisticated medical facility in all the Polynesian islands. 'Since coming here my health has been growing worse. I suffer terribly from my foot. There are two sores, and the doctor is not able to make them heal; in warm countries that's bad. When night comes, I have spells of violent twitching which keep me awake until midnight.'[3] Cuts and scratches infect easily in the tropics, quickly turning septic. The eczema on his legs might have been exacerbated by prickly heat, an intensely irritating rash caused by blocked sweat glands. With the sweat unable to evaporate, the skin becomes soggy and red blisters appear. Gauguin was fond of alcohol and coffee: neither helps the condition. He might also have been suffering from the effects of the no-no fly, *Simulium buissoni*, whose bites can cause suppurating skin lesions and transmit diseases such as hepatitis B. Polynesia's sandy beaches were infested with them in Gauguin's day. (When I visited Hiva Oa in 2022, there were still beaches closed to visitors with huge signs warning against the no-no fly.) The doctor who treated Gauguin in Papeete's hospital was familiar with syphilis, which was widespread on the island. He did not diagnose syphilis but 'eczema complicated by erysipelas and with rupture of the little varicose veins'.[4]

Despite his doctor's diagnosis, the legend of Gauguin's syphilis persisted for over a century before being disproved thanks to an act of commemoration marking the centenary of his death. Gauguin died in 1903 on the tiny island of Hiva Oa where he had built himself a hut of traditional materials. He lived there for the last three years of his life. The centenary was to be marked by building a recreation of the hut on its original site. The hut itself, built from perishable local materials, bamboo and pandanus, was long gone but the exact site was known and there were photographs and contemporary accounts to guide the recreation. In 2000, work began on clearing the site. During the excavation of the ground, four heavily decayed teeth were discovered in a glass bottle in his well which was being cleared of rubbish.

It so happened that the SS *Paul Gauguin*, a medium-sized cruise ship that tours the islands, was calling in on Hiva Oa at the time. On board, giving

RETURN TO TAHITI

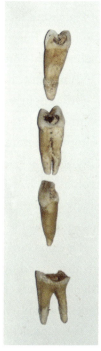

Recreation of Gauguin's hut on Hiva Oa. The well where the teeth were found is the stone structure on the lawn. Gauguin kept his drinks cold in the well. He rigged up a fishing line from his studio window (here seen open) to haul up bottles when he wanted a drink.

Right: Gauguin's teeth discovered in the well of his house in Hiva Oa in 2000.

lectures, was the distinguished art historian and writer Caroline Boyle-Turner. Among the passengers was William A. Mueller, a founding member of the Dental Anthropological Association. Boyle-Turner and Mueller arranged for the teeth to be taken to America to be tested, to see if they were Gauguin's.

The pulpal tissue was removed by the University of Illinois Chicago School of Dentistry and analysed by the university's Anthropology Department for comparison with a known descendant living in Europe.

The Human Genome Project at Cambridge University analysed the teeth for location of origin. Strontium isotope analysis proved the teeth to be consistent with a childhood in western Peru, Gauguin's home for the first seven years of his life. Researchers at the Human Genetics Program of the University of Chile heard of the project, and a team sprang into action under the physical anthropologist Jacqueline Galimany. They located the body of Gauguin's father, Clovis, in his shallow grave in the icebound ground of Tierra del Fuego. The Y chromosome data was extracted from the bodily material and compared to Gauguin's grandson, Marcel Tai Gauguin. Family DNA had now been established both up and down the family tree.

Off went a tooth to the Faculty of Science at the University of Cape Town, South Africa, to be analysed by Dr Petrus le Roux for radiogenic strontium isotope signatures. Meanwhile, tests were carried out in the Field Museum, Chicago, for cadmium, mercury and arsenic, the standard treatment for syphilis. All leave mineral traces in the teeth. Gauguin's teeth showed no trace of any of them. It confirmed Gauguin's own doctor's diagnosis that he did not have syphilis.[5]

Though Gauguin was disgusted with the electrification of Papeete, its tennis mania and overall galloping inauthenticity, he was reluctant to leave the island. He rented a plot of land in the pretty little village of Punaauia, eight miles south of Papeete, far enough to be properly pastoral but too far to walk to the capital for the necessary hospital treatment, to collect his post and keep up with island gossip, so he bought a pony and trap.

His plot was beautifully situated on the shore facing due west, looking across the ocean to the island of Moorea's jagged cones behind which the sun set with tropical panache. 'The site is wonderful, in deep shadow on a roadside, and from behind, a magnificent view of the mountain. Imagine a great bird cage railed in with bamboo, its roof thatched cocoanut leaves, and divided in two parts by my old studio curtains. I use one partition as a bedroom, with very little light for the sake of coolness; the other forms the studio and has a large window at the top. Mats and my old Persian rug cover the floor; it is all decorated with hangings, knick-knacks and drawings.'[6]

His hut was built in the traditional oval shape, with walls of unsplit bamboo canes and a roof of plaited palm leaves. He had bent strict tradition by

dividing the space into two parts and separating them with his old curtains from Rue Vercingétorix, also by putting a window in the studio for more light. In the spirit of reviving a pan-Polynesian tradition that he had seen in New Zealand, he carved the two main doorposts into the shapes of forbidding idols.

Since arriving in September, he had not touched a brush except to paint the stained-glass window in the studio, but in November, once the building was finished, 'I'm going to stop this truck driver's life and get a sensible woman into the house. Then work without interruptions, especially as just now I'm in the mood for it, and I believe that I shall do better things than ever before . . . I see by your letter,' he was writing to de Monfreid, 'that you are busy with the divorce. But you don't tell me how it is turning out. Inevitably one makes so many troubles for oneself by marriage – that stupid institution!'[7]

He sent word to Tehamana that he was back. While he had been in France, she had taken a husband, but she came back to live with Gauguin for about a fortnight before returning to her newer obligation. It was clear that her child conceived with Gauguin was no longer. We do not know if the child died, or if she had a miscarriage or abortion. In the wake of her departure, his neighbours offered him a girl, as was their custom. Her name was Pau'ura a Tai, but Gauguin couldn't manage the complicated glottal stop involved in saying her full name, so he called her Pahura. She was fourteen and a half when she moved into his hut in the New Year of 1896.[8]

Pahura was bouncingly self-confident and irrepressibly sociable. She was local, with a large extended family in the village, with whom she spent as much time as she did with Gauguin. This made his time with her very different from his time living with Tehamana, who had come to Mataiea as an outsider and been thrown back almost exclusively on Gauguin's company. The relationship with Tehamana had been intense. She was quieter, more introverted and reserved than Pahura. He had fallen in love with Tehamana within the first week, after which their relationship had deepened as they explored each other's gods, myths and legends, their conversations affirming his belief in humankind's subconscious, borderless synthesis.

Pahura did not incline towards speculative thought, or difficult questions of any kind. She took life lightly. She loved nothing better than to sit around chatting and gossiping. She took other lovers. She was an undemanding

companion. She loved to be indolent. This made her an excellent model: doing nothing was no hardship. Convenience held them together rather than passion. Domestically, Gauguin was easy-going. Pahura didn't have to cook much. The local Chinese convenience store was just over the road, and he reverted to his health-destroying diet of tinned food. Inside the door of his hut stood a 200-litre cask of red wine, constantly replenished. When dusk fell – no electricity here – locals dropped in, the guitar and the mandolin came out, and the level sank in the cask of red wine. Gauguin was proud of his skill in making a good French *omelette baveuse*, runny in the middle. So long as Pahura's hostess leanings did not impinge on his painting time, he relished the *salon*-like village sociability after dark. Pahura enjoyed her time with him, too. Years after Gauguin's death, when Pahura was an old woman making a living from breeding guinea pigs, she was asked about him. She did not grumble or air any grievances but recalled him with affection, laughingly calling him a *coquin*, a rascal.[9]

He had not painted seriously since the disaster at Concarneau but now he was back at the easel. Pahura inspired him to great heights. One of the first pictures he made of her was yet another challenge to the world canon of full-frontal female nude. This time he referenced one of his 'little friends', the early-Renaissance painter Lucas Cranach the Elder, who liked to adorn his female nudes with a flamboyant prop, often a wide-brimmed hat with a curly feather. It made the nudity more arresting. Gauguin borrowed the idea, placing a red pleated fan, the symbol of Tahitian royalty, behind Pahura's head. She lies in front of the tree of knowledge from which her servant is picking fruit. Round its trunk winds something that you may take as a mere innocent liana but, in this world of Polynesian/Greek/Christian symbolic synthesis, must be the snake that guards the sacred tree in the gardens of Eden and the Hesperides. A cow wanders by. The background orchard of golden trees flows down to the coast and the sea. Referring to the red royal fan, he called the picture *Te Arii Vahine* (*The King's Wife*). 'I think it is the best thing I have ever done . . . I think I have never done anything so sonorous in colour.'[10]

Images of Pahura poured off the canvas. In June, they discovered she was pregnant. He immortalised his delight in the Motherhood series, *Nave nave*

RETURN TO TAHITI

Gauguin, *Te Arii Vahine* (*The King's Wife*), 1896

mahana (*Delicious Days*), *Te tamari no atua* (*The Son of God*), *No te aha oe riri* (*Why Are You Angry?*), *Te Rerioa* (*The Dream*).

Pahura gave birth to their daughter around Christmas. The baby died a few days later. In February, he painted *Nevermore*. Pahura lies on the bed, her blank eyes open in the gloomy night, her face sad. High up on a studio windowsill behind her head perches a black raven, the bird that Edgar Allan Poe used as the symbol of mourning and never-ending remembrance of death in his poem *The Raven*, the poem that Mallarmé had translated into French, in reference to which Gauguin had placed a raven on Mallarmé's shoulder when he drew his portrait. In the painting of Pahura, next to the raven, Gauguin wrote, uniquely for him, a word in the English language, the word the raven croaks in the poem's refrain: 'Nevermore'.

This closed the Motherhood series with a tragedy. Soon afterwards there came a letter from Mette with further tragic news. Their daughter, Aline, had died. She was only nineteen years old.

293

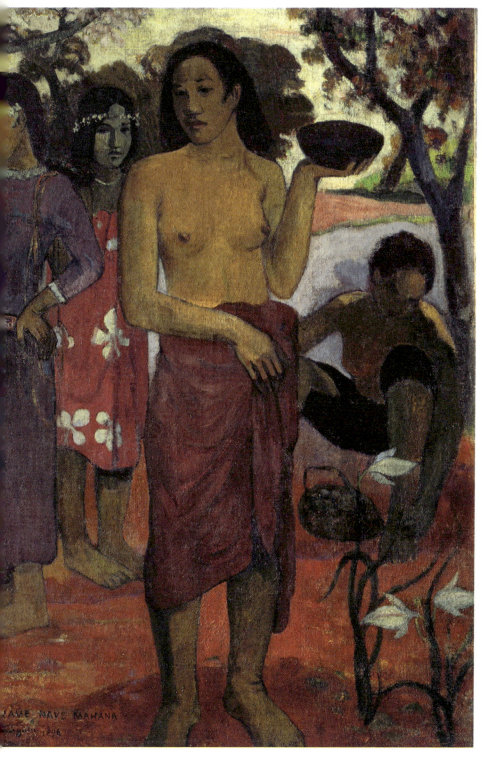

Gauguin, *Nave nave mahana* (*Delicious Days*), 1896

WILD THING

'In the last years, she had unfurled her wings; last summer she had fluttered like a butterfly in the sunshine, basking in the joy of life among her flock of friends. Winter came early, cold, hard and strong but this did not stop her giddy round; she was happy and in love . . .' wrote Mette who, with her passion for individual freedom, had seen no need to clip her daughter's wings. 'Following a brilliant New Year's Ball, which she had enjoyed tremendously, she had been sent home in a freezing-cold cab. The next day she had a high fever, towards evening the family doctor, Dr Carøe, was sent for. He found her condition so serious that he sent for Professor Saxtorp. For two days they fought to save her but the cold had gone to her lungs and she died of pneumonia a few days before her twentieth birthday.'[11]

Aline, the most loving of all his children, his only daughter, named after his mother. The little girl who had said that when she grew up, she wanted to marry him. Gauguin was crazy with grief. He could not cry, only rage.

'I have just lost my daughter. I no longer love God. Like my mother she was called Aline. We all live in our own way; some love exalts even to the sepulchre. Others – I do not know. And her tomb is over there with flowers – it is only an illusion. Her tomb is here, near me. My tears are her flowers; they are living things.'[12]

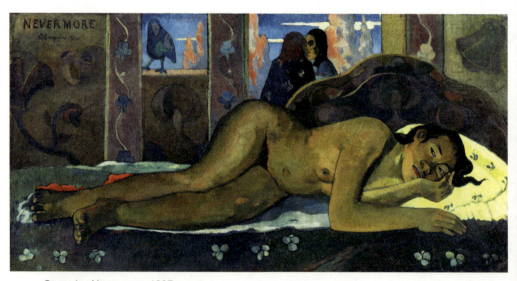

Gauguin, *Nevermore*, 1897

Though Aline had died in January, he had received the news only in April. She had been in the tomb a quarter of a year. He heard no more. June passed. Tormented with misery, anxiety and ignorance he wrote a letter calling down a curse on Mette, that her unfeeling coldness towards him should be rewarded by eternal unrest.

'I asked you [before I left France] that the children should write to me on the 7th of June, my birthday. No more was necessary than; "Dear Papa" and a signature, I said. And you answered me; "You have no money, do not expect it." I will not say "God keep you." Instead I say, "May your conscience sleep to prevent you welcoming death as a deliverance."'[13]

That was the end of personal letters between them. Three years later, when their son Clovis died at the age of twenty-one, Mette did not even write to tell him. Gauguin went to his own death without knowing that Clovis had preceded him into the tomb.

'If you knew the state of my soul after all these years of suffering,' he wrote to de Monfreid. 'If I can no longer paint, I who love only that – neither wife nor children – my heart is empty. Am I a criminal? I don't know. I seem condemned to live when I have lost all moral reasons for living. There is no glory but that of one's own conscience. What does it matter whether the others recognise or acclaim it? There is no true satisfaction outside of one's self and just now I'm disgusted.'[14]

Self-Portrait (*Near Golgotha*), painted in this terrible year, leaves us in no doubt of his despair. Titled, signed and dated, '*Près du Golgotha, P. Gauguin, 1896*', it continues the line of self-portraits as the suffering Christ. Already he had painted himself in the Garden of Gethsemane, but this was one further step on the road to the Cross. *Ecce homo*, behold the man, stripped of all vanities, illusion and pretence. There is no trace of stylisation or swagger; he does not even romanticise and enlarge the 'Inca' nose he was so proud of. Almost full face, an ordinary-looking middle-aged man with sagging skin and eyes that avoid meeting ours. Humble and defeated, he wears the dingy white, round-necked shift that he had worn all those weeks in hospital; it recalls the homespun seamless garment that was taken off Jesus Christ before He was nailed to the Cross on Golgotha, the Place of the Skull, where, as He was enduring death agonies, the Roman soldiers played dice for the garment.

WILD THING

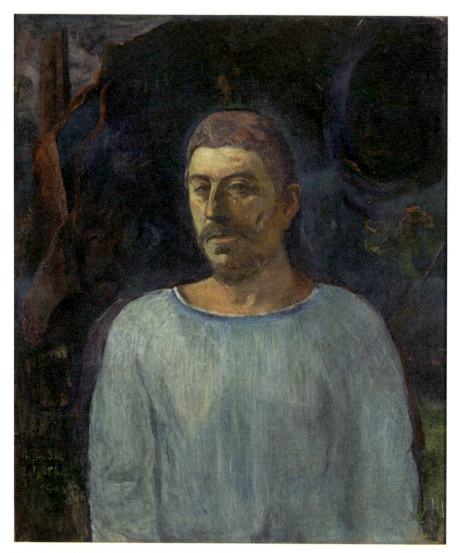

Gauguin, *Self-Portrait (Near Golgotha)*, 1896

Gauguin's Golgotha is a Polynesian garden, spectral in the dusk. The branches of a tree form the shape of a cross. Out of the gloom loom the shadowy faces of the two thieves. Despair pervades the painting whose indistinctness might owe a certain amount to a further blow dealt him by unrelenting fate. He had developed conjunctivitis in both eyes and had difficulties seeing. Nothing could be more frightening to a painter. He admitted himself to hospital where he was presumably cured, as he does not mention eye problems again for a

while. But trouble's battalions had not finished with him yet. The man from whom he rented the land on which he had built his house died. His heirs wanted to realise the asset. The land was to be sold. Gauguin had to move out.

He was fifty years old. Time to take charge of his destiny. Nobody should have the ability to throw him out of his home ever again. Not enough remained of Uncle Zizi's legacy to buy his own plot of land, so he visited the Caisse Agricole de Papeete where he recklessly borrowed 1,000 francs at 10 per cent interest, repayable within the year. He bought a beautiful plot of two and a half acres in Punaauia, close to where he had been living before. His land stretched from the road to the sandy shoreline. The plot included a number of delightful palm trees, whose coconuts he would sell. Vanilla commanded a good price and he resolved to interplant his coconut palms with vanilla orchids to generate a steady income. His land looked westward across the ever-changing sea, striped with the line of white waves breaking on the coral reef, and stretching beyond, towards the jagged outline of Moorea's volcanic chimneys silhouetted against fugitive skies.

'I have the feeling of the never-ending of which I am the beginning.

'Moorea on the horizon; the sun approaches it. I follow its mournful progress; without comprehending, from this point onwards I have the feeling of a perpetual movement: a universal life that will never extinguish.

'And here comes the night. Everything rests. My eyes close in order to see, and without grasping it, the dream in the endless space disappearing before me; and I have the sweet feeling of the mournful procession of my hopes.'[15]

For the first time in his life, he owned the land he lived on. It was a significant moment. This time, he would not build himself a draughty birdcage. He'd had enough of drenching rain driving in between the bamboos, enough of living beneath a plaited roof that blew away at a gust of wind when you needed it most. He commissioned a wooden house, or, rather, two houses. One for living and one for working. Consciously or not, he laid it out to resemble Rue Vercingétorix. The main house, the dwelling house, measured about nineteen metres by eight. It was raised up on metre-high piles to keep it clear of rodents and other marauding creatures, and to lift it above the waters when they rose in the rainy season. It was connected to the studio by a veranda commanding the sunset view. The walls and floor were constructed

of sawn wooden planks. Wood was a very expensive material in Tahiti because most of it had to be imported from America. He had already paid 700 francs to purchase the plot. The cost of construction was so high that he had to put off paying the workmen in full.

'All credit has been stopped. I owe 1,500 francs and I have no idea how I am going to live, though my diet is austere,' he wrote to Molard.[16] One of the first communications he had received on his arrival in Tahiti had been a letter from the agent Lévy cancelling the agreement to act as Gauguin's agent. This left the part-time dealer/artist Chaudet as his sole agent. Gauguin had already received one payment from Chaudet of 1,035 francs for works sold: a cause for optimism, though he had already spent it. Whenever a boat arrived bearing mail from France, he met it in hope of receiving more money from Chaudet, but none came.

It was vital he get a steady source of income, however small. The agricultural cycle of coconut and vanilla harvest was too slow. He needed money now. In June, he wrote to de Monfreid proposing a scheme.[17] De Monfreid was to get together a syndicate. He was to identify about fifteen people in Paris who either wished to own Gauguin's work for its own sake or who wished to speculate on it. Gauguin's suggested list included the painter Sérusier and the wealthy art patron the Comte de Rochefoucauld who was already supporting Sérusier and Émile Bernard with an annual allowance of 1,200 francs each. It would seem to demonstrate Gauguin's drastic lack of self-confidence at this moment that he did not include either of his major enthusiasts Degas or Mallarmé on the list; presumably because both were figures of such importance that he would be embarrassed to approach them cap in hand. Once de Monfreid had identified the fifteen or so investors, they would each send Gauguin 160 francs a year. This would give him a steady 2,400 francs per annum, sufficient to live on. In exchange, he would send back fifteen pictures. On arrival of his artwork, the investors would draw lots, ensuring fair distribution. After that, they would do with them whatever they wished. Enclosed in the letter of proposal, Gauguin drew up an official-looking agreement, signed it and sent it off in high hopes. De Monfreid was left with the unenviable task of telling him that nobody wished to become an investor, sweetening the message by suggesting Gauguin petition the French State for a grant. 'This is

the thing I should dislike most of all,' replied Gauguin. 'I ask *friends* to help me but to beg from the State has never been my intention. All my struggles to keep clean, the dignity I have struggled to maintain all through my life, would lose their meaning on that day. From then on, I should be no more than a scheming rascal. Truly, this is sorrow I never expected to endure.'[18] Nevertheless, de Monfreid applied to Roujon, the Minister of Culture and one of Gauguin's *bêtes noires*, who had previously refused to support him. Roujon sent the insulting sum of 200 francs, which Gauguin returned.

Visitors to the newly built house in Punaauia unanimously describe it as chaotic. This was probably due to Pahura's lack of interest in domestic order, combined with Gauguin's ill health. Normally Gauguin was neurotically tidy and orderly, as many ex-sailors are, but the condition of his leg suddenly declined with alarming rapidity. He was back on morphine to kill the pain, and spending more time than he wanted in bed. Nevertheless, one of many visitors gives an impressive description: 'He was powerfully built, with blue eyes, a high complexion, a slight tan, and chestnut-brown hair and beard – thin imperial to be exact – which were already greying. At home he invariably dressed in native fashion, wearing a cotton tunic and a loincloth – and always barefooted. But when visiting Papeete, he wore European clothes: a high-collared jacket and white, or more often blue, linen trousers of Vichy fabric, white canvas shoes, and a broad-brimmed hat of plaited pandanus leaves. Because of his unhealed leg ulcers – evidence of his impaired health – he had a slight limp and supported himself by a stout stick.'[19]

The injured ankle became worse and the skin on both legs was badly infected. Pahura proved a devoted nurse but eventually Gauguin had to admit himself to hospital, where he was treated with arsenic powder, rubbed into his legs to heal the infected skin. After eight days he discharged himself, unable to pay the bill of a couple of hundred francs. This led him to be described in the register as 'indigent', a classification that would cause difficulties in all his subsequent dealings with officialdom. When he got home, the ankle that had been broken caused him so much pain that he could not put any weight on it but only lie down, stupefied by morphine. Getting up induced fits of giddiness and fainting. He also had bouts of fever. Any sort of work was out of the question. It says much for Pahura that she nursed him faithfully

in the large, expensive wooden house that none of the villagers visited any more. The wine-guzzling party crowd had dried up. They did not think he had syphilis (they were familiar with the disease, rife through the islands) but they believed he had leprosy, also widespread. White people normally did not get it. When their own people did, they drove them out of the village to take their chances of life and death in the stark ravines of the island's interior, or they were deported to a remote island in the Tuamotu group.

Ill and despairing in the aftermath of Aline's death, Gauguin had forsworn God. 'Almighty, if You exist, I charge You with injustice and spitefulness. What use are virtue, work, courage, intelligence? Crime alone is logical and rational,'[20] he raged, but even as he denied God, he could not leave Him. Gauguin had repeatedly taken on the identity of Jesus Christ in self-portraits. This was his highest ideal and his deepest touchstone; there was nowhere else for his profound self to go. Now wrestling with God as Jacob had wrestled with the angel, he began writing his spiritual testament. It would eventually stretch to nearly a hundred manuscript pages, remaining unfinished at his death. He gave it the title *L'Église catholique et les temps modernes* (*The Catholic Church in Modern Times*). As it evolved he changed the title, and the focus of the manuscript, to the more personal *L'Esprit moderne et le catholicisme* (*The Modern Thought and Catholicism*).

On the front cover he pasted a transfer drawing of Mary Magdalene in the brothel. The back cover shows the Virgin Mary with the newborn Christ child. Witnesses to the holy birth are an angel, Mary Magdalene and Gauguin himself. The symbolism is obvious. Between the covers he will explore the journey from transgression to redemption.

The text is prefaced with a dedication to Charles Morice, to whom he planned to send it for publication. Then it plunges straight into what he calls 'the perpetual problem thus posed – Where do we come from? What are we? Where do we go?'[21] The three great questions posed by Bishop Dupanloup every school morning in his catechism. Questions that had stuck in Gauguin's mind ever since he had arrived in Europe, felt alienated and fought back with the words, 'I am a savage from Peru.' Scarcely an adequate answer to Dupanloup's existential probing.

Meditative passages ponder the great spiritual mysteries of creation, the

significance of the similarity between creation myths across different civilisations, and the conundrum of the human soul. Fierce passages attack Western culture and the Catholic Church, placing the blame for modern society's ills on the divorce of the Church from true Christianity. The Catholic Church has long lost sight of its spiritual principles and acts instead as an arm of the State that upholds an oppressive system of law and government whose sole purpose is the preservation of property and social inequality, through the enslavement of women and of other races.

'To colonise means to cultivate a region, to make a hitherto uncultivated country produce things which are useful primarily for the people who inhabit it: a noble goal. But to conquer that country, raise a flag over it, set up a parasitical administration, maintained at enormous cost, by, and for the glory of, the mother country alone – that is barbarous folly, that is shameful!'[22]

He had already written a lot on the oppression of women. Now, between the cover images of Mary Magdalene and Mary the mother of Jesus, he wrote, 'Woman, who after all is our mother, our daughter, our sister, has the right to love whomever she please. She has the right to dispose of her body and her beauty . . . and she has the right to be respected just as much as the woman who sells herself only in wedlock (as commanded by the Church). She consequently also has the right to spit in the face of anyone who oppresses her.'[23]

Sometimes he veers into half-digested scientific speculative nonsense. 'When the first nebulous agglomerations (of atoms) have formed, then becomes the point of departure of a geometrical progression – the point to which the infinitely small, infinitely slow reason can return – the first stage which may be regarded as zero in relation to something which is infinite, having no beginning . . .'[24] When we read these passages it is charitable to remember that when he was writing *The Modern Thought and Catholicism*, he was often taking morphine, often in great pain, and always lonely intellectually, lacking a sounding board or sparring partner.

Dupanloup had found the infallibility of the pope as hard to swallow as the miraculous properties of holy relics. Gauguin echoed the sentiment. If he ever got haemorrhoids, he wrote, he'd try stuffing the Turin Shroud up his arse, to see if it would do the trick. His health problems, which fortunately did not include haemorrhoids, reached crisis point. He had daily suffocating

WILD THING

fits, he was vomiting blood, it choked him at night when he was lying down, and his heart was hammering. He could not go back to the hospital, where he had left an unpaid bill. The Chinese merchant who ran the convenience store over the road refused to extend further credit, not even for a loaf of bread. Pahura gathered mangoes and guavas and waded into the shallows to catch shrimp. They would have starved had not her extended family sent generous meals. Their pity stuck in his throat.

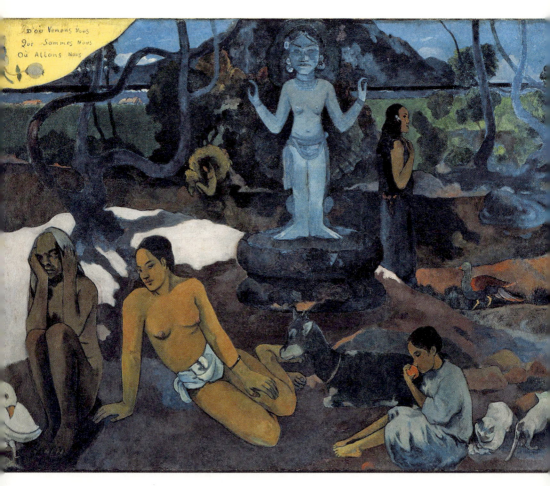

Gauguin, *Where Do We Come From? What Are We? Where Are We Going?*, 1897–8

He suffered a series of heart attacks. 'I regret my heart did not kill me . . . I want only silence, silence and again silence. Let me die quiet and forgotten.'[25] 'If I have done beautiful things, nothing can tarnish them and if I have done trash, why gild it and deceive people? In all events Society cannot reproach me with taking from its pockets by means of lies. I have never exploited Society.'[26]

But his heart had not killed him. He must take matters into his own hands.

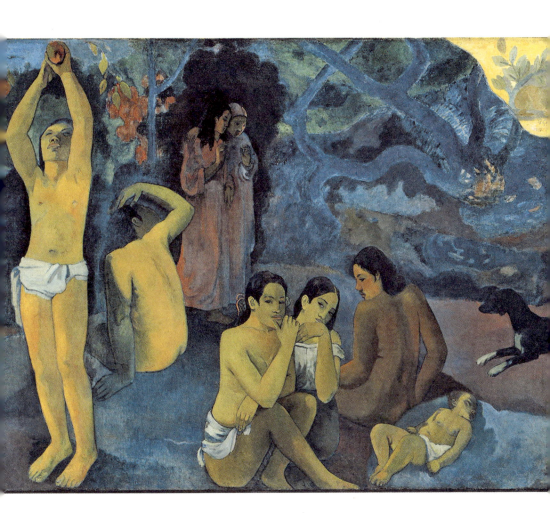

'I went into the mountains where my body would be devoured by ants. I had no revolver, but I had arsenic which I had saved up while I was so ill with eczema. Whether the dose was too strong or whether the vomiting counteracted the action of the poison, I don't know; but after a night of terrible suffering, I returned home.'[27]

It was the ultimate failure: he could not even manage to kill himself. Before the suicide attempt, when he had been lying in bed writing his religious testament, he had not had the strength or the will to paint, but now he felt an urgent need. Words were not enough to leave behind; he would paint his spiritual creed and confession. He gave it the title: *Where Do We Come From? What Are We? Where Are We Going?*

He had no canvas. He could not afford it. But there were rolls of woven copra lying around, ready to be made into sacks for the fruit and vegetable trade. The rolls were over a metre wide, and he cut a length of four metres. On this he would create his own monumental frieze, a challenge to the great testamental friezes: to Borobudur, to pharaonic Egyptian, to Raphael's Vatican *stanze*, and to the bloodless, magisterial silences of Puvis de Chavannes.

It would tell the story of humanity's Creation and Fall, referencing and synthesising cultural and religious context to bring universality to the depiction of the problematic condition of being human. The first insult Gauguin flung at so-called civilisation was to reverse the rigid artistic convention followed in the West that a painting should be composed to 'read' from left to right, as are the lines in a printed book. 'Reading' a picture the other way around is something we find counter-instinctive and difficult but Gauguin forces us by placing the most strongly coloured figure second from left, making a dominant oblique chunky diagonal leading our eye to the edge of the canvas. But there is nothing there but the frame. Our eyes dart to the right, as Gauguin intended. We see a Moche dog fox bounding into the world, Gauguin's alter ego, the creature that accompanied Peruvian mythological heroes on their adventures. Wildness, anarchy, chance and lust have entered Eden. The picture is set at that primal moment of creation when the elements have not yet fully separated but are still resolving out of a blue-green swirl. Everything is fluid. The firmament has not been divided into earth, sea and sky. The paws of the ebullient dog fox point to the baby: new life starts.

Keeping watch over the baby is a group of three figures, possibly referencing the three Fates, sitting in eternal harmonious balance. Above them hangs the red fruit from a tree. Here the canvas is vertically divided in two by the standing figure plucking fruit, referencing Eden and the Hesperides. Man has fallen. On the left side of the tree of knowledge is the fallen world: the child eating the forbidden fruit, the looming figure of the idol with whom, under different names and in different guises, mankind seems unable to live without worshipping. Some of the people around the idol are now dressed in clothes that conceal their bodies from top to toe, like the Mother Hubbards the missionaries imposed upon the Polynesians to hide their nakedness. Innocence has been lost. Flesh has become shameful. 'Behind a tree are two sinister figures, shrouded in garments of sombre colour, recording, near the tree of science, their note of anguish caused by science itself.'[28] Finally, an ancient woman, naked and withered, crouches on the ground in the pose that Gauguin recollected from his earliest days, the pose of the Peruvian mummy. Two such mummies had crowned the gateposts of his Uncle Pío's palace in Lima. The crouched mummy-figure presents us with our own final alienation: death. Lastly, in the very bottom corner of the canvas, the end of the story is marked by a white full stop: a silly white goose, an innocently foolish creature, crushing a lizard in its claws. It is, Gauguin explained, a symbol of the futility of words.

17

REINVENTIONS

Well, I must see about doing something different.[1]

Time to renew his acquaintance with the lawyer and desiccated coconut magnate Auguste Goupil, who had bought Gauguin's hunting gun and lent him the fascinating books by Moerenhout. Clip-clopping in his pony and trap up the drive leading to Goupil's curlicue mansion, life-size, bright-white, copies of famous classical statues had taken up their poses between the coconut palms. He would use the image as a symbol of colonialist pretension in later writing and painting.

Maître Goupil welcomed him warmly enough. Gauguin's pictures were not to his taste; he had no desire to buy any but, as a charitable gesture, he commissioned Gauguin to paint a portrait of the least important member of his family, his youngest daughter Jeanne, aged nine, who was also known by the Tahitian name Vaïte.

Jeanne was dressed in her best head-to-toe Mother Hubbard and dispatched to Gauguin's hut, where he placed her in an elaborately carved high-backed chair. Gently nurtured in the servant-scattered mansion of one of Tahiti's ruling elite, Jeanne had never before seen anything like Gauguin's studio with its polyglot clutter all strewn about in an atmosphere of careless disregard, reinforced by the figure of the artist. White men did not dress like locals in a *pareu* wound round their hips. White men wore trousers. Apprehensive but self-contained, the nine-year-old child composed her features to deal with this bewildering, disordered world. A magnificent portrait resulted. Intelligence shines from her fine-featured face. Spare, wary and seemingly invulnerable, Jeanne possessed a classical profile and the alertness of the introverted observer. Gauguin turned her into a young hierarchic priestess, her chiselled features as perfectly impersonal as Nefertiti's. Her skin is startlingly white, like a painted geisha or a Noh mask,

REINVENTIONS

Gauguin, *Portrait of a Young Girl. Vaïte (Jeanne) Goupil*, 1896

her complexion having been shielded all her life from the browning sun by servants bearing parasols.

According to Jeanne, the painting was accomplished in a single sitting, after which she was extremely glad to get back home to polished furniture, well-upholstered armchairs and orderliness. She liked Gauguin, for all his oddness, and she was not disconcerted when Goupil extended his benevolent patronage to engage Gauguin as drawing master for her and her sisters.

309

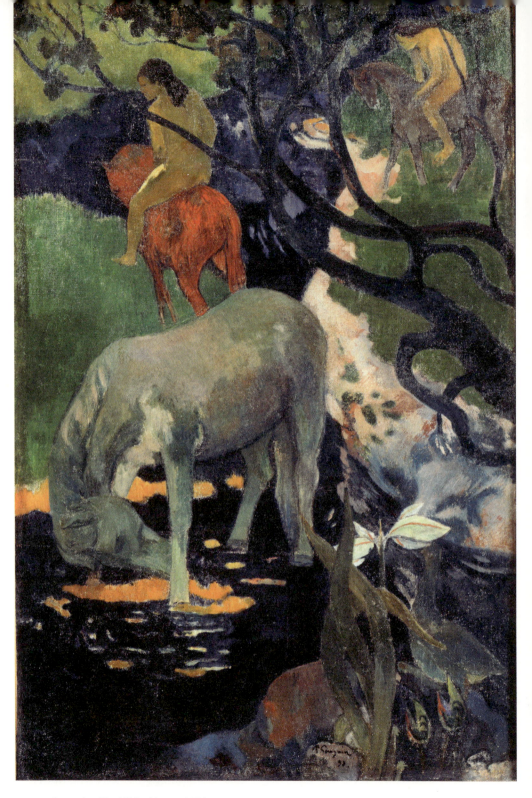

Gauguin, *The White Horse*, 1898

Gauguin was pleased to accept. It meant money, and it meant copious and delicious meals on teaching days. It also meant him occupying the social no-man's-land that is such a rich vein in the literature of the time: the tutor, the governess, the specialist music or art master, all of whom stood in the uneasy position of cultural superior but social inferior. Above the servants but below the boss, he joined the family table at meals. All worked well so long as he remained firmly in his place, keeping his views to himself and deferring to his host. But Goupil saw the family meal as a golden opportunity to deliver long monologues over his bounteous board. He was self-believing, blinkered, capitalist, racist and misogynist. When asked at table, 'What are the duties of a woman?' he answered, 'To look after the house, sir, and mind the children, to be good wives, good mothers, to leave politics alone and darn the clothes.'[2] Gauguin could not agree. Goupil had equally reactionary views on art. Subservience, tact, diplomacy and compromise had never been the greatest of Gauguin's strengths and, after a couple of months they had a blazing row and Gauguin walked out. His stint chez Goupil had been useful in bringing him back to the world. His combative appetite for life had been revived.

He received a commission from a pharmacist whom he must have known well from his purchases of painkillers, and he dreamed up a scene of paradisical serenity, a place where a river bordered by pink sand meandered through banks lush with grass, foregrounded and brought into focus by the sharp outline of a striped amaryllis flower. Carrying the eye up by using one of his favourite pictorial conceits, the contorted branches of a tree form a lacy Japanese screen leading the eye into the depth of the flowing composition where two bareback riders on coloured horses are riding away from a solitary white horse which is the subject of the picture as it stands drinking in the middle of the stream.

The white horse symbolises death. White is the colour sacred to death in Polynesia. The ghostly animal is as spiritually charged as a *tupapau* as it stands alone in the middle of the river of death that, like the river Styx, reflects the Tahitian belief about the passage of the soul into another world. Gauguin emphasised the white horse's other-worldliness by shading its coat with green reflections of the surrounding vegetation. The pharmacist refused the picture on the grounds that he had never seen a green horse. No more commissions were forthcoming.

Waiting around for mailboats to disgorge money was no task for a self-respecting person. He went to Papeete to apply for a job as secretary-treasurer of the Caisse Agricole de Papeete, the bank that had underwritten his mortgage. The 4,000-franc salary that went with the post would have solved his money worries, but he was turned down. Following the occasion on which he had left hospital without paying his bill of 168 francs, he had officially been classified as an 'indigent', and as such, he was disqualified from the post. Instead, he was offered the job of assistant draughtsman in the Department of Public Works at six francs a day. 'From that I must deduct four Sundays, the rent of a house in town and the wear on my clothes. Well what does it matter? I must swallow my shame.'[3] To be a civil servant in the pay of the despised colonial administration was another bad joke and the pay was terrible, but he couldn't think of any other way to get money. The office was in Papeete, and this would mean a daily commute of eight miles; impractical, even in the pony and trap. He rented a small place on the outskirts of Papeete from a friend of Pahura, and the two of them moved there together.

The day began as soon as it became light at four o'clock. To build up his bodily strength, and for enjoyment, he paddled to the office in an outrigger canoe. His office was in a typical French government building, solidly built along European lines to withstand cold and eliminate draughts. As the sun climbed in the heavens, the advantages of walls built of bamboo canes with gaps between became all too apparent. By ten in the morning the build-up of heat drove them all out of the office to enjoy their two-hour lunch. When they came back at twelve, it was hotter than hell. The processes of digestion took over, bodies slumped over desks, snores rang out. However farcical the twelve-hour working day, Gauguin had to stay until going-home time at five, or he would lose his day's pay. 'Not very intellectual' was how he described his work. Mainly he made copies of plans and technical drawings but sometimes he had to go out to act as foreman on the construction of a road and then the Frenchmen who had once enjoyed his company pretended not to see him as they passed by, and his name was struck off the list of members at the Cercle Militaire, the French club. His Tahitian friends also distanced themselves from him. How could they trust him, now that he was a civil servant working for the colonial administration? He was doubly lonely.

Pahura got bored home alone all day, and homesick for her village. She left him, to spend an increasing amount of her time back in his house in Punaauia, where she entertained her friends and extended family rather too freehandedly. Things went missing. People treated his land as their own. They broke through his garden fence and occupied his garden. One strange, unsettling lady took to haunting his land in the middle of the night sweeping between the bushes with a broom, like a *tupapau* obsessed with tidiness. Gauguin locked up the house. Pahura broke in. More things disappeared: a coffee grinder, a key, a ring, copra sacks he used for his canvases to paint. He reported the incursions to Public Prosecutor Charlier, who made it plain he had no interest in prosecuting the case. Gauguin challenged Charlier to a duel. Charlier threw the challenge in the wastepaper basket. Gauguin became as worked up as any bourgeois householder defending his material possessions.

A new monthly paper had been started in Papeete, called *Les Guêpes* (*The Wasps*). It was the political news-sheet of the opposition, the Catholic party, devoted to bringing down the Protestant party in power, not that either political group was particularly religious or even principled. *Les Guêpes*'s stings often took a satirical tone as they uncovered scandals, exposed corruption and targeted individual *fonctionnaires*, so when Gauguin composed a satirical open letter to Prosecutor Charlier and sent it in, they published it immediately. His letter accused Charlier, 'always impelled by vanity and stupidity', of being too feeble to conduct an investigation, and went on to suggest that he be sent back to France to refresh his knowledge of the law, which he had plainly forgotten. The letter exactly fitted the paper's tone and political agenda. It caught the eye of the proprietor, François Cardella, leader of the opposition party and mayor of Papeete. Cardella was a rough, tough, Corsican adventurer. His original fortune came from his monopoly on growing opium poppies on the island. The next logical step from growing drugs being to sell them, Cardella went on to open Papeete's chief pharmacy. This made him even richer. Money made, time to turn his attention to power. He got himself elected as mayor of Papeete and extended his influence as a leading light in the Catholic party through *Les Guêpes*. He offered Gauguin a job as a writer. Gauguin was happy to take up the role of paid mudslinger that came with the marvellous, miraculous, salary of fifty francs a month.

It suited him well. Four pages coming out once a month did not represent strenuous effort. Gauguin could do it while moving back to his house and garden in Punaauia. The place had become badly dilapidated while he had been away. The roof had been eaten by rats, and rain had poured in. Cockroaches, unchecked, had marauded triumphantly into the studio where they had feasted on drawings and an unfinished painting. Pahura moved back in with him as though it were the most natural thing in the world. He was delighted and surprised. It was not that she had disliked living with Gauguin, it was living in Papeete she disliked. They set about repairing the house together, mending the wooden fence and restoring the garden. He perused French nurserymen's catalogues and sent to Paris for packets of seeds of the flowers he adored. He strictly specified *single* dahlias, seeing them as symbols of nature's superiority over civilisation's so-called improvements. 'For fifty years, gardeners have been hybridising double dahlias,' Gauguin fumed, 'then, one fine day, they come back to the single dahlia.' Like Monet, he adored the extravagantly prolific colours and shapes of flowers: nasturtiums, gladioli, irises, anemones. He ordered sunflowers 'in many varieties' for Vincent's sake. He sowed the seeds in the garden, and he began painting again. Between June 1899 and August 1901, he fitted in working as a journalist with producing ravishing paintings that concentrate far less than previously upon portraying the human condition. It is as if *Where Do We Come From?* had quieted the question of the meaning of life. Even if it had not settled it for good, now was a time for rejoicing in the created world, whoever or whatever had created it. Sun-gilded rivers yellow as butter flowed from his brush; blue-black palms, speckled with shadow, moved with the breeze. He even went back to painting still lifes for the first time since the Yellow House. When, in due course, his flowers bloomed, he picked great blowsy bouquets to paint, stuffing them into 'barbaric' clay vases of his own making, whose strange animalistic shapes were inspired by cross-fertilisation between the Moche pottery of long ago and the Maori motifs he had sketched in New Zealand. And Vincent lived on, in his loving depictions of sunflowers.

The soft, consistent lyricism of Gauguin's pictures during this time could hardly contrast more strongly with his spiky political journalism. It was as if the steady income from *Les Guêpes* took the stress out of his painting. Putting

brush to canvas no longer represented the bread he was able, or unable, to put in his mouth or the mortgage he was able, or unable, to pay. Steady income from journalism, however paltry, had turned painting back into a private joy, a beloved pastime. Nobody here or in France wanted to look at his pictures. – So? – Here people wanted to read his words as he waged a political war that he didn't actually believe in. Protestant party, Catholic party, both were vying for control over a small island that would best be left uncontrolled by France. However, there were fifty francs a month at stake, he would have fun pricking pomposities and prejudices, and he would be following his grandmother Flora and his father in the honourable family tradition of stinging the fat flank of the political establishment through journalism.

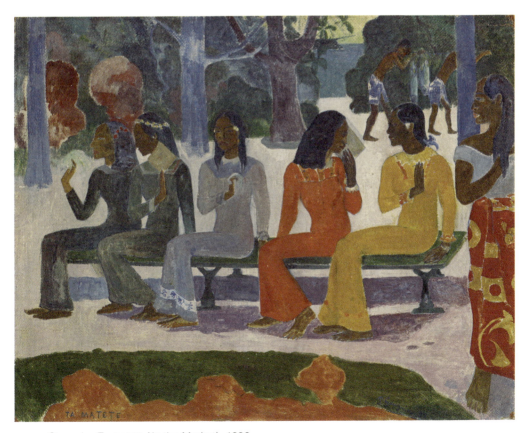

Gauguin, *Ta matete* (*In the Market*), 1892

Gauguin had already brought anti-colonialist political comment into paintings, in his most stylised composition, *Ta matete* (*In the Market*, 1892). A row of women sit on a bench in Papeete's market square. They are given neither volume nor movement, frozen in formal attitudes that deliberately replicate the stylised figures of ancient Egyptian tomb paintings. It is only when you look more closely that you realise the mocking humour. Behind them, two men parody the 'Egyptian' dance poses fashionable in French cabarets and nightclubs. You only fully realise that the women are prostitutes when you see that the one in yellow is holding a cigarette between her fingers and two others, who at first glance are holding fans, are in fact holding their health-inspection certificates.

Early on in Gauguin's career, when he had been incensed by pointillism's 'little green dots', he had faked up and 'discovered' a manuscript written by the ancient sage Zunbul-Zadi who lived 'in the time of Tamerlane' and wrote startlingly relevant observations on colour designed to crush Seurat's scientific colour theory. Now Gauguin rediscovered the joys of constructing an alter ego, several in fact, as he wrote articles for *Les Guêpes* pseudonymously, using a variety of names and voices. As 'Tit-oil' (the masturbator or the shit) he dished the dirt on local political figures. 'Tit-oil' was in the happy position of availing himself of the satisfying opportunity to avenge personal slights or wrongs when they coincided with the paper's interests. Lawyer Goupil was one of the leaders of the party in government, and the paper's inclination to annoy him coincided with Gauguin's own. Goupil was in the throes of forming a company that would build a railway all the way down the west coast of Tahiti from Papeete in the north to Mataiea in the south. The rail track would gobble up a substantial ribbon of the narrow flat coastal strip that was the island's only cultivatable arable land. The proposed rail line ran through a jigsaw of smallholdings belonging to islanders who had lived and farmed there for generations. Goupil's claims that the railway would be a universal benefit to the island could hardly be justified. It would, however, benefit Goupil's desiccated coconut business. Gauguin attacked it in a Swiftian satire, letting his imagination run free as he painted a word-picture for his readers describing the opening of Goupil's new railway line, with the inaugural train chugging out of the station to a razzmatazz of flag-waving, fanfares, uniforms, marching

bands and military music. He pictured the first load of passengers innocently marvelling at the fact that every station on the line happened to be the site of a Goupil plantation or a Goupil factory. At each stop this delightful new form of transportation either loaded or unloaded workers and equipment necessary to the industry of turning the cannonball-like nuts into tiny, delicious flakes that, by happy coincidence, were the only refreshment sold on the train to satisfy the hunger of the passengers. The crowning glory of the line was the central station. Gauguin did not name its location, but it was obvious to all his readers that it was Goupil's house he was satirising. 'It looks like a pile of sardine cans arranged in storeys, as if a carpenter had wanted to copy a castle. In civilised manner, exactly as at Versailles, statues decorate the garden . . . Looking through the door, I thought I saw a pair of hands playing a guitar. I thought also that I heard a sweet refrain, "I love this money."'[4]

The railway line was never built, and Gauguin was never reconciled with Goupil. He mocked Goupil further by carving and erecting statues between the coconut palms of his own little plantation. One, depicting a nude female, so incensed the local priest that he went to the magistrate to get Gauguin's obscene and corrupting figure taken down. Bad copies of naked Greek and Roman gods in the garden of a local millionaire were acceptable to the church but a naked lady in the garden of a local artist was not. The priest's case against Gauguin, like Gauguin's case against his marauders, was thrown out.

Writing for *Les Guêpes*, Gauguin also used the personas of Aretenia (Virgin), a female theatre critic whose seemingly naïve musings uncovered truth in paradox, and Oviri (Savage), a more mature female; but it was under his own name that he wrote as an advocate for women's rights. He was persuaded by the Catholic party to take to his feet to deliver his first and only political speech on the question of the unlimited immigration of Chinese arriving in Tahiti, an issue uniting both the colonial French and the indigenous Tahitians. The French saw the Chinese as canny shopkeepers, rather better at business than themselves, who put nothing back into the island's economy but sent everything home. The Tahitians saw them as grasping traders and merciless moneylenders. Both were united in resentment against them.

The meeting took place in Papeete's main square. He got a huge audience; there was, after all, not much else to do in the evening. Gauguin proved

himself an effective soapbox orator. His audience was much moved as he gave a racist rant worthy of Donald Trump. 'Our illustrious ancestors purchased our liberty with their blood . . . This yellow blot on our country's flag makes me blush with shame.' You wonder where Gauguin got his figures when he claimed, 'The statisticians tell us that there are no fewer than twelve million Chinese circulating about the Pacific and gradually obtaining control over the trade of the South Seas. Does not the barbaric invasion of Attila, described by the history books with such horror, pale in comparison?'[5] How much of this he believed himself is moot; he never again took to the hustings.

However, he had discovered real enjoyment in journalism. For the brief period between August 1899 and April 1900, 'partly for relaxation, partly to bring together certain favourite ideas', he brought out his own little newspaper *Le Sourire* (*The Smile*) subtitled *Journal méchant* (*The Naughty Newspaper*). It strongly resembles his other writings such as *Noa Noa*, *Avant et après* and *Cahier pour Aline* in avoiding linearity and taking an anarchically fragmentary approach to content. Free of a newspaper proprietor imposing a political agenda on him, Gauguin published anything that amused him: personal reflections, reminiscences, political fragments, local scandals, absurdities, gossip. Each issue consisted of four handwritten pages produced by the very latest in printing technology.

Ever experimental, never careful with money, Gauguin had purchased the newly invented Edison Mimeograph duplicating machine.[6] It came in a chic wooden box containing roller, printing frame, writing plate, electric pen, and rolled-up sheets of stencil paper in a cardboard tube. The process was to write or draw with the electric pen on the flimsy stencil paper which was then rolled over with ink and printed. The chief joy that differentiated this from his previous experiments with printing lay in its opportunity to marry text with illustration. He made woodcuts for the mastheads. They were, he confessed, far from perfect as his eyesight was not yet completely mended but this, he thought, rendered them more artistic as they bypassed verisimilitude for suggestion. He also enjoyed peppering his handwritten texts with little drawings and cartoons. The island's governor Gustave Gallet became the butt of his jokes. One cartoon showed Gallet running along the beach with his beer-belly wobbling, looking as if he was about to build

a sandcastle, but the bucket in his hand was not full of sand but labelled 'a bucket of public hatred'. Gauguin caricatured the chubby governor as *le dindon de la farce*, a stuffed turkey, but also a farcical individual. His naughty newspaper made the French-speaking locals chuckle as they passed it from hand to hand. He could only print it in small numbers because the printing got fainter and fainter with each sheet that rolled through the machine. It goes without saying that he made no money from it, but that had never been the point. More seriously, he received no money either from *Noa Noa*, which had now first appeared in print. The perfidious Morice had published part of it in *La Revue blanche* and sent Gauguin a copy of the paper without enclosing his share of the fee.

In April 1899, Pahura gave birth to a boy. He was named Émile, like Gauguin and Mette's eldest son, but this time spelled in the French way. Gauguin wished to be registered as the father, but he was not. This was probably at the behest of Pahura's family. If he were the legal father, his rights over the child would include the right to remove the child from its mother if he ever left the island.

He had been sending his paintings back to France and in return receiving occasional payments: roughly 1,000 francs per year. Together with his journalistic salary of 50 francs a month it paid his modest living costs and covered instalments on the mortgage on the land. In 1896 Chaudet sent 1,200 francs. In 1897, he sent 700 francs from a show that he had organised at Galerie Vollard. And in 1898, Vollard sent 1,000 francs from a show in his gallery featuring *Where Do We Come From?* and eight other paintings. When Gauguin learned that Vollard himself had first bought all the paintings in the show for the paltry sum of 1,000 francs so that he could sell them on, he felt betrayed. This was an act of insider dealing and a terrible breach of trust. The 'crocodile of the worst sort' was living up to his sobriquet. But the same year he received 950 francs from de Monfreid for the sale of three paintings, one of which had been bought by Degas. That was happiness.

Nothing gave Gauguin greater pleasure than de Monfreid's report of a running duel in the saleroom between Degas and the collector Stanislas-Henri Rouart bidding against each other for Gauguin's pictures. De Monfreid further reported that Degas had requested to be alerted in good time when shipments of Gauguin's paintings were expected in Paris. 'Write to him,' said

Gauguin. 'I have always been afraid to do so, and with good cause. He would only think I was doing it for a purpose, and I know him. If he can, and wants to help me, he will do it more easily and more gladly of his own volition than if I were to ask him.'[7]

Gauguin was starting to feel secure that a market in his paintings, though small, was steady. So it came as a shock when, in 1899, after receiving 1,000 francs from de Monfreid in January (half of which came from the sale of *Nevermore* to the composer Frederick Delius, a great devotee of Edgar Allan Poe), no money arrived throughout the rest of the year. By June, he was getting desperate.

The Exposition Universelle 1900 was coming up in Paris to mark the dawn of the new century. It would be the ideal showcase for his Tahitian paintings, but he was running low on colours and had no proper canvas, only sacks. De Monfreid had not been enamoured of the copra sacking on which *Where Do We Come From?* had been painted. The paint, laid thinly on coarsely woven sacking, resulted in the picture arriving in France in a terrible state. To make it hangable Gauguin had sent detailed instructions similar to those he had sent Van Gogh years before: the terrifying process involving wax, wet newspaper, flour paste and a very hot iron. Shuddering at a repeat performance, de Monfreid sent primed canvases and a good supply of colours. He also forwarded an invitation from the artists who had exhibited at the Volpini café during the first expo, who wished to hold a reunion exhibition at the coming expo. Gauguin refused. He had no intention of exhibiting ever again with Émile Bernard and his friends who had repeatedly branded him a plagiarist as their own art dissolved into wishy-washy, undisciplined spirituality. Instead – maybe to snub them, or maybe spurred on by their remembered insult – he started on a vaunting ambition to create a monumental frieze bigger even than *Where Do We Come From?* As big as anything he had seen at his first expo.

He would show the world he could equal the greatest set pieces. His re-mythologising of the world would take up its place among them. He took an enormous canvas, two metres by six metres, stretched it and primed it. He planned a synthesised Age of Gold: part Polynesian, part classical Greek, part Javanese, fragrant with *noa noa*, devoted to birth, motherhood, the cultivation of bountiful Mother Earth and the benevolent care of trusting animals.

A world without fear. A world before the Fall. Why, by the way, did there even need to be a Fall? A stupid by-product of religion, pressing on to humankind the unbearable, inescapable burden of existential guilt. The great work would carry the title *Ruperupe (Luxury)*,[8] the title forming a link in a strong historical line as it looked back to Baudelaire's lines in *Les Fleurs du mal*, published in 1857, conjuring the world of *luxe, calme et volupté* on which Pierre Loti had built his lotus-eating fantasies, and which looked forward to Matisse, who was one of the worshippers at the temple of *The Talisman* and who remained greatly influenced by Gauguin when he painted his great paradisal vision *Luxe, calme et volupté* (1904), paying homage to the same ideal.

It proved too much for Gauguin to accomplish the gigantic representation of the ever-desired state of primal, paradisal innocence. He made, and sent, smaller paintings around the theme. But, as he rolled up the smaller canvases to be shipped to France, he made a mistake on the address label of the parcel. The paintings arrived much too late for the exhibition, where only one of his canvases was shown, an early Breton landscape that was included in the group of Impressionists.

Throughout 1899, in the build-up to the expo, Gauguin had heard nothing from Chaudet. Neither news, nor money. Eventually he discovered that Chaudet had died the preceding year. His gallery had closed, and Gauguin's paintings had passed into possession of his brother. On learning of Chaudet's death, he realised he had no option but to approach the crocodile.

He opened negotiations in January 1900. By March, they had agreed terms. Gauguin would send Vollard between twenty and twenty-four paintings a year. Vollard would sell them for 200–250 francs each and pay Gauguin an allowance of 300 francs per month. At the critical point of signing, a Rumanian prince named Emmanuel Bibesco proposed to become his dealer on matching terms. Gauguin chose the reptile over the unknown prince.

Twenty to twenty-four paintings was a large number to produce in a year. All his recent paintings had been sent to the expo. With nothing else, he bundled up 500 woodblock prints that he had made over the last two years and sent them along instead. Happy in the feeling that he had fulfilled his side of the contract, he felt sufficiently secure to give up his job at *Les Guêpes* but, just as he was ready to start painting again, he was cruelly struck down

in health, disabled by his legs, his heart and his lungs all at once. Again he was on morphine, in and out of hospital, continually fretting, unable to stand or to concentrate on work. He felt insecure, and out of touch with France. Schuff had ceased writing altogether, and Gauguin puzzled over why. The reason was that Schuff could not bear to tell him that he had lost another child. Mette had written to Schuff in June 1900, telling him that Clovis had died. He was only twenty-one. Three years earlier an accident had left him with a stiff hip. It was thought an operation would remedy the condition but twelve days after the operation, Clovis died of blood poisoning. Too upset to pass the news on to Gauguin, Schuff never wrote to him again.

Fragile, both mentally and physically, it did not take him too much effort to sit down and produce flower paintings. This hardly justified his existence in Tahiti. He had come halfway around the world to dream and had ended up a political satirist making pretty pictures of flowers. He had betrayed both his dream and himself. He reproached himself for the compromises he had made. His original sin had been laziness. Right from the start he had been aiming at the Marquesas, knowing they were the unspoiled Eden, and yet he had wasted years lotus eating on the island of Tahiti which, when he first landed, he had recognised as a place despoiled by civilisation. He had contributed to the despoliation. His very first night, when he had joined the Cercle Militaire high in the tree spying on the dancing crowd, he had become part of the machine that had created this situation. Always accommodating, always ready with an ironical smile. 'At school I learned to hate hypocrisy,' he had written, and what had he become but a hypocrite? He had adjusted his dream to verisimilitude. He would leave this rotten island, start again. Make a better job of it. This time, dream properly.

To sell his house and land was complicated by the fact that the document of sale required both his signature and Mette's. Some corner of Mette's bruised heart must still have contained love and sympathy for her husband, for she responded promptly, nobly and with real humanity to his request. She signed the document punctually and sent it back without including any reference to Clovis's death, so he never learned of it from her either. Mette's signature opened the way to sell the property to a Swede named Axel Nordman, who bought it for 4,500 francs. Taking possession, Nordman

was annoyed to find the house full of 'lumber', which he instructed his son to burn. The son remembered burning 'hundreds of sketches, many wood carvings, and several rolls of dusty pictures'.[9]

The Swede's 4,500 francs enabled Gauguin to pay off the bank. At last he was free to sail to the Marquesas. He invited Pahura to come with him. She refused. Her stay in Papeete had already taken her too far from her village; another island would spell utter misery. He would leave her and their son. Still, he hesitated; still, he missed his boats. The Moche dog fox had morphed into the domesticated lapdog reliant on scraps falling from the dining table, scraps that kept him in thrall . . . the hospital, the generosity of Pahura's family, the security of his friends. It took an outbreak of bubonic plague in San Francisco to galvanise intention into action. A frightened fog of siege mentality enveloped the island. Ships from the United States bearing the island's supplies were quarantined. Shipboard rats, however, survived the forty days, and through them the plague continued to spread unchecked.

Gauguin had tried to kill himself. Death by his own hand and for his own reasons was honourable but to be coffined by a bubo imported from America would be ridiculous. His fighting spirit was roused. 'I am making a final effort by going to settle in Fatu Hiva, a still almost cannibalistic island in the Marquesas. I believe that there, in savage surroundings, complete solitude will revive in me before I die. A last spark of enthusiasm will kindle my imagination and form the culminating point of my talent.'[10]

He packed up his jackdaw belongings: mandolin, guitar, harmonium, the self-portrait as Christ before Golgotha that he had sworn he would never part with, textiles, pieces of furniture, ceramics and the ever-growing reference library of 'little friends'. All were loaded on to the ship, *Le Croix du Sud*. Knowing how difficult it was to get hold of wood on the islands, he purchased a quantity of good timber, sufficient to build himself a house when he arrived, and to make carvings. On 6 September 1901, he embarked. It would take ten days to steam through the nearly 900 miles stretching between Tahiti and the Marquesas Islands. This time, when he landed, there would be no sniggering behind hands, no murmur of *mahu, mahu*. He would arrive with respectable hair.

18

KOKÉ

> Spend yourself, spend yourself again! Run till you are out of breath and die madly! Prudence . . . how you bore me with your endless yawning![1]

On a brief stop during the voyage, the ship put in at the little island of Fatu Hiva, where Gauguin encountered an old man who had once been imprisoned for cannibalism. 'I ask him if human flesh is good to eat; then his face lights up. With an intensely sweet smile (that smile peculiar to the unsullied), he reveals a formidable set of teeth.'[2]

Taking leave of his cannibal acquaintance, he reembarked on the *Croix du Sud*. A shadowy molehill on the infinite horizon resolved into a brownish-blue cone with black lines running down from the summit like they did in Hokusai's pictures of Mount Fuji. As the ship drew closer, the lines resolved into steep, inaccessible canyons. The mighty cones of Hiva Oa's extinct volcanoes rose mercilessly sheer; no flat band of shore softened the meeting with the crashing sea.

Here was no cosy harbour, as existed in Papeete. No encircling coral to calm the watery rim, no sheltering bay to welcome the arriving boat. Access, navigable in few places, was a far-out anchorage, followed by a critically judged jump into a little boat riding the swells of the ferocious Humboldt current. Risky for passengers, disembarkation of goods seemed impossible, but Gauguin's bulky boxes, the timber for his house, and his harmonium, all made the watery switchback successfully, to be stacked neatly on land.

The arrival of a boat on Hiva Oa was a great occasion. People crowded the shore. He recognised two faces: Dr Buisson, who had treated him in hospital in Papeete in 1896 and who was now the government-appointed medical doctor for Hiva Oa; and Brigadier Désire Charpillet, whom Gauguin was pleased to see. He was that rare thing, a gendarme with whom Gauguin had

had cordial relations while in Tahiti. The crowd was surprisingly excited and pleased to see Gauguin. *Koké, Koké,* they greeted him by name, the sound of the letter G being impossible for them to pronounce. *Les Guêpes* had flown this far, where the people had hooted with laughter at his cartoons ridiculing Governor Gallet. They even knew his own little magazine, *Le Sourire*, his ironical smile, which, for all its tiny print runs, had been sent on by their friends in Tahiti and enjoyed. They were welcoming him as a political campaigner, saluting his self-identification with the people of the islands. That he was an artist was neither here nor there, as far as they were concerned.

When Gauguin had first landed in Papeete, Lieutenant Jénot had taken charge of him. Here, a slim, distinguished upright man in his twenties assumed that role. Conventionally dressed in a suit and tie and yet obviously far from a stuffed-shirt Frenchman, he was born Nguyen Van Cam in north Vietnam.[3] When he had reached the age of seven his schoolteachers had named him Ky Dong, meaning 'marvellous child' or 'infant prodigy', and commended him to the emperor, who was so impressed he paid for Ky Dong's education. The legend spread that he was the reincarnation of Nguyen Binh Khiem, the thirteenth-century poet, astrologer and saint.

The French conquest of Vietnam had been a twenty-six-year protracted struggle, running between 1858 and 1885. The Vietnamese had still not wholly submitted in 1887, when the twelve-year-old Ky Dong was carried high on a palanquin as the figurehead of the anti-French resistance. The demonstration was broken up by soldiers, and the leaders were exiled to outer darkness. Ky Dong escaped this fate. In admiration of his precocious intellect, the French authorities sent him to Algiers to continue his education with all expenses paid by the French State. It would be extraordinarily useful to French interest if they managed to turn him politically to support French rule.

The French conquest of Algeria had not been gentle. Ky Dong spent his years there keeping his head down training as a doctor as his hatred of French colonialism grew. In 1896, he was returned to Vietnam, where he combined working as a doctor with undercover work subverting the French regime. Principally he devoted himself to recruiting resistance fighters for the legendary revolutionary leader De Tham, 'The Tiger of Yên Thē'. Lightning guerrilla attacks on Hanoi spread terror among the occupiers but failed to cohere in the

more organised campaign of 1898, known after Ky Dong as the Marvellous Child Rebellion. It failed, and Ky Dong was exiled to the dreadful Devil's Island where his imprisonment would have coincided with Dreyfus's, had not a processing error sent him instead to Tahiti where he lived pacifically, working as a nurse. But word must have come through to the French colonial governors who, fearing his potential influence, moved him on to the more remote Marquesas in 1901. He had not been there long before the arrival of Gauguin.

We probably owe the fact that Gauguin's final home rested in Hiva Oa to Ky Dong's burning need for an intellectual companion. He saw the opportunity and seized the moment. Gauguin could not speak Marquesan, a different branch of the Polynesian language from Tahitian, but Ky Dong smoothed over all difficulties. He took Gauguin to the house of a Chinese-Tahitian restaurateur called Matikaua, who rented out rooms for two francs a day. Once this was settled, Ky Dong treated Gauguin to a meal, after which he gave him a tour of the village-sized capital, the two men proceeding in a slow and stately progress during which Gauguin unleashed his charm on every woman they met, inviting them all for tea and cakes. By the end of the tour a whole procession of women was following them to the guesthouse, where Gauguin made good on his promise of refreshment and merrymaking. He was obviously most attracted to a tall twenty-year-old named Fetuhonu, and this irritated the other women. Fetuhonu had been born with talipes, a foot turned in and under. This made her an object of scorn in a society that prized physical perfection very highly. Gauguin had no idea how he had insulted the others, who made fun of his choice, but only in their own language so the white man would not understand. Ky Dong, who understood perfectly, hurried home to write a farcical play on the afternoon's doings, *Les Amours d'un vieux peintre sur les Îles Marquises* (*The Loves of an Old Painter on the Marquesas Islands*). He looked forward to Gauguin enlivening his exile.

With money in his pocket from the sale of the Tahitian house, Gauguin took advantage of the tea party to ask about plots of land for sale in the tiny capital Atuona, a scattering of about a hundred Western and Polynesian houses occupying a small, flat plain about half a kilometre across and a few metres above sea level. Mountains rose sheer on three sides of Atuona; about five hundred people lived there, roughly 160 of whom were Europeans. As

usual in Pacific islands, rival Christian missionaries had squabbled over souls and it was plain to see the Catholics had come out on top. Their cathedral, with its sad-faced stained-glass saints, dominated the capital, looming above even the gendarmerie that every morning hoisted the French tricolour. The Anglicans had been nudged out to the edge of the plain, practically into the sea, where they worshipped beneath a cheap tin roof on an exposed, windy site prone to flooding. You could hardly hear the liturgy for the crashing of the waves.

Gauguin's rented room was in the centre of the village, just below the Catholic cathedral, at the crossroads with the gendarmerie and the general store run by a sociable young American named Ben Varney. A small stream wiggled past. As he scouted where to settle, he realised how convenient it would be to live exactly here. It did not take him long to discover that the Catholic Church was the major landowner on the island and that he would stand no chance of buying anything unless he was approved by Monsignor Joseph Martin,[4] apostolic administrator of the province.

Charpillet, the friendly gendarme, introduced him to Bishop Martin, a skeletal, fanatical-looking man with a long, straggly beard and piercing Rasputin eyes. Gauguin played the convincing Catholic. He attended Mass daily and after eleven days the bishop sold him a plot of land for 650 francs, and that was the end of churchgoing. He now owned one of the best sites in the village, an acre of flat land accessed by a little bridge over the convenient stream in which he would bathe every morning, and right across the road from Ben Varney's general store. Unlike his houses in Tahiti, the plot did not command sublime views, but Hiva Oa's greater ruggedness demanded shelter rather than high vantage. Soon he was compensating by taking an evening stroll up the hill to the Calvary Cemetery, where the dead enjoyed the best views of the sun sinking over Traitor's Bay.

Gauguin's little Eden was fertile and, he hoped, self-sufficient. Grassy enough to graze a horse and a goat and a pig, all species that ran wild in their thousands over the island, along with uncountable chickens. Watching chickens at their antics had always amused him, and now he would keep a flock and imitate the Dutch Old Masters by incorporating their slaughtered bodies into his still lifes before popping them into the cooking pot.[5] There were coconut

and banana palms and a magnificent breadfruit tree forming a dramatic, lustrous pyramid, with sunpools on its shiny, almost black leaves contrasting with its pompom clusters of pale green fruit that could be used in pictures to give sharp accents against incoherent masses of creeping jungle. A multi-stemmed mango tree with thick, almost white trunks gave glowingly pale verticals.[6]

By now experienced in island living, Gauguin knew exactly what he wanted of a house, and it was not the authentic Marquesan model. The locals here lived in houses that looked like thatched roofs on stilts. At the back, the roof came right down to the ground, while the front and sides were completely open. Houses served mainly for storage of possessions and for shelter in extreme conditions. Most local living was done in between the houses. Gauguin needed a building in which to work and live. He designed a two-storey house about twelve metres by four with a pitched roof and a gable either end. The ground floor was divided into three rooms: a walled woodcarving studio, a walled kitchen and, between the two, an open-sided dining room. The upper storey spanned all three rooms. He must have been feeling confident of his legs, for the only way to access the top floor was by climbing an outside stair, little more than a ladder with a handrail. At the top, a door in the gable end of the building, led straight into his small bedroom whose only piece of furniture was the narrow bed, which he had carved with a writhing phantasmagoria of gargoyles and grotesques.[7] A woven wall separated the little bedroom from the long, large studio running the length of the building with good windows on three sides. The eastern window overlooked the full panoply of Catholic triumphalism: the cathedral, the cloister and the high-walled girls' school from which a crocodile of teenagers muffled from head to toe in missionary dresses emerged on an irregular basis decided by a mystery timetable, to snake down to the beach beneath the watchful eyes of several black-clad nuns. His western window showed Mount Temetiu, a mist-shrouded peak clad in black jungle with waterfalls dropping straight down in narrow white ribbons. The window at the gable end pointed towards Calvary, the graveyard with the excellent view. He set up his easels in the steady light of the north window, through which he poked a fishing line to raise or lower a bucket down into the well in the garden below, where he kept his bottles of water and absinthe cool. When thirst struck, he had only to haul up a bottle. He placed his harmonium in the

centre of the studio floor. Somewhere along the line he had acquired a harp. He had no idea how to play it, but it was delicious to pluck *en passant*, leaving the mysterious music of the spheres hanging in the air. Against the walls stood two chests of drawers that had followed him all the way from Paris, and some Marquesan chests in which, following local custom, and maybe with Pahura and her raiding relatives in mind, he kept his valuables padlocked.

Architecturally innovative, his house would be only the third two-storey house to be constructed on the island, and the first using traditional materials, but the project held no concerns for Atuona's two best carpenters, Samuel Kekela and Tioka Tissot. Following Gauguin's design, they achieved elegance, stability and a strong enough upper storey not to collapse beneath the weight of the harmonium and other paraphernalia. The secondary elements of construction, the weaving of the bamboo walls and the plaiting of pandanus for the roof, were a group village effort that turned into a month-long party fuelled by barrels of red wine rolled over the road from Ben Varney's general store. By the end of the month when the house was finished, Gauguin had become so much a part of the village community that he was invited to exchange names

Reproduction of Gauguin's house in Atuona

with one of the carpenters who had worked on the house, Tioka Tissot. This was the highest honour a Marquesan could bestow, equivalent in other societies to becoming blood brothers. Tioka became Koké and Koké became Tioka. Taking the name of the other was more than a statement of equality, trust and respect. By exchanging names, the two mystically became one. They shared wives, possessions, social rank and *mana* (power, or soul).

Gauguin had always been an essentially sociable introvert. However much of an outsider he was, his understanding of humanity had never come from isolation, never from locking himself away, but from being among people while retaining the position of observer. In urban Paris, this had been the easiest thing in the world. In Brittany, eager landladies had spread out *la comédie humaine* richly before him while he remained detached. In Tahiti, he had drifted lazily between both sides of the racial and social divide. In so doing, he had collaborated with the colonial catastrophe.

He would connive no longer.

He would fight for these generous people, his friends, who laughed as they cut their fingers on sharp bamboo to build him the home he wanted. He gave his house the name the Maison du Jouir, a name guaranteed to infuriate the local priests and officials, meaning the House of Pleasure, or the House of Orgasm. Privately, he referred to it as 'my little fortress in the Marquesas'.[8] It would be his centre of operations, his centre of resistance as he set out seriously, at the age of fifty-three, to grow from being a satirist to becoming a campaigner of conscience championing the rights of the Marquesan people, and a thorn in the flesh of their French colonial masters.

The Marquesas Islands had been discovered in 1595 by Álvaro de Mendaña, who named them for the wife of his patron García Hurtado de Mendoza, the Marquis de Cañete, viceroy of Peru. When Mendaña's ship had approached the island of Fatu Hiva, he had been thoroughly scared by a reception committee of outrigger canoes paddled by 400 long-haired, naked warriors tattooed in blue patterns. He massacred them unprovoked. After that, he followed a policy of shooting on sight. The exceptional brutality of Mendaña's conquest explained the extremely hostile reception given to the next white man to land, Captain Cook, in 1774. Next, in the 1790s, American whalers and trading vessels made regular calls, bringing with them

firearms, disease, alcohol and the notorious 'blackbirders' involved in the kidnap and transportation of Pacific islanders for forced labour. In 1842, the French Admiral Dupetit-Thouars annexed the islands for France, but this did not stop a raiding party of Peruvian slavers who, in 1863, kidnapped Marquesan men to work in their South American plantations and mines. French diplomacy brokered their return, but on coming home they brought with them a catastrophic smallpox epidemic that wiped out thousands.

The population of the Marquesas Islands had stood at about 50,000 when annexed by the French. Sixty years later, in 1901, when Gauguin arrived, it was fewer than 5,000. The French authorities looked forward, without sympathy or regret, to the impending extirpation of the entire indigenous population. Meanwhile, their heathen souls must be saved by the Church.

The French Catholics, forerunners of Bishop Martin, made their first missionary attempt at conversion in 1843, the year following French annexation, but they did not stay long. The ferocity of tribal warfare and cannibalism frightened them away for twenty years until the smallpox outbreak had drastically cut numbers and weakened the population. By 1887, they had established a church and two separate-sex boarding schools in Atuona. Three years later, Bishop Martin took up his post and his cudgels with all the intolerance of the fanatic. The Old Testament is fairly unambiguous on the subject of tattoos, which appear on the list of prohibitions in Leviticus, between a long list of people you must not have sex with and the sinfulness of shaping your beard.[9] Bishop Martin wore his beard untrimmed, forbade the sacred art of tattooing as well as sexual activity outside marriage, and marriage itself was no longer allowed to be polyandrous. Erotic Polynesian dances such as the *upa upa* were forbidden, as were drinking, piercing of any kind, and male supercision at puberty, the cutting of the flesh round the top of the penis to form a thick scarred ridge, that apparently greatly increased the partner's pleasure during sexual intercourse. Nudity was forbidden. Women and girls who had been used to flitting as freely and colourfully as butterflies with a bark-cloth *pareu* knotted round their hips or just a loincloth were muffled from chin to toe and neck to wrist in missionary modesty.

Sacred sites were smashed, the ancient stones uprooted from the oblong temple sites. These sites were laid out, as it happened, to the same proportions

as the ground plan of Gauguin's newly built house; they were divided into a larger dancing platform and a modular smaller platform of sacrifice. The stone tikis (gods) looming over the temple platforms had their faces and genitals smashed. Human sacrifice followed by cannibalism was of course forbidden. The ritual had never been a Dionysian orgy of bloody feasting but something far closer to the Christian sacrament of Holy Communion: the eating of a small piece of the sacrificed body by which you absorbed its *mana* and holiness through the symbolic act of taking a piece of the sanctified flesh into your own body.

At the time of Gauguin's arrival, sacred sites remained hidden high in the steepness of the remote hills and valleys where the old worship was carried on in parallel with the new. Ritual murder and human sacrifice had probably died out, infanticide also: within the context of the fast-disappearing race, every life was precious. 'Here, for everyone, children are the greatest boon of nature, and everyone wants to adopt them. Such is the savagery of the Maoris, which I have chosen. All my doubts are dispelled. I am and will remain this sort of savage. Christianity here understands nothing. Happily, in spite of all its efforts, conjoined with the civilised laws of succession, marriage is only a sham ceremony. The bastard, the child of adultery, remains, as in the past, monsters that exist only in the fancy of our civilisation.'[10]

Subversive protest was there for Gauguin to see. It remained in canoeing, seen by the French as useful for fishing and getting places though its hidden secret significance lay in its age-old demonstration of physical power combined with ritual chant and song. The historical art of canoe carving and canoeing was magic hidden in plain sight.

Three years before Gauguin arrived, in 1898, Governor Gallet had visited the island. His official report back to Paris kept collapsing into exasperation, reverting to the fact that the whole population was 'debauched and barbaric'. What was he to do, he asked Paris, in the face of a population who complained to him that he had forbidden them to do the two things they liked best, eating human flesh, and drinking fermented coconut juice?[11] With alcohol forbidden they made a sport of their masters. From time to time, Gallet reported, groups of forty or fifty persons would fill a canoe with orange juice. When it had fermented for a few days, they would carry it up to one of the remote valleys of their ancestors, high in the hills, where they

would lose themselves in drunken Dionysian revels, all completely naked, drinking, fighting and copulating for days on end. On such occasions the gendarmes knew it was dangerous to appear and they kept away but they noted the culprits and cracked down on them afterwards.

Unlike Governor Gallet, Gauguin did not see barbarian debauchery in this. He saw a people unjustly oppressed. A people ruled by the French but who were very unequal as French citizens. 'Pure' French citizens could buy and drink as much alcohol as they wanted, while even a cupful was forbidden those over whom they ruled. Gauguin wrote to the Colonial Inspectorate, appealing for justice.

'If . . . you make special laws to prevent them from drinking . . . it is preposterous to tell them that they are French electors, and to impose on them schools and other religious nonsense. There is a singular irony in this hypocritical esteem for Liberty, Equality, Fraternity under a French flag.'[12] He went on to plead against the disproportionate fines imposed for drinking.

He also took up the cause of the wanton killing of pigs by the French colonists.

'Permit me to submit for your good judgement some observations concerning the law about rampant pigs,' ran his letter to the president of the Tahitian General Council. 'In the Marquesas there are hardly any coconut plantations, and the damage caused [by these pigs] is almost nil . . . The pig to an indigene is like the cow to a peasant in some of our regions. For many European colonists, however, it is different. A pig that crosses their property for even a few minutes provides sufficient rationale to kill the animal and carry it to the brigadier who will sell it . . . Thus there occurs a daily killing for the singular pleasure of killing . . . an immoral spectacle and a wicked example to the indigenes, one little worthy of a people who have left barbarism behind.'[13]

Murders were very unusual on the island, but a rare one occurred around Christmastime 1902. The islanders felt that the gendarme's investigation had been cursorily conducted and the wrong man had been accused because the gendarme was racially prejudiced and fundamentally lazy. Gauguin once more took up his pen at the people's behest. In January 1903 he wrote to the investigative judge whose job it was to tour the islands dispensing justice on behalf of the French State.

'Allow me to inform you of certain facts in connection with this murder which you are going to investigate . . . We, the Public, are imperfectly informed about what the police Sergeant has said in his declaration: on the other hand, we know all that has not been done. That is because we have taken the trouble to do the work, ourselves.' A woman who had endured two stab wounds and been sexually penetrated by a wooden stake had been discovered by a gendarme while she was still alive. The injury to her vagina passed unnoticed by the police investigation until, days later, it was discovered crawling with maggots and the woman's life was past saving. Why, Gauguin's letter asked, had the gendarme not immediately called for help from the best doctor on the island? 'Out of vanity, no doubt: the stupid, autocratic vanity of a policeman.' A black man had been accused, falsely in the general opinion of the islanders, who believed that her lover, a Polynesian, was probably the murderer. Witnesses, friends of the murdered woman, testified that they had been in the company of the accused at the time of the murder. While the woman was dying, Gauguin reported, 'her lover was at her bedside constantly, urging her with protestations of love intermingled with threats to keep silent . . . The lover has never been examined or troubled by the police and no one has been questioned about him.'[14]

Gauguin's repeated allegations of laziness, prejudice and corruption among the gendarmes won him no friends in the French administration, but he persisted and went further, taking an interest in the larger issue of the island's children.

Colonising foreign powers have weaponised children from time immemorial. The tactic of separating the children of occupied territories from their parents by taking them from their homes will, if thoroughly carried out, destroy national identity, religion and language in a single generation. An effective part of this deracination of the future generation resides in educating the children in the language of the oppressor, thus imposing a 'first' language upon them that is not the language of their parents and their heritage. In Hiva Oa, the Catholic Church had set up two boarding schools in the capital Atuona, one for boys, one for girls. The children of the island were made to attend these schools up to the age of fourteen. The school for girls was run by the Sisters of Saint-Joseph de Cluny and housed in a very securely fenced

compound adjoining the Catholic cathedral. The boys' school was run by the Brothers of Ploërmel. All lessons, printed books and communications were in French.

Separation from their children caused great distress to families, and this caused Gauguin to delve into the legality of the forced internment of children. He called a meeting on the beach, the traditional place of assembly where men met to discuss local issues. In two paintings, *Riders on the Red Beach* and *Riders on the Beach* (both strongly reminiscent of Degas's racehorses milling about at Longchamp racecourse), Gauguin shows the schoolchildren's fathers riding bareback on horses on the beach, whose dull black sand he has turned to a glorious shrimp pink. Here, at their de facto parliament, Gauguin told them that he had discovered a French law passed on 27 August 1897, that only children living within a four-kilometre radius of a school were bound to attend it. This caused a considerable strategic flight from the capital. The girls' school lost a third of its pupils. Gauguin had exposed the practice of enforced internment of children as illegal. With this, he became a marked man. It caused him no distress. On the contrary, it stimulated him to further activism. He went to war on several fronts at once: on taxation and on the corruption of the gendarmes, an insecure body of racist bullies overendowed with power and underendowed with morals. The gendarmes extorted a cut on every transaction. One of their simpler means of enforcement was to stamp hard with their sturdy gendarme's boots on the bare feet of the locals.

In March 1902, Governor Édouard Petit, who had taken over from Governor Gallet, arrived on an inspection tour of the island. As Gauguin was by now a well-known troublemaker, Petit refused to see him. But Gauguin was determined to take up the two issues of the corruption and bribe-demanding of the gendarmes and the brutal burden of taxes imposed by the French regime. Prevented from a face-to-face meeting, he detailed the injustices in a long letter demanding that taxes should be proportionate to the wealth of the island, 'for it is immoral and inhumane that a country which yields only 50,000 francs for example from its products should have fines of more than 75,000 francs imposed upon it in addition to the taxes, the payments in kind, and the dock duties which, by the way, go into another coffer than that of the colony, at the absolute disposition of the governor'.[15]

The taxes collected from the islanders, he pointed out, were not spent on their own islands but went back to Papeete and ultimately to France, to be spent in both places. Questioning the natural justice of this, he refused to pay, and advised the islanders to do the same. The result was that tax revenues fell in one year from 20,000 francs to 13,000. Charpillet, the one gendarme who had till now supported him, pursued Gauguin for the sum of sixty-five francs he owed in tax. When Gauguin refused to pay, Charpillet seized a gun and two carvings from Gauguin's house. He then announced a public auction of the items. Gauguin showed up at auction with his local friends, and they stood around drinking rum and champagne, joking and laughing waiting for the auction to begin. When the bidding opened, everyone kept schtum. Eventually, to raucous laughter, Gauguin shouted a bid of 'Sixty-five francs!' He gave the money to the official, took his things back, and the official had been made a thorough fool of.[16]

His campaigns and letters to the authorities governing the island represented one strand of resistance. The other was his house, the Maison du Jouir.

As Captain Cook and those who had followed him observed, sexual experiment from the age of puberty, and earlier, was part of traditional Marquesan upbringing. Polyandry was the norm. In Hiva Oa, it was the custom for one woman to have two husbands. Marriages were not made for love; they were strategic, arranged according to clan status, economics and war trophies. 'Faithfulness' in the Christian sense was simply not a meaningful concept. The Western idea that sex should be monogamous, and that it should only take place within the context of romantic love was, frankly, laughable. That this attitude continued in Gauguin's time was well attested to by the exasperated Governor Gallet. That it continued beyond Gallet and into modern times has been recorded by numerous anthropologists and other visitors.[17] When Gallet went on his tour of inspection in 1898, three years before Gauguin arrived, he had reported back to his Ministry: 'As for the family, it does not exist there. Marriages made by the missionaries and [the French] civil authorities hardly last two or three months.'[18] 'The best households', Governor Gallet's report continues, 'always comprise a third man, the *pétcio*, chosen by the husband to live on equal footing with his wife

[for her pleasure]. At the age of puberty, the young daughters are initiated by their second fathers and then made to service all the other parents and friends in the vicinity, sometimes fifteen, twenty or even thirty individuals.'[19]

Observing the evasive duality of everyday Marquesan life, Gauguin wrote little vignettes purely for his own amusement. Here he describes a Christian marriage and its unchristian aftermath.

'Monseigneur, with the eloquence that characterises missionaries, thunders against adulterers and then blesses the new union . . . As they are going out of the church, a groom says to the maid of honour, "How pretty you are." And the bride says to the best man, "How handsome you are." Not long afterwards and a new couple goes off to the right, another to the left, deep into the underbrush, where in the shelter of the banana trees and before the Almighty, two marriages took place instead of one. Monseigneur is satisfied and says, "We are beginning to civilise . . ."'[20]

The island's Monseigneur himself, pious Bishop Martin, was hardly innocent of duality. He had a schoolgirl mistress, probably aged fifteen, named Thérèse. The horny bishop married her to the verger who also lived in the church compound. Thérèse's duties included sweeping out the bishop's bedroom and everybody knew that the 'celibate' priest was the *péctio* in this domestic arrangement.[21] On an island that lived by double standards, this caused no commotion, only laughter. Gauguin carved two satirical freestanding tikis and set them up in his garden as a public joke.[22] One was a portrait of Bishop Martin, with the words *Père Paillard* (*Father Lechery*) inscribed on the base. The other was a portrait of Thérèse and inscribed with her name. Nobody passed by without a happy giggle. Gauguin had carved horns on the bishop's head. It was doubly delicious to see their spiritual leader portrayed as a devil as well as a cuckold. Everyone knew Thérèse cheated on both men.

He placed the joke tikis either side of the foot of the stairs leading up to the top floor of the Maison du Jouir, making it a place out of bounds to decent, God-fearing citizens who did not wish to offend the French colonial establishment. This was exactly the point. Abandon Western decency all ye who enter here. The downstairs of the house, the kitchen and the al fresco dining room and the sculpture studio were all neutral spaces, but you could not go

WILD THING

upstairs without choosing to go back to the old world, before the French had arrived. Passing between the bishop and his mistress you climbed the stairs knowingly, by choice, entering beneath the lintel inscribed *Maison du Jouir*, either side of which was carved a profile head of Taaroa, the Polynesian god of creation.[23] In the days before the French occupation, a *maison du jouir* was the place where young Marquesans hung out together, fully approved by society. They danced, they sang, they played, they had sex as they felt inclined, freely, with pleasure, without guilt and without money changing hands. The women chose the partners. And so he carved a woman on each vertical doorpost; everyday, local, unerotic figures, they carry no pretensions to beauty, nor any symbolic references to Eve or the Virgin Mary or even the

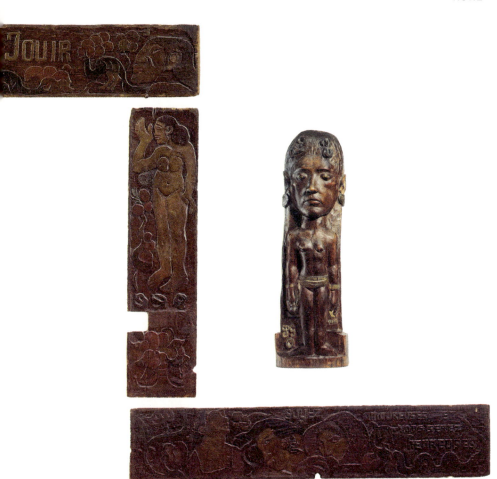

Gauguin, five decorative panels carved for the entrance of Maison du Jouir, 1901–2
Gauguin, *Père Paillard* (*Father Lechery*), 1902
Gauguin, *Thérèse*, 1902

Tahitian goddess Vairaumati. Behind them meanders a decorative pattern of vines and leaves and a snake and a dog. Horizontal panels extending either side read *Soyez mystérieuses* ('Be mysterious') and *Soyez amoureuses et vous serez heureuses* ('Be in love and you will be happy').

That the entryway was a spontaneous and somewhat haphazard creation seems to be borne out by the fact that Gauguin carved it from sequoia, a timber that is not native to the island. It arrived in the form of packing cases for cargo. The odd nail hole can still be seen.

Once through the entrance, you came directly into his claustrophobically small bedroom with its elaborately carved bedstead, above which he pinned up some pornographic postcards purchased in Port Said on the journey out. They were by all accounts 'pretty tame stuff: buxom ladies, a hint of amazing underwear, seldom what the connoisseur might call the real thing'.[24] He exhibited them in the same spirit as he had painted the motto *Honi soit qui mal y pense* on the ceiling of Marie Poupée's inn at Le Pouldu: evil to him who finds evil in this. They could be taken lightly as a ridiculous joke or more seriously as a comment on the sexual hypocrisy of the civilisation he had left behind.

'Men, women and children laughed at them, nearly everyone, in fact: but it was a matter of a moment, and no one thought any more of it. Only those people who profess to be respectable stopped coming to my house, and then, while on their own, they thought about it the whole year round . . . Think this over and nail up some indecency in plain sight over your door: from that time forward you will get rid of all respectable people, the most insufferable folk God has created.'[25]

The Maison du Jouir was not a brothel. There are no full and extensive first-hand accounts of exactly what went on there but from bits and pieces it sounds as if it could better be described as a *salon* with more overtly acknowledged erotic overtones than the average Paris *salon*.[26] A place of drinking, dancing forbidden Polynesian dances, talking, politicking, flirting and a great deal of music-making on the guitar, mandolin and harp. Gauguin would take to his harmonium to play Schumann's *Berceuse* and favourite Handel reveries, which hardly sounds riotous. 'Since he had lots of money, he always had at his disposal five or six unabashed young women from the valley. His staff would invite them to take turns modelling and they would spend the night.'[27] These were 'older adolescent girls [who] leave home and parental authority to indulge in promiscuity, making themselves available to virtually all males, old and young, married and unmarried, Marquesan and foreign . . . Strangers, particularly Europeans, are usually directed to the promiscuous girls to eliminate the potential threat such individuals pose to previously established unions. Assigning white males to promiscuous girls is often a means

of expressing antagonism against the whites, the implication being that only the girls that no one really wants are good enough for them.'[28]

As always, it took Gauguin some time to absorb the new place before he could begin to paint. He had arrived on 16 September. By November his mind had settled. Time to start work, discontinue the studio parties, regularise his domestic situation. With Vollard sending money on a regular basis, he adopted an almost bourgeois domestic existence, engaging a cook and a gardener, and he went looking for a girl who would like to come and live with him.

He found her in a village about twenty-five kilometres east along the coast from Atuona, where her father, Hapa, was the chief. She was called Vaeoho Marie-Rose and she was probably fourteen. When Gauguin had revealed the illegality of the incarceration of the schoolchildren, her father Hapa had gratefully brought her home from school. Now he was happy for her to go and live with Gauguin in exchange for thirty-one metres of cotton fabric and a 200-franc sewing machine, all bought from Ben Varney's store.

19

THE BAREFOOT LAWYER

The house suited him well. Vaeoho Marie-Rose probably did too, though we know little about her. Although she lived with Gauguin for nine months, she does not survive in anybody's account of the time. Nor, so far as we know, does she feature in any of his paintings, though when she became pregnant, he painted several tender maternity scenes, including *Group with Angel* (1902), *Nativity* (1902), *Mother and Child* (1902). In August she travelled home to have her baby, a daughter named Tahiatikiaomata Vaeoho Marie-Antoinette, born on 14 September 1902. After that, she remained in her parents' village, where she settled into a long relationship or marriage with a man called Putoanu who adopted Tahiatikiaomata. According to unverified legend, Gauguin wished to acknowledge the child by registering as father on the birth certificate but the family refused for the same reason as Pahura had previously refused in Tahiti: his name on the certificate would give him the legal right to take the child with him if he left the island. This was the last thing Gauguin wanted, but he was gallant Frenchman enough to wish to legitimise the child in French eyes by a public declaration of fatherhood.

The important model from this time is Tohotaua, the remarkably beautiful adopted daughter of Kahui, Gauguin's cook. She was from Tahuata, the smallest island in the Marquesas group, some four kilometres distant from Hiva Oa, where quite a large section of the population had glorious red hair. Tohotaua's brilliant hair clouding round the marvellous bone structure of her face gave her an awe-inspiring beauty set off by her glowing skin. Here, on the plain of Atuona, where mosquitoes and the no-no fly made the air a perpetual torment, people rubbed bright orange turmeric powder into their faces and bodies as an insect repellent. It gilded their skin. As their radiant figures moved through the murk of cobalt jungles one might almost think the Golden Age had never passed. Eager to do justice to this marvel, Gauguin asked Vollard to send him five large tubes of the best-quality yellow ochre paint and two of red.

A portrait of Tohotaua (*Young Girl with a Fan*, 1902) is similar in composition to the portrait he made nine years previously of his Polynesian lover, *Merahi metua no Tehamana* (*Tehamana Has Many Parents*, 1893). Both portraits show the subject seated, full-frontal and half-length, but the similarity stops there. Gauguin had come a long way in those nine years. *Many Parents* shows exactly that – many parents; it shows Tehamana the human being as a synthesis of what went into her making, a jigsaw composed of both worlds: the indigenous world she sprang from, and the colonial one imposed upon her and her people. It is a political picture. The narrative symbols crammed around her steer us towards conclusions. The antique temple frieze, the line of runic Easter Island script, and the *tupapau* behind her, all speak to her non-European otherness. The voluminous Mother Hubbard missionary dress, enveloping her like a cultural shroud, symbolises the stifling of one civilisation by another. Her facial timidity is expressive of the uncertainty of the colonised and the racially oppressed.

Like the painting of Tehamana, the photograph of Tohotaua in Gauguin's studio is rich in multicultural references. Behind her on the wall are Holbein's *Woman and Child*, Degas's *Harlequin*, Puvis de Chavannes's *Hope*, a carving, and an image of the Buddha. The photograph was taken not by Gauguin but by Louis Grelet, a Swiss-born professional photographer who was visiting the island at the time. Like the earlier photos by Charles Spitz that had become so popular during the Paris expo of 1889 that people stole them from the Tahitian pavilion, Louis Grelet's photographs confirmed and upheld the stereotyping colonial gaze, the objectification of peoples through cultural references. Tohotaua's body is wrapped in a cotton *pareu* printed with a bold 'South Sea' pattern, designed and commercially manufactured in the dark satanic cotton mills of Manchester, England, whence they were shipped out in their thousands for sale to the islanders as superior to the *pareus* in which they had wrapped their bodies from time immemorial. The traditional *pareu* was made by pounding the bark of certain trees until it turned into *tapa*, cloth that would wrap softly and comfortably round the body. Its colour varied between cream and brown depending on from which tree bark it came. It was not dyed, and it was not patterned. The imported *pareus*, like the Mother Hubbards and the cotton shirts foisted upon the men

WILD THING

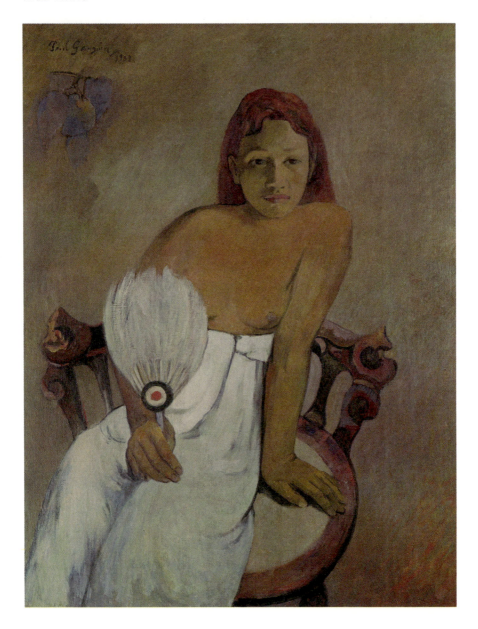

to conceal their bare chests, were weapons of control, imposing European standards of modesty. *Pareus* had always been knotted beneath the bosom. It was the incomers, the priests and the administrators, and particularly their wives, who rewrote the Polynesian decency code.

No wonder Tohotaua holds her body tensely in the photograph, and her

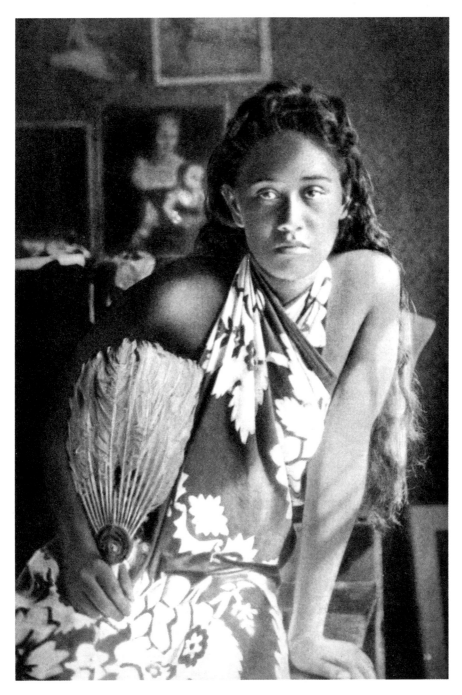

Opposite: Gauguin, *Young Girl with a Fan*, 1902
Above: Tohotaua in Gauguin's studio, 1902. Photo by Louis Grelet

sideways glance is apprehensive and a touch resentful as she poses for a visiting foreigner, and a professional photographer at that.

The painted portrait by Gauguin in the identical pose emphasises how Gauguin's gaze had changed over the years. He sweeps away all the contextualising clutter from the wall behind her. There is not a symbol in sight. Dressed in the plain, cream bark-cloth *pareu* of her ancestors, Tohotaua is a person, not a construct. She is a Polynesian woman, a subject of her own history.

It is one of his most pared-back portraits. The extremely subtle colour palette seems at first glance to be so quiet and restrained as to be almost monochrome. Closer examination shows both the wall and the figure built up of myriad cool shades of beige, olive, cream, grey, blue, citron and gold that flow into the warmer amber shades of her skin. Her red hair is hectic with little strokes of red, purple, green and orange. But despite so many colours, their subtle blending risks insipidity without the strongly painted bull's-eye tricolour on her fan, pulling the figure out of two- into three-dimensionality (try putting your finger over the bull's eye and see how it flattens the picture). As she sits for Gauguin, her body is notably more relaxed than in the photograph, the fear has gone from her face; it has softened into a calm, interior gaze.

Tohotaua was married to Haapuani. Together they inspired an important pair of paintings: *The Sorcerer* (1902), and *Barbarian Tales* (1902).

Haapuani was Atuona's *taua*, its magician. Each village or tribe had a *taua*, a child brought up from birth to be the magus, shaman or sorcerer of his generation. The *taua* was the spiritual conduit through which history, custom and occult knowledge flowed down the generations in a people to whom writing was unknown. Mighty in magic, all-conquering in the dance, Promethean in his control over secret knowledge, Haapuani was feared and venerated in the community. *The Sorcerer* shows Haapuani looking uncannily focused, a symbol of hidden power standing upright in a beautifully balanced composition where vertical figures and tree-trunks counter the heavy bend in the deep river of knowledge. But Gauguin the satirist of *Le Sourire*, Gauguin who existed between two worlds and could not quite commit fully to either, could not help subverting the solemnity of this magical, harmonious world by bringing in the dog fox of sensuality to nuzzle the beautiful, idiotic peacock of worldly vanity.

Gauguin, *The Sorcerer*, 1902

Taua Haapuani was the Polynesian equivalent of Meyer de Haan, the European magus who had initiated Gauguin into the arcane texts of Milton, Carlyle, Baudelaire and Balzac, introducing Gauguin to the idea of the initiate as satanic creator.

Haapuani is more openly twinned with de Haan in a painting which is

the pendent to *The Sorcerer*, called *Barbarian Tales*. Three figures sit in a glade. Tohotaua, with her unmistakeable red hair, is the foreground figure, an unspoiled Eve. She looks out at us, seemingly unaware of the two figures behind her. The furthest figure is Meyer de Haan, instantly recognisable from the portrait Gauguin had painted on the back of the door of Marie Poupée's *buvette* in Le Pouldu. De Haan gazes at Tohotaua with the intense malevolence of a magician casting a spell or a curse. Gauguin has dressed de Haan bizarrely to represent his hybrid mosaic of complex knowledge. He wears a Jewish kippah on his head and a missionary Mother Hubbard woman's dress, referencing the sexual fluidity of Balzac's Séraphitus-Séraphita that they had studied together. One hand protruding from an incongruously frilly cuff raises the finger to the mouth in the symbolic gesture of the initiate that Gauguin had already used in the earlier portrait of de Haan. His foot poking out from beneath the Mother Hubbard is an elongated animal's claw, the foot of a *tupapau*. Staring intensely and threateningly at Tohotaua, he appears to embody the synthetic construct of Western civilisation that has led to the corruption of 'the simple beings in a virgin nature which might be the human idea of paradise'.[1] Between the de Haan devil and the threatened girl sits Haapuani the *taua* in the pose of the Buddha that we have already seen behind Tohotaua in the photograph of her in the studio. Haapuani's magic powers act as the shield protecting the indigenous girl and by implication her people, against the evils of Western influence.

Gauguin and Tohotaua would have occasional sex when they felt inclined, but neither was in any danger of a death spell from Haapuani. 'If I have a friend and he temporarily desires my wife, Toho, I am glad if she is willing. But my enemy shall not have that privilege with my consent,' he said when interviewed on whether Gauguin and Tohotaua had been lovers.[2]

Gauguin was comfortable within the community, and as prosperous and secure as he had ever been since becoming an artist. He painted prolifically during the first eight months of 1902, producing twenty or more signed and finished pictures celebrating the beauty, grace and harmony he found in the island and its people. Landscapes, mythological subjects, portraits, still lifes

Gauguin, *Barbarian Tales*, 1902

and biblical scenes recall Gauguin's advice to Sérusier that had given birth to the Nabi movement and would blaze yet more brightly in Matisse and the Fauves. 'You see red? Take your best red . . .' Colours were conflagrations. Olive seas lapped cyclamen pink beaches, scarlet palms reached up to purple skies, green and magenta horses frolicked in deep-blue fields, waxy white flowers bordered glossy black rivers, jungles of emerald and lime swayed above musky mauve earth.

The day began at dawn with a bathe in the stream followed by a long morning's painting. Gauguin imposed only one rule in the house: lunch must be ready at eleven o'clock precisely. The cook, Kahui, who was Tohotaua's adoptive father, did not have a demanding job. Ben Varney's meticulous book-keeping attests to Gauguin's continuing preference for the food that sabotaged his health. Endless tins are involved. Tinned butter, beef, asparagus, anchovies, beans, peas, rice, sardines, sausages, tomato sauce, the horror of tinned tripe and other varieties of meats. Mountains of sugar, barrels of red wine, rum and absinthe. Occasionally Gauguin would go down to the shore with his gun to shoot seabirds for fresh meat, but daggered rocks and boisterous waters made coastal fishing impossible for a man no longer young nor fit. When locals arrived to share a meal, they would bring fresh fish and fresh vegetables which he loved to eat. Otherwise, within this island of abundance, he lived on convenience foods. If he had no guests, he would ask Kahui to place all the pots and pans of reheated tinned food on the table and he would share out the food in three parts: one share for himself, one share for Kahui and the gardener, one share for his dog Pego, and his cat.

Parties no longer mattered. They had dwindled to casual hospitality. He kept close company with a few who were precious to him. Foremost, his name-brother Tioka, who assigned godlike power to Gauguin the artist by naming him 'the man who makes men', a hierarchical title linking Gauguin to Tioka's own ancient pre-Christian belief attributing a binding power to the exact invocation of a name. Ky Dong was easy company. Each recognised in the other a fellow spirit: a polished, secretive outsider who treated the world with princely carelessness. The two of them shared libertarian political views and a well-honed sense of irony. But principally it was a time for himself, a time of painting.

THE BAREFOOT LAWYER

The agreement with Vollard was being honoured on both sides. Paintings and money sped across the Pacific Ocean in both directions. When, in July, Vollard had sold a bunch of paintings and sent him 3,000 francs, Gauguin felt so prosperous that he even talked of saving.

Fortunately, none of his paintings were on board the *Croix du Sud* when it sank in the Tuamotus. The sinking meant that contact with the outside world stopped completely for eighty-five days. Cut off from exchanges with Paris between May and August, anxiety ballooned. His health had been good throughout the year but around September his previous troubles returned. His eyesight was deteriorating and the sores on his legs were growing wider and deeper. He bandaged his legs every day, but he did not give up his daily afternoon walk around the village, where he enjoyed keeping up with the local gossip. He needed the support of a walking stick and he carved himself one with a rounded top in the shape of a penis. It roused the clergy and the gendarmes to impotent fury, and this made him, and the locals, laugh.

One afternoon, stopping in a clearing to sit on a rock and enjoy a cigarette, he heard a rustling in the bushes. Out of the undergrowth slowly emerged a greeny-blue creature the size of a human, and the shape of a toad. Dragging itself along almost on all fours, with the aid of a stick, it recalled one of the creatures from the pantheon of Polynesian ghosts and spirits, a *tupapau* emerging from the dark forest to destroy the unwary. Gauguin froze in superstitious fear. The creature approached him with a queer, staggering gait. When it got close enough, he grabbed its stick and tried to shout a fierce 'Whoo' to scare it away but only a feeble sigh came out of his frightened mouth. At close quarters he could see that if this was a *tupapau*, she had taken the shape of an aged human woman, all hunger and sores, so emaciated that with every step the thrust of her bones rearranged the slack folds of her greenish skin. Every inch of her was covered with blurring, faded tattoos. The artist in him was fascinated. She put her hand up to his face. Her touch was repellent, reptilian and dusty, but he stood still as her dry, cold hand slithered down his body, investigated his nipples, moved to his navel, pushed away the *pareu*, forcefully fumbled beneath the fabric, found his penis, and explored it. 'Pupa!' (European) she spat in disgust on failing to feel

351

the pleasure-inducing ridge of raised flesh caused by supercision. Dropping his penis, she shuffled off through the clearing.

When he got back to the village, they told him that she was both mad and blind. She lived in the bush and refused to wear clothes. Whatever she was given she tore to pieces, but she knew two things: she was aware of the hours of day and night, and she knew how to weave garlands. Like Ophelia, she dressed herself in flowery remembrances.

For two months after this, she remained a haunting vision he could not get out of his head. It gave, he said, a ferocious sharpness to his subsequent pictures, countering the natural sweetness of the island, the *noa noa*.[3]

His ramshackle frame was aching. As his legs deteriorated further, he had to give up on his afternoon walks, and so he bought a horse to ride. When riding became too uncomfortable, he bought a cart for the horse to draw.

The island of Hiva Oa was now without a doctor because 'that stupid machine they call colonial administration'[4] had sent Doctor Buisson to look after another island. Ky Dong did his best to help Gauguin but he had always been far more interested in politics and literature than medicine.

One day, as Gauguin was sitting on the steps of the Maison du Jouir bandaging his suppurating legs, the Protestant pastor came by and stopped to help him. Paul-Louis Vernier was thirty-two, a well-educated man who had qualified in theology in Paris and medicine in Edinburgh before coming to Polynesia as a missionary in 1899. He had until now avoided Gauguin's acquaintance. As shepherd of the little flock that worshipped in the lesser church on the outskirts of the village, he could not approve of the Maison du Jouir.

When Vernier had finished dressing his legs, Gauguin offered him a painting, but Vernier answered, 'No. Our friendship is enough.' And friendship did quickly spring up between the two isolated men, both of whom cared deeply for the people and the place, and both of whom were hungry for decent conversation on theology, literature and art. They discovered a shared goal in helping the people free themselves from colonial exploitation and religious imposition. Vernier, like Gauguin, was driven by the question of how to innovate without giving up the important influence of the past. He did not see it as his religious mission to destroy the islanders' heritage, but rather to enlarge their religious capacity by adding to it an understanding of his own religion,

which, his faith gave him certainty, would lead to their voluntary conversion. His softer attitude towards religious syncretism chimed well with Gauguin.

Vernier had started up a little day school in Atuona which was currently educating sixteen girls and twenty-four boys. Unlike Bishop Martin's Catholic school, Vernier's school did not imprison its pupils behind high walls but worked co-operatively with the children's families. He was beloved for this, and further beloved for his medical work. Vernier appreciated how kind and respectful Gauguin was to the locals and how they returned his kindness. 'He had a real cult for the country here,' Vernier wrote, 'for this nature so wild and beautiful in itself, where his soul found its natural frame. He was able to discover almost instantly the poetry of these regions, blest by the sun, parts of which are still inviolate . . . The Maori soul was not mysterious for him, though Gauguin felt that they were daily losing a part of their originality.'[5]

Their friendship was deepened by the fact that Gauguin's name-brother Tioka was deacon in Vernier's church. A further bond was that both men were writing serious religious works. Vernier was working on translating Saint Matthew's Gospel into Marquesan, and Gauguin was still adding to *L'Esprit moderne et le catholicisme*, his exploration of religion and philosophy. A hint of their long-vanished intellectual exchanges remains in the fact that Gauguin lent Vernier the copy of Mallarmé's *L'Après-midi d'un faune* that Mallarmé himself had given Gauguin, and that he gave Vernier a copy of the etching he had made of Mallarmé with Poe's raven whispering into his ear.

Bastille Day on 14 July was celebrated in the French colonies as vigorously as in the mother country. Islanders paddled in from the smaller islands to Hiva Oa for days of feasting and competitions of Western-style singing and approved styles of dancing. Gauguin found himself in the unexpected position of having been elected judge of the singing competition between the Catholic and the Protestant church choirs, who warbled against each other in a very unchristian spirit of rivalry. He exercised rare tact by splitting the prize between both: the Catholics for a hymn to Joan of Arc, the Protestants for a rousing rendition of 'The Marseillaise', the French national anthem.

The sinking of the *Croix du Sud* in May had unsettled him. It demonstrated how very fragile his survival as an artist was while he remained here. He wrote to de Monfreid that he was thinking of returning to Europe.

'I am ready to go to Spain to find new subjects. The bulls, the Spaniards, their hair plastered with lard, all that has been done, overdone, but I see them differently.'[6]

De Monfreid wrote back hastily, warning strongly against return. 'You are currently seen as that legendary, unforgettable artist who from the depths of Oceania is sending works that are bewildering and unique, works characteristic of a great man who has supposedly disappeared from the world . . . Simply stated, you are blessed with the immunity of the dead and famous, you have passed into art history.'[7]

In his heart of hearts, a return to Europe had never been a serious idea. He doubted his health was sufficiently robust to withstand the voyage. Besides, his soul belonged here in the anguished pastoral that he had dedicated himself to defend, much to the exasperation of the gendarmes, who reported back to the authorities in Papeete that though Gauguin could hardly walk, he still managed, with the aid of his obscenely carved walking stick, to get down to the informal local parliament on the beach.

Following his liberation of the schoolchildren, Gauguin was seen as the people's representative. They went to him for justice. In 1902, the land registry system was reformed, leading to Alice-in-Wonderland-style edicts decreeing that even people who had lived for ever in one place had no right to stay there unless they could produce title deeds. He must have become renowned for helping the people in Hiva Oa with the associated paperwork, for he received a letter from a lady in Tahuata, the smallest of the Marquesan islands, who wrote to him in Marquesan, asking for help establishing ownership of her land. She had never had a title deed, and the gendarme was demanding she produce one.[8]

He gathered up a bunch of grievances in a long letter to the Inspector of the Colonies analysing the evils he saw in the running of the colony.[9] He named names, detailed examples of financial corruption, and demonstrated the link to unequal administration of justice. He described how, when the magistrate arrived on the island, about once every eighteen months, he was in a tearing hurry, due to the build-up of cases to be settled. The magistrate would be briefed by the gendarme who had brought the charge. The magistrate would look no further than the gendarme's report. He would investigate

nothing, learn nothing from the people of the island. Seeing before him a tattooed face, the magistrate would assume he was a cannibal and a brigand. The most common charges were drinking, or singing, or dancing, for which the fine would be a hundred francs or more. Until recently, the gendarmes had been awarded one third of all fines levied. The percentage had recently been lowered but this only meant that they brought a larger number of charges, to make up their fee.

'Is this human? Is this moral?' Gauguin's letter demanded, going on to recommend that the Inspectors enquire widely and diligently into the cases they were sent to investigate and that, to ensure that the gendarmes were acting within the law, the regulations governing their legitimate conduct be nailed up on the wall of the courthouse. Any breach of regulations should be punished. Any refraction should quash a resulting sentence.

The letter ended with his now usual flourish castigating 'the hypocritical proclamation of Liberty, Equality, Fraternity under the French flag [which] takes on a singular irony with respect to men who are no more than tax fodder in the hands of a despotic gendarme'.[10]

He wrote to the head of the gendarmerie in Papeete pointing out the illegal behaviour of Gendarme Charpillet, who treated the prisoners in the gaol as his personal servants, making them grow his vegetables, chop his wood, and perform domestic tasks. When the gaol was empty and there were no prisoners, he made the gaoler do the same. A couple of months later, Charpillet was quietly moved to another island. His place was taken by Gendarme Claverie. This did not promise well; Gauguin and Claverie had already crossed swords in Tahiti.

Soon after Claverie's arrival, on 2 January, a great storm announced itself. Leaden light dimmed the sky. The earth lurched to and fro. Palm trees bent double, screaming in the wind.

> God, whom I have so often offended, has spared me this time: at the moment when I am writing these lines a quite exceptional storm has just been making the most terrible ravages. In the afternoon, the day before yesterday the weather, which had been gathering for several days, took on threatening proportions. By eight in the evening, it was a storm. Alone

in my hut, I expected each instant to see it collapse: the enormous trees which, in the tropics, have few roots, and those in a soil that has no resistance to wind when it is wet, were cracking on all sides and falling to the ground with a heavy thud, especially the *maiores*, the breadfruit trees, the wood of which is very brittle. The gusts shook the light roofing of coconut palm leaves and, rushing in from all sides, prevented me from keeping the lamp burning. My house destroyed, with all the drawings and materials I had collected for twenty years. I was ruined. Towards ten o'clock a continuous noise, like the crumbling of a stone building, caught my attention. I could endure it no longer and went outside; at once my feet were in water.

By the pale light of the moon, just risen, I could see that I was in the midst of nothing more nor less than a torrent which, sweeping the pebbles along with it, was dashing against the wooden pillars of my house. There was nothing for me to do but await the decisions of Providence and resign myself. The night was long.

The moment dawn broke I stuck my nose outside. What a strange spectacle, this sea of water, these granite rocks, these enormous trees coming from who knows where. The road in front of my house had been cut in two sections: I found myself shut up on an island. The Devil would have been better off in a basin of holy water.

I must tell you that what they call the valley of Atuona is a gorge, very narrow in certain spots where the mountain forms a wall. In similar cases, all the waters of the upper plateaux come down in an almost perpendicular torrent. The administration, as usual with little wisdom, had done just the opposite of what it should have done. Instead of facilitating the flow of water, it did just the opposite by shutting them off on all sides with piles of stones. Moreover, along the banks, even in the middle of the stream, it has allowed trees to grow, which are naturally overthrown by the torrent and become instruments of destruction, sweeping everything before them on their way. The houses in these warm and poor countries are lightly built and a mere nothing turns them upside down: they become agents of disaster . . ."[11]

Atuona was devastated, a child was killed, and not a tree was left standing. The trees ripped from the ground were the vital supply of shelter, building materials and food. Replacement coconut and banana palms, mango and breadfruit trees would take years to grow to cropping stage; meanwhile, there would be extreme hardship and malnourishment. Now was the time for the French authorities to use some of the taxes they collected so assiduously, to help rebuild the colony.

A few well-built houses like Gauguin's and Ben Varney's raised their shoulders above a swimming sea of sticky, salty mud, jumbled with boulders and clogged with the debris of broken trees and smashed houses. Gauguin waded across the receding waters to Gendarme Claverie, to ask him to cancel, or at least to delay, the ten days of road mending that had been scheduled for the men. First give them time to repair their houses and their lives, he pleaded. Claverie refused. There was a programme of public works to be carried out, and timetables must be adhered to. And so, the pitiable men slaved to repair roads, while surrounded by the wrecked remains of their homes. Gauguin's name-brother Tioka lost his hut. His plot of land was a couple of metres below Gauguin's, which made it more vulnerable to flooding. Gauguin gave Tioka a piece of his own land where he built a new home and planted a garden. But this was a small, individual gesture within the context of the island and its people. 'Where is the money?' Gauguin fretted. 'If they would only let us, humble colonists, manage our affairs and use the money for useful works, instead of maintaining all these insolent, mediocre officials. They would see then what a little colony can become.'[12]

In February, a judge visited the island to hear the trial of a group of twenty-nine men accused of drunkenness. Gauguin arrived in court to argue in their defence. Limping, looking ill, he was dressed in his usual outfit: a scruffy shirt over a *pareu*. Judge Horville expelled him from the court for contempt and told him not to come back until he was properly dressed. By the time he had put on his trousers, the case had been heard and the men found guilty. He vowed to appeal on their behalf.

Since his arrival in Hiva Oa, the gendarmes reporting back to Papeete had

repeatedly complained about him. He was a defender of 'native vices', a man who from the start had made it his business to set the indigenes against the authorities, a subverter of the rule of law and a dangerous anarchist. Governor Petit's exasperation had reached its limit. When Gendarme Claverie applied to him for permission to prosecute Gauguin should the occasion arise, permission was granted. It would only be a matter of time.

Gauguin's long-drawn-out fight against injustice was taking its toll on his health. On the occasion he had been thrown out of court for wearing a *pareu* to defend the drinkers, he had vomited blood again. His legs were so painful that he was spending most of his time in bed. He had been injecting himself with morphine against the pain for some time. Frightened that he would overdose himself, he gave his syringe to Ben Varney for safekeeping. Ky Dong, who saw the state of his buttocks, described them as black with bruises from injections.

His eyesight was deteriorating, and even though he got a pair of spectacles, they did not help much. He was in terror of going blind. The laudanum he was also taking for the pain was making him sleepy. He was painting little. He knew he was painting badly. By day he lay in bed wrestling with God, adding to the long manuscript *L'Église catholique et les temps modernes*. Since arriving in Hiva Oa, he had already set down his thoughts on art and art criticism in an extended essay *Racontars de rapin* (*Ramblings of an Apprentice Artist*),[13] and had sent it off to André Fontainas, the art critic of the *Mercure de France*, the periodical that focused on the authors, artists and critics of the Symbolist movement. Fontainas had rejected the essay, but Gauguin was determined that his thoughts be known. He wrote a stream-of-consciousness autobiography, *Avant et après* (*Before and After*). Part reminiscence, part wish, part fantasy, part self-mockery, part mockery of the world, the 213-page manuscript of thoughts and reminiscences was preoccupied with memories of childhood, of his beloved mother, of Van Gogh, of the execution of Prado, and of the painters who had gone before him whose line he was proud to extend. He wrote humorous and scabrous anecdotes, mocked hypocritical priests and the injustice of colonial rule. It is a tough, defiant and optimistic text, finding interest, humour and ridicule in the human condition. He only admits a rare chink of pessimism when he

laments the fate of the island peoples, the fragility of whose Edenic existence is vanishing before his eyes. He knows he is witness to the defeat of the whole natural world by 'civilisation' but he does not succumb to sentimentality in describing it. Instead, he makes this deeply felt and melancholy point through brusque observation: 'Soon a Marquesan will be incapable of climbing a coconut tree . . . They are all beginning to wear shoes and their feet, by now fragile, will not be able to run over the rough paths and cross the torrents on stones. Thus we are witnessing the sad spectacle that is the extinction of the race, a large part of which is tubercular, with barren loins and ovaries destroyed by mercury.'[14]

When the light of day had faded and he could no longer see the paper to write, Gauguin would get up to sit at his harmonium, playing into the dark. Ky Dong was sad to see his friend Gauguin depressed, spending long days peering through his spectacles to write down obsessive thoughts and seeming to have given up on making pictures. Ky Dong was no artist, but one day he took up a position at the easel and started, or pretended to start, to make a portrait of Gauguin.

This had the desired provocative effect of launching him from his bed to grab the brush from Ky Dong, take up a mirror and finish the portrait himself. It was his last self-portrait. Innovative as ever, *Self-Portrait, 1903* looks forward, as well as back. Forward to his own death, back to the Graeco-Roman mummy portraits from Roman Egypt that he had seen decades ago in the Louvre, and that now he was referencing while he forged another link in the chain. He portrayed himself to the funerary formula: full face, limited colour palette, short Roman haircut, antique tunic, exaggerated highlights on forehead, cheek and throat. His temples are grizzled; his eyes behind the wire-rimmed spectacles are thoughtful and calm, as though fixed on another world. He gave the picture to Ky Dong.[15]

In March 1903, news reached Gauguin of another abuse of power by a gendarme, that he felt he needed to bring to the attention of the authorities.

Étienne Guichenay, the gendarme of the nearby island of Tahuata, had been accepting bribes to turn a blind eye to goods coming ashore from American whaling boats without paying customs duties. Gauguin requested an investigation. This was Gendarme Claverie's chance. Longing to muzzle

the troublesome artist, he applied to Papeete for permission to take legal action. The governor assented. On 27 March, Gauguin was served with a summons to appear in court four days later, on the charge of libel of a police officer. On 31 March, the case was heard by his old enemy Judge Horville, who found him guilty and sentenced him to three months in prison and a 500-franc fine.

'I have been trapped by the police and I have been found guilty.'[16]

Gauguin did not have the money to pay the fine. He knew his health would never survive prison. Two days after the trial, a messenger entered the schoolroom where Pastor Vernier was teaching, to hand him a note.[17]

Dear Monsieur Vernier,
 Would it be troubling you too much to ask you to come to see me. My eyesight seems to be going and I cannot walk. I am very ill.
 PG

Vernier could do little but change his bandages and advise against too much laudanum, but the pain had become more than Gauguin could bear and he begged Ben Varney to give him back his little glass bottles of morphine and his syringe. They revived him sufficiently to write a letter of appeal to the court authorities.

Given his desperate physical state, it is rather marvellous that his letter to 'the insolent scoundrel' Claverie challenges him to fight a duel to defend his honour. Characteristically vigorous in tone, mixing the violent and the absurd, the grotesque and the romantic, the ironical and the compassionate, Gauguin finally points out that 'these poor defenceless people' have no one but himself to defend them, while 'animals at least have a society to protect them'.[18]

Barely a year after he wrote this letter, his appeal would be examined by the administrator of the Marquesas who would admit that Gauguin's accusations were justified. But by that time, it was too late. Gauguin would be dead and Claverie would have been promoted to the rank of sergeant.

Following this great epistolary effort, Gauguin shut himself up in his room and was not seen for a week.

Gauguin, *Self-Portrait*, 1903

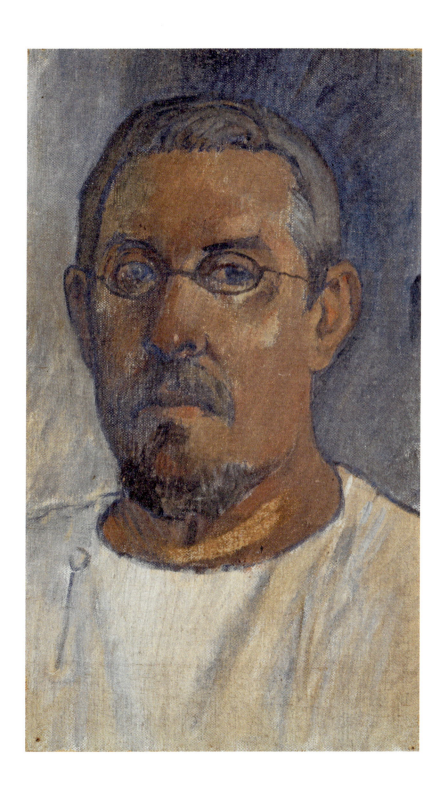

On 8 May, he once more sent for Pastor Vernier. Evidently blind, Gauguin asked Vernier whether it was day or night. He complained of pains all over. Soon bored of the dreary subject of his health, he abruptly switched to talking about Flaubert's novel *Salammbô*, a dreamy, symbolist, oriental reverie set in the days following the First Punic War. Reassured by his friend's reassumption of alert interest in the tangled skein of ideas, Vernier felt free to return to his classroom obligations.

Gauguin's name-brother Tioka always called out a greeting to Gauguin as he passed the Maison du Jouir. Later that day, receiving no reply to his greeting, Tioka climbed the stairs.

Beneath the jolly display of Port Said postcards, Gauguin lay on the very edge of the bed as though interrupted in the act of trying to get up. One leg was hanging down, reaching towards the floor.

'Koké, Koké,' cried Tioka, and ran to fetch Vernier.

They returned together. The traditional way of discovering if a person was still alive was to bite the skin of the forehead at the hairline. If no blood rose to pearl in the teeth marks, life was extinct. Tioka bent over the prone body and bit. The depressions remained white and bloodless.

The news of the artist's death quickly spread, bringing Bishop Martin to step for the first time between the two mocking tikis representing himself and Thérèse, to climb the wooden stair between the two naked maidens, and to enter the studio beneath the provocative words *Maison du Jouir*. Looking to his left, he saw the body on the bed. The dead man was, or had once been, a Catholic. He would reclaim him, body and soul, for the Catholic Church. In a final act of revenge in the long-running duel between the two men, Bishop Martin pronounced a conditional absolution over Gauguin's corpse.

That evening, Pastor Vernier and Tioka discussed what they should do next. Burial happens quickly in the tropics. They decided to bury him without a religious ceremony in the common cemetery the next morning at eight o'clock, but when the two friends arrived to take him there, the body had gone. Gauguin's fate after death mirrored the fate of the Christ with whom he had so often identified in life. Just as Jesus's body had vanished from the tomb, so Gauguin's had vanished from his house.

Bishop Martin, that stealer of souls, had snatched his body and quickly buried it in the Catholic cemetery on the hill above Atuona. Here in his grave, Gauguin would enjoy the view he had so loved on his evening walks around the island. This was the best place to watch the sun go down. Now, sunset after sunset would spread its colours before him until the end of time.

Bishop Martin himself had several years to rejoice in the anticipatory satisfaction that his own tomb was to be exactly two grave-rows uphill from the hated painter. He would have the joy of looking down upon his enemy throughout eternity.

But Gauguin had the last laugh. As he wished, his statue of *Oviri*, the Polynesian goddess of mourning and death, was eventually placed upon his tomb, leaving the high-up bishop forever doomed to gaze down upon her naked back and buttocks. She stands there to this day.[19]

'The only noteworthy event', Bishop Martin reported to the authorities, 'has been the sudden death of a contemptible individual named Gauguin, a reputed artist but an enemy of God and everything that is decent.'[20]

The official administrator in charge of selling the contents of the Maison du Jouir wrote, 'I have requested the creditors of the deceased to submit duplicate statements of their accounts but am already convinced that the liabilities will considerably exceed the assets, as the few pictures by the late painter, who belonged to the decadent school, have little prospect of finding purchasers.'[21]

You wish to teach me what is within myself: learn first what is within you. You have solved the problem, I could not solve it for you. It is the task of all of us to solve it.

Toil without end; otherwise, what would life be?

We are what we have been since always; and we are what we shall always be, a ship tossed about by every wind.

Shrewd, far-sighted sailors avoid dangers to which others succumb, partly, however, thanks to an indefinable something that permits one to live under the same circumstances in which another, acting in the same manner, would die.

Some use their wills, the rest resign themselves without a struggle.

I believe life has no meaning unless one lives it with a will, at least to the limit of one's will. Virtue, good, evil, are nothing but words, unless one takes them apart in order to build something with them; they do not gain their true meaning until one knows how to apply them. To surrender oneself to the hands of one's creator is to cancel oneself out and to die.

 Paul Gauguin, *Avant et après*, Atuona, 1903

ACKNOWLEDGEMENTS

In 2020, through the UK government's Acceptance in Lieu scheme, administered by the Arts Council, the Courtauld Institute acquired Paul Gauguin's most important manuscript, *Avant et après*. It is not published as a printed book but online in the original French with a parallel text in English, translated by Dr Ketty Gottardo, Rachel Hapoienu and Rachel Sloan. I would like to extend my heartfelt thanks to all three, and to the Courtauld Gallery and Institute for kindly permitting me to quote freely from their translation of the text.

In 2021, the Wildenstein Plattner Institute published the second and final part of the catalogue raisonné of Gauguin's works. It is a remarkable resource. In view of how frequently artworks change hands, I have not given the location of the paintings in my book. An up-to-date way of discovering the location or owner of any painting is to consult the catalogue raisonné, which is constantly updated.

I would like to thank so many people for all sorts of generosity. For conversations, scholarly exchanges, books, lectures, colloquia, conferences, food, drink, technical help, editorial help, provocation and inspiration. Listed in no apparent order – how do you prioritise the sparks that light the fires in the brain? Mette Gauguin, great-granddaughter of Paul Gauguin, fantastically generous with her knowledge, sharing family legends, private papers, contacts, knowledge and insights. Christopher Riopelle, the Neil Westreich curator of post-1800 paintings at the National Gallery, London. Mary-Anne Stevens, director of academic affairs, Royal Academy of Arts, London, and secretary to the Royal Academy (retired), inspired curator of many shows including *After Impressionism: Inventing Modern Art*, 2023, at London's National Gallery. Profound thanks to Caroline Boyle-Turner, omniscient on Gauguin in Polynesia, Le Pouldu and Pont-Aven, who shared her knowledge

ACKNOWLEDGEMENTS

as freely and graciously as her hospitality, together with her husband Hank Turner, who photographed the teeth and most generously gave me permission to use the picture. Thank you Dr John Kilborn and Jan, both of whom have long taken an interest in Gauguin's health, who have shared their work with me, and have provided an invaluable channel to the descendants of Pastor Paul Vernier, Gauguin's doctor, priest and friend throughout his last years.

Thanks, too, to Dr Ernst Vegelin, Head of the Courtauld Gallery, London, and his immensely helpful team. I have learned much from Gauguin scholars Elizabeth C. Childs, Flemming Friborg, Linda Goddard, Cornelia Homburg, Nicholas Thomas, Belinda Thompson and many more. Thank you Martin Bailey for long-time support, and for writing enlightening books and eye-opening 'Adventures with van Gogh' in the *Art Newspaper*. Thank you Waldemar Januszczak for sparking sometimes alarming *tupapaus* in the brain through your writing. Thank you Georgia, Mary and Laura Sanderson for design and technical help. Thank you David Bond and Ruth Killick for dynamic insights and steadying support. Thank you John Prideaux for resolving a fruit salad of problems. Thanks to the staff of many libraries, notably the London Library.

At Faber, my warmest thanks to Laura Hassan, knife-sharp editor, encourager and friend. Thank you Sara Cheraghlou and Jess Kim, Lily Levinson for emergency rescue from a deplorable tech crisis, Sam Matthews for meticulous copy-editing and fact-checking, Sarah Ereira for indexing, Sarah Stoll and Lauren Nicoll. Special thanks to Henry Petrides for designing the brilliant cover. Thank you Amanda Russell for pictures, Sara Talbot, and Kate Ward for pulling together the overall design.

In the USA thanks to John Glusman and Helen Thomaides at W. W. Norton, and to George Lucas at Inkwell Management.

Special thanks to Catherine Clarke at FBA who took over as my agent after the death of my beloved agent Felicity Bryan, to whose memory I have dedicated this book. Thank you Michele Topham and all the team at FBA for your unfailing professionalism and unstinting support.

My greatest thanks as always go to my husband Michael, editor of first resort and a genius at organising research trips.

SELECT BIBLIOGRAPHY

PAUL GAUGUIN'S WRITINGS

Ancien culte mahorie (ms 1893), facsimile, ed. Nathalie Bailleux, Bérénice Geoffroy-Schneiter, Gallimard, 2017.
Avant et après (ms 1903), online original and translation by Ketty Gottardo, Rachel Hapoienu and Rachel Sloan, Courtauld Gallery, 2021.
Cahier pour Aline (ms 1892–4), facsimile, ed. Suzanne Damiron, Société des Amis de la Bibliothèque d'Art et d'Archéologie de l'Université de Paris, 1963.
Diverses choses (ms 1896–8), Cabinet des Dessins, Musée du Louvre, RF7259.
L'Église catholique et les temps modernes, ed. Othon Printz, Jérôme Do Bentzinger, 2015.
Noa Noa (ms 1893–7), trans. Jonathan Griffin, Pallas Athene, 2010.
'Notes sur l'art à l'Exposition universelle I–II', *Le Moderniste illustré*, nos. 11 and 12, 4 and 11 July 1889.
Notes synthétiques, first published in *Vers et proses*, 1910, included in *Paul Gauguin: Écrits sur l'art*, ed. Frédéric Chaleil, Les Editions de Paris, 2017.
Racontars de rapin (ms 1902–3), ed. Bertrand Leclair, Mercure de France, 2003.

CATALOGUES RAISONNÉS

Brettell, Richard R., and Elpida Vouitsis, *Gauguin: Catalogue Raisonné of the Paintings, 1891–1903*, Wildenstein Plattner Institute (online publication), 2023.
Wildenstein, Daniel, *Gauguin: A Savage in the Making: Catalogue Raisonné of the Paintings (1873–1888)* (2 vols), Wildenstein Institute and Skira/Seuil, 2002.

LETTERS

The Letters of Paul Gauguin to Georges Daniel de Monfreid, trans. Ruth Pielkovo, Dodd, Mead and Company, 1922.
Paul Gauguin: Letters to His Wife and Friends, ed. Maurice Malingue, trans. Henry J. Stenning, MFA Publications, 1946 (repr. 2003).
Paul Gauguin et Vincent van Gogh, 1887–1888: Lettres retrouvées, sources ignorés, ed. Victor Merlhès, Éditions Avant et Après, 1989.

SELECT BIBLIOGRAPHY

Vincent van Gogh: The Letters, ed. Leo Jansen, Hans Luitjen and Nienke Bakker, trans. (Dutch) Lynne Richards, John Rudge and Dianne Webb, and (French) Sue Dyson and Imogen Forster, Thames and Hudson, 2009.

BIBLIOGRAPHY

Aurier, Albert, 'Le Symbolisme en peinture: Paul Gauguin', *Mercure de France*, March 1891.
Bailey, Martin, *The Sunflowers Are Mine*, White Lion, 2013.
——, *The Studio of the South: Van Gogh in Provence*, Frances Lincoln, 2016.
Balzac, Honoré de, *Seraphita*, trans. Katharine Prescott Wormeley, Dodo Press, 2004.
Baudelaire, Charles, 'Richard Wagner et *Tannhäuser* à Paris (1861)', 'Critiques littéraires' in *L'Art romantique*, vol. 1 of *Œuvres complètes de Charles Baudelaire*, 8 vols, ed. Jacques Crépet, Louis Conard, 1925.
——, *The Painter of Modern Life*, trans. P. E. Charvet, Penguin, 2010.
Bodelsen, Merete, *Gauguin og van Gogh i København i 1893*, Ordrupgaard, 1984.
Boyle-Turner, Caroline, *Paul Sérusier: Studies in the Avant-Garde*, UMI Research Press, 1983.
——, *Paul Gauguin and the Marquesas: Paradise Found?*, Éditions Vagamundo, 2016.
——, *Paul Sérusier: Legends and Spells*, Réunion des Musées Nationaux, 2018.
Brettell, Richard R., and Anne-Brigitte Fonsmark, *Gauguin and Impressionism*, Yale University Press, 2005.
Carlyle, Thomas, *Sartor Resartus*, first published as a serial in *Fraser's Magazine*, 1833–4.
Childs, Elisabeth C., *Vanishing Paradise: Art and Exoticism in Colonial Tahiti*, University of California Press, 2013.
Cook, James, *The Three Voyages of Captain Cook round the World*, vol. 1, Longman, Hurst, Reese, Orme and Brown, 1821.
Danielsson, Bengt, *Love in the South Seas*, trans. F. H. Lyon, George Allen and Unwin, 1956.
——, *Gauguin in the South Seas*, trans. Reginald Spink, George Allen and Unwin, 1965.
Denekamp, Nienke, *The Gauguin Atlas*, trans. Laura Watkinson, Yale University Press, 2019.
Dorra, Henri, *The Symbolism of Paul Gauguin*, University of California Press, 2007.
Dupanloup, Félix, *Où allons-nous?* Douniol, 1876.
——, *Evangiles de toute l'année, traduits en français, avec des notes littérales pour en faciliter l'intelligence: À l'usage des catéchismes, des maisons d'éducation et des écoles chrétiennes*, Rocher, 1877.
Eisenman, Stephen F., *Gauguin's Skirt*, Thames and Hudson, 1997.
——, ed., *Paul Gauguin: Artist of Myth and Dream*, Skira, 2007.
Fénéon, Félix, *Œuvres plus que complètes*, 2 vols, ed. Joan U. Halperin, Librairie Droz, 1970.
Figura, Starr, *Gauguin: Metamorphoses*, Museum of Modern Art, 2014.
Figura, Starr, Isabelle Cahn and Philippe Peltier, *Félix Fénéon: The Anarchist and the Avant-Garde*, Museum of Modern Art, 2020.
Friborg, Flemming, *Gauguin: The Master, the Monster and the Myth*, Strandberg, 2023.

SELECT BIBLIOGRAPHY

Gattey, Charles Neilson, *Gauguin's Astonishing Grandmother*, Femina, 1970.
Gauguin, Aline Maria, *Noen erindringer fra mine barneår i Frankrike, 1924–1928* (unpublished typescript kindly shared with Sue Prideaux by Mette Gauguin).
Gauguin, Pola, *My Father, Paul Gauguin*, trans. Arthur G. Chater, Cassell, 1937.
——, *Mette og Paul Gauguin*, Gyldendal, Nordisk Forlag, 1956.
Gayford, Martin, *The Yellow House: Van Gogh, Gauguin and Nine Turbulent Weeks in Arles*, Penguin, 2007.
Goddard, Linda, *Savage Tales: The Writings of Paul Gauguin*, Yale University Press, 2019.
Hien V. Ho, 'Revolutionaries in Politics and in Art: The Marvelous Child and the Old Painter: The Stories of Ky Đong and Gauguin', https://www.advite.com/TheStoriesofKyDongandGauguin.htm, 2 Dec. 2009.
Homburg, Cornelia, and Christopher Riopelle, *Gauguin: Portraits*, 2019.
Horne, Alastair, *Seven Ages of Paris: Portrait of a City*, Macmillan, 2002.
House, John, and Mary Anne Stevens, eds, *Post-Impressionism: Cross-Currents in European Painting*, Weidenfeld and Nicolson, 1979.
Huysmans, J.-K., *L'Art moderne*, Charpentier, 1883.
——, *À rebours*, Charpentier, 1884.
Januszczak, Waldemar (dir.), *Gauguin: The Full Story* (documentary), 2019.
Kessler, Harry, *Journey to the Abyss: The Diaries of Count Harry Kessler, 1880–1918*, ed. Laird M. Easton, Knopf, 2011.
Lemoine, Serge, ed., *From Puvis de Chavannes to Matisse and Picasso: Toward Modern Art*, Thames and Hudson, 2002.
Loti, Pierre, *The Marriage of Loti (Rarahu)*, trans. Clara Bell, T. Werner Laurie, 1925.
Malingue, Maurice, *La Vie prodigieuse de Paul Gauguin*, Éditions Buchet/Chastel, 1987.
Mallarmé, Stéphane, *L'Après-midi d'un faune*, Derenne, 1896.
——, *Collected Poems and Other Verse with Parallel French Text*, trans. E. H. and A. M. Blackmore, Oxford World Classics, 2008.
Merlhès, Victor, *Paul Gauguin, pages inédites*, Avant et Après, 1995.
Millan, Gordon, *A Throw of the Dice: The Life of Stéphane Mallarmé*, Farrar, Straus and Giroux, 1994.
Morice, Charles, *Paul Gauguin: L'homme et l'artiste*, H. Floury, 1920.
Mowll Mathews, Nancy, *Paul Gauguin: An Erotic Life*, Yale University Press, 2001.
Mueller, William A., and Caroline Boyle-Turner, 'Gauguin's Teeth', *Anthropol*, 6:1, 2018.
Nayeri, Farah, 'Is It Time Gauguin Got Canceled?', *New York Times*, 18 November 2019.
Patry, Sylvie, ed., *Inventing Impressionism: Paul Durand-Ruel and the Modern Art Market*, National Gallery, 2015.
Pissarro, Camille, *Letters to His Son Lucien*, ed. John Rewald, Boston Museum of Fine Arts, 2002.
Poe, Edgar Allan, *The Complete Tales and Poems of Edgar Allan Poe*, Vintage, 1975.
Prideaux, Sue, *Strindberg: A Life*, Yale University Press, 2012.
Renan, Ernest, *La Vie de Jésus*, Michel Lévy Frères, 1863.
Said, Edward W., *Orientalism*, Pantheon, 1978.
Sweetman, David, *Paul Gauguin: A Complete Life*, Hodder and Stoughton, 1995.
Thomson, Belinda, ed., *Gauguin's Vision*, National Galleries of Scotland, 2005.

SELECT BIBLIOGRAPHY

——, *Gauguin: Maker of Myth*, Tate Publishing, 2010.
Tristan, Flora, *Flora Tristan, Utopian Feminist: Her Travel Diaries and Personal Crusade: Selected Writings*, trans. and ed. Doris and Paul Beik, Indiana University Press, 1993.
Van Dijk, Maite, and Joost van der Hoeven, *Gauguin and Laval in Martinique*, Van Gogh Museum/Thoth, 2018.
Vollard, Ambroise, *Souvenirs d'un marchand de tableaux*, Albin Michel, 1937.
Zafran, Eric M., ed., *Gauguin's Nirvana: Painters at Le Pouldu 1899–1900*, Yale University Press, 2001.
Zola, Émile, *The Kill*, trans. Brian Nelson, OUP, 2004.
——, *The Ladies' Paradise*, trans. Brian Nelson, OUP, 2008.
——, *Nana*, trans. Helen Constantine, OUP, 2020.

NOTES

ABBREVIATIONS

CR 1873–1888: Daniel Wildenstein, *Gauguin: A Savage in the Making: Catalogue Raisonné of the Paintings (1873–1888)* (2 vols), Wildenstein Institute and Skira/Seuil, 2002.

CR 1891–1903: Richard R. Brettell and Elpida Vouitsis, *Gauguin: Catalogue Raisonné of the Paintings, 1891–1903*, Wildenstein Plattner Institute (online publication), 2023.

de Monfreid *The Letters of Paul Gauguin to Georges Daniel de Monfreid*, trans. Ruth Pielkovo, Dodd, Mead and Company, 1922.

Malingue: Paul Gauguin, *Letters to His Wife and Friends*, ed. Maurice Malingue, trans. Henry J. Stenning, MFA Publications, 1946 (repr. 2003).

VG Letters: *Vincent van Gogh: The Letters*, ed. Leo Jansen, Hans Luitjen and Nienke Bakker, trans. (Dutch) Lynne Richards, John Rudge and Dianne Webb, and (French) Sue Dyson and Imogen Forster, Thames and Hudson, 2009.

1: REVOLUTIONARY ROAD

1 Paul Gauguin, *Avant et après* (ms 1903), online original and translation by Ketty Gottardo, Rachel Hapoienu and Rachel Sloan, Courtauld Gallery, 2021, p. 84.
2 Charles Neilson Gattey, *Gauguin's Astonishing Grandmother*, Femina Books, 1970, p. 114. The description is by Jules Janin, French writer and critic.
3 Flora Tristan, 'A Visit to the Houses of Parliament', in *Flora Tristan, Utopian Feminist: Her Travel Diaries and Personal Crusade: Selected Writings*, trans. and ed. Doris and Paul Beik, Indiana University Press, 1993, pp. 56–61.
4 Flora Tristan, 'Prostitutes', in *Utopian Feminist*, pp. 70–1.
5 Gauguin, *Avant et après*, p. 85.
6 Gauguin, *Avant et après*, p. 87.
7 Gauguin, *Avant et après*, p. 87.
8 Gauguin, *Avant et après*, p. 86.
9 Gauguin, *Avant et après*, pp. 85–6.
10 Gattey, *Gauguin's Astonishing Grandmother*, p. 76.
11 Tristan, *Utopian Feminist*, pp. 27–33.
12 Gauguin, *Avant et après*, 87.

NOTES

2: 'I AM A SAVAGE FROM PERU'

1. Pola Gauguin, *My Father, Paul Gauguin*, trans. Arthur G. Chater, Cassell, 1937, p. 9.
2. Nancy Mowll Mathews, *Gauguin: An Erotic Life*, Yale University Press, 2001, p. 11.
3. Paul Gauguin, *Avant et après* (ms 1903), online original and translation by Ketty Gottardo, Rachel Hapoienu and Rachel Sloan, Courtauld Gallery, 2021, p. 88.
4. Gauguin, *Avant et après*, p. 193.
5. Paul Gauguin, *Avant et après*, p. 193.
6. Félix Antoine Phillibert Dupanloup (1802–79), author of numerous books including *De l'éducation* (1850), and *De la haute éducation intellectuelle* (1866).
7. Clémence Royer's French translation of Charles Darwin's *On the Origin of Species by Means of Natural Selection* was published in 1862.
8. Dupanloup wrote two books on the subject: *Où allons-nous?*, Douniol, 1876, and *Evangiles de toute l'année, traduits en français, avec des notes littérales pour en faciliter l'intelligence: À l'usage des catéchismes, des maisons d'éducation et des écoles chrétiennes*, Rocher, 1877.

3: THE OUTSIDER

1. The Goncourt brothers, quoted in Alistair Horne, *Seven Ages of Paris*, Macmillan, 2002, p. 273, and Mary McAuliffe, *Paris, City of Dreams: Napoleon III, Baron Haussmann, and the Creation of Paris*, Rowman and Littlefield, 2020, p. 99.
2. David H. Pinkney, *Napoleon III and the Rebuilding of Paris*, Princeton University Press, 1958, pp. 3–24.
3. Quoted in the Introduction by Brian Nelson to Émile Zola, *Nana*, trans. Helen Constantine, OUP, 2020, p. xii.
4. Émile Zola, *The Kill*, trans. Brian Nelson, OUP, 2004, pp. 213, 179.
5. McAuliffe, *Paris, City of Dreams*, p. 135.
6. This description of her by her grandson Pola Gauguin, in *My Father, Paul Gauguin*, trans. Arthur G. Chater, Cassell, 1937, p. 10.
7. Nadar, *Arosa, financier*, Bibliothèque Nationale de France, 1850s.
8. Richard Brettell and Anne-Birgitte Fonsmark, *Gauguin and Impressionism*, Yale University Press, 2005, p. 12.
9. Aline Gauguin's will, Departmental Archives, Hauts-de-Seine.
10. *Catalogue des tableaux modernes composant la collection de M. G. Arosa: dont la vente aura lieu Hôtel Drouot, le lundi 25 février, 1878*, Hôtel Drouot, 1878.
11. Paul Gauguin, *Avant et après* (ms 1903), online original and translation by Ketty Gottardo, Rachel Hapoienu and Rachel Sloan, Courtauld Gallery, 2021, p. 63.
12. Paul Gauguin, *Avant et après*, p. 135.

4: BECOMING

1. Paul Gauguin, *Avant et après* (ms 1903), online original and translation by Ketty Gottardo, Rachel Hapoienu and Rachel Sloan, Courtauld Gallery, 2021, pp. 149–50.
2. Pola Gauguin, *My Father, Paul Gauguin*, trans. Arthur G. Chater, Cassell, 1937, pp. 19–20. This book, written by Gauguin's son Pola, was based on conversations

with Mette and on Gauguin's letters to her, which Mette gave to Pola with the words, 'Read them, and if you think as I do that they explain your father's strong and complex character, you must try to get them known.' Pola tells us this in the other book he wrote about his parents, *Mette og Paul Gauguin*, Gyldendal, Nordisk Forlag, 1956, p. 201. The latter has not been translated into English; the words taken from it are my translation throughout.

3 Prince Napoléon-Joseph-Charles-Paul Bonaparte (1822–91), usually known by his father's name of Jérôme Napoleon. Jérôme Napoleon the elder (1784–1860) was brother to Napoleon I.

4 The cause of Aline's death is not recorded. Mette Gauguin (her great-great-granddaughter) did not know, and she kindly enquired to see if any of the cousins had any idea but no answer came up. Given the historical period and her long and gradual decline, heart disease seems most probable.

5 Gauguin, article in *Les Guêpes*, no. 5, 12 June 1899, quoted in *CR 1873–1888*, vol. 2, p. 573.

6 Though not under Haussmann himself. He had been charged with extravagance and forced to resign.

7 Henry James, *Parisian Sketches*, Collier, 1961, pp. 35–6, quoted in Mary McAuliffe, *Dawn of the Belle Epoque: The Paris of Monet, Zola, Bernhardt, Eiffel, Debussy, Clemenceau, and Their Friends*, Rowman and Littlefield, 2011, p. 60.

8 Archibald S. Hartrick, *A Painter's Pilgrimage through Fifty Years*, Cambridge University Press, 1939, p. 31.

9 *Winter, Spring, Summer* and *Autumn*, signed and dated 1872/3, oil on canvas in four parts, each approx. 55 x 131 centimetres.

10 It is known retrospectively as the first Impressionist exhibition. The group did not take on the title until the third exhibition in 1877 when they adopted the critic Louis Leroy's term of abuse as a badge of honour.

11 Gauguin, *Avant et après*, p. 193.

12 Émile Schuffenecker, 'Paul Gauguin', ms in Getty Center for Art, quoted in *CR 1873–1888*, vol. 1, p. xiii.

13 This is how he described it to his son Pola. See Pola Gauguin, *My Father*, pp. 36–7. Later scholars have placed the meeting chez Arosa. It's a question of later scholarship versus possibly romanticised memories coming down in family legend. Actuality is difficult to discover here.

14 Pola Gauguin, *Mette og Paul Gauguin*, p. 16.

15 For this analysis of Mette's time chez Estrup, see Pola Gauguin, *Mette og Paul Gauguin*, pp. 10–13.

16 This description of their courtship comes from Pola Gauguin's two books *My Father, Paul Gauguin* and *Mette og Paul Gauguin*. Pola writes in the former (p. 37) that his mother was staying *en pension* chez Aubé. This is probably incorrect, but they certainly ate there.

17 Pola Gauguin, *Mette og Paul Gauguin*, p. 105.

18 Pola Gauguin, *Mette og Paul Gauguin*, pp. 105 and 104.

19 Letter of 25 Dec. 1872, in *CR 1873–1888*, vol. 2, p. 574.

20 Wednesday, 29 March; this party took place chez Madame Fouignet.

21 Gauguin to Mette, March 1892, in *CR 1873–1888*, vol. 1, p. xxxi.

NOTES

5: IMPRESSIONISM AND BOURGEOIS BLISS

1 Gauguin to Madame Heegaard (Marie's mother), 25 April 1874 (Malingue 2).
2 Gauguin to Madame Heegaard, 12 Sept. 1874 (Malingue 5).
3 Paul Gauguin, *Avant et après* (ms 1903), online original and translation by Ketty Gottardo, Rachel Hapoienu and Rachel Sloan, Courtauld Gallery, 2021, p. 111.
4 Pola Gauguin, *My Father, Paul Gauguin*, trans. Arthur G. Chater, Cassell, 1937, p. 41.
5 Pola Gauguin, *My Father*, pp. 41–2.
6 To see the paintings and some drawings that survive from this period, see *CR 1873–1888*, vol. 1, pp. 5–49.
7 Precise identification of Gauguin's Salon canvas has so far dodged scholarship. The catalogue describes it as a landscape around Viroflay. There are several Viroflay landscapes of the same date (see *CR 1873–1888*, vol. 1, pp. 5–49).
8 No. 1 Impasse Frémin. The three-year lease on the five-roomed, 480-square-metre corner house, with garden, owned by August Achille Boucard, cost Gauguin 850 francs per quarter.
9 David Sweetman, *Paul Gauguin: A Complete Life*, Hodder and Stoughton, 1995, p. 87; Richard R. Brettell and Anne-Brigitte Fonsmark, *Gauguin and Impressionism*, Yale University Press, 2005, p. 55.
10 Marcel Mirtil to Raymond Cogniat, 13 Oct. 1955, quoted in *CR 1873–1888*, vol. 2, p. 580.
11 A sale in June 1878 records a Monet going for thirty-five francs, a Renoir for thirty-one francs, and two Pissarros for seven francs and ten francs. Sweetman, *Paul Gauguin*, p. 90.
12 Gauguin's collection is listed and described in Brettell and Fonsmark, *Gauguin and Impressionism*, pp. 55–66.
13 Émile Zola for a Russian publication quoted in Charles S. Moffat et al., *The New Painting: Impressionism, 1874–1886*, Fine Arts Museums of San Francisco, 1986. See also Brettell and Fonsmark, *Gauguin and Impressionism*, p. 52.
14 Albert Wolff, quoted in Sweetman, *Paul Gauguin*, p. 80.
15 Edmond Duranty, quoted in Anne Fonsmark, 'Gauguin's Debut as a Sculptor', in Brettell and Fonsmark, *Gauguin and Impressionism*, p. 70.
16 Edmond Renoir, review, *La Presse*, 9 April 1880.
17 Gauguin to Mette, Tahiti, March 1892 (Malingue 127).
18 J.-K. Huysmans, *L'Art moderne*, 1883 (retrospectively published review of the 1881 exhibition), pp. 262–7/8.
19 Gauguin, *Avant et après*, p. 63.
20 Gauguin, *Avant et après*, p. 73.
21 Gauguin to Mette, Tahiti, March 1892 (Malingue 127).
22 Pissarro to his son Lucien, in Sweetman, *Paul Gauguin*, p. 77.
23 Compressed from Gauguin, *Avant et après*, pp. 35–6, and *Racontars de rapin*, Mercure de France, 2003, p. 49 (my translation).
24 Emil Gauguin, Preface to *Paul Gauguin's Intimate Journals*, Boni and Liveright, 1921.

6: LOST

1. The painting is probably *Abandoned Garden* (1884) but the titles and numbers of the paintings deposited with Durand-Ruel are not clear from his deposit book. See *CR 1873–1888*, vol. 1, p. 136.
2. Gauguin to Pissarro, mid-May 1884, in *CR 1873–1888*, vol. 1, p. 136.
3. Gauguin to Schuffenecker, Copenhagen, 14 Jan. 1885 (Malingue 11).
4. Birth register of the fifteenth arrondissement, Paris, 1883, no. 2966.
5. 'Notes synthétiques', first published in *Vers et proses*, 1910, included in *Paul Gauguin: Écrits sur l'art*, ed. Frédéric Chaleil, Les Editions de Paris, 2017.
6. The fragmentary quotations in this and the following paragraph are taken from Gauguin's letters to Pissarro, late Nov. to early Dec. 1884, and letters to Schuffenecker Jan. 1885. For a wider discussion of this, see Anne-Brigitte Fonsmark, 'A Painter–Philosopher Develops', in Richard R. Brettell and Anne-Brigitte Fonsmark, *Gauguin and Impressionism*, Yale University Press, 2005, pp. 224–31.
7. Clovis might well be mistaken for a girl, but it was the custom of the time to leave boys' hair long.
8. Gauguin to Pissarro, Jan. 1885, in *CR 1873–1888*, p. 594.
9. Pola Gauguin, *My Father, Paul Gauguin*, trans. Arthur G. Chater, Cassell, 1937, p. 81.
10. Pola Gauguin, *Mette og Paul Gauguin*, Gyldendal, Nordisk Forlag, 1956, p. 30 (my translation).
11. Gauguin to Pissarro, 3 Jan. 1885, in *CR 1873–1888*, p. 594.
12. Gauguin to Schuffenecker, Copenhagen, 14 Jan. 1885 (Malingue 11).
13. Gauguin to Schuffenecker, 14 Jan. 1885, in *CR 1873–1888*, p. 594.
14. Gauguin to Schuffenecker, 24 May 1885 (Malingue 22).
15. Gauguin to Schuffenecker, 24 May 1885 (Malingue 22).
16. Decorated wooden box, pearwood with iron hinges, leather insert and netsuke masks, 22 × 14.8 × 51.5 centimetres. Plaque on the back dated 1884. Art historians have suggested it was inspired by a Bronze Age coffin containing a mummified corpse in the Copenhagen National Museum. Equally, it might have harked back to the Peruvian memento mori that had been swimming round in his subconscious.
17. Gauguin to Schuffenecker, in Nienke Denekamp, *The Gauguin Atlas*, trans. Laura Watkinson, Yale University Press, 2019, p. 46.
18. Gauguin, article in *Les Guêpes*, no. 5, 12 June 1899, quoted in *CR 1873–1888*, vol. 2, p. 596.
19. Gauguin to Mette, Paris, undated, beginning of Oct. 1885 (Malingue 26).
20. Gauguin to Mette, Paris, about 25 April 1886 (Malingue 35).
21. J.-K. Huysmans, 'Les Indépendants', *Revue indépendente*, no. 6, April 1887, pp. 51–7.
22. Gauguin presented the hoax text as fragments from a book of crafts by Zunbul-Zadi. Seurat was reportedly worried by the text, even though he took it to be a manual on the colouring of carpets (extracted quotes are from *Avant et après* pp.35 and 36). Gauguin included the Zunbul-Zadi writings in his books *Diverses choses*, *Avant et après* and, in modified form, *Cahier pour Aline*. Félix Fénéon published the hoax as genuine in *L'Art moderne de Bruxelles*, 10 July 1887.

NOTES

7: EVOLUTION OF A DREAM

1 Gauguin to Mette, Feb. 1888 (Malingue 61).
2 Adolphus Trollope, quoted in André Cariou, *Pont-Aven cité de peintres: De la Colonie artistique à l'École de Pont-Aven*, Coop Breizh, 2016, p. 12 (my translation).
3 Gauguin to Mette, undated, Pont-Aven, end June 1886 (Malingue 41).
4 Almost certainly the *Moulin du Bois d'Amour Bathing Place*, 1886.
5 A. S. Hartrick, *A Painter's Pilgrimage through Fifty Years*, Cambridge University Press, 1939, p. 30.
6 Hartrick, *A Painter's Pilgrimage*, pp. 30–1.
7 Gauguin to Madeleine Bernard, 15–20 Oct. 1888 (Malingue 69).
8 Gauguin to Mette, Paris, about 25 April 1886 (Malingue 35).
9 Gauguin to Mette, Pont-Aven, undated, end June 1886 (Malingue 41).
10 Pola Gauguin, *My Father, Paul Gauguin*, trans. Arthur G. Chater, Cassell, 1937, p. 101.
11 The 'historic exhibition of the art of engraving in Japan' opened in Bing's gallery, 22 Rue de Provence, 28 May 1888. Magazine *Le Japon artistique, documents d'art et d'industrie* ran from May 1888 to April 1891.
12 Paul Gauguin, 'Notes sur l'art à l'Exposition universelle', *Le Moderniste*, 4 and 11 July 1889.
13 Gauguin, describing the worst time in Paris with Clovis, from *Cahier pour Aline* (ms 1892–4), facsimile, ed. Suzanne Damiron, 1963, pages unnumbered.
14 Gauguin to Bracquemond, undated, Paris, Jan. 1887 (Malingue 46).
15 Theo van Gogh letter to Vincent van Gogh, 22 Dec. 1889, *VG Letters*, vol. 5, p. 169.

8: 'I'VE NEVER PAINTED SO CLEARLY'

1 Émile Bernard, *L'Aventure de ma vie*, ms in the Bibliothèque du Louvre, p. 84.
2 Gustave de Molinari, *À Panama, l'isthme de Panama, la Martinique, Haiti: Lettres adressées au 'Journal des débats'*, Librairie Guillaumin et Cie, 1887, p. 61.
3 Gauguin to Mette, undated, Panama, early May 1887 (Malingue 52). It is disputed whether Gauguin actually swung a pickaxe or worked as a clerk in the office of the Panama Canal Company.
4 Gauguin to Mette, undated, Saint-Pierre, Aug. 1887 (Malingue 55).
5 A map of the identifiable locations of the paintings by Gauguin and Laval shows they were made between Anse Latouche and Le Carbet, within a five-kilometre area. See Maite van Dijk and Joost van der Hoeven, *Gauguin and Laval in Martinique*, Van Gogh Museum/Thoth, 2018, p. 81.
6 The White Sketchbook, the Blue-Grey Sketchbook and the Small Sketchbook.
7 Gauguin to Schuffenecker, Sept. 1887 (Malingue 57).
8 Quoted in Charles Morice, *Paul Gauguin: l'Homme et l'artiste*, 1920, p. 45 (my translation).
9 This is a phrase of Mirbeau in a letter to Claude Monet in early 1891, in response to Monet's criticism of Gauguin's art as over-cerebral, arguing that the artist could only stimulate thought by first appealing to the eye.
10 Gauguin to Mette, from Paris, 24 Nov. 1887 (Malingue 58).

11 Gail Feigenbaum, *Degas and New Orleans: A French Impressionist in America*, New Orleans Museum of Art, 1999, p. 29.
12 Laval to Gauguin, 9 Dec. 1887, quoted in Van Dijk and Van der Hoeven, *Gauguin and Laval in Martinique*, p. 74.
13 Gauguin to Vincent van Gogh, c.25–7 Sept. 1888, in *VG Letters*, vol. 4, p. 287.
14 Much later, in 1921, Paul Sérusier claimed to be part of the party. It seems likely he misremembered. Émile Bernard's contemporary account is definite in specifying a party of three consisting of himself, Laval and Gauguin. See Belinda Thomson, *Gauguin's Vision*, National Galleries of Scotland, 2005, p. 138, n. 24.
15 Thomson, *Gauguin's Vision*, p. 69.
16 Gauguin to Vincent van Gogh, c.10 Sept. 1888, quoted in Bradley Collins, *Van Gogh and Gauguin: Electric Arguments and Utopian Dreams*, Westview, 2004, p. 121.
17 *La Cravache parisienne*, no. 410, 2 March 1889, cited in Thomson, *Gauguin's Vision*, p. 78.

9: VINCENT. 'MY GOD, WHAT A DAY!!'

1 Paul Gauguin, *Avant et après* (ms 1903), online original and translation by Ketty Gottardo, Rachel Hapoienu and Rachel Sloan, Courtauld Gallery, 2021, p. 13.
2 Vincent van Gogh to Theo van Gogh, on or about 15/16 June 1888, in *VG Letters*, vol. 4, p. 125.
3 Vincent van Gogh to Émile Bernard, 3 Oct. 1888, in *CR 1873–1888*, vol. 1, p. 179.
4 Gauguin to Vincent van Gogh, c.25–7 Sept. 1888, quoted in *CR 1873–1888*, vol. 2, p. 480.
5 Quotations from Gauguin's letters, 8 and 11 Oct. 1888, in *CR 1873–1888*, vol. 2, p. 481.
6 Vincent van Gogh to Gauguin, Arles, 3 Oct. 1888, in *VG Letters*, p. 304.
7 Gauguin, *Avant et après*, p. 9.
8 These were the original four, painted in August. By January 1889, there were seven Sunflower paintings, the four originals and three *répétitions*, non-identical copies.
9 For more on this very exact dating, see Martin Bailey, *The Sunflowers Are Mine*, White Lion, 2013, pp. 51–2.
10 Vincent van Gogh to Theo van Gogh, 16 Oct. 1888, in *VG Letters*, p. 330.
11 A. S. Hartrick, *A Painter's Pilgrimage through Fifty Years*, Cambridge University Press, 1939, quoted in Martin Gayford, *The Yellow House*, Penguin, 2007, p. 9.
12 Jeanne Calment of the shop Calment et Fils, where Vincent bought his canvases. Gayford, *The Yellow House*, p. 72.
13 Gauguin, *Avant et après*, p. 10.
14 Gauguin, *Avant et après*, p. 10.
15 Gauguin, *Avant et après*, p. 11.
16 Vincent van Gogh to Theo van Gogh, 10 Nov. 1888, in *VG Letters*, vol. 4, p. 355.
17 Gauguin, *Avant et après*, p. 11.
18 Vincent van Gogh to Theo van Gogh, 27 or 28 Oct. 1888, in *VG Letters*, vol. 4, pp. 336–47.
19 Vincent van Gogh to Theo van Gogh, 11–12 Nov. 1888, in *VG Letters*, vol. 4, p. 356.
20 Vincent van Gogh to Émile Bernard, 27 June 1888, in *VG Letters*, vol. 4, p. 157.

NOTES

21 Gauguin to Émile Bernard, Nov. 1888, quoted in *CR 1873–1888*, vol. 2, pp. 519–20.
22 Vincent van Gogh to Theo van Gogh, 8 Sept. 1888, in *VG Letters*, vol. 4, p. 258.
23 Gauguin to an unnamed recipient in Jan. 1889 (Stargardt auction, Berlin, 1–2 April 2008, lot 573b), cited in Bailey, *The Sunflowers Are Mine*, p. 84.
24 Bradley Collins, *Van Gogh and Gauguin: Electric Arguments and Utopian Dreams*, Westview, 2004, p. 177.
25 Vincent van Gogh to Theo van Gogh, 10 Sept. 1889, in *VG Letters*, vol. 5, p. 92.
26 This quote and the following accounts are from Gauguin, *Avant et après*, pp. 13–15.
27 Martin Bailey's years of detective work on the night in question can be traced through his Adventures with Van Gogh series in the *Art Newspaper* and Bailey's book *Studio of the South: Van Gogh in Provence*, Frances Lincoln, 2016, pp. 155–8.
28 Vincent van Gogh to Gauguin, 21 Jan. 1889, in *VG Letters*, vol. 4, p. 393.
29 Vincent van Gogh to Gauguin, 4 Jan. 1889, in *VG Letters*, vol. 4, p. 730.
30 Vincent van Gogh to Gauguin, 21 Jan. 1889, in *VG Letters*, vol. 4, p. 393.
31 Gauguin to Vincent van Gogh from Paris, second week in Jan. 1889, in *VG Letters*, vol. 4, p. 382.

10: THE MARCH OF SCIENCE

1 *New Zealand Herald*, vol. 25, issue 9160, 15 Sept. 1888, p. 2 (supplement).
2 Paul Gauguin, *Avant et après* (ms 1903), online original and translation by Ketty Gottardo, Rachel Hapoienu and Rachel Sloan, Courtauld Gallery, 2021, p. 113.
3 Jules Ferry, speech before the French Chamber of Deputies, 28 March 1884.
4 As reported in *Le Petit Journal*, 8 May 1889, quoted in Maud Chirio, '1889: Order and Progress in the Tropics', in Patrick Boucheron and Stéphane Gerson, eds, *France in the World: A New Global History*, Gallic Books, 2021, p. 606.
5 Paul Gauguin, 'Notes sur l'art à l'Exposition universelle', articles published in *Le Moderniste illustré*, 4 and 11 July 1889.
6 Gauguin to Émile Bernard, Le Pouldu, June 1890 (Malingue 106).
7 Gauguin, *Avant et après*, p. 16.
8 A. S. Hartrick, *A Painter's Pilgrimage through Fifty Years*, Cambridge University Press, 1939, p. 30.
9 André Cariou, *Gauguin et ses camarades de l'École de Pont-Aven au Pouldu*, Coop Breizh, 2016, p. 32 (my translation).
10 Gauguin to Émile Bernard, Pont-Aven, early Sept. 1889 (Malingue 87).
11 Gauguin to Émile Bernard, undated, Le Pouldu, Nov. 1889 (Malingue 91).
12 Gauguin to Émile Bernard, Le Pouldu, Aug. 1890 (Malingue 110).
13 Gauguin to Madeleine Bernard, Pont-Aven, Oct. 1888 (Malingue 69).
14 Gauguin to Vincent van Gogh, Le Pouldu, on or about Friday 13 December 1889, in *VG Letters*, vol. 5, pp. 163–4.
15 Cariou, *Gauguin et ses camarades*, p. 43 (my translation).
16 Gauguin to Vincent van Gogh, Le Pouldu, on or about 13 Dec. 1889, in *VG Letters*, vol. 5, pp. 163–4.
17 The words *Ludus pro Vita*, 'Game for Life', that occurred beneath de Haan's fresco were probably written later by another hand.
18 Richard Wagner, from the short story 'Eine Ende in Paris' (my translation).

11: A THROW OF THE DICE

1. Pola Gauguin, *My Father, Paul Gauguin*, trans. Arthur G. Chater, Cassell, 1937, p. 132.
2. Richard Brettell et al., *The Art of Paul Gauguin*, National Gallery of Art, Washington DC, 1988, p. 146.
3. See Gauguin's letters to Vincent van Gogh, 17 Jan. 1890 and 23 Jan. 1890, in *VG Letters*, vol. 5, pp. 186, 190.
4. Gauguin to Vincent van Gogh, June 1890, in *VG Letters*, vol. 5, p. 259.
5. Vincent van Gogh to Theo van Gogh, 17 June 1890, *VG Letters*, vol. 5, p. 266.
6. Gauguin to Émile Bernard, early Aug. 1890 (Malingue 102).
7. Gauguin to Émile Bernard, undated, Paris, 1890 (Malingue 102).
8. Paul Sérusier, *ABC de la peinture*, La Douce France and Henry Floury, 1921. Sérusier's paintings and theories are examined in Caroline Boyle-Turner, *Paul Sérusier: Legends and Spells*, Réunion des Musées Nationaux, 2018.
9. Vincent van Gogh to Émile Bernard, c.26 Nov. 1889, *VG Letters*, vol. 5, pp. 146–53.
10. Pola Gauguin, *My Father*, p. 134.
11. Émile Bernard to Paul Gauguin, quoted in Bengt Danielsson, *Gauguin in the South Seas*, trans. Reginald Spink, George Allen and Unwin, 1965, p. 28.
12. Quoted in Danielsson, *Gauguin in the South Seas*, trans. Spink, pp. 29–30.
13. Published in *Le Figaro*, 18 Sept. 1886.
14. 'Les Isolés: Vincent Van Gogh', *Mercure de France*, Jan. 1890, pp. 24–9, and 'Le Symbolisme en peinture: Paul Gauguin', *Mercure de France*, March 1891, pp. 155–65.
15. Gordon Millan, *A Throw of the Dice: The Life of Stéphane Mallarmé*, Farrar, Straus and Giroux, 1994, p. 85.
16. Pola Gauguin, *Mette og Paul Gauguin*, Gyldendal, Nordisk Forlag, 1956, p. 107 (my translation).
17. Pola Gauguin, *Mette og Paul Gauguin*, p. 105.
18. Pola Gauguin, *Mette og Paul Gauguin*, pp. 106–8.
19. Pola Gauguin, *Mette og Paul Gauguin*, p. 119.
20. David Sweetman, *Paul Gauguin: A Complete Life*, Hodder and Stoughton, 1995, p. 110.
21. Pola Gauguin, *Mette og Paul Gauguin*, p. 119.
22. Gauguin refers to this in an undated letter to Aline from Paris, around Christmastime 1893 (Malingue 146). 'Do you remember 3 years ago when you said you would be my wife? I sometimes smile at the recollection of your simplicity.'
23. Pola Gauguin, *My Father*, p. 140.
24. Charles Morice, *Paul Gauguin*, H. Floury, 1920, pp. 29–30, quoted in Danielsson, *Gauguin in the South Seas*, trans. Spink, pp. 47–8.
25. *Mercure de France*, 1 May 1891.
26. Gauguin to Mette, Paris, 24 March 1891 (Malingue 123).

12: POISONED PARADISE

1. Gauguin to Mette, 4 May 1891 (Malingue 124).
2. Gauguin to Mette, 4 May 1891 (Malingue 124).

NOTES

3 Pola Gauguin, *My Father, Paul Gauguin*, trans. Arthur G. Chater, Cassell, 1937, pp. 153–4.
4 Louis-Antoine de Bougainville, *A Voyage round the World*, trans. John Reinhold Forster, J. Nourse and T. Davies, 1772, pp. 220–2.
5 James Cook, *The Three Voyages of Captain Cook round the World*, vol. 1, Longman, Hurst, Reese, Orme and Brown, 1821, ch. 12.
6 A Roman marble copy of a Greek bronze original, the Apollo Belvedere was discovered around 1500 and first displayed in the Belvedere court in the Vatican in 1523.
7 As Antony Gormley said when the picture was acquired by London's National Portrait Gallery, this was the first time that the English establishment represented a member of a tribal society with dignity and respect (*Guardian*, 25 April 2023).
8 A summary of Jénot's account is in Bengt Danielsson, *Gauguin in the South Seas*, trans. Reginald Spink, George Allen and Unwin, 1965, p. 57.
9 Henry Adams, quoted in Danielsson, *Gauguin in the South Seas*, trans. Spink, p. 58.
10 Gauguin to Mette, letter erroneously dated 4 June 1891 – he did not arrive until 9 June (Malingue 125).
11 Pola Gauguin, *My Father*, pp. 156–60.
12 Richard Brettell and Elpida Vouitsis, 'Introduction: Gauguin in Tahiti, First Period, 1891–1893', in *CR 1891–1903*.
13 *Suzanne Bambridge* (1891). Legend had it that Suzanne's Polynesian family was part of the royal family. This is even written in the catalogue to the Gauguin's Portraits exhibition held in London's National Gallery 2019–20, but a Bambridge descendant visiting that exhibition told the exhibition's curator Christopher Riopelle that this was not so. He passed this on to me.
14 Paul Gauguin, *Noa Noa*, trans. Jonathan Griffin, Pallas Athene, 2010, p. 14.
15 Pola Gauguin, *My Father*, p. 164.
16 Gauguin, *Noa Noa*, p. 23.
17 Pola Gauguin, *My Father*, pp. 168–9.
18 Gauguin to de Monfreid, 5 Nov. 1892 (de Monfreid V).
19 Gauguin, *Noa Noa*, p. 18.
20 Gauguin, *Noa Noa*, pp. 31–2.

13: TEHAMANA

1 Gauguin to de Monfreid, June 1892 (de Monfreid IV).
2 Gauguin used the words Maori, *mahori* and *mahoi* almost interchangeably in his writings. Throughout the twentieth century this was treated as careless spelling on his part, but the spelling of the Polynesian language had not been standardised in Gauguin's time and, as he noted, the words seemed interchangeable. It is the same today. Gauguin speculated on theories about their origins in *Avant et après*, p. 40, concluding that this was as impossible a question to answer as in which epoch the Deluge took place.
3 Bengt Danielsson, *Love in the South Seas*, trans. F. H. Lyon, George Allen and Unwin, 1956, pp. 176–7.

4 Paul Gauguin, *Ancien culte mahorie*, facsimile edition, Gallimard, 2017, p. 31 (my translation).
5 Gauguin to de Monfreid, quoted in David Sweetman, *Paul Gauguin: A Complete Life*, Hodder and Stoughton, 1995, p. 312.
6 Pola Gauguin, *My Father, Paul Gauguin*, trans. Arthur G. Chater, Cassell, 1937, pp. 175–6.
7 Paul Gauguin *Noa Noa*, trans. Jonathan Griffin, Pallas Athene, 2010, p. 45.
8 Gauguin has been criticised for his inaccurate spelling of Tahitian words but when he arrived in Tahiti the only book printed in the Tahitian language was the Bible. The language was still in the stages of development of phonetic script. In addition, the inhabitants of different small communities, such as villages or valleys, used linguistic variations such as different spoken words for the same thing.
9 The information in this paragraph is mostly taken from Danielsson, *Gauguin in the South Seas*, trans. Spink.
10 Gauguin, *Noa Noa*, p. 64.
11 Gauguin, *Noa Noa*, p. 64.
12 Given the different variations of her name that Gauguin writes in his different accounts of living with her, I have simplified this by referring to her as Tehamana throughout, despite the fact that in the particular version I am quoting he calls her Tehura. My reason for this is that he writes her name Tehamana in the inscription of the famous portrait of her entitled *Tehamana Has Many Parents* (1892).
13 Pola Gauguin, *My Father*, pp. 184–5.
14 Gauguin to Mette, 8 Dec. 1892 (Malingue 134).
15 *Parau na te varua ino* (Words of the Devil), 1892; *Barbarian Tales*, 1892; *Still Life with Flowers and Idol*, 1892; *Parau hanohano* (Frightening Talk), 1892.
16 Gauguin to Mette, Tahiti, 8 Dec. 1892 (Malingue 134).
17 The titles are as he wrote them in his covering letter to Mette, 8 Dec. 1892 (Malingue 134). Today, some take different titles in the catalogue raisonné.
18 Rohde, *Journal fra en Resje i 1892* (1955, pp. 87–8) quoted in Merete Bodelsen, *Gauguin og Van Gogh i København*, Ordrupgaard, 1984, p. 25.
19 *Dannebrog* newspaper, 26 March 1893.
20 Bodelsen, *Gauguin og Van Gogh i København*, p. 30.
21 Quoted by Gauguin in letter to de Monfreid, 11 Feb. 1893 (de Monfreid VIII).
22 Gauguin to de Monfreid, 31 March 1893 (de Monfreid IX).

14: 'I HATE NULLITY, THE HALFWAY'

1 Paul Gauguin, *Avant et après* (ms 1903), online original and translation by Ketty Gottardo, Rachel Hapoienu and Rachel Sloan, Courtauld Gallery, 2021, pp. 186, 187.
2 Edvard Brandes to Gauguin, undated, in Pola Gauguin, *Mette og Paul Gauguin*, Gyldendal, Nordisk Forlag, 1956, p. 181 (my translation).
3 Mette to Schuffenecker, Copenhagen, 15 Sept. 1893, in Pola Gauguin, *Mette og Paul Gauguin*, pp. 166–7.
4 Gauguin to Mette, undated, Paris, Oct. 1893 (Malingue 143).
5 Octave Mirbeau, 'Retour de Tahiti', *L'Echo de Paris*, 14 Nov. 1893, p. 1.

NOTES

6 As reported in Henri Mondor's 1841 biography of Mallarmé, quoted in Malingue, p. 187, n. 1.
7 See catalogue *Vente de tableaux de Paul Gauguin*, in the library of the Metropolitan Museum of Art.
8 Described in Julien Leclercq, 'Exposition Paul Gauguin', *Mercure de France*, no. 13, Feb. 1895, pp. 121–2, quoted in Linda Goddard, *Savage Tales: The writings of Paul Gauguin*, Yale University Press, 2019, p. 96.
9 Eugène Tardieu, 'Paul Gauguin', *Echo de Paris*, 13 May 1895.
10 Gerda Kjellberg, *Hänt och sant* (including memoirs of Judith Gérard), Norstedts, 1951, p. 63, quoted in Lionel Carley, *Delius: The Paris Years*, Triad Press, 1975, p. 53.
11 Carley, *Delius*, p. 50.
12 It was not until April 2021 that a bill was passed through the French parliament establishing fifteen as the age of consent.
13 David Sweetman, *Paul Gauguin: A Complete Life*, Hodder and Stoughton, 1995, p. 381.
14 Strindberg, letter to Leopold Littmansson, 14 July 1894, in *Strindberg's Letters, Vol. 2*, ed. and trans. Michael Robinson, Chicago University Press, 1992, p. 480.
15 Sweetman, *Paul Gauguin*, p. 377.
16 The art school was founded by Louis-Joseph-Raphaël Collin (1850–1916), pupil of Bouguereau and Cabanel, and pioneer of art nouveau.
17 Richard Brettell et al., *The Art of Paul Gauguin*, National Gallery of Art, Washington DC, 1988, p. 320.
18 Sweetman, *Paul Gauguin*, p. 386.
19 Watercolour monotype 1894 includes *Te nave nave fenua* in several versions and *The Man with the Axe*.
20 See *Selected Works of Alfred Jarry*, ed. Roger Shattuck and Simon Watson, 1965
21 Gauguin to William Molard, undated, Pont-Aven, Sept. 1894 (Malingue 152).
22 Gauguin to William Molard, undated, Pont-Aven, Sept. 1894 (Malingue 152).
23 Gauguin to William Molard, undated, Pont-Aven, Sept. 1894 (Malingue 152).
24 Gauguin to William Molard, undated, Pont-Aven, Sept. 1894 (Malingue 152).

15: PENT UP IN PARIS

1 *Rave te hiti aamu (The Idol)*, 1898.
2 Emanuel Swedenborg, *Heaven and Hell*, trans. George F. Dole, Swedenborg Foundation, 2010, pp. 50, 53.
3 Paul Gauguin, Special Issue of *Le Sourire*, 1899. Musée du Louvre, Paris.
4 *La Paix*, 19 Jan. 1883.
5 Quoted in Jan Verkade, *Le Tourment de Dieu*, Librairie de L'Art Catholique, 1956, pp. 83–4.
6 Gauguin to Strindberg, Paris, 5 Feb. 1895 (Malingue 154).
7 Quoted in Paul Gauguin, *Avant et après* (ms 1903), online original and translation by Ketty Gottardo, Rachel Hapoienu and Rachel Sloan, Courtauld Gallery, 2021, pp. 19–21.

8 The translation of the article appears in Bengt Danielsson, *Gauguin in the South Seas*, trans. Reginald Spink, George Allen and Unwin, 1965, pp. 170–2.

16: RETURN TO TAHITI

1 Gauguin to André Fontainas, Tahiti, March 1899 (Malingue 170).
2 Auckland Sketchbook, 1895–7, in private hands.
3 Gauguin to Daniel de Monfreid, April 1896 (de Monfreid XVII).
4 Gauguin to de Monfreid, 22 Feb. 1899 (de Monfreid XXXIX).
5 William A. Mueller and Caroline Boyle-Turner, 'Gauguin's Teeth', *Anthropol*, 6:1, 2018; Helen Swingler, 'Mystery Tooth Linked to Paul Gauguin', University of Cape Town website, 26 Sept. 2016; Caroline Boyle-Turner, *Paul Gauguin and the Marquesas: Paradise Found?* Éditions Vagamundo, 2016, Introduction and pp. 152–3, 205–6; see also Martin Bailey, 'Remains of Paul Gauguin's Father Found off Antarctica', *Art Newspaper*, 7 Nov. 2016.
6 Gauguin to de Monfreid, Nov. 1895 (de Monfreid XVI).
7 Gauguin to de Monfreid, Nov. 1895 (de Monfreid XVI).
8 Bengt Danielsson discovered her birth certificate, dated 27 June 1881.
9 David Sweetman, *Paul Gauguin: A Complete Life*, Hodder and Stoughton, 1995, p. 416.
10 Gauguin to de Monfreid, April 1896 (de Monfreid XVII).
11 Pola Gauguin, *Mette og Paul Gauguin*, Gyldendal, Nordisk Forlag, 1956, p. 197 (my translation).
12 Gauguin to Mette, undated, Tahiti, Aug. 1897 (Malingue 165).
13 Gauguin to Mette, undated, Tahiti, Aug. 1897 (Malingue 165).
14 Gauguin to de Monfreid, Papeete, 12 Dec. 1898 (de Monfreid XXXVII).
15 Gauguin, *Avant et après* (ms 1903), online original and translation by Ketty Gottardo, Rachel Hapoienu and Rachel Sloan, Courtauld Gallery, 2021, p. 17.
16 Danielsson, *Gauguin in the South Seas*, trans. Spink, p. 103.
17 Gauguin to de Monfreid, June 1896 (de Monfreid XVIII).
18 Gauguin to de Monfreid, Aug. 1896 (de Monfreid XX).
19 Henry Lemasson cited in Bengt Danielsson, *Gauguin in the South Seas*, trans. Reginald Spink, George Allen and Unwin, 1965, pp. 194–5.
20 Gauguin to William Molard, Tahiti, Aug. 1897 (Malingue 164).
21 Paul Gauguin, *Modern Thought and Catholicism*, unpublished manuscript, trans. Frank Pleadwell, Saint Louis Museum of Art Collection, p. 1.
22 Paul Gauguin, *Les Guêpes*, no. 5, 12 June 1899, cited in Stephen F. Eisenman, *Gauguin's Skirt*, Thames and Hudson, 1997, p. 159.
23 Paul Gauguin, *Modern Thought and Catholicism*, trans. Pleadwell, pp. 88–9.
24 Danielsson, *Gauguin in the South Seas*, trans. Spink, p. 197.
25 Gauguin to de Monfreid, Tahiti, Feb. 1898 (de Monfreid XXXI).
26 Gauguin to de Monfreid, Tahiti, Nov. 1897 (de Monfreid XXIX).
27 Gauguin to de Monfreid, Tahiti, Feb. 1898 (de Monfreid XXXI).
28 Gauguin to Charles Morice, Tahiti, July 1901 (Malingue 174).

NOTES

17: REINVENTIONS

1. Gauguin to de Monfreid, Tahiti, Feb. 1898 (de Monfreid XXXI).
2. Bengt Danielsson, *Gauguin in the South Seas*, trans. Reginald Spink, George Allen and Unwin, 1965, p. 189.
3. Gauguin to de Monfreid, Tahiti, April 1898 (de Monfreid XXXIII).
4. Danielsson, Bengt, *Gauguin in the South Seas*, trans. Reginald Spink, George Allen and Unwin, 1965, p. 228.
5. Danielsson, *Gauguin in the South Seas*, trans. Spink, p.237.
6. An example can be seen in London's Science Museum. In 1905, it was adapted to a rotary system that remained popular until the 1960s, when it was displaced by the photocopier.
7. Gauguin to de Monfreid, Tahiti, June 1899 (de Monfreid LXIII).
8. The largest remaining of these paintings is *Faa iheihe*, probably the most famous is *Two Tahitian Women*.
9. Told to Bengt Danielsson by Nordman's son. See Danielsson, *Gauguin in the South Seas*, trans. Spink, p. 230.
10. Gauguin to Charles Morice, Tahiti, July 1901 (Malingue 174).

18: KOKÉ

1. Paul Gauguin, *Avant et après* (ms 1903), online original and translation by Ketty Gottardo, Rachel Hapoienu and Rachel Sloan, Courtauld Gallery, 2021, p. 185.
2. Paul Gauguin, *Racontars de rapin*, Mercure de France, 2003, p. 37 (my translation).
3. Hien V. Ho, 'Revolutionaries in Politics and in Art: The Marvelous Child and the Old Painter: The Stories of Ky Đong and Gauguin', https://www.advite.com/TheStoriesofKyDongandGauguin.htm, 2 Dec. 2009.
4. Joseph Martin (1849–1912), bishop *in partibus d'Uranopolis*. The position took its title from Uranopolis, a city in ancient Macedonia allegedly founded by Alexarchus, brother of King Cassander of Macedonia.
5. *Still Life with Rooster* (c.1902), *Still Life with Exotic Birds* (1902), *Still Life with Exotic Birds and Idol* (1902).
6. *Landscape with Horses* (1901).
7. This information is from a letter of 1 March 1960 to Bengt Danielsson from Louis Grelet, a Swiss commercial traveller in liquor who supplied Ben Varney and often visited Gauguin. See Danielsson, *Gauguin in the South Seas*, trans. Reginald Spink, George Allen and Unwin, 1965, pp. 238 and 290. The carved bedstead, sadly, has not survived.
8. Gauguin to de Monfreid, Nov. 1901 (de Monfreid LV).
9. Tattoos: Leviticus 19:28. Promiscuity: Leviticus 20:10–21. Beard: Leviticus 19:27.
10. Gauguin, *Avant et après*, p. 190.
11. Colonial Governor Gustave Gallet to the Minister in Paris, 12 Oct. 1898.
12. Gauguin, *Avant et après*, pp. 207, 208.
13. Cited in Stephen F. Eisenman, *Gauguin's Skirt*, Thames and Hudson, 1997, pp. 170–1.
14. Gauguin, *Avant et après*, p. 92.
15. Gauguin, *Avant et après*, p. 212.

16 Guillaume le Bronnec, 'La vie de Gauguin aux Îles Marquises (depuis son arrivée en 1901 jusqu' à sa mort en 1903)', *Bulletin de la Société des Études Océaniennes (Papeete)*, no. 106, March 1954, pp. 207–8, cited in Caroline Boyle-Turner, *Paul Gauguin and the Marquesas: Paradise Found?*, Éditions Vagamundo, 2016, p. 197.
17 See Danielsson, *Gauguin in the South Seas*, trans. Spink, and *Love in the South Seas*, trans. F. H. Lyon, George Allen and Unwin, 1956; Robert C. Suggs, *Marquesan Sexual Behaviour*, Constable, 1966; Boyle-Turner, *Paul Gauguin and the Marquesas*.
18 Governor Gallet to the Ministry of Marine and Colonies in Paris, letter dated 1898. Archives d'Outre-Mer, Aix-en-Provence, SG Océanie, carton 131, cited in Eisenman, *Gauguin's Skirt*, p. 167.
19 Governor Gallet's report, as cited above.
20 Gauguin, *Avant et après*, pp. 6–7.
21 Gauguin, *Avant et après*, p. 7.
22 *Père Paillard* (1901–2) 67.9 centimetres tall. Carved from *Thespesia populnea* wood, signed PGO. *Thérèse* (1902–3) 66 centimetres tall. *Thespesia populnea*, signed PGO.
23 The profile head of Taaroa features in the suite of late woodcuts, 1898–9, referred to in letters to Vollard in January 1900 when setting up the agreement for Vollard to represent him.
24 Sweetman, *Paul Gauguin: A Complete Life*, Hodder and Stoughton, 1995, p. 413.
25 Gauguin, *Avant et après*, p. 3.
26 The best source of information comes from Le Bronnec's 'La Vie de Gauguin'. Le Bronnec was a Frenchman who arrived on the island soon after Gauguin's death and made it his mission to discover everything he could about Gauguin's time on the island.
27 Le Bronnec, 'La Vie de Gauguin'.
28 Suggs, *Marquesan Sexual Behaviour*, p. 74.

19: THE BAREFOOT LAWYER

1 Phrase used in a letter from Gauguin to Charles Morice from Tahiti, July 1901, describing *Where Do We Come From? What Are We? Where Are We Going?* (Malingue 174).
2 Bengt Danielsson, *Gauguin in the South Seas*, trans. Reginald Spink, George Allen and Unwin, 1965, p. 245.
3 Paul Gauguin, *Racontars de rapin*, Mercure de France, 2003, p. 39.
4 Gauguin to William Molard, Atuona, 16 March 1902 (Malingue 175).
5 David Sweetman, *Paul Gauguin: A Complete Life*, Hodder and Stoughton, 1995, p. 515.
6 Gauguin to de Monfreid, 25 Aug. 1902 (de Monfreid LXI).
7 Explanatory note after Gauguin to de Monfreid, Feb. 1903 (de Monfreid LXI).
8 Unpublished letter from Madame Anaimioi, dated 25 Dec. 1902. De Monfreid Archives, Musée Départemental, Maurice Denis, Saint-Germain-en-Laye, cat. no. 315, cited in Caroline Boyle-Turner, *Paul Gauguin and the Marquesas: Paradise Found?*, Éditions Vagamundo, 2016, p. 199. We do not have the follow-up result.
9 Gauguin to the Inspector of Colonies, Feb. 1903, Atuona (Malingue 179).
10 Gauguin to the Inspector of Colonies, Feb. 1903, Atuona (Malingue 179).

NOTES

11 Paul Gauguin, *Avant et après* (ms 1903), online original and translation by Ketty Gottardo, Rachel Hapoienu and Rachel Sloan, Courtauld Gallery, 2021, pp. 48–9.
12 Gauguin, *Avant et après*, p. 49.
13 Eventually published in Paris by Falaise in 1951.
14 Gauguin, *Avant et après*, p. 53.
15 The anecdote about Ky Dong beginning, or pretending to begin, the portrait is told in Danielsson, *Gauguin in the South Seas*, trans. Spink, p. 258.
16 Gauguin to de Monfreid, April 1903, Atuona (de Monfreid LXIII).
17 Sweetman, *Paul Gauguin*, p. 537.
18 Danielsson, *Gauguin in the South Seas*, trans. Spink, p. 274.
19 *Oviri* cast in bronze from Gauguin's 1894 ceramic sculpture, in 1959 by Claude Valsuani. Installed on the grave in 1973.
20 Sweetman, *Paul Gauguin*, p. 536.
21 Both the above quotations are in the archives of the Papeete Museum, quoted in Danielsson, *Gauguin in the South Seas*, trans. Spink, p. 276. Unavailable to me as the Papeete Museum was closed while I was there.

PERMISSIONS CREDITS

IMAGES

a = above, **b** = below, **l** = left, **r** = right: **page 7** akg-images. **13** Metropolitan Museum of Art, New York. Gift of Judith Riklis, 1983 Accession Number: 1983.546.4. CC0 1.0 Universal. **14** Chrysler Museum of Art, Norfolk, VA Gift of Walter P. Chrysler, Jr. 71.510. **29** Musée d'Orsay, Paris, France / Bridgeman Images. **59** Photo by Bertholdi 1884. **61a** Metropolitan Museum of Art, New York / Gift of the Joseph M. May Memorial Association Inc., 1963. CC0 1.0 Universal. **61b** Photo © The Courtauld / Bridgeman Images. **65** Photo: Tarker / Bridgeman Images. **73** The National Museum of Art, Architecture and Design / The Fine Art Collections. **76** Luisa Ricciarini / Bridgeman Images. **81** © Kimbell Art Museum / Bridgeman Images. **88–9** National Gallery of Art, Washington. Collection of Mr. and Mrs. Paul Mellon, Accession Number, 1983.1.19. **96–7** Hiroshima Museum of Art / akg-images. **99** Neue Pinakothek Munich. CC BY-SA 4.0 DEED. **102a** Petit Palais, City Museum of Fine Arts. CC0 1.0 Universal. **102bl** The Art Institute of Chicago. Through prior purchase of the Estate of Suzette Morton Davidson, Major Acquisitions Centennial Endowment, Dellora A. Norris Funds. **102br** Ny Carlsberg Glyptotek, Copenhagen. **112–13** Private collection. CC0 1.0 Universal. **119** Paul Gauguin, *Vision of the Sermon (Jacob Wrestling with the Angel)*, National Galleries of Scotland, Purchased 1925. www.nationalgalleries.org **124** Van Gogh Museum / Bridgeman Images. **125** Photo © President and Fellows of Harvard College. **128** Van Gogh Museum / Bridgeman Images. **131** Musée d'Orsay. Photo © Photo Josse / Bridgeman Images. **132–3** Kröller-Müller Museum / akg-images. **136** Pushkin Museum, Moscow, Russia. **137** Image © Yale University Art Gallery, 2008. **143** State Hermitage Museum, Moscow. **147** Heritage Images / Fine Art Images / akg-images. **158** Photo © Photo Josse / Bridgeman Images. **162** Pola Museum of Art, Japan. **166l** Museum of Modern Art, New York / Bridgeman Images. **166r** National Gallery of Art, Washington / Chester Dale Collection. **171** Howard Agriesti, Cleveland Museum of Art. CC0 1.0 Universal. **181** Metropolitan Museum of Art, New York. Harris Brisbane Dick Fund, 1936. CC0 1.0 Universal. **186** Bridgeman Images. **190–1** Musée d'Orsay / Bridgeman Images. **207** Royal Museums of Fine Arts of Belgium, Brussels / photo: J. Geleyns – Art Photography. **212** Ny Carlsberg Glyptotek, Copenhagen / Bridgeman Images. **215** Private Collection / Bridgeman Images. **220** Metropolitan Museum of Art, New York. Bequest of Sam A. Lewisohn, 1951. CC0 1.0 Universal. **223** Photo: © Fine Art Images / Bridgeman Images. **231** © Museo Nacional Thyssen-Bornemisza, Madrid / Bridgeman Images. **242** © Albright–Knox Art Gallery. Image courtesy of the Albright–Knox Art Gallery, Buffalo, New York. **246** Art Institute of Chicago. Gift of Mr. and Mrs. Charles Deering McCormick. **263** Van Gogh Museum / akg-images. **264** Metropolitan

PERMISSIONS CREDITS

Museum Art. Gift of the Print and Drawing Club. Reference Number 1940.91. CC0 1.0 Universal. **266** Private Collection. CC0 1.0 Universal. **274** Musée d'Orsay / akg-images. **286** Granger / Bridgeman Images. **289l** © Sue Prideaux. **289r** © Hank Turner. **293** Pushkin Museum of Art, Moscow. **294–5** Musée des Beaux Arts, Lyons, Luisa Ricciarini / Bridgeman Images. **296** Photo © The Courtauld / Bridgeman Images. **298** Museu de Arte São Paulo. Luisa Ricciarini / Bridgeman Images. **304–5** Museum of Fine Arts, Boston. Tompkins Collection. Arthur Gordon Tompkins Fund. **309** akg-images. **310** Photo © Photo Josse / Bridgeman Images. **315** Kunstmuseum Basel – Martin P. Bühler. **329** © Sue Prideaux. **338l** National Gallery of Art, Washington / Chester Dale Collection. **338–9** RMN-Grand Palais / René-Gabriel Ojeda / RMN-GP / Dist. Foto SCALA, Florence. **339r** photo © Christie's Images / Bridgeman Images. **344** Bridgeman Images. **347** akg-images / Erich Lessing. **348** Bridgeman Images. **361** Kunstmuseum Basel. Martin P. Bühler.

TEXT

We are grateful to the following for permission to reproduce copyright material:

Extracts from *My Father, Paul Gauguin* by Pola Gauguin, translated by Arthur G. Chater, Cassell, 1937; and *Mette og Paul Gauguin* by Paul Gauguin Snr, Gyldendal, Nordisk Forlag, 1956. Reproduced with kind permission of the Gauguin family; and Gyldendal Agency, Denmark; extracts from *Paul Gauguin: Lettres à sa femme et ses amis*, edited by Maurice Malingue. Translated as *Paul Gauguin: Letters to His Wife and Friends* by Henry J. Stenning, MFA Publications, copyright © Editions Grasset & Fasquelle, 1949. Reproduced with permission from Éditions Grasset; and extracts from *Vincent van Gogh: The Letters*, vols 4 & 5, ed. Leo Jansen, Hans Luitjen and Nienke Bakker; translation in Dutch by Lynne Richards, John Rudge and Dianne Webb, translation in French by Sue Dyson and Imogen Forster, Thames and Hudson, 2009. Reproduced with permission from the Van Gogh Museum and Mercatorfonds.

INDEX

Page numbers in *italics* refer to illustrations.

Ahutoro (Tahitian traveller to France), 196
Albert (ship), 1, 5–6
Anani (Orange, Gauguin's landlord), 209, 224, 229
Annah la Javanaise: background, 262; character, 262; modelling, 262, 267; monkey, 262, 267, 268, 270; relationship with Gauguin, 262, 265, 267–69; return to Paris, 270; thefts from Gauguin's studio, 272
Anquetin, Louis, 114, 150, 157
Arioi (Polynesian religious cult), 213, 227–29, 273
Arles: brothels, 126, 128, 130, 135, 139, 141; chief of police, 139–40; ear-cutting incident, 139–42; Gauguin's arrival, 126; Night Café, 126, *136*, *137*; Place Lamartine, 126; Roman amphitheatre, 126, 141; Theo's visit, 140; Vincent van Gogh in, 122–23, 126; the Yellow House, 123, 126, 128–30, 133, 137, 139, 141, 142, 244, 314
Armand Béhic (steamship), 248
Arnaud, Captain Charles (pirate), 225, 229
Arosa, Achille, 31, 47, 63, 181
Arosa, François-Ezéchiel, 31
Arosa, Gustave: appearance, 32; art collection, 33, 36, 44, 47, 49, 56, 77, 193; costume ball, 52; cultural circle, 32, 33, 47–48, 63, 100; death, 70; death of Aline, 43; family background, 31, 36–37, 47–48; Gauguin's wedding, 53; houses, 36, 42, 44–45; marriage, 32; photography, 33, 36, 44, 193, 275; relationship with Aline, 31, 32–33, 36, 43, 188; relationship with Gauguin, 31, 35–38, 45, 47, 53, 63; wartime in Channel Islands, 43, 44; wealth, 31
Arosa, Marguerite, 36, 47
Arosa family, 31–32, 36–37, 47–48, 52
L'Art moderne (periodical), 87
Atuona: Ben Varney's general store, 327, 329, 341; capital of Hiva Oa, 326; Catholic boarding schools, 331, 334–35, 341; Catholic cathedral, 327; Catholic cemetery, 327, 328, 363; Catholic repression of Polynesian culture, 331–33; day school, 353; Gauguin's arrival, 326; Gauguin's bedroom, 340, 362; Gauguin's death, xiii, 362–63; Gauguin's grave, 362–63; Gauguin's house (Maison du Jouir), xiii, 328–29, 336–42; Gauguin's studio parties, 340; informal local parliament on the beach, 335, 354; landscape, 356–57; languages, 334–35; replica of Gauguin's house, xiii, 329; storm damage, 356–57; taxation, 357; *see also* Hiva Oa; Marquesas Islands
Aube (battleship), 287
Aubé, Jean-Paul, 50, 60
Aubé, Madame, 50–51
Aurier, Albert, 177–78
L'Australien (steamer), 285
avant-garde: Arosa's art collection, 32; Denmark, 184, 243; exhibition at Restaurant du Chalet (1887), 114; Gauguin's status, 94; Les Vingts group, 121, 140; magazine (*Le Moderniste illustré*), 150; Paris, 3, 167, 176, 218, 252, 259; pointillism, 86

Balzac, Honoré de: Gauguin reading, 53, 277, 347, 349; on middle-class life, 17; on Paris, 28, 33; *Séraphita*, 276–77, 349
Bambridge, Suzanne, 206, 207
Barbizon School, 36, 49, 93, 177
Bastien-Lepage, Jules, 92–93
Baudelaire, Charles: Gauguin introduced to his work, 167, 347; *Les Fleurs du mal*, 321; Paris avantgarde, 157; symbolist path, 254; "The Painter of Modern Life," 168, 179
Berlatier, Gabrielle, 142
Bernard, Émile: family background, 174; patron, 300; portrait, 124; relationship with Gauguin, 120–21, 161, 174–76, 182, 189, 261, 320; relationship with Van Gogh, 115, 134–35; Synthetist group, 157, 182; Volpini exhibition, 150; works, 134, 320
Bernard, Madeleine, 124–25, 161, 163
Bertin, Paul, 53
Bertin's stock-trading business, 45–46, 48
Bibesco, Emmanuel, Prince, 321
Bjornson, Bjornstjerne, 260
Blackburn, Henry, 92
Blanche, Jacques-Émile, 82–83

389

INDEX

Blavatsky, Madame, 260
Bolívar, Simón, 1
Bonnard, Pierre, xiv, 157
Borgia family, 8
Bougainville, Comte de, 153, 194–96, 199
Bouillot, Jules-Ernest, 60, 82, 83, 178
Boussod, Valadon & Cie, 115, 248
Boyle-Turner, Caroline, 289
Bracquemond, Félix, 100–101, 103
Brandes, Edvard, 249–50
Brandes, Georg, 244, 277
Brittany: coiffed women, 87, 91, 99, 101, 118, 119, 153, 155–56; Gauguin's flight from, 272; Gauguin's journey to Pont-Aven, 90–92; Gauguin's view of, 34, 90, 96, 234, 265, 330; history, 90; language, 90; pardon ceremony, 117–20; religion, 117–18; *see also* Le Poul'd; Pont-Aven
Buisson, Dr, 324, 352
Burty, Philippe, 47, 100

Calzado, Adolfo, 45
Cardella, François, mayor of Papeete, 313
Carlyle, Thomas, 167–68, 347
Caröe, Kristian, 249
Carriere, Eugene, 178
Cézanne, Paul: distrust of Gauguin, 62, 67; first Impressionist exhibition, 48; Gauguin copying his techniques, 67, 72, 75–76; Gauguin's collection of his paintings, 62, 63, 193, 249–50; Impressionism, 27; painting with Pissarro and Gauguin, 67, 71
Chaplet, Ernest, 101, 103, 111, 216
Charcot, Jean-Martin, 178–79
Charlier, Public Prosecutor on Tahiti, 313
Charlopin, Charles, 172, 176
Charpillet, Brigadier Désire, 324, 327, 336, 355
Chaudet, Georges, 281, 300, 319, 321
Chazal, André (grandfather of Gauguin), 2–3, 12, 21
Chessé, General Isidore, 287
Chili (ship), 40, 41
Claverie, Gendarme, 355, 357–60
Cloisonnism, 114, 165
Colarossi's Académie, 256–57, 262
Concarneau, 269–71, 292
Cook, Captain James, 194–97, 199, 245, 330, 336
Cormon, Fernand, 94, 115
Courbet, Gustave, 32, 36, 96
Cranach, Lucas the Elder, 29–30, 256, 282, 292
Le Croix du Sud (ship), 323, 324, 351, 353
Crowley, Aleister, 260
Cubism, xiv, 157
Curie, Pierre and Marie, 278

Danielsson, Bengt, 235
Darwin, Charles, 22, 24, 30, 224
Debussy, Claude, 82, 181–82
Degas, Edgar: attending Gauguin auction, 182; collecting Gauguin's paintings, 64, 140, 253, 280, 319; description of Gauguin, 273; Gauguin's collection of photographs, 193, 256, 343; Gauguin's copies of his dancers, 80, 99; Gauguin's gift of walking stick, 253; imitated by Laval, 106; Impressionist exhibitions, 62, 84–85; *japonisme*, 100; paintings in Gauguin's collection, 60, 63; painting with Blanche in Dieppe, 82–83; racehorse paintings, 335; relationship with Pissarro, 84–85; sales of works, 115, 116; skyscapes and water studies, 16; studio painting, 56; support for Gauguin, 43, 121, 249, 300; view of Gauguin's ceramics, 104; wartime experiences, 43; work exhibited at Durand-Ruel's gallery, 48
De Haan, Meyer: appearance, 167, 169, 179, 348, 349; birth of child, 176; death, 261; decoration of Buvette de la Plage, 165–66; family background, 163, 170, 175; finances, 164; love affair with Marie Poupée, 169, 175–76, 187–88; portrait, 167–70, 172; relationship with Gauguin, 161, 163–64, 167–68, 347; return to Holland, 175–76; staying in Le Pouldu, 163–65, 172–73; works: *Is This Chicken Kosher?*, 163; *The Talmudic Dispute*, 163–64; *Uriel Acosta*, 164
Delacroix, Eugene: ceramics, 100; Gauguin copying his paintings, 77; horses, 77, 283; *Jacob Wrestling with the Angel*, 261; *Liberty Leading the People*, 36; paintings in Arosa's collection, 32, 36, 77; Paris avant-garde, 3
Delavallée, Henri, 94, 98
Delius, Frederick, 259, 320
de Monfreid, Annette, 261
de Monfreid, George-Daniel: advice on return to Europe, 245, 353–54; business manager to Gauguin, 177, 300–301; relationship with Gauguin, 248–49, 261, 291, 297; sale of Gauguin's paintings, 319–20; studio, 177, 248–49; supplies of canvas and paints, 320; Synthetist group, 157; Volpini exhibition, 150; works, 177
Desaix (warship), 44
Dillies et Freres, 77, 78
Dolgorouki, Princess, 151
Drollet, Sosthene, 222
Duchauffault (warship), 245, 248
Dujardin, Édouard, 114
Dumas, Alexandre, 31, 37

INDEX

Dupanloup, Félix, Bishop: appearance, 22; catechism, 24, 302; director of Petit Séminaire, 22–24; influence on French education, 23, 30; influence on Gauguin, 24–25, 35, 117, 219, 302; rationalist Christian views, 22, 117, 303

Durand-Ruel, Paul: buying Gauguin's work, 64; exhibitions of Gauguin's work, 71, 218, 251–53, 255, 256, 258, 271, 281; exhibitions of Impressionists, 48, 66, 84, 251; gallery, 48, 218, 249, 251–52; New York exhibitions, 84, 251; sales of Gauguin's work, 253; wartime experiences, 48

Durrio, Paco, 262

L'Écho de Paris, 182, 281
Eiffel, Gustave, 108
Émile (Gauguin's son by Pahura), 319, 323
Enchenique, José Rufino, 35
Engels, Friedrich, 154
Estrup, Jacob, 50–51, 78

Fatu Hiva island, 323, 324, 330
Fauché, Léon, 150, 157
Fauves, xiv, 350
Favre, Charles, 78
Fénéon, Félix, 87, 116
Filiger, Charles, 158, 159, 161
Fontainas, André, 358
Freud, Sigmund, 179, 260
Friedrich, Caspar David, 20
Futterer, Charlotte, 256, 276

Gad, Mette (wife of Gauguin), *see* Gauguin
Gad family, 50, 56, 78, 80, 183
Galimany, Jacqueline, 290
Gallet, Gustave, Governor, 318–19, 325, 332, 335, 336–37

Gauguin, Aline (daughter): appearance, *186*; birth, 57, 68; care of, 80–81; death, 293, 296; education, 80; father's response to news of her death, 296–97, 302; father's visit, 186, 243; living with mother in Denmark, 72; portrait, 57; relationship with father, 186, 296

Gauguin, Aline (Tristan, mother): appearance, 6, 7, 32, 161, *162*; arrival in Peru, 7; birth of children, 1, 5; career in Paris, 21, 26, 28, 30, 33–34, 42, 52, 104, 188, 262; character, 6, 32, 42; childhood, 3, 6; death, 42–43, 103; death of husband, 6; education, 3; family background, 1, 3, 5, 7–8, 18; father's imprisonment, 3; finances, 5, 15, 18, 45; head of the family, 50; health, 42–43; journey to Peru, 5–7; life in Orléans, 19, 21; life in Paris, 26–28; life in Peru, 8–9, 11–13; marriage, 1, 5; Peruvian art collection, 15, 32–33, 44; political record ("person of danger"), 1, 5; portraits, 6, 7, 161, *162*; relationship with Arosa, 31, 32–33, 36, 42–43, 188; relationship with son Paul, 32, 35, 37, 38, 45; return to France, 15; Saint-Cloud cottage, 42, 44; will, 35, 45

Gauguin, Clovis (father): death, 6, 43, 103; family background, 15, 17, 18; grave, 6, 290; journey to Peru, 5–6; radical journalism, 1

Gauguin, Clovis (son): apprenticeship, 186; birth, 68; care of, 82, 83–84, 87, 101; childhood, 82, 83–84; death, 297, 322; education, 84, 87, 105, 186; father's painting (*Clovis Asleep*), 76, 76–77, 118, 241, 265; father's visit, 186–87, 243; health, 84, 183; life with father, 83–84; life with mother, 183; move to Copenhagen, 105, 186; relationship with father, 186

Gauguin, Emil (son): appearance, *186*, 251; birth, 55, 68; bust, *61*, 62, 63, 244; childhood and education, 71–72; father's visit, 185–87, 243; godfather, 56; naval career, 183, 251; portrait as a baby, 57

Gauguin, Guillaume (grandfather), 15–19
Gauguin, Jean-René (son), 68, 186
Gauguin, Marcel Tai (grandson), 290
Gauguin, Marie (sister), *see* Uribe
Gauguin, Mette (Gad, wife): appearance, 49–53, 72, 185; bust of, *61*, 62, 185; career, 50, 78–79, 184; character, 50–52, 184–85, 236; children, 55, 68, 70, 72, 80, 82; cigar smoking, 185; death of daughter Aline, 293, 296–97; death of son Clovis, 297, 322; divorce concerns, 72, 183–84, 187; dress, 52, 185; engagement, 52–53; exhibition of Gauguin's work in Copenhagen, 242–45, 249, 250; family background, 50, 56, 78, 80, 183; fear of the dark, 184, 243; finances, 68, 71, 80, 105, 115, 184, 249–51, 268, 280; first meeting with Gauguin, 49–51; Gauguin's visits to Denmark, 185–87, 243; health, 95; homes, 58, 70–72, 77–79, 184, 186; letters from Gauguin, 84, 90, 95, 105, 111, 114, 183, 192, 201–2, 222, 241, 242, 249–50; letters to Gauguin, 84, 95, 111, 183–84, 249–50, 280, 322; marriage, 53–54, 63, 66, 71–72, 78–79, 82, 135, 161, 163; move to Denmark with whole family, 77–79; Paris visit and meeting with Gauguin, 105; portraits, 57–58, 71–72, 73, 77; power of attorney for Gauguin, 105; return to Denmark, 72; sale of Gauguin's works, 105, 243, 250, 268; sale of paintings from Gauguin's picture collection,

391

INDEX

82, 184, 249–50, 268; separation from Gauguin, 82, 84, 87, 94–95, 183–84; social life, 67–68, 184

Gauguin, Paul: appeal against sentence, 360; in Arles with Vincent, 126–40; arrival in Tahiti, 194, 197–201; arrival on Hiva Oa, 324–25; attacked and injured at Concarneau, 269–70, 292; auction at Hotel Drouot (1891), 182; auction at Hôtel Drouot (1895), 280–81; birth, 5; birth of daughter Tahiatikiaomata, 342; birth of son Émile, 319; births of children, 55, 68, 70, 265, 293, 319, 342; buying land and building house in Punaauia, 299–300; buying plot of land for house in Atuona, 327–29; career as salesman in Denmark, 77, 78; career in merchant navy, 38, 39–41; career in stocktrading, 45–47, 58, 60, 63, 70; care of children, 71–72, 80–84; childhood, 1, 6, 8–11, 15, 17–21; death, xiii, 360, 362; death of baby daughter, 293; death of daughter Aline, 293, 296–97, 302; death of son Clovis, 297, 322; death of Uncle Zizi and inheritance from him, 249–51; in Dieppe, 82–83; drawing master for Goupil family, 309–11; drawing obsessively, 55–56; education, 18, 19, 21–24, 35, 37–38, 49, 219; employment and lodgings in Papeete, 312–13; engagement and marriage, 52–54; exchanging self-portraits with Vincent van Gogh, 123–26; exhibition at Kunstforeningen, 79–80; exhibition in Copenhagen (1892), 242–45, 249; exhibition in his gallery, 272–73; exhibition in Norway, 77; exhibition in Paris at Durand-Ruel's gallery, 249, 251–53, 255, 258, 281; family background, 1–5, 7–9, 17; father's death, 6, 35; finding somewhere to live on Tahiti, 206–8; first attempts at painting, 49, 55–56; first meeting with Mette, 49–51; first sexual relationships, 39–40; grave, 273, 362–63; Groupe Impressioniste et Synthésiste exhibition, 150–51; in hospital in Papeete, 222–23; house in Atuona (Maison du Jouir), 328–30, 336–41; illness and in Papeete hospital, 321–22; illness and suicide attempt, 305–6; influence and reputation; discovery and analysis of teeth, xiv, 288–90; investment scheme, 300–301; job as caretaker, 229; job-seeking, 70, 83, 312; journalism, 313–17, 321; journey to Marquesas Islands, 323, 324; journey to Panama, 104–5; journey to Tahiti, 188, 193–94, 197–98; journey to Tahiti (1895), 284, 285–86; judge of singing competition, 353; lawsuit against Marie Poupée, 268, 271; learning Tahitian, 205–6; learning to sculpt, 58, 60; legal aid for islanders, 335, 341, 354–55, 357–58; legal guardians, 18, 35; in Le Pouldu, 156, 158–70, 172–73, 176, 265, 267–68; libel case and sentence, 359–60; living in Mataiea, 208–14, 224, 232–40; London visit, 83; Madagascar plans, 173–74; on Martinique, 108–11; member of "Manet gang," 64, 74; move to Pont-Aven, 90–100; move to Rouen, 70–71, 77; move to Vaugirard home, 58, 60; in Orléans, 15, 16–21; Pahura in Punaauia, 313; Pahura's pregnancy, 292; painting accepted by Salon (1876), 58; painting with Pissarro, 66; in Panama, 106–8; in Papeete hospital, 301; in Paris, 26, 34–37, 177; Paris Exposition Universelle (1900), 320–21; pasting up posters, 83, 84; in Peru, 7–15; plans for return to Europe, 354; at Prado's execution, 146–47; protests on behalf of islanders, 333–36, 359; publishes his newspaper (Le Sourire), 318–19; relationship with Pahura, 291–92, 323; relationship with Tehamana, 232–37, 291; relationship with Tohotaua, 349; relationship with Vaeoho Marie-Rose, 341, 342; renting land for hut in Punaauia, 290–91, 299; returning to Pont-Aven, 170; return to Le Pouldu, 267–68; return to Papeete, 286–88; return to Paris, 82, 101–4, 111–16, 140; return to Pont-Aven, 116–21, 268–71; return to Punaauia and repairing house and garden, 314; return voyage from Tahiti, 245, 248; reviews of work, 63, 64, 69, 71, 116, 182, 244–45, 253; sale of house and land, 322–23; school of followers in Pont-Aven, 100; Spanish conspiracy, 77, 83; speech on Chinese immigration, 317–18; stock market crash (1882), 70; studio, exhibition space and social salon at 6 Rue Vercingétorix, 255–57; studying Polynesian history, 226–29; on Taboga island, 108; teaching at Colarossi's Académie, 256–57, 262; Tehamana's pregnancy, 245, 247, 291; travelling in Tahiti, 229–32; trial of attackers, 271; Vincent's ear-cutting incident, 139–45, 147, 160, 225; visiting Exposition Universelle (1889), 151–53; visit to Denmark, 185–87, 243; wartime experiences, 41–44; weekly Thursday *salon* (Studio of the South Seas), 258–62; work shown at Impressionist exhibitions, 63–64, 69, 85, 87, 101; writing *Avant et après*, 358; writing *L'Esprit moderne et le catholicisme (The Modern Thought and Catholicism)*, 302–3, 358; writing *Noa Noa*, 253–55, 263

CARVINGS: *Be Amorous and You Will Be Happy* (wood panel), 172; carving of Hina and Fatu,

392

INDEX

252–53; carvings destroyed, 323; clogs, 117, 176; decorative panels carved for the entrance of Maison du Jouir, 338–39; figure of a black, kneeling Virgin Mary, 176; *Idol with Pearl*, 252–53; *Idol with Shell*, 252–53; *La Toilette*, 101; narrative panels, 176; *Père Paillard (Father Lechery)*, 337, 338–39, 362; reviews, 253; *Thérèse*, 337, 339, 362; walking sticks, 253; wood carving, 49, 104

CERAMIC and PLASTER WORKS: *Anthropomorphic Pot*, 160; "barbaric" clay vases, 314; early work, 58, 100–101; exhibition (1903), 104; influence, 104; *Oviri* statue, 273–74, 274, 277, 283; *Oviri* statue (bronze version on grave), 363; partnership plan, 111; portrait pot of Louise, 114; pots, 101–3, 102, 314; sale of pieces, 103, 105, 115–16; *Self-Portrait in the Form of a Jug*, 147, 273; *Self-Portrait Oviri* bas-relief (plaster and bronze version), 274–75; signatures, 274; work, 100–104

FINANCES: borrowing money for home in Punaauia, 299, 300, 319, 323; building house in Atuona (Maison du Jouir), 328–30, 336; buying land in Atuona, 327; buying pictures, 60, 62, 64; buys duplicating machine, 318; care of children, 71–72, 80–84, 87, 104–5, 186–87; classified as "indigent," 301, 312; cost of canvases, 172, 267, 306; cost of frames, 251–52; cost of paints, 172; damages for attack injury, 271; debts, 70, 77, 90, 126, 170, 176, 248; earnings as caretaker, 229; earnings as drawing master, 309, 311; earnings from giving painting lessons, 156, 206, 256–57; earnings from journalism, 313, 314–15, 319; earnings from pasting posters, 83, 229; employment as assistant draughtsman in the Department of Public Works, 312; exhibition expenses, 251; extravagance, 60, 67–68; gifts from pirate, 225, 229; hospital expenses, 222, 224; inheritance from Uncle Zizi, 249–51, 281, 299; investment scheme, 300–301; job-seeking, 70, 71, 77, 83, 104–5, 107, 173, 224, 312; journey to Tahiti, 121, 175–77, 182, 188; life insurance, 77; living expenses in France, 250; living expenses in Hiva Oa, 326; living expenses in Martinique, 109; living expenses in Pont-Aven, 90; living expenses on Tahiti, 211, 213–14, 222, 224–25, 319; loan to Morice, 222, 254; medical expenses, 222, 224, 271, 301, 312; paintings left with Marie Poupée, 176; Panama labouring work, 108; portraits commissioned, 206, 308–9; refused credit, 304; renting furniture, 83; repatriation issue,

225, 229, 245, 248; returning grant from Ministry of Culture, 301; salary and bonus, 45, 46, 60, 67–68; sale of his gun, 225–26, 308; sale of house and land in Punaauia, 322–23, 326; sale of pictures from his collection, 80, 83, 101, 105; sale of works, 64, 105, 115–16, 126, 140, 172, 176, 182, 188, 206, 243–45, 253, 255, 280–81, 300, 319–21, 351; sending money to wife, 115; staying in Arles with Vincent, 122, 123; stock market crash, 70; syndicate scheme, 300–301; tax protest, 335–36; wife's earnings, 80; wife's sale of paintings, 244, 249–51; wife's sale of pictures from his collection, 249–50

HEALTH: angina, 103; bedbound, 270, 271; depressed, 159; despair, 187–88; diet, 83–84, 100, 103, 213–14, 292, 300, 304, 350; DNA, 290; dysentery, 109–11; eyesight, 129, 298–99, 318, 351, 358, 360; fever, 301; foot sores, 288; heart, 214, 222, 305, 321–22; hepatitis, 111; homeopathy, 109; hospital in Paris, 103; hospital in Pont-Aven, 270; hospital on Tahiti, 222–24, 288, 298, 301, 304, 312, 322–24; laudanum, 358, 360; leg injury, 270–72, 284, 301; legs, 222, 321–22, 351; limping, 271, 272, 301, 354, 357; lungs, 222, 321–22; malaria, 108–11; morphine, 270–73, 301, 306, 358, 360; physical collapse, 101, 103; restored in Pont-Aven, 100; skin problems, 272, 288, 301; stomach pains, 111, 116; suffocating fits, 303–4; suicide attempt, 305–6, 323; syphilis story, xiii, 288, 290, 302; teeth, xiii, 288–90; venereal disease, 284; vomiting blood, 304

PAINTINGS, PRINTS and DRAWINGS: bedbound art, 270; brushstrokes, 64, 67, 76, 96, 100, 116, 130, 346; canvases, 66, 193, 251–52, 267, 306, 313, 320; canvas treatment, 143, 320; cartoon of Lascascade, 224; cartoons in *Le Sourire*, 318–19; catalogue raisonné, xiv, 365; copra sacking, 306, 320; copying Cezanne, 67, 72, 76; copying Delacroix, 77; copy of Manet's *Olympia*, 28, 280; decoration of the Buvette de la Plage, 165–69; dog fox symbolism, 13–15, 169, 172, 179, 306, 323, 346; drawing of Mary Magdalene in the brothel, 302; drawing of Virgin Mary with the newborn Christ child, 302; early works, 49, 55–58; experiments with space, 100; flower paintings, 57, 79, 314, 322; frames, 79, 251–52, 255; geese, 98–99, 101, 152, 166, 307; landscapes, 49, 56–57, 63, 71, 72, 79, 83, 85, 110–11, 148, 210, 244–45, 263, 268–69, 321, 349–50; nudes, 63–64, 96, 160–61, 170–71, 242, 267, 292; paintings

393

INDEX

destroyed, 323; paintings of children, 57, 96–97, 223; paints, 79, 127, 193, 320, 342; pointillism experiment, 86; preparation of Tahitian paintings for exhibition, 251–52, 256; preparation of works for exhibition, 272; printmaking, 148; reviews, 63, 64, 69, 71, 116, 182, 244–45, 253; signatures, 123, 274, 297; signatures forged, 106; sketchbooks, 98–99, 110–11, 146, 152–53, 206, 286; sketches destroyed, 323; sketches of *porteuses*, 109–11; spatial anarchy, 67; still lifes, 56–57, 63, 86, 137–38, 314, 327, 349; tree motif, 120; use of colour, xiv, 83, 93–94, 111, 115–16, 119–20, 123–24, 130, 148, 152, 156–57, 210–11, 230, 233–34, 241, 252, 255, 264, 268–69, 281–83, 292, 346, 350; woodblock prints, 263–64, 270, 321; zincographs, 148, 150–51; works: *Abandoned Garden*, 72; *Aha oe feii? (Are You Jealous?)*, 235, 243; *Aita tamari vahine Judith te parari (The Child-Woman Judith Is Not Yet Breached)*, 265–67, 266; *Aline*, 7; *Arearea*, 1, 190–91, 192; *Atiti*, 223; *Barbarian Tales*, 346, 348, 349; *Blue Roofs, Rouen*, 72; *Breton Women Chatting*, 99, 99; *Christ in the Garden of Olives*, 160; *Clovis Asleep*, 76, 76–77, 118, 241, 265; *Conversation (Tropics)*, 116; *Exotic Eve*, 161, 162; *In the Forest, Saint-Cloud I*, 56; *Fruit-Picking* or *Mangoes*, 115; *Fruit Porters at Turin Bight*, 110–11, 112–13; *The Grape Harvests*, 143; *The Green Christ*, 160; *Group with Angel*, 342; *Haere mai - Come Here*, 235; *Hina Tefatou (The Moon and the Earth)*, 253; *Ia orana Maria (Hail Mary)*, 24, 219–21, 220, 271; *Ictus*, 160–61; *I raro te oviri (Under the Pandanus)*, 243; *The Kelp Gatherers*, 164; *Leda and the Swan* (zincograph), 148; *Les Alyscamps*, 130, 131; *Life and Death*, 170, 172, 187, 244; *The Loss of Virginity*, 14, 179, 187; *Mahana maa - Saturday*, 235; *Manaò tupapaú (Spirit of the Dead Watching)*, 241–43, 242, 267, 271; *The Man with the Axe*, 215, 216–18, 271; *Maruru* (woodcut), 264; *Matamoe (Death)*, 214; *Matamua*, 230, 231; *Merahi metua no Tehamana (Tehamana Has Many Parents)*, 246, 247, 343; *Mette Asleep on a Sofa*, 57–58, 72; *Mette in Evening Dress*, 72, 73, 77; *Mother and Child*, 342; *The Moulin du Bois d'Amour Bathing Place*, 93, 95–98, 96–97, 110; *Nafea faaipoipo - When Will You Marry?*, 235; *Nativity*, 342; *Nave nave mahana (Delicious Days)*, 292–93, 294–95; *Nevermore*, 296, 320; *Night Café, Arles*, 136; *Noa Noa Suite* (woodcuts), 263–65, 264, 270; *No te aha oe riri (Why Are You Angry?)*, 293; *The Painter of Sunflowers*, 138; *Pape mo - Mysterious Waters*, 235; *Parahi te marae (Temple place reserved for worship of the gods and human sacrifice)*, 243; *Parau api - News*, 235; *Parau parau (Word, Word)*, 243; *Paris in the Snow*, 263, 263; *Portrait of Jeanne Goupil*, 308–9, 309; *Portrait of Meyer de Haan*, 166, 167–69, 172; *Portrait of Stéphane Mallarmé* (etching), 181, 182; *Riders on the Beach*, 335; *Riders on the Red Beach*, 335; *Riverside*, 115; *Round Dance of the Breton Girls*, 88–89; *Ruperupe (Luxury)*, 321; *Self-Portrait*, 359, 361; *Self-Portrait (Near Golgotha)*, 297–98, 298, 323; *Self-Portrait at the Easel*, 80, 81, 244; *Self-Portrait Dedicated to Van Gogh, Les Misérables*, 123–26, 124, 160; *Self-Portrait with Halo and Snake*, 166, 167, 211; *Self-Portrait with Hat*, 267; *Self-Portrait with Idol*, 267; *Self-Portrait with Yellow Christ*, 160; *The Sorcerer*, 346, 347, 349; *Sower with Setting Sun*, 120, 129; *Still Life with Horse's Head*, 86; *Sunflowers on a Chair*, 143; *Suzanne Bambridge*, 206–7, 207; *Ta matete (In the Market)*, 315, 316; *Te Arii Vahine (The King's Wife)*, 30, 292, 293; *Te Faaturuma (Silence)*, 243, 253; *Te fare maorie (The Maorie Dwelling)*, 243; *Te raau rahi (The Great Tree)*, 235, 243; *Te Rerioa (The Dream)*, 293; *Te tamari no atua (The Son of God)*, 293; *Vahine no te tiare (Woman with a Flower)*, 211, 212, 243; *Vahine no te vi (Woman with a Mango)*, 280; *The Vision of the Sermon*, 118–21, 119, 122, 123, 160; *In the Waves/Ondine*, 170–72, 171, 187; *Where Do We Come From? What Are We? Where Are We Going?*, 24–25, 304–5, 306–7, 314, 319, 320; *The White Horse*, 310, 311; *Woman Sewing*, 63–64, 65, 68, 69, 243, 244; *Women Bathing*, 244; *Working the Land*, 49; *The Yellow Christ*, 160; *Young Girl with a Fan*, 343, 344, 346

PERSON; agitated, 129; alter egos, 14–15, 53, 268, 270, 273–74, 306, 316; appearance as a sailor, 41, 94, 301; appearance at forty-two, 185, 186; appearance in Paris (1893-4), 256; beard, 38, 301; boxing, 41, 47, 116, 121; Buffalo Bill kit, 151, 161, 199, 267; "built like a Hercules," 256, 282; charisma, 8, 19; childhood appearance, 8, 19; clogs, 35, 68, 117, 164; collection of "little friends" (postcards and photographs), 193, 211, 286, 292, 323; cooking, 109, 134, 292; cowboy boots, 151, 199, 284; diet, 83–84, 100, 103, 213–14, 292, 300, 304, 350; distant, 98; DNA, 290; dress, 34–35, 94, 185, 206, 252,

394

275, 301, 357; drinking, 136–37, 271, 288, 292; eyes, 38, 80, 123, 256, 282, 298–99, 301, 359; fencing, 37–38, 116, 121; hair, 38, 161, 185, 199–200, 206, 239, 256, 282, 301, 323; height, 35, 38, 41, 94; humour, 41, 94, 99, 159; "hungry wolf without a collar," 273; identifying with Jesus, 159–61, 297, 302, 362; languages, 18, 19, 23, 77, 78, 186, 205–6, 285, 326; limping, 271, 272, 301, 354, 357; low forehead, 94; manners, 19, 35, 46; music, 74, 75, 104, 165, 176, 180, 205, 222, 259, 282, 340; musical instruments, 75, 165, 176, 193, 255, 259, 276, 292, 323, 324, 328–29, 340, 359; nose, 38, 41, 80, 185, 297; photography, 275; pseudonyms, 86–87, 316, 317; relaxing, 98; "savage from Peru," 18–19, 23, 35, 38, 40, 179, 302; self-contained and confident, 46, 94; self-portraits, 34, 80, *81*, *124*, *147*, 159–60, *166*, 211, 267, 297, 302, 359, *361*; silent, 46, 94; smile, 256, 282; sociable introvert, 330; swagger, 189, 297; swimming, 41, 98, 121, 270; swordsman, 38, 46; synaesthesia, 74, 75, 180; tastes, 46–47; teaching, 121, 156–57, 164, 170, 194, 205, 206, 222, 256–57; teenage appearance, 35, 38; teeth, xiii, 288–90; tidiness, 127, 301; walking stick, 271, 301, 351, 354; "wild gaze," 83; wrestling, 41

RELATIONSHIPS; agent (Chaudet), 281, 300, 319, 321; agent (Joyant), 245, 249; agent (Lévy), 281, 300; agent (Theo van Gogh), 115–16, 122, 150; agent (Vollard), 262, 319, 321, 341, 342, 351; business manager, 177; children, 57, 68, 70, 71–72, 76–77, 80–84, 95, 183, 185–87, 192, 243, 265, 293, 296–97, 319; divorce concerns, 72, 183–84, 187; followers (disciples), 98, 100, 106, 121, 150, 156–57, 161, 163, 173–74, 179, 256, 261; friendship with Ky Dong, 326, 350, 352, 358, 359; friendship with Strindberg, 258, 260–61, 276–78; friendship with Vernier, 352–53, 360, 362; legal guardians, 18, 35; Marquesan community in Atuona, 329–30, 335–36; membership of Cercle Militaire, 202, 203, 312, 322; name-brother relationship with Tioka, 329–30, 350, 353, 357, 362; relationship with Annah la Javanaise, 262, 265, 267–69, 272; relationship with Arosa, 31, 35–38, 45, 47, 53, 63; relationship with Jotepha, 214–19; relationship with Juliette Huet, 187–88, 265–66; relationship with mother, 32, 35, 37, 38, 45, 358; relationship with Pahura, 291–92, 314, 323; relationship with sister, 17–18, 35, 82, 83, 87, 107, 249, 251; relationship with Tehamana, 232–37, 291; relationship with Titi, 207–8, 210, 257; relationship with Vaeoho Marie-Rose, 341, 342; relationship with Vincent van Gogh, 122, 126–27, 129–30, 132–34, 136–40, 142–44, 148, 172–73; sexual relationships, 39–41, 63, 94–95, 126, 185, 187–88, 207–8, 262, 265, 268, 349; Tahitian communities, 205–6, 211, 213–14, 219, 238–40, 291–92, 302, 312

SCULPTURES; bust of Emil, *61*, 62, 63, 244; bust of Mette, 61; Gauguin's work, 103; learning to sculpt, 58, 60, 62; review, 63; signatures, 274

VIEWS: of "civilisation," 30, 90, 286–87, 306–7, 314, 322, 332, 340, 359; of colonialism, xiii–xiv, 2, 198–99, 206, 230, 303, 308, 315–16, 330, 333–37, 343, 352, 358; of indigenous people, xiv, 2, 30, 161, 221, 285, 343, 349; of labelling, 153, 182–83, 247; of meaning of life, 363–64; of pointillism, 86–87; political activism, 2, 313, 316–18, 330, 333–36, 354–55, 357–60; of religion, xiv, 117, 219, 228–29, 261, 302–3, 320–21, 352–53, 364; symbolism, 14–15, 118–20, 123–25, 166–69, 218–19, 247, 302, 311, 343; of women, xiv, 161, 163, 182–83, 236, 275, 303, 311, 317; world art, 151–53

WRITINGS: *Ancien culte mahorie*, 226; *Avant et après*, xiii–xiv, 236, 279, 318, 358–59, 363–65; *Cahier pour Aline*, 150, 313–19, 325; journalism, 2, 150, 313–19, 325; *Le Sourire* (*The Smile*) (newspaper), 318–19, 325, 346; *L'Esprit moderne et le catholicisme* (*The Modern Thought and Catholicism*), 302–3, 353, 358; literary hoax, 86–87, 316; *Noa Noa*, 218, 235, 253–55, 259, 263, 281, 284, 318–19; notebook, 75–76, 98–99; *Paul Gauguin's Intimate Journals* publication; "The Pink Shrimps" (short story), xiv, 144; *Racontars de rapin* (*Ramblings of an Apprentice Artist*), 358

Gauguin, Paul Rollon (Pola, son): birth, 68, 70; birth certificate, 74–75; childhood, 70, 72, 186; description of Gad family, 78; description of his mother, 184

Gauguin, Zizi (Isidore, great-uncle): appearance, 20; career, 19–20; death, 249; finances, 18; guardianship of Paul and Marie, 19; house, 19–20; memories of Paul's childhood, 19–21; old age, 105; will, 249–51, 281, 299

Germaine (Gauguin's daughter by Juliette Huet), 265

Gide, André, 158–59

Ginoux, Monsieur and Madame, 126, 135–36

Gloanec, Madame, 92, 100, 170, 256, 268, 270

Gobineau, Arthur de, 154

INDEX

Goupil, Auguste, 225–26, 229, 308–9, 311, 316–17
Goupil, Jeanne, 308–9, 309
Goupil et Cie, 123, 245
Grelet, Louis, 343
Grétor, Willy, 260–61
Groupe Impressioniste et Synthésiste, 150
Les Guêpes (The Wasps)
Gauguin's alter egos, 316, 317; Gauguin's income from, 313, 314–15, 321; Gauguin's satirical writings, 2, 313–16, 325; mockery of Goupil, 316–17; political news-sheet, 313; popularity of Gauguin's work, 315, 325; proprietor, 313;
Guichenay, Étienne, 359

Haapuani, *taua* (magician) of Atuona, 346–49
Hapa, chief of village on Hiva Oa, 340
Hartrick, Archibald S., 46, 93
Haussmann, Georges-Eugene, 26–28, 46, 58, 199
Heegaard, Marie, 51–52
Heegaard, Mrs (mother of Marie), 71
Henry, Charles, 85
Hiva Oa island: Bastille Day celebrations, 353; capital, *see* Atuona; Catholic boarding schools, 331, 334–35, 341; corruption of gendarmes, 335, 354–55; discovery of Gauguin's teeth, xiii, 288, 289; French colonial administration, 354–58; Gauguin's arrival, 324–25, 358; Gauguin's death, xiii, 288, 362; Gauguin's friendship with Ky Dong, 326; Gauguin's house, xiii, 288, 289; Gauguin's legal aid for islanders, 335, 341, 354–55, 357–58; informal local parliament on the beach, 335, 354; landscape, 324, 327, 356–57; language, 334–35; magistrate's job, 224; mail boats, 351; medical care, 352; no-no fly infestation, 288; polyandry, 336; taxation, 335–36, 357; *see also* Marquesas Islands
Hokusai, 198, 324
Horville, Judge, 357, 360
Huet, Juliette, 187–88, 265–66
Hugo, Victor, 26, 108, 123, 146
Huysmans, Joris-Karl, 64, 69, 86, 157

Ibsen, Henrik, 260
Impressionism: Arosa's art collection, 32, 47–48; brushstrokes, 27, 86; Durand-Ruel's support, 66, 252; exhibition (1874), 62; exhibition (1876), 99; exhibition (1879), 63; exhibition (1880), 63; exhibition (1881), 63–64, 68; exhibition (1882), 69, 101; exhibition (1886), 84–87, 101; frames, 79; Gauguin's art collection, 60, 63, 249; Gauguin's status, 18, 27, 56; Gauguin's work exhibited, 63–64,

68–69, 85, 87, 101; Groupe Impressioniste et Synthésiste, 150; New York, 84, 251; Norway, 77; Nouvelle Athenes café group of Impressionists, 64, 94, 177; painting out of doors, 27, 55–56; Pissarro's work, 62, 63, 66; Pont-Aven artists' response to, 93–94; Salon attitude to, 58, 62; "scientific Impressionism," 85; way forward from, 114–15

James, Henry, 46, 154
japonisme, 100
Jarry, Alfred, 270–71
Jénot, Paulin: friendship with Gauguin, 205–6, 222, 287; Gauguin's arrival on Tahiti, 200, 202, 325; painting lessons from Gauguin, 194, 205, 222; portrait of Swaton, 194; posted away from Tahiti, 287
Jérôme-Napoléon (yacht/warship), 41–42, 44
Jörgensen, Johannes, 277
Jotepha (young man on Tahiti), 214, 216–19
Jourdan, Émile, 269

Kahui (Gauguin's cook), 342, 350
Kekela, Samuel, 329
Koning, Arnold, 115
Kon-Tiki expedition, 235
Ky Dong (Nguyen Van Cam), 325–26, 350, 352, 358, 359

Lacascade, Étienne Théodore Mondésir, Governor: appearance, 201; eulogy at king's funeral, 205; Gauguin's repatriation, 225, 229, 245, 248; relationship with Gauguin, 201, 224–25; returning to France, 248; role on Tahiti, 200–201, 204
Laval, Charles: appearance, 106; character, 163, 174; death, 163; engagement, 163; illness, 108–11, 173–74, 261; journey to Martinique, 108–9, 261; journey to Panama with Gauguin, 106–7, 261; journey to Taboga, 108; living on Martinique with Gauguin, 109–11; painting styles, 106; Panama journey, 106; relationship with Gauguin, 98, 106, 110, 116–17, 120, 173, 261; return to Pont-Aven, 116–17; suicide attempt, 110, 117; Synthetist movement, 157; Volpini exhibition, 150, 157
Le Bon, Gustave, 154
Leclercq, Julien, 189, 192, 258, 262
Le Pouldu: accounts of Gauguin's group, 158–59, 161, 165; Buvette de la Plage, 164–67, 169, 224, 268, 340, 349; De Haan's arrival, 163–64; Gauguin's arrival, 156; Gauguin's debts, 176, 265; Gauguin's disciples, 156, 160, 161, 256;

INDEX

Gauguin's pictures, 160–61; Gauguin's return, 267–68; Gauguin's view of, 170, 268; Van Gogh's planned visit, 172–73
le Roux, Petrus, 290
Lesseps, Ferdinand de, 106–8
Les Vingts group, 121, 140
Lévy (agent), 281, 300
Lima, 5, 7, 9–13, 307
London, 3–5, 83, 196–97
Loriol Institute, 37–38
Loti, Pierre (nom de plume of Julien Viaud): account of Tahiti, 153–55, 197, 211, 219, 253, 321; belief in "science of race," 154; career, 153–54; death, 154; Gauguin's opinion of, 133, 174, 233, 253–54; *La Livre de la pitié et de la mort*, 154; *Madame Chrysanthème*, 130, 132, 153; *Le Mariage de Loti*, 153–54, 174; popularity and status, 154, 155, 189
Louise, Sister, 219
Lugné-Poë, Aurelien, 260
Luzitano (passenger ship), 38–40

Mai (Tahitian traveller to Europe), 196–97
Mallarmé, Stéphane: appearance, 179–80; concept of symbolism, 180–81, 254, 265; *Mardis* (Tuesday salons), 179, 182, 189, 258; poetry recited by Synthetists, 157; portrait by Gauguin, 181, 182, 242, 293, 353; relationship with Gauguin, 159, 181, 182, 189, 192, 253, 265, 300; synaesthesia, 180–81; "The Tomb of Edgar Poe," 192; translation of Poe's *The Raven*, 182, 293; works: *L'Après-midi d'un faune*, 181–82, 353; *Un coup de dés jamais n'abolira le hasard* (*A Throw of the Dice Will Never Abolish Chance*), 180
Manet, Édouard: Exposition Universelle (1889), 150; Gauguin's copy of *Olympia*, 28–29, 280; Gauguin's photographs of his works, 28–29, 193, 256; influence on Gauguin, 28–30, 96, 253, 283; paintings in Gauguin's art collection, 64, 80; relationship with Gauguin, 64; "the Manet gang," 64, 74; wartime experiences, 43; works: *Luncheon on the Grass*, 96; *Olympia*, 28–30, 29, 43, 58, 193, 211, 262; *Vue de Hollande*, 64
Mani-Vehbi-Zunbul-Zadi (pseudonym of Gauguin), 86–87, 316
Marquesas Islands: American contact, 330–31; Catholic repression of Polynesian culture, 331–33; Cook's arrival, 330; French annexation, 331; French Catholic missionary activities, 331–32; Gauguin's arrival, 324–26; Gauguin's attack on French colonial rule, 333–34; Gauguin's journey to, 322, 323; Gauguin's political activism, 330, 333–36, 354–55, 357–60; governor's report on barbarian debauchery, 332–33; houses, 328; language, 326, 334–35; marriages, 336–37; missionaries, 327, 328, 331, 336–37, 343, 349, 352; name, 330; population, 331; Spanish conquest, 330; *see also* Atuona; Hiva Oa
Martin, Joseph, Bishop, 327, 331, 337, 362–63
Martinique: colonial history, 108; Gauguin's arrival, 108–9; Gauguin's experiences, 111; Gauguin's illness, 109–10; Gauguin's work, 115, 150, 153, 244; landscapes, 161; Laval's experiences, 108–11, 163, 173, 261; Laval's return, 116–17; *porteuses*, 109–11, 148, 153
Marx, Karl, 1
Mataiea village, Tahiti: churches, 209; Gauguin's hut, 208–9; Gauguin's landscapes, 210; Gauguin's move to landlord's house, 224; Gauguin's relationship with community, 219; Gauguin's relationship with Tehamana, 291; Gauguin's return to, 229, 232; landscape, 208, 209; population, 208; railway project, 316
Matisse, Henri: discovery of "primitive" and "tribal" art, 32; Gauguin's influence, xiv, 224, 321; *Luxe, calme et volupté*, 321; use of colour, 350; view of Gauguin's ceramics, 104
Maugham, W. Somerset, 224
Mendana, Álvaro de, 330
Mercure de France, 244–45, 358
Milton, John, 167, 347
Mirbeau, Octave, 116, 182, 253
Le Moderniste illustré (avant-garde magazine), 150
Moerenhout, Jacques-Antoine, 226–30, 308
Molard, Ida, 257–58, 267, 272, 274
Molard, Judith, 257–59, 267
Molard, William, 257–59, 267, 272, 281, 300
Moltke, Countess, 71–72
Monet, Claude: flower paintings, 129, 314; *Impression: Sunrise*, 62; Impressionist exhibitions, 62, 84; Norway visit, 56; painting on Belle Île, 92; painting out of doors, 27; relationship with Durand-Ruel, 48; Rouen cathedral paintings, 71; skyscapes and water studies, 16; Theo van Gogh's sales of his work, 116; view of Gauguin's work, 104; work collected by millionaires, 252; works in Gauguin's art collection, 60; works rejected by Salon, 62
Moréas, Jean, 177
Moret, Henry, 98
Morice, Charles: career, 178; finances, 222, 254, 319; introduces Gauguin to Mallarmé, 182;

397

INDEX

introduction to Durand-Ruel exhibition, 255; *Noa Noa* collaboration, 254–55, 263, 281, 284, 319; relationship with Gauguin, 178, 182, 188–89, 254–55, 261, 272, 302, 319
Mucha, Alphonse, 83, 256, 258, 261, 275
Mueller, William A., 289
Munch, Edvard, xiv, 56, 151, 243

Nabis, xiv, 157, 261, 265, 277
Nadar (photographer), 33, 43, 47–48, 193, 275
Napoleon, Jérôme (Prince Plon-Plon), 41–42
Napoleon III (Louis Napoleon), Emperor, 1, 26, 42, 148
Natanson, Thadée, 253
New Zealand, Auckland Museum, 285–86, 286
Nizon, Church of Saint-Amet, 120–21, 160
Nordman, Axel, 322–23

L'Océanie française (Tahitian newspaper), 225
Océanien (steamer), 193
O'Conor, Roderic, 268, 269, 273
Offenbach, Jacques, 33, 39
Ofili, Chris, 30
Orléans: Aline and Marie move to Paris, 21, 32; cityscape, 16; climate, 16; Gauguin's childhood, 16–21, 49, 104, 230; Gauguin's education, 18, 19, 21, 38, 219; Gauguin's family background, 15–17, 19–20, 35, 249
Orsolini, Charles, 60

Pahura (Pau'ura a Tai): age, 291; baby daughter's birth and death, 293; birth of son Émile, 319, 342; character, 292; family, 291, 304, 323, 329; housekeeping, 292, 301, 304; Motherhood series, 292–93; move back to Punaauia house, 313, 314; move to Papeete lodgings, 312; *Nave nave mahana*, 292–93, 294–95; *Nevermore*, 296; nursing Gauguin, 301–2; pregnancy, 292; relationship with Gauguin, 291–92, 314, 323; social life, 292; *Te Arii Vahine* (*The King's Wife*), 292, 293
Painters of the Petit Boulevard, 114–15
Palladino, Eusapia, 278
Panama: Canal, 5, 104, 106–8, 202; climate, 104; Gauguin's career plans, 104–8; Uribe's career, 104, 106, 107
Papeete city: architecture, 198–99; Caisse Agricole de Papeete, 299, 312; capital of Tahiti, 198; Catholic Cathedral, 221; Cercle Militaire, 202, 203, 312, 322; Chinatown, 202–3; colonial behavioural code, 208; electric lighting, 286–87, 290; French administration, 198–201; Gauguin's arrival, 198–201, 239;

Gauguin's employment, 312, 313; Gauguin's friendships, 222–23; Gauguin's lodgings, 201, 287–88, 312; Gauguin's return, 286–87; Gauguin's speech, 317–18; Gauguin's view of, 198–99, 205, 206, 290; harbour, 198, 324; hospital, 222, 288, 324; mail boats, 222, 300; market square, 316; mayor, 313; politics, 313, 317–18; railway plan, 316; royal palace, 203, 287; social circle, 206; tax collection, 336; *see also* Tahiti
Paris: Académie Vitti, 262; Aline in, 21, 26, 28, 30–35, 42; balloonists, 33, 43; Bourse, 32, 33, 45–48, 58, 63, 83; Café des Variétés, 272; Café Voltaire, 177, 179, 187, 189, 192; Colarossi's Académie, 256–57, 262; *L'Écho de Paris*, 182, 281; Eiffel Tower, 108, 148–49, 151; Exposition Universelle (1889), 148–53, 181; Exposition Universelle (1900), 320, 321; fashion, 33–34, 275; Franco-Prussian war, 42, 43–44, 46; Gauguin's arrival, 26; Gauguin's studio, exhibition space and social salon at 6 Rue Vercingétorix, 255–56, 272–73, 299; Haussmann's modernisation, 26–28, 31, 46; Hotel Drouot, 182, 280, 281; Madame Charlotte's Cremerie, 256, 261, 276; "new Babylon," 26, 32, 33, 35; Northern Lights, 259–60; Nouvelle Athenes café, 64, 94, 177; occult and symbolist circles, 276–78; Palais des Beaux Arts, 149–50; railway lines, 27; Rue Cail, 83, 87; siege (1870-1), 43–44; Sorbonne University, 278; stock market crash (1882), 70; women's professions, 30
Paul Gauguin, SS (cruise ship), 288–89
Peru: Aline's pre-Columbian art collection, 13, 15, 32–33, 44; ceramics, 101, 114, 216; education, 9; Gauguin's childhood, 8–11, 15, 16, 23, 138, 290; Gauguin's family background, 5, 7, 11, 18; Gauguin's journey to, 1, 5–6; Gauguin's visit, 40; guano, 8, 11, 31; indigenous culture, 12–15; Moche dog fox, 13, 14–15, 169, 172, 179, 306, 323, 346; Moche pottery, 13, 13–14, 114, 226; mummies, 307; mythology, 13–15, 306; position of women, 11–12; president, 11, 35; slavery abolished, 11; slave traders, 331; sunflower symbol, 127
Petit, Édouard, Governor, 335, 358
Petit Séminaire de la Chapelle Sainte-Mesmin, 21–23, 26
Philipsen, Theodor, 243–44
Pia, Gaston, 206
Picasso, Pablo, xiv, 32, 104, 178, 262
Pissarro, Camille: appearance, 66; Arosa commission, 47; Arosa's art collection,

32, 56; Cézanne painting with, 67; family background, 47, 48, 66; *The Four Seasons*, 47–49; Gauguin asks for lessons, 62; Gauguin painting with, 67, 74; Gauguin's art collection, 60, 63, 83; homeopathy, 109; Impressionist exhibitions, 48, 62, 63, 84–85; painting in Rouen, 71; relationship with Durand-Ruel, 48, 66; relationship with Gauguin, 77, 109; relationship with Mette, 67; teaching Gauguin, 62, 66; teaching Marguerite Arosa, 47; view of Gauguin's work, 64, 71, 152; view of pointillism, 87; works traded by Theo van Gogh, 115
Pius IX, Pope, 22
Poe, Edgar Allan: Annabel Lee heroine, 42, 47; Gauguin and De Haan reading, 53; Gauguin's *Nevermore*, 320; Gauguin's portrait of Mallarmé, 181, 182, 353; Mallarmé's poem, 192; *Manaò tupapaú* (*Spirit of the Dead Watching*), 241–42; *Noa Noa Suite*, 265; notion of perfect beauty, 211; popularity, 145–46; *The Raven*, 182, 242, 293; reality and symbolism, 238, 254; Synthetist group's readings, 157
pointillism, 85–86, 114–15, 174, 177, 316
Politiken (Danish newspaper), 244
Pomare V, King, 203–5, 204, 287
Pont-Aven: artists' colony, 92–94, 97–98, 155–56; Bois d'Amour, 95, 126, 156; church, 120–21; "Gauguin gang," 98; Gauguin's debts, 126; Gauguin's followers, 100, 106, 150, 161, 256, 268; Gauguin's health, 270, 271; Gauguin's landscapes, 204, 268; Gauguin's returns to, 116, 268; Gauguin's sexual abstinence, 187; Gauguin's sketchbooks, 95; landscape and architecture, 91–92; *The Moulin du Bois d'Amour Bathing Place*, 95–98, 96–97, 110, 126; Pension Gloanec, 90, 92, 106, 116, 155, 170, 256, 270, 271; stone bridge, 92; Trémalo Chapel, 160
Post-Impressionism, 18, 157
Poupée, Marie (Henry): appearance, 164, 169; Buvette de la Plage, 164–65, 172–73, 268; career, 164–65; children, 175–76; deserted by De Haan, 175–76, 188; finances, 170, 176; Gauguin's and De Haan's interior decoration of the *buvette*, 165–68, 224, 340, 349; Gauguin's debts to, 176, 265; Gauguin's lawsuit for return of paintings, 268, 271; keeping Gauguin's paintings, 176, 265, 268, 271; lover of De Haan, 169, 187; marriage, 268; memories of Gauguin and De Haan, 165; pregnancies, 164–65, 175, 188
Poussin, Nicolas, 68, 95, 230, 253

Prado (conman and jewel thief), 145–46, 273, 358
La Presse, 63
Proudhon, Pierre-Joseph, 1
Proust, Marcel, 27, 51, 82, 154
Puigaudeau, Ferdinand Loyen du, 93–94, 98
Puvis de Chavannes, Pierre, 230, 253, 255, 306, 343

Raiatea-Tahaa, island, 287
Ranson, Paul, 157
Realism, 32, 36
Redon, Camille, 173
Redon, Odilon, 173, 273
Renoir, Auguste: last Impressionist exhibition, 84; painting out of doors, 27; *The Theatre Box*, 72; work collected by Gauguin, 60, 83; work collected by millionaires, 252; work exhibited at Durand-Ruel's gallery, 48, 252; work rejected by Salon, 62
La Revue blanche, 319
Reynolds, Sir Joshua, 197
Richmond (steamer), 286
Rimbaud, Arthur, 177, 179, 180
Rodin, Auguste, 58, 178, 275
Rohde, Johan, 243–44
Rothschild family, 31, 46, 70, 252
Rouart, Stanislas-Henri, 319
Rouen: Gauguin and two sons in, 72; Gauguin family in, 70–72; Gauguin leaves, 78; Gauguin's landscapes, 85, 244; Gauguin's notebook, 75–76, 98–99; Gauguin's still lifes, 137; Mette and two children leave, 72
Roujon, Henri (director of the Beaux Arts), 188, 283, 301
Roy, Louis, 150, 157

Sand, George, 6
Schneklud, Fritz, 262
Schuffenecker, Émile ("Schuff"): arranging Volpini exhibition, 150; artistic career, 48, 67, 112–13; background, 48; character, 48; finances, 67, 71, 112–13, 177; introducing Van Gogh brothers to Gauguin's Martinique pictures, 115; marriage, 114, 177, 261; relationship with Gauguin, 48–49, 55, 80, 82, 101, 105, 112–13, 170, 176–77, 189, 244, 261, 322; relationship with Mette, 67, 71, 105, 244, 251, 322; storing Gauguin's pictures, 244; Synthetist group, 157
Schuffenecker, Louise, 114, 177, 261
Séguin, Armand, 268, 269
Sérusier, Paul: colour theory, 174; finances, 174, 248, 273, 300; in Le Pouldu, 158–59, 166; painting lesson from Gauguin, 156, 350;

INDEX

relationship with Gauguin, 156, 158–59, 168, 174, 248, 261, 273; Synthetist group, 157; *The Talisman*, 156–57, 158, 174; "The Temple" cult, 157, 174, 177, 261

Seurat, Georges, 85–87, 116, 316

Sisley, Alfred, 27, 48, 62, 84

Ślewiński, Władysław, 256, 261–62, 265

Société de Publicité Diurne et Nocturne, 83

Société Nationale des Beaux Arts, 188, 283

Spitz, Charles, 155, 343

Strindberg, August: alchemy, 277, 278; amateur theatricals, 275; concerts, 259, 275; *Creditors*, 260; description of, 258; family in Austria, 261, 276; *The Father*, 275–76; finances, 260–61, 276; friendship with Gauguin, 258, 260–61, 276–78; health, 276; paintings, 260–61; photography, 258, 265, 275; preface to Gauguin's auction catalogue, 278–80; religious views, 261; swindled by con-man, 260–61; theatrical successes in Paris, 260

Suhas, Atiti (Aristide), 222–23, 223

Suhas, Jean-Jacques, 222–23

Surrealism, 177

Swaton, Captain, 194, 200

Swedenborg, Emanuel, 276–78

Symbolism: group, 177–79, 181; manifesto (1886), 177; *Mercure de France*, 358; origins, 157, 177; snake symbol, 167; Swedenborgian "correspondences," 277

Symbolist-Synthetists: agenda, 241; Gauguin denies label, 174, 182–83, 247; Gauguin's landscapes, 244; Gauguin's portraits, 123, 124, 247; Gauguin's role, 75, 123, 174, 181, 182–83

Synthetists, 157, 189

Taboga island, 106, 108

Tahiatikiaomata Vaeoho Marie-Antoinette (Gauguin's daughter by Vaeoho Marie-Rose), 342

Tahiti: Bougainville's account, 153, 194–96, 199; capital, *see* Papeete; Chinese community, 202–3, 317; Chinese immigration issue, 317–18; clothing, 199; Cook's account, 196, 199, 245; Cook's voyages, 194–97; financing Gauguin's journey to, 121, 175–77, 182, 188; French accounts of, 153–54, 174–75; French colonial administration, 2, 153, 198–201, 312, 326; French government handbook for emigrants, 174; Gauguin's arrival, 15, 194, 197–201; Gauguin's first visit as a sailor, 40–41; Gauguin's lodgings, 201, 205–6, 208–11, 287–88, 312; Gauguin's paintings, 24; Gauguin's political activism, 2, 316–18; Gauguin's social position, 199–203, 206; governor, 200–201, 204, 205, 224–25, 229, 245, 318–19; houses, 198–99; language, 205–6, 216; legal status of indigenous population, 200–201; "living off the land," 211, 213; marriages, 235–36; Mataiea village, 208–10, 219, 224, 229, 232, 291; missionaries, 199, 200, 208–9, 216, 230, 273, 307; Point Venus, 194; population, 201, 227, 245; royal family, 203–5, 204; sexual roles, 199; Tahitian "village" at Exposition Universelle (1889), 154–55

Tanguy, Pere, 115

Tarawera (steamer), 285

Tardieu, Eugene, 281–84

Tehamana: age, 236; appearance, 232; background, 232, 235–36; character, 291; fear of the dark, 240–41, 243; first meeting with Gauguin, 232–33; *Manaò tupapaú* (*Spirit of the Dead Watching*), 242; *Merahi metua no Tehamana* (*Tehamana Has Many Parents*), 246, 247; photograph, 234; pregnancy, 245, 247; relationship with Gauguin, 232–33, 235–38, 240, 291

Teraupoo, Chief, 287

Thaulow, Frits, 56, 77

Thaulow, Ingeborg (Gad, sister of Mette), 56

The Talisman (Sérusier), 156–57, 158, 174, 261, 321

Tioka Tissot, Gauguin's name-brother in Atuona, 329–30, 350, 353, 357, 362

Titi, 207–8, 210, 257

Tohotaua: adoptive father, 342, 350; appearance, 342; *Barbarian Tales*, 348, 349; marriage, 346, 349; photograph, 343–46, 345; portrait (*Young Girl with a Fan*), 343, 344, 346; relationship with Gauguin, 349

Toulouse-Lautrec, Henri de, 83, 100, 115

Tristan, Flora (grandmother of Gauguin): appearance, 2–3, 186; artistic career, 2; court cases, 3; custody of children after separation from husband, 3, 50; death, 4, 43; description of Lima, 11–12; feminist and libertarian political opinions, 1, 32; husband's imprisonment, 3; influence on Gauguin, 1–2, 44, 315; investigation of London prostitutes, 4–5; marriage, 2, 30–31; monument in Bordeaux, 5; political career, 1, 3–4; publication of *L'Union ouvrière*, 1; relationship with George Sand, 6; shot by husband, 3; statue in Paris, 1; swindled out of family inheritance, 5, 8; writing and reporting, 1, 3–4, 44, 315

Tristán-y-Moscoso, Don Pío (great-great-uncle of Gauguin): appearance, 8, 12; career, 8; death,

18, 19; estates and mines, 9; family network, 8, 11, 35; family wealth, 8, 31; Lima house, 9–10; portrait, 10; relationship with Aline, 8–9, 12, 15, 18; relationship with Gauguin, 8–9; will, 18; workforce, 11
Tristán-y-Moscoso, Mariano (great-grandfather of Gauguin), 8
Tristán-y-Moscoso family, 5, 7–8, 18
Trollope, Adolphus, 92
Turner, J. M. W., 16, 70–71

Uribe, Juan (brother-in-law of Gauguin), 82, 104, 107, 249
Uribe, Marie (Gauguin, sister of Gauguin): appearance, 35; birth, 1; career, 104; care of nephew Clovis, 82, 87; character, 35, 45; childhood, 11, 15, 17–18, 21, 26, 138; education, 18, 36; finances, 15, 249, 251; husband's position in Panama, 104, 107; life in Colombia, 249, 251; life in Germany, 104; marriage, 82; Paris home, 82; social life, 36, 45; wartime life, 43

Vaeoho Marie-Rose, 341, 342
Van Gogh, Theo: arranging for Gauguin to live with Vincent, 122–23, 148; career, 115; control of Vincent's work, 150; death, 175; Gauguin's agent, 115–16, 126, 140, 150, 161; health, 175; letters from Gauguin, 137; letters from Vincent, 127, 130, 134, 173; letters to Gauguin, 148; letters to Vincent, 148; living with Vincent, 123, 134; relationship with De Haan, 164; suggests printmaking to Gauguin, 148; view of Gauguin, 104; view of Gauguin's work, 115; Vincent's death, 173; visit to Arles, 140; widow, 244, 263
Van Gogh, Vincent: appearance, 125, 126, 129, 130, 138, 160; art studies, 115; Aurier essay on, 178; collection of Japanese prints, 133, 148; "colour gymnastics," 127; death, 173, 175; drinking, 137; ear-cutting incident, 139–45, 147, 160, 225; exchanging pictures with Gauguin, 115, 123–26, 159; exhibition at the Haagse Kunstkring, 244–45; friendship with Boch, 176; Gauguin's arrival in Arles, 126–30; Gauguin's memories of, 314, 358; horror of weapons, 126–27; house in Arles, 118, 126–28; *japonisme*, 100, 132–33, 148, 153; letters from Gauguin, 118, 120, 127, 142–43, 164, 165; letters from Theo, 104, 148; letters to Bernard, 134–35; letters to Gauguin, 122, 142–44, 148, 172; letters to Theo, 127, 129, 130, 134, 143–44, 148, 172; living with Gauguin in Arles, 57, 122, 133–34, 136–39; living with Theo, 123, 134; mental problems, 122–23, 127, 129, 136–39, 144; Painters of the Petit Boulevard exhibition, 114–15; painting with Gauguin, 130, 144; paints, 126, 127, 129, 133, 143; plans for twelve disciples (Studio of the South), 122, 124, 127, 132–33, 140; Prado debate, 145; religious views, 122–23, 126, 134–35, 144, 160, 168, 173; reviews, 150; sex life, 126, 134–35; skies, 198; untidiness, 127, 128, 133; view of Gauguin's appearance, 94; view of Sérusier, 174; works: *The Bedroom*, 128, 129; *Falling Leaves* (*Les Alyscamps*), 130, 132–33; *Gauguin's Chair*, 138; *The Kelp Gatherers*, 164; *The Langlois Bridge*, 244; *The Night Café*, 137; *The Poet: Eugène Boch*, 176; *Poplars*, 244; *Self-Portrait Dedicated to Paul Gauguin*, 125, 126; *Sorrow*, 244; *Sower with Setting Sun*, 120, 129, 263; *Still Life with Two Sunflowers*, 115; Sunflowers series, 127–29, 244; *Van Gogh's Chair*, 138; *The White Orchard*, 244
Varney, Ben, 327, 329, 341, 357, 358, 360
Verlaine, Paul, 177, 180
Vernier, Paul-Louis, Pastor, 352–53, 360, 362
Vire (schooner), 194
Vollard, Ambroise: exhibition of Gauguin's ceramics (1903), 104; exhibitions and sales of Gauguin's paintings (1897,1898), 319; financial agreement with Gauguin, 321, 341, 351; gallery, 104, 319; introducing Annah to Gauguin, 262; relationship with Gauguin, 262, 319, 342
Volpini café exhibition (Groupe Impressioniste et Synthésiste), 150–51, 157, 159, 268, 320
Vos, Hubert, 93, 95
Vuillard, Édouard, xiv, 157

Wagner, Richard: Gauguin's view of, 74–75, 166, 167, 257; Molard's performances, 257, 259; quoted by Gauguin, 166, 170; *Ring* cycle, 227, 257; synaesthesia, 74, 180; on the true artist, 74, 167; on will and representation, 168
Wildenstein Plattner Institute, xiv, 365

Zola, Émile: *Au bonheur des dames* (*The Ladies' Paradise*), 34; description of Paris, 28; friendship with Cézanne, 27; Gauguin on, 248; on Impressionism, 63; novels translated by Mette, 184; painting, 27; on women's fashion, 34, 51; writings, 154
Zorrilla, Ruiz, 77, 83
Zunbul-Zadi (pseudonym of Gauguin), 86–87, 316